Music and Media

Music
and Media
in the Arab World

Edited by
Michael Frishkopf

The American University in Cairo Press
Cairo New York

First published in 2010 by
The American University in Cairo Press
113 Sharia Kasr el Aini, Cairo, Egypt
420 Fifth Avenue, New York, NY 10018
www.aucpress.com

Chapter 1 was translated from the Arabic by Marwa Zein Nassar. Chapters 3, 6, 12, and 14 were translated from the Arabic by Somaya Ramadan.

An earlier version of Chapter 2 appeared as "Arab Music Video and Its Implications in the Realm of Arab Media." *Global Media Journal* 3 (5) (Fall 2004), http://lass.calumet.purdue.edu/cca/gmj/fa04/graduatefa04/gmj-fa04grad-aziz.htm. Reproduced by permission.

An earlier version of Chapter 6 appeared as "Musiqa al-shari': qissat barnamij tilifizyuni," in *Amkina*, no. 8 (June 2007). Translated and reproduced by permission.

An earlier version of Chapter 8 appeared as "al-Fidyu klib wa-l-jasad wa-l-'awlama," in *al-Ahram*, April 8, 2004, and subsequently as "Ruby and the Chequered Heart" in *Al-Ahram Weekly*, March 12–23, 2005, Issue no. 734. Reproduced by permission.

An earlier version of Chapter 10 appeared as "Video Clips and the Masses: 2 Worlds Apart." *Daily Star* (Beirut), June 10, 2004. Reproduced by permission.

An earlier version of Chapter 11 appeared as "What Would Sayyid Qutb Say? Some Reflections on Video Clips." *Transnational Broadcasting Studies*, no. 13. Reproduced by permission.

An earlier version of Chapter 14 appeared as "Sawarikh al-ithara al-musawwara min Bayrut ila al-Qahira," in *al-Mustaqbal*, October 1, 2003, Issue no. 1414, Culture and Arts section, p. 20. Translated and reproduced by permission.

Dar el Kutub No. 4108/09
ISBN 978 977 416 293 0

Dar el Kutub Cataloging-in-Publication Data

Frishkopf, Michael
 Music and Media in the Arab World / edited by Michael Frishkopf.—Cairo: The American University in Cairo Press, 2010
 p. cm.
 ISBN 978 977 416 293 0
 1. Music—Arab countries I. Frishkopf, Michael (ed.)
 780.953

1 2 3 4 5 6 15 14 13 12 11 10

Designed by Adam el-Sehemy
Printed in Egypt

Contents

Cultural Critique, Cultural Analysis

Contributors

Moataz Abdel Aziz is an adjunct faculty member and audio-visual supervisor at the Department of Performing and Visual Arts, the American University in Cairo. He is a composer, audio and video editor, cinematographer, instructor, and technical consultant.

Wael Abdel Fattah is a writer, critic, and journalist (Cairo). Well-known throughout the Arab world, he has served as journalist and editor at a number of periodicals, including *Sawt al-umma*, *al-Fajr*, and *Rose al-Youssef*. In 2006 he became head of the Cairo office of Lebanon's *al-Akhbar* newspaper. He also wrote a number of episodes entitled *al-Abb al-ruhi* (The Godfather) in 1998 about Fouad Haddad, Zaki Tolaymat, and Zakerya Al Hegawy, followed in 2006 by a documentary called *The History of Short Films,* a production of Al Jazeera. He was a member of the judges committee for the Beirut Festival for Documentaries. In 2005 and 2007, he published two books about the lives of the two well-known critics Samir Farid and Kamal Ramzy. His first collection of poetry, entitled *Kassala* (Lazy People) was published in 2006 on the Internet, followed by a new collection of poetry, entitled *al-Gharam* (Passion) published by Dar al-Nahda al-'Arabiya in 2009.

Yasser Abdel-Latif is a writer and journalist (Cairo). He graduated from Cairo University with a degree in philosophy. An established literary figure, his novel, *Qanun al-wiratha* (The Law of Inheritance, 2002) received the Sawiris prize for literary creativity in 2005, and was translated into Spanish as *Herencias de el Cairo* in 2007. His two collections of poetry are entitled *Nas wa ahjar* (People and Stones, 1995) and *Jawla layliya* (Noctural Round, 2009). Yasser has published literary texts, articles, and translations in magazines such as *Rose al-Youssef*, *Akhbar al-adab*, *Akhir sa'a*, *al-Fann al-sabi'*, *al-Kitaba al-ukhra*, *Zawaya*, and *Amkina*, and has written scripts for a number of documentary films: *No One Came Back* (2007); *The Eagle Road* (a Hot Spot Film production for Al Jazeera Channel, 2004); and *An Upright Citizen from Maadi* (2002). The latter film was shown at the al-Ismailiya Short Film Festival; the Arabic Film Biennale, Institut du Monde Arabe (Paris); and the Nova Cinema, Brussels, Belgium (2004). He works as a scriptwriter at the Egyptian Radio and Television Union, where he has prepared many television shows about music and cinema in Egypt for the Nile Variety Channel.

Walter Armbrust is the Albert Hourani Fellow of Modern Middle Eastern Studies at St. Antony's College, and university lecturer in Oriental studies, University of Oxford (UK). He is the author of *Mass Culture and Modernism in Egypt* (1996) and editor of *Mass Mediations: New Approaches to Popular Culture in the Middle East and Beyond* (2000). He has written numerous articles and book chapters on popular culture and mass media in the Arab world. Dr. Armbrust is also a senior editor of the electronic journal *Arab Media and Society* (http://www.arabmediasociety.org/). The working title of his current research project is "A History of New Media in the Arab World."

Tamim Al-Barghouti is a poet, journalist, political scientist, and musician. A Palestinian, he was born in Cairo, Egypt, in 1977. He studied politics at Cairo University, the American University in Cairo, and Boston University, where he received his PhD in 2004. Tamim has published five poetry collections and two academic books on political theory and Middle East History, including *Fi-l-Quds* (In Jerusalem, 2008), *Maqam Iraq* (The Iraqi Ode, 2005), and *The Umma and the Dawla: The Nation State and the Middle East* (2008). Besides his performances in many Arab countries, Tamim is also known as a columnist for the Lebanese *Daily Star*, where he wrote a weekly feature on Arab culture, history, and identity in 2003 and 2004. After working at the United Nations (Division of Palestinian Rights, Department of Political Affairs) in

New York, he was appointed an assistant professor of political science at the American University in Cairo. In 2005–2006 he joined the United Nations Mission in Sudan, becoming a fellow at the Berlin Institute for Advanced Study and a visiting lecturer at the Free University in Berlin in 2007. Al-Barghouti is currently Visiting Professor of Political Science at Georgetown University, Washington, D.C.

Elisabeth Cestor is a researcher, SHADYC (Marseille). She has a PhD in sociology, and is a correspondent member of the research laboratory at Sociologie, histoire, anthropologie des dynamiques culturelles (SHADYC) of the École des Hautes Études en Sciences Sociales (EHESS, France). She works for the review *La pensée de midi* (Actes Sud) and is an expert in the study of world music, in particular that of the Mediterranean.

Hany Darwish is a writer, journalist, and cultural critic (Cairo). He is an editorial coordinator at *al-Badil* newspaper in Cairo, and has written a number of scripts for the Egyptian Radio and Television Union, such as "Mulid gabal al-tayyer," "Ibtisamit al-sendbgad," and "E'shek al-dafayer," and published an article entitled "Rayya and Sekina: Eighty-Five Years of Jaded Adaptation" in *Alif, Journal of Comparative Poetics*, No. 28 (2008). In 2008, at Ashkal Alwan Forum (Lebanon), he gave a lecture entitled "Cairo Underground: The Mirror of the City Transformations," and has participated in numerous cinema, criticism, and creative writing workshops. Hany is a regular contributor to periodicals of the Arab world, including *al-Mustaqbal* (Lebanon), *Zawaya* (Lebanon), *Bidoun* (New York), and *Annahar* (Lebanon), and also writes for the Now Lebanon Web site (http://www.nowlebanon.com/).

Abdel-Wahab Elmessiri (1938–2008) was professor emeritus at the English department, Ain Shams University (Cairo). He received his PhD in comparative literature from Rutgers University in 1969, and was renowned throughout the Arab world for his research on Judaism and Zionism; secularism and prejudice; Western culture; modernism and postmodernism; literary theory; and comparative literature.

Michael Frishkopf is associate professor at the department of music, and associate director of the Canadian Centre for Ethnomusicology, University of Alberta (Canada). He received his doctorate from UCLA's Department of Ethnomusicology in 1999. His research centers on the Arab music industry,

Sufi music, and sound in Islamic ritual. Recent articles and book chapters include "Nationalism, Nationalization, and the Egyptian Music Industry" (*Asian Music*), "Music" in *The Islamic World* (2008), "Globalizing the Soundworld: Islam and Sufi Music in the West" (in *Sufis in Western Society: Global Networking and Locality*, 2009), and "Mediated Qur'anic Recitation and the Contestation of Islam in Contemporary Egypt" (in *Music and the Play of Power in the Middle East, North Africa and Central Asia*, 2009). Two books are in progress: *The Sounds of Islam* and *Sufism, Ritual, and Modernity in Egypt: Language Performance as an Adaptive Strategy*.

James R. Grippo is a doctoral candidate at the department of music, University of California, Santa Barbara (USA). In the course of his research on *sha'bi*, a relatively new form of popular music in Egypt, James has interviewed stars, working-class musicians, industry professionals, and Egyptians from all walks of life. He has also conducted extensive research on contemporary Arab American music and identity with San Francisco DJs. Recent publications include "'I'll tell you why we hate you!' Sha'ban 'Abd al-Rahim and Middle Eastern Reactions to 9/11" (*Music in the Post-9/11 World*, 2007), and "The Fool Sings a Hero's Song: Shaaban Abdel Rahim, Egyptian Shaabi, and the Video Clip Phenomenon" (*Journal of Transnational Broadcasting Studies,* no. 16, 2006). He plays *oud* and *qanun*, and is currently the *qanun* player for the UCSB Middle East Ensemble and Souhail Kaspar's Near East Ensemble.

Walid El Khachab is associate professor of Arabic studies at the department of languages, literatures and linguistics, York University (Canada). He received his doctorate from Université de Montréal (Canada) in 2003, with a dissertation entitled "Le Mélodrame en Égypte," and has published extensively on Sufi motifs in cinema and literature, as well as on Arabic popular culture. His recent publications include a chapter entitled "Ironies urbaines" in the volume *Rira bien . . . Humour et ironie dans les littératures et le cinéma francophones*, and another called "Sufis on Exile and Ghorba: Conceptualizing Displacement and Modern Subjectivity," in *CSSAAME*, 2010, Duke University Press. Ongoing projects include two books: *The Rhetoric of Melodrama* and *Tarjamat al-tasawwuf.*

Patricia Kubala is a doctoral candidate at the department of anthropology, University of California, Berkeley (USA). She has an MA in Religious

Studies from the University of California, Santa Barbara. Her articles on satellite television and music in the Arab world have appeared in publications such as *Arab Media and Society* (formerly known as *Transnational Broadcasting Studies*) and *ISIM Review.*

Katherine Meizel is lecturer in ethnomusicology at the department of music, University of California, Santa Barbara (USA). She received her doctorate from the University of California Santa Barbara in 2007 with a dissertation entitled "America Singing: The Mediation of Identity Politics on American Idol." She holds a second doctorate, as well as a master's degree in vocal performance, from UC Santa Barbara and the San Francisco Conservatory of Music, respectively. Her doctoral research in vocal performance addressed Eastern Mediterranean Sephardic tradition in diaspora and in Western art song settings.

Zein Nassar is professor at and head of the Music Criticism Section, High Institute for Artistic Criticism, Academy of Arts (Giza). He has written a number of books about music in Egypt, including a work on orchestral music and a three-volume encyclopedia about music and singing in Egypt in the twentieth century. He is a well-known media personality, having hosted a number of regular programs on Egyptian radio and television.

Laith Ulaby is an independent scholar (USA). A specialist in the music traditions of the Arab Persian Gulf, he completed his PhD in ethnomusicology at UCLA in 2008. His research interests revolve around issues of cultural policy as well as music and urban space. He has taught at UCLA and University of Redlands and works as a freelance musician in Los Angeles.

Mounir Al Wassimi is a composer, studio director, and a professor at the Academy of Arts (Giza). He is one of Egypt's most highly esteemed composers, with a distinguished record of artistic contributions in musical theater, television, and popular song to his credit. He has served as vice-president of Egypt's mechanical and performing rights organization (SAC-ERAU) and head of the Musician's Syndicate of Egypt. Besides teaching at the Academy of Arts, Al Wassimi owns and directs a professional recording studio in Cairo.

Translators

Marwa Zein Nassar is an editor and translator (Cairo). She graduated from al-Alsun Faculty, Ain Shams University, Cairo, in 2003. After working for two years as a freelancer she joined the Middle East News Agency (MENA) in 2005, as an editor on the English desk.

Somaya Ramadan is a writer, translator, and critic (Cairo). She received her BA from the English Department at Cairo University, and her PhD in 1983 from Trinity College, Dublin. After two successful collections of short stories—*Khashab wa nahas* (Wood and Brass) in 1995 and *Manazil al-qamar* (Phases of the Moon) in 1999—she published a novel, *Awraq al-nargis (Leaves of Narcissus)* in 2001. This pseudo-autobiographical narrative, set between Egypt and Ireland, won her instant acclaim within Egyptian literary circles as well as the American University in Cairo's Naguib Mahfouz Literary Award in December 2001. She is one of the founding members of the Women and Memory Forum, a non-profit organization working on the history of women in the Arab world. Somaya worked as a teacher of English in AUC's Freshman Writing Program from 1983 to 1989, and is currently a lecturer in English and translation at the National Academy of Arts.

Acknowledgments

My sincere thanks to:

The American Research Center in Egypt (ARCE) and the National Endowment for the Humanities for funding my research on music and media in Egypt, 2003–04.

The Social Sciences and Humanities Research Council of Canada for funding further research on music and media in Egypt, 2004–08.

Gerry D. Scott, ARCE director in Cairo, for providing financial and logistical support for the 2004 conference, "Music and Television in Egypt," and translations.

The entire ARCE staff, especially Neveen Serry, Mary Sadek, Susanne Thomas, and Yasser Hamdy, for their support of the conference.

Jere Bacharach and Irene Bierman for sage counsel.

The authors for their contributions, and cooperation throughout the editorial process.

The translators for helping bridge the linguistic divide.

The editorial staff at the American University in Cairo Press.

My wife Iman Mersal, for ever-wise counsel, support, and love; my children, Mourad and Joseph, for their love and patience.

Introduction

Music and Media in the Arab World and *Music and Media in the Arab World* as Music and Media in the Arab World: A Metadiscourse

Michael Frishkopf

The extended title of this introductory essay encapsulates the idea that the volume you're now reading is itself an instance of the phenomenon—the intersection and interaction of music and media in the Arab world[1]—it purports to study and represent, and thus constitutes a valid object of analysis in its own introduction. In other words, this book is about itself, at least in part. Or, inasmuch as most humanistic writing is already metadiscourse, perhaps this introduction could be regarded as a meta-metadiscourse on music and media in the Arab world.

For when 'music' is broadly construed to include 'discourse about music' (and for the ethnomusicologist, indeed for the contemporary music scholar, such recursive breadth is essential) the present volume (published in Cairo, and written by Arabic-speaking authors involved in Arab music) itself appears as a form of 'music in the Arab world,' shaped by, and disseminated through, the Arab print media system (including the American University in Cairo Press).[2]

While the global system of academic publishing is rarely the object of academic studies—*a fortiori* for studies concerned with cultural content (since most academic discourse depends on maintaining a clear distinction between the object of study, and the metalanguage used to discuss it)—the claim of self-referentiality is particularly apt for this volume, which is unusual in the

following regard: a number of its essays were written by influential public intellectuals and critics whose work regularly appears in the popular Arab press, that is, by writers whose work academics would ordinarily situate within the realm of discourse that is the scholarly object of study.

Thus the chapters by Elmessiri, Abdel Fattah, Al-Barghouti, and Abdel-Latif have been previously disseminated (in slightly different forms) through more 'popular' Arab media. These critical opinion pieces, already diffused within contemporary Arab discourse, have therefore already affected perceptions and attitudes of the Arab public (including perhaps Arab musicians), and may even have already impacted (indirectly, at least) the Arab music industry itself. And they are treated as cultural phenomena—as 'data'—by other chapters in this book.

In a further act of self-reference, a number of this volume's chapters explicitly cite the authors of other chapters (or even the chapters themselves) in the same volume (and not only those of Arab public intellectuals), bringing more than half the book into a connected citation network, as shown in Figure 1. This network is only partly the result of prior publication, indicating also parallel social networks among researchers and critics themselves, networks that could easily be extended (especially via significant Arab musical figures, such as the esteemed Egyptian composer Mounir Al Wassimi, scholar-critic Zein Nassar, or composer-technologist Moataz Abdel Aziz—all contributors to this volume) into the broader social world of Arab music media.

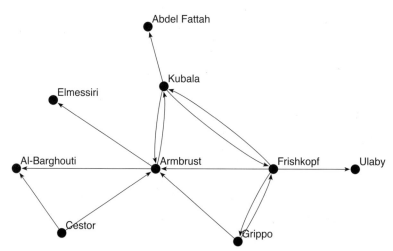

Figure 1. Network diagram indicating inter-author citations in this book (arrows point from citing to cited author).

In addition, the contemporary media are distinctive for their own infinite regress of self-referentiality through the postmodern pastiche (sometimes intentional and ironic, more often not)—the continuous transformation of signifier into signified, the permutation and recombination of media and meaning, the tangle of critique and object, a set of semiological processes already greatly facilitated by technologies of digital cut-and-paste editing across media (text, image, audio, video) in the latter part of the twentieth century, before being massively web-accelerated in the twenty-first. This book participates in these processes, and its introduction celebrates them.

Indeed, the categorical jumbling of discourse and metadiscourse, music and text, Arabic and English, criticism and scholarship, 'Arab' and 'West,' promoted by this book and highlighted in this essay (implicitly an acknowledgement of the futility of their separation), is salutary, I think, as a small but meaningful step toward ameliorating some of the rifts of the postcolonial world, for the unexamined Western claim to the exclusive possession of a scholarly metalanguage (however implicit) is only an echo of a more far-reaching European universalism (however faint).

Beyond its philosophical dimensions, (meta-)metadiscourse also serves as a personal introduction to an intellectual venture whose tortuous course has wound through the past five years of my life.

The genesis of this mediated text, like that of many mediated communications, lay in an unmediated face-to-face social event, a bilingual conference I organized in 2004, on May 19 and 20, with support from the American Research Center in Egypt (where I held a fellowship and served as Scholar in Residence from September 2003 to August 2004), entitled "Music and TV in Egypt: New Directions (a conversation about music, media, technology, culture and society in contemporary Egypt)."

Having spent many years studying music and Sufism in Egypt in the 1990s, I'd returned to Cairo in 2003 with a rather different research agenda. Building on the seminal work of Peter Manuel (1993) and Salwa El-Shawan (Castelo-Branco 1987) I sought to explore the arc of commercial cassette production and consumption in Egypt, from its origins in the 1970s to its contemporary decline in the face of piracy, on the one hand, and competing 'new media'—the Internet, satellite television, mobile phone, and private-sector radio (also 'new' in Egypt)—on the other, initially via a study of Egypt's national recording company, Sawt al-Qahira (SonoCairo) (Frishkopf 2008b).

This new research direction was not unrelated to my earlier work, for since the advent of the cassette medium in 1970s, Egypt, catalyzed by—and embedded in—a radically transformed economic environment (Anwar Sadat's *infitah*)[3] that was suddenly favorable to free markets, global trade, and private enterprise, the careers of some professional Sufi singers (the *munshidin*), formerly constrained to local recognition and performance contexts, were dramatically boosted with the rapid emergence of a private-sector cassette industry, as small cassette producers mushroomed all around the country, as well as with the development of informal networks for cassette recording, duplication, and exchange among fans. Understandably, many of the new cassette producers specialized in precisely those genres of folk and religious sound that had been excluded (implicitly or explicitly) from older state-controlled media institutions: radio, television, and SonoCairo, whose aesthetic filters (enforced by state censors and 'listening committees' charged with maintaining ethical-aesthetic standards) were always informed (indirectly or directly) by the politics of taste (as many of this book's chapters explicate).[4]

But my new topic also resulted from a conviction that as a maturing, socially and intellectually responsible ethnomusicologist I should now finally turn from the music I loved (Sufi music, and the Arab art music heritage called *al-musiqa al-'arabiya*) toward that which enjoys overwhelming social salience today—mediated music—regardless of the degree of overlap between these two categories. It is by means of aesthetic and affective criteria (that is, the music they like) that most ethnomusicologists enter their field, but scholarly relevance, it seems to me, necessitates engagement with the salient socio-cultural phenomena of the day.

Worldwide, mediated music is certainly one of those phenomena, as the current profusion of popular music studies in ethnomusicology clearly attests.[5] As elsewhere, such music (most of it more or less overtly commercial) is omnipresent in Arabic-speaking regions through mass media channels, which have continued to proliferate in number and type over the past one hundred years: analog phonograms (first cylinders, then discs), radio, film, television, cassette tape, VHS tape, CD, DVD, satellite television, mobile phone networks, and the Internet.

Such music is deeply implicated in social, economic, and political networks, both as an expressive medium and as a formative one, though it is only rarely investigated by social science and humanities scholars outside of music studies, perhaps because of music's frequent tendency (as a partly

non-discursive expressive form, disguised as 'mere' entertainment, and often relegated to the cognitive background for both culture observers and participants) to fly under the radar of critical discourse (Frishkopf 2009); perhaps because (and perhaps for similar reasons) within academia, sonic culture (like film soundtracks) is (wrongly) perceived as secondary to the more explicitly semiotic realms of text and image (Bull and Back 2003), which are also always more compatible with academia's own preferred communicative media (speech-text-print), and thus more 'visible' through the scholarly 'lens' (and such visual metaphors are themselves telling);[6] or perhaps because many social scientists and humanists feel themselves (rightly or not) incompetent to investigate it.

Since the onset of media technologies, Arab scholars, intellectuals, music connoisseurs *(sammi'a)*, trained musicians, and social conservatives have frequently criticized newly emerging mediated music as aesthetically inferior and low-brow, overly commercial, excessively Westernized, even dissolute. The social importance of this music thus tends to be downplayed (if not decried) by those eager to assert what is sometimes assumed to be 'timeless' Arab 'art' or 'classical' traditions (the *turath*, or heritage) of *al-musiqa al-'arabiya* in its stead, though ethnographically *turath* is a highly chronocentric term, a temporally moving target observed, nostalgically, as those genres or styles preceding—by a generation or two—music popular among those who are presently young.[7]

Furthermore, the supposed 'timelessness'—both in the Arab world and elsewhere—of pre-mediated music can, on the contrary, often be dated precisely to the onset of technological mediation, due to media's ironically twinned effects of both rapidly transforming, and preserving (usually for the first time) musical sound.[8] Technologies of mass media (typically linked to nationalist agendas and sentiments, especially in the postcolonial world where such agendas have been particularly urgent) therefore always generate profound nostalgia for whatever unmediated musical phenomena they happen to encounter first, by fashioning, out of the flux of such phenomena, durable mediated objects later assumed to represent the infinite expanse of an unmediated past, before socially marginalizing those same objects within a new mediated music system centered on the moving target of current musical fashion. Within a widely diffused scholarly discourse (for example, Touma 1996, chapter 1), later mediated music is therefore regarded principally in negative terms, except insofar as it is capable of preserving purported musical timelessness, despite the fact that media always play a

critical (if well-disguised) role in the cultural invention and maintenance of 'classical,' 'roots,' and 'folk' categories.

Such negativity is itself worthy of study, linking as it does advocates of Arab nationalism with a late Orientalist discourse of the West adhering to a decline-theory of Arab culture and civilization, and perhaps resulting also from something similar to what Rashid Khalidi terms the "heady influence" of nationalist ideologies on scholarship itself (Khalidi 1991, 1364), in favor of music which elite Arab discourse itself deems worthy of support. Thus only lately has the mainstream of Middle East studies (scholars of history, literature, politics, and, to a lesser degree, anthropology) turned toward fuller consideration of currents of mediated popular and transnational culture (Abu-Lughod 1989, 1997; Beinin 1994; Booth 1992; Cachia 2006; Gershoni 1992; Ismail 1998; W.F. Miller 2002; Mitchell 1989; Saada-Ophir 2007; Shannon 2003b; Shechter 2005; Sreberny-Mohammadi 1990; Starrett 1995; Stein and Swedenburg 2004; Tucker 1983; Wedeen 2002).

A systematic analysis of the relation of media and music throughout the Arab world is a large undertaking, much bigger than the project that culminated in the present volume. A plurality of extant scholarly sources concerns Egypt, which has in any case remained—until quite recently—the undisputed center of music production, and which provides a ready source of examples illustrating the principal socio-musical trends of the past hundred years or so.

Since the turn of the twentieth century, increasingly rapid musical change—in sonic content, social relations, and cultural meaning—has been tightly connected to developments in the nature and extent of media in the Arab world, themselves responding to shifting technological, economic, legal, and political environments, and incorporation within a global media economy. At the same time, the centrality of music within audiovisual media—particularly radio, cinema, and television—has shaped production formats and pushed technological adoption. As authors in this volume argue, music media reflect, form, contest, and reimagine social realities, providing key affective indices linked to the formation of social networks (real or virtual), cultural trends, and individual identities. Music media also become objects for *public discourse* (and such discourse is also 'music,' broadly speaking) carried by many of the same media channels carrying music itself.

In Egypt, print publications about music—scholarly, technical, pedagogical, and popular—date from the late nineteenth century (such as *al-Muqtataf*; see Racy 1985, 166), while foreign companies (initially, British Gramophone)

produced the first audio recordings around 1904, supporting an expanding, literate, increasingly affluent musical culture, and the advent of musical stars enjoying previously inconceivable celebrity (Racy 1978).

But music itself was rapidly changing as a result of such mass dissemination. For instance, improvisation and extended performer-audience interactions in live musical performance had supported an emotional resonance known as *tarab*. Early mechanical recordings—limited to a few minutes of sound and a small musical group performing directly into a horn, and separating performer from listener—may have preserved instances of nineteenth-century melodies and rhythms, but the evolution of this technology radically transformed musical sound and practice, ultimately undermining the *tarab* aesthetic (El-Shawan 1980, 91–93; Frishkopf 2001; Lagrange 1994; Racy 1976, 1977, 1978, 1985, 2003; Sawa 1981; Shannon 2003a).

Despite a downturn in the 1930s–1940s, phonogram production continued uninterruptedly into the 1970s (when cassettes took over), shifting from

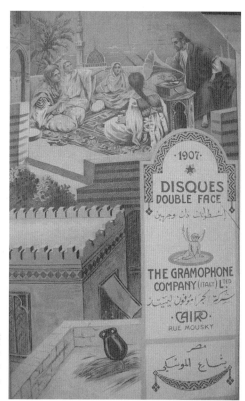

Figure 2. The Orientalist cover of a 1907 Gramophone Company catalog from Cairo. Photograph by Michael Frishkopf, from EMI Group Archive Trust, Hayes, UK.

cylinders to brittle shellac discs to flexible LPs, though playback equipment was never widespread in private homes due to its relatively high cost. As with cinema, phonogram-mediated musical consumption tended to occur in public spaces, primarily cafés *(ahawi)*, where radio and phonograph extinguished live music, and associated genres and careers.[9] (See Danielson 1997, 85; El-Shawan 1980, 91–93, 109–10, 112; Reynolds 1995, 106.)

Radio-broadcast music flourished in Cairo starting in the 1920s via private operators, while the Egyptian national radio service was established in 1934. Radio facilitated longer performances (though phonograms were often broadcast, too) and wider listenerships, but also restricted *tarab* and catalyzed further change (El-Shawan 1980, 94–95). As for phonograms, radio audiences were initially constrained by cost, though again cafés could broaden them. Battery-powered transistor radios, introduced in the 1950s, rendered the medium more widely accessible (Boyd 1993). (See Nassar in this volume.) Recording and broadcast studios, having become central nodes in musicians' social lives, strongly shaped their social networks, leading for instance to the meeting of prominent singers from Iraq and Egypt (see Ulaby in this volume).

But it was not only new media 'hardware'—technology—from the West that impacted Arab music in the twentieth century, but media 'software' as well, including increasingly audible sounds of Western and global musical trends (for instance, the worldwide sweep of the Argentine tango (Frishkopf 2003, 155)).

Radio broadcasts of Arab popular music also began to colonize the unmediated traditions of folk music production, long before the mediation of those traditions themselves. For instance, rural performers incorporated urban musical materials (melodies, texts, instruments) into their repertoires, a means of appearing modern and pleasing audiences increasingly accustomed to radio-transmitted urban sounds.

Less audibly, the same period also witnessed the importation of legal frameworks and organizations regulating ownership and use of mediated music objects in the Arab world, protecting the rights of mediated artists, but also defining and promoting the legal existence of artistic roles and aesthetic objects based on Western models for popular music production, and hastening integration with the global media economy.

According to such models, each performance (live or recorded) should be based on an underlying 'song,' with two creators—a composer *(mulahhin)* and a lyricist *(mu'allif)*—who hold performance and mechanical reproduction rights

to their works, while the recordings themselves are protected by other legislation. Throughout most of the Arab world, legal frameworks were modeled on French law, and new rights organizations (such as Egypt's SACERAU (Sociétés des Auteurs, Compositeurs et Editeurs de la République Arabe d'Egypte)) affiliated with the French SACEM (Société des Auteurs, Compositeurs et Editeurs de Musique), which continues to compute royalty distributions for Arab artists to the present day (Castelo-Branco 1987; Frishkopf 2004c; Racy 1978, 49).

These models and corresponding legal frameworks were developed within contrastive musical systems and economic environments of the industrialized, colonizing world. Introduced into the Arab world they tended to reproduce (alongside other colonial reproductions) the categories of those systems in a dissimilar socio-cultural environment, featuring, for instance, different divisions of musical labor and different concepts about musical products. Arab musical specializations had tended to be concentrated in a single individual, often a singer/performer/composer. As most music was not notated, the composition was not reified as a completely independent aesthetic object, but rather blurred into its performances, which were often improvised to some degree. The new legal framework required the differentiation of a fixed composition, independent of performance, and rights were attributed to its putative creators (composer and lyricist). Fully improvised genres (the vocal *mawwal* or instrumental *taqsim*) clearly didn't fit this model; at SACERAU, improvised performances were assigned a null composer—the 'heritage' *(turath)* (Frishkopf 2004b). This attempt to delineate 'composer' and 'composition' challenged the traditional musical system, and could even induce conflict. The celebrated Egyptian singer Umm Kulthum, for instance, often asserted ownership of the songs she sang, as her interpretations were central to the final product, but legally they were not hers.

Such changes in musical categories and roles were only proximately due to imported legal frameworks. More generally, they accompanied the absorption of Arab music within a global music media system, a system undeniably shaped by Western culture, but equally propelled by a supracultural economic logic: the drive for standardization, efficiency, and profit. As in the West, the evolution of that system has gradually entailed greater division of labor in music production, leading to increasing specialization, decreasing performer freedom (for instance, the decline of improvisation), and ever-larger production teams, partly obscured behind the singer-star, in order to maintain the mystique of individual talent. Today's cassette labels

explicitly divide artistic credit among singer *(mutrib)*, composer *(mulah-hin)*, lyricist *(mu'allif)*, arranger *(muwazzi')*, sound engineer *(muhandis sawt)*, and producer *(mudir al-intaj)* (cf. Marcus 2007, 168; Castelo-Branco 1987, 38–39); in this volume, Wael Abdel Fattah insightfully observes that a singer's agent *(mudir a'mal)* now plays a pivotal career management role (for example, selecting repertoire, creating an image, even sculpting a body) analogous to that of the composer in earlier times. With the advent of music videos (since the early 1990s), there has been a sharp increase in the number of music production roles, primarily executive producer, agent, and direc-tor (Rizk 2009, 344), but also cinematographer, choreographer, dancer, set designer, makeup artist and—arguably—actor. As in the West, even visual and auditory roles are separated; Arab music connoisseurs and critics bitterly complain that female singers are selected more for looks than for musical talent, and studio-manipulated vocals (such as pitch correctors) are increas-ingly common (and necessary!).[10] These changes have been driven by musi-cal mediaization and commodification, as well as a concomitant enmeshing within a global music system dominated by the West.

While the boundary between 'art' and 'popular' music is not clearly defined in the Arab world (Racy 1981, 6), a sharper boundary between 'popu-lar' and 'religious' gradually emerged, as the latter category could not follow the former's path to the new media-based music economy. The bifurcation between religious and non-religious domains widened via the social process Gregory Bateson identified as "schismogenesis," the progressive polarization of a socio-cultural system (1972), as each domain distanced itself from (and defined itself in contrast to) the other.

Formerly the religious/secular boundary had hardly existed, as the ambiguous zone joining the two musical domains was broad (Frishkopf 2000; Nelson 2001, 153ff). Prior to the music media economy—and even a few decades in—most professional singers trained their voices in the call to prayer *(adhan)*, Qur'anic recitation, or religious hymnody *(inshad dini)*. Such training took place in the mosque, at the *kuttab* (Qur'anic school), or in the Sufi *hadra*, social spaces where great vocal talents could also be discovered and nurtured.[11] Tropes of love and longing abounded in both secular and religious repertoires, the latter understood, metaphorically, in a mystical sense. Amorous songs—not always drawing on explicitly religious poetry—could be performed in religious contexts, where the Beloved was interpreted as God, or His Prophet. Religious genres, such as the Egyptian *tawashih*, were performed for a wide range of non-liturgical events by the

mashayikh, Muslim singer-reciters bearing the title 'shaykh,' who might also perform overtly non-religious material, or even move entirely to the secular side, while retaining their titles: Shaykh Zakariya Ahmad, Shaykh Sayed Darwish. Religious training confered an ethical-musical authority, legitimacy, and authenticity into the early mediated period (Danielson 1990; Frishkopf 2002a). Sacred and secular song were united by shared social values.

But this state of affairs could not persist. With the rise of a commodified music media economy, and in conjunction with both educational seculariza-tion (and the concomitant decline of the *kuttab*) and Islamic reform (criti-cal of inherited musical-spiritual traditions), the popular music system dis-engaged from religious vocal practice, generating profits by means of sex appeal (especially the rise of the female singing star), a direction the divinely principled religious genres simply could not take. Subject to different values, religious and popular domains became increasingly differentiated, the former necessarily remaining tied to live social contexts (ritual), the latter liberated from them. *Tarab* persisted primarily in the religious domain, where it has continued to serve an essential spiritual function (Frishkopf 2001).

This is not to say that religious genres were resistant to mediaization. They weren't. Early phonograms included religious repertoires, and Qur'anic recitation, Islamic sermons, and religious hymnody (Sufi music in particular) have all thrived on cassette tape (Frishkopf 2000; Hirschkind 2006; Nelson 2001, xxvii) and radio (Boyd 1993, 26); more recently new genres of Islamic popular music (including Islamic music videos) have become very popular. (See Armbrust, Kubala in this volume).

However, within the media domain, differences between the religious and non-religious are now clearly marked, though their shared media space has led to some searing paradoxes. For instance, in the 1930s, Egyptian radio, concerned about immodesty (*'awra*), banned female Qur'an reciters, all the while cheerfully promoting the careers of sultry female stars such as Asma-han (Daoud 1997, 82). More recently, gender marks the differences between audio-visually mediated religious genres and secular music, as the former realizes its value in the media economy: while the new Islamic music vid-eos do not feature women (*a fortiori* the scantily clad dancing girls now *de rigueur* on the secular side), handsome young men are strikingly present. And juxtapositions of these two types—sequentially, from one video to the next on a single channel, or simultaneously, on channels (sometimes owned by the same company) broadcasting in parallel,[12] are starkly ironic.

To return to our history: The Egyptian musical cinema began in 1932 with *Unshudat al-fu'ad* (starring Nadra and Shaykh Zakariya Ahmad, who also composed the music) and peaked in the 1950s. Cinema tended to feature shorter, lighter songs, closely linked to image and drama, suitable for diegetic use. But the urban, public cinema was also a restrictive medium, providing few rural venues and discouraging respectable women, while ticket costs introduced class barriers. Musical film production declined after the 1960s, a result of recently introduced television, and nationalization of the cinema industry (Armbrust 2002, 238; El-Shawan 1980, 93), though these films continue to provide a television staple, and recent years have witnessed a revival of the musical film genre, in which singing stars and film stars become interchangable. Musical film (and especially televised song clips) constructed a new visual dimension of mediated music, emphasizing artist apperance and foreshadowing music videos in the 1990s. (See Nassar, Abdel Aziz in this volume.)

Musical mediation via phonograms, radio, film, and print (with all their intermedia synergies, for example, film songs on radio or LP; newspaper reviews) led to the emergence of an unprecedented star system in the Arab world (Danielson 2002; Racy 1978; Zuhur 2001). Through extensive dissemination networks enabled by these media, spheres of celebrity expanded far beyond what was formerly possible, bestowing upon certain artists enormous quantities of social capital, which could be exchanged for economic or even political capital. Yet mediated fame could also delegitimize; in an environment where music had always been closely tied to socio-religious values and occasions, a strong connection to unmediated musical-cultural value was critical to perceived authenticity. Performers thus have had to navigate a tricky terrain, exploiting the media without appearing to depend on it entirely. In this game, the first generation of media stars—straddling the border between pre-mediated and mediated eras, well-rooted in the former, benefiting from the latter—enjoyed a unique advantage.

After the 1952 revolution, Egypt's president Gamal Abdel Nasser, appreciating the ideological importance of mass media, quickly boosted the broadcast hours and wattage of national radio. By the early 1960s, music from Egypt (and produced not only by Egyptians, but by musicians from throughout the Arab world who gravitated to Cairo as its musical media center) could be heard across a broad swath of the Arab world via short and mediumwave broadcasts, thus becoming the first true pan-Arab music, a category called into existence by mass media.[13]

Pan-Arab music broadcasting during the Nasser era was characterized by a small number of state-owned radio and television channels, dominated by Egypt. This concentrated, state-controlled output tended to unify Arab listeners around a common media experience, to consolidate taste (according to dictates of Egypt's governmental 'listening committees'; see Abdel-Latif in this volume), and to project Egyptian music—especially the great pan-Arab media stars—as a primary affective basis for pan-Arabism.

The stunning success of these stars, especially Umm Kulthum, Mohamed Abdel Wahhab, Farid al-Atrash, and Abdel Halim Hafez, cannot be attributed simply to musical talent, but rather must be viewed as resulting from the power (high) and number (low) of pan-Arab media channels based in Egypt. Furthermore, the same factors that served to elevate particular artists to unprecedented fame simultaneously ensured that others (less talented, less ambitious, or less lucky) would remain obscure. Highly skewed distribution of celebrity is a property of commodified media systems worldwide (mediated celebrity appears to generate markedly scale-free networks—see Barabasi and Bonabeau 2003), but the reduced number of pan-Arab channels during this period intensified the effect in the Arab world.

Perhaps the quintessential example of succesful media navigation was the remarkable career of the Egyptian Umm Kulthum (c. 1904–75), whose immense talent combined with fortuitious birth at the cusp of the media era enabled her to stake a claim to pre-mediated legitimacy (she trained in Muslim vocal traditions), while benefiting enormously from the power of the media era, which developed almost exactly in parallel with her own life, catapulting her to pan-Arab celebrity (Danielson 1997, 196–97). This power was likely enhanced by the limited number of music media channels available up until the cassette era: with so little variety, everyone—young and old, rich and poor—necessarily tuned to the same ones, and Umm Kulthum thereby attained a breadth of fame (across regions, classes, and generations) never achieved before, or since. This social capital rendered her politically influential as well, particularly with President Nasser. Today, many Arabic speakers quip that "there can never be another Umm Kulthum." Perhaps so, but why? Vocal talent is surely available in all societies and eras. However, what may indeed never recur is the media topology that helped facilitate her magnificent career. Without minimizing Umm Kulthum's tremendous musical gifts, it must also be said that no one has been better *structurally* situated to become a media star.

Until the 1990s advent of satellite television, Egyptian broadcasts were entirely controlled by the state, supporting state power.[14] Except in Lebanon

(where private broadcasting has been linked to sectarian politics) the situation in other Arab countries was similar (Boyd 1993). With the recent development of satellite radio and television channels and their expansive viewership, the pan-Arab broadcast music media have become ever more powerful. However, there are new twists. Most new channels are private-sector and transnational, with production and financing distributed across the Arab world, primarily Egypt, Lebanon, Saudi Arabia and the Gulf states, and Morocco, often targeting subregional audiences. Together with the dramatic increase in the number of pan-Arab radio and television channels, audiences have fragmented, stars have proliferated, and pan-Arab stardom has become both more ephemeral and geographically variable than before. With privatization and the absence of direct government censorship have also come market pressures driving the media system toward risqué imagery, though free-market limits are imposed by consumers themselves. (See Abdel-Fattah, Elmessiri, Al-Barghouti, Darwish, Kubala, El Khachab, Armbrust in this volume.)

The history of product (non-broadcast) media in relation to the state is rather different. In the beginning most recording companies operating in Egypt were private foreign firms (with the exception of Mechian's record-pressing operation in Midan Ataba (Racy 1976, 43–44)), until Cairophone emerged as the Egyptian branch of Lebanese Baidaphone, with singer-composer Mohamed Abdel Wahhab as partner (El-Shawan 1980, 109; Racy 1976, 41). Still, most records were manufactured outside the Arab world, and governments controlled imports. In the late 1950s, Egyptian singer-composer Mohamed Fawzy founded Misrphone and Masna' al-Sharq to record and manufacture LPs, the Arab world's first such enterprise, later entering into a partnership with Dutch Philips (through its Egyptian subsidiary Philips Orient). However in 1962 Misrphone was effectively seized as part of Nasser's nationalization program, and reinvented in the public sector as SonoCairo (Sawt al-Qahira) (Frishkopf 2008b). Smaller private labels lacked manufacturing arms.

Thus until the early 1970s, the Egyptian government exerted tremendous control over product media (objects for sale, such as LPs), as well as broadcast media, in Egypt (and therefore over pan-Arab music media as well). Directly or indirectly, the state could manipulate music media in a top-down fashion to promote desired artistic, social, and political values. Government 'listening committees' *(lijan istima')* screened music to be broadcast or recorded for lyrical, compositional, and vocal quality, based on aesthetic and moral criteria, precluding direct market feedback. Private-sector music

production was also affected, through the power of censorship. What wasn't actually produced by the state could easily be controlled via the censor (in Egypt, al-Raqaba 'ala al-Musannafat al-Fanniya), whose criteria (a trinity of sex, politics, and religion), once anticipated by producers, triggered self-censorship in the manner of Jeremy Bentham's (later Michel Foucault's) panopticon, entering (along with market factors) directly into the music industry's aesthetic computations for financial success. While the media certainly effected drastic musical change, particular elements (tonal, rhythmic, timbral, instrumental, social, emotional) of the old *tarab* music were retained in the mediated sphere, forging a distinctive 'Oriental music' *(musiqa shar-qiya)* of intergenerational popularity, what A.J. Racy has termed the "central domain" of the mid-twentieth century (Racy 1981, 12). This mediated musical domain, accompanying a formative period (the ending of colonialism, and the emergence of independent states) of Arab nationalism, henceforth assumed a critical role within nationalist discourse as representing the highest aesthetic-ethical value of the modern Arab musical heritage. (Subsequent musical change thus posed political as well as aesthetic-ethical challenges to the nationalist intelligentsia; see Kubala and Elmessiri in this volume.)

This state of affairs was radically shaken in the mid 1970s, when the state's near production monopoly was undermined by the advent of cassette technology, enabling cheaper and faster production, smaller print runs, and hence an adaptable microeconomy of music (cf. Manuel 1993). Offering both drastically expanded capacity and user choice, cassettes filled the gap between status quo music production, and market demand. Government-owned Sono-Cairo was itself an early adopter. But in the atmosphere of *infitah*, cassette technology led to the proliferation of localized private-sector production, targeting particular market segments, and often keyed to the subregion, city, or even neighborhood of production, fragmenting the broader musical styles (for instance Racy's "central domain") associated with Arab nationalism and pan-Arabism. At the same time, cassettes could enable larger circulatory radii, as migrant workers, for instance, brought cassettes back home from abroad (facilitating significant popularity of certain Gulf stars in Egypt), forming deterritorialized communities of taste. (See Grippo, Kubala, Abdel Aziz in this volume.)

A new generation gap began to open, as the lucrative youth market could be separately addressed. Cassettes were relatively inexpensive, and player-recorders were portable. The new 'cassette culture' expanded via individual bootleg recordings of live events, especially Qur'anic and Sufi recitation

(in which improvisation marked every performance as unique), which were duplicated and exchanged through informal fan networks (Frishkopf 2000; Nelson 2001, xxvii, 235). As the economy became more open, the prices of cassette players (like those of radios or televisions) dropped as well.

During the 1980s, mediated music reception and playback equipment—radios, televisions, and cassette players—rapidly became ubiquitous in Egypt, a result not only of rising consumerism (flourishing in response to an increasingly free-market economy), but of remittances from migrant workers in the Gulf and Iraq as well. By the late 1980s it was unusual for an Egyptian household—even the most modest village home—not to own at least one radio, cassette player, and television. Entering domestic spaces, these media became more widely influential, not only through broader dissemination (especially to youth), but because of the ability (first of cassette, more recently of radio and TV) to adapt to the local environment, through a limited free-market system and higher media capacity: more stations, more channels, and more cassettes. Potential profits increased, and the cassette market expanded rapidly, becoming a veritable 'cassette revolution' (Castelo-Branco 1987).

Meanwhile, live music of performers (whether professional, semiprofessional, or amateur) working entirely outside the music media system (including what is generally known as 'folk' music), formerly sustained by cherished, unmediated oral traditions, began to be extinguished at a precipitous rate. Though revered in theory, in practice most such traditions were either neglected (in favor of more 'modern' mediated music), or absorbed into the media system (and radically transformed—musically, textually, and socially—as a result). Only a few genres (for instance, women's wedding songs and religious liturgies) have resisted this erasure of traditional oral culture, and the concomitant reduction of musical participation to a form of consumption, at least for the vast majority.

Unlike public-sector broadcast media, or even earlier product media, the private sector cassette industry responded rapidly to market pressures, and though the government censor retained the right to refuse publication, refusals were rare in practice (at least in comparison with cinematic censorship), due to high flow (Castelo-Branco 1987) combined with the fact that censorship criteria were not formulated for music per se, but rather for lyrics (see Nassar in this volume). Furthermore, cassette production operated, to a great extent, in an informal or semi-formal economy. The proliferation of duplication equipment (many cassette shops also ran duplication services in a back

room) facilitated circumvention of censorship. As a consequence, a wide range of illegal cassettes—pirated, or not approved by the censors—also flooded the market. Flourishing piracy undermined artist profits, and limited investments of time or money. With such a broad and distributed production base, including the rise of the underground cassette economy, governments lost censorial control, tax revenues, and the ability to protect intellectual property rights (Khalafallah 1982).

Although the new product media model has provided far more market sensitivity than in the pre-cassette era (when virtually the entire music media system responded to state directives indirectly serving political agendas) it has also exhibited features quite different from the music industry of the West. Cassette (later CD) producers—nearly always privately held—have tended to be exceedingly risk-averse. Developing economies meant that prices have had to be kept low. With profit margins so narrow, production investment (in composition, lyrics, musicians, rehearsals, and recording) has necessarily been limited. Low levels of trust in business dealings has entailed artists' understandable insistence on being paid up front rather than receiving royalties computed according to sales (which tend to be drastically under-reported as they are linked to taxation and royalties; see below). Since artists are not co-investing in the production—the artist fee must come out of *expected* revenues—there have been powerful incentives for producers to minimize costs.

Risk-aversion has been exacerbated by lack of market information. Industry sales statistics are not publicly available (Hammond 2007, 177), concealed by producers to avoid taxation and payment of mechanical royalties. As a consequence of limited budgets and authoritarian state suspicion of sociological studies, market research remains extremely rudimentary (Amin 2008). Lack of information produces a conservative, uncreative system. The only reliable market feedback being their own sales, most producers tend merely to imitate the previous hit. Creative investment has been further stifled by high piracy rates (IFPI 2005), which drastically reduce a recorded product's effective shelf-life, at least from a copyright-owner's perspective.

These factors encourage dominant industry players to create inexpensive, catchy albums—typically showcasing a single hit song—aimed at producing a rapidly subsiding flare of sales, thus mitigating the negative consequences of the piracy that inevitably follows in the wake of any successful album. In such an environment, the industry has consistently preferred short songs featuring upbeat tempos, melodic-harmonic clichés, small ensembles, simple

repetitive colloquial texts, and visually attractive singers (depicted on cassette liners, later in music videos), over the longer, slower, audiocentric *tarab* hits prevailing into the early 1970s. Oriented primarily to the youth, such songs are quickly consumed (the metaphor of 'fast food' is oft-invoked (cf. Marcus 2007, 161)), and generally do not sustain extended listening (even by fans). In this way, producers seek to recoup their initial investment as quickly as possible, generating enough marginal profit to fund the next production (Frishkopf 2004c).

What has occurred is not simply a shift from aesthetics to commerce (as some critics would have it), but a transformation in the system's economic logic. In earlier days top composers and poets—such as Riyad al-Sunbati (1906–81) and Ahmed Rami (1892–1981)—labored to create and polish musical masterpieces for top singers, such as Umm Kulthum, a strategy which also brought financial rewards. Rehearsed to perfection by the best musicians, sometimes over a period of many months, this process generated recordings subsequently cherished for years, and steady sales. Even today SonoCairo sells upwards of 20,000 Umm Kulthum songs monthly, on cassette and CD (Castelo-Branco 1987, 37; Frishkopf 2004c).

By contrast, most post-1980 albums have been produced quickly and comparatively inexpensively through studio overdubbing and extensive cutting-and-pasting (literally so, in the era of digital audio) of formulaic melodies, *lawazim* (melodic fills), harmonic sequences, texts, and forms, designed to burst *(yitfar'a')* predictably onto the scene, and rapidly fade. Trendy Western, Caribbean, and Latin sounds and styles (Frishkopf 2003), from rock to reggae, and especially the popular music ensemble featuring guitar, bass, drums, and *org* (synthesizer—see Marcus 2007, 160; Rasmussen 1996) introduced to the Arab world through the same media channels, have become increasingly prominent. The youth audience found the new styles—called *shababi* ('youth') in Egypt (Marcus 2007, 160), *rai* ('opinion') in Algeria (Mazouzi 2002)—an exhilarating and refreshing change, while older listeners complained of declining standards and limited aesthetic range. Gradually a variety of such youth songs came to dominate each subregional soundscape (North African, Gulf, Egypt, Levant, Sudan) as inflected by local aesthetics, constituting the origins of pan-Arab popular music today.

Some of the new Westernized pop music was soon broadcast on radio and television. Conversely *tarab* songs and Qur'anic recitations by famous shaykhs,[15] well-known via radio and TV, were reissued on cassette—along with a much wider selection of reciters than broadcasts could accommodate,

and a broad range of Western music—pop, rock, jazz, classical—as well. But a media schizophrenia also ensued, with the rise of cassette celebrities deliberately unrecognized by 'official' state media, due to perceived ethical, aesthetic, or political deficiencies. Such was often the case for commercial cassette musics more rooted in local, marginal, or rural traditions.

In Egypt, for instance, commercial cassette recordings of *qisa*s (religious stories) or *dhikr* (Sufi music), religious genres that broadcast media authorities judged as not 'properly' Islamic (Frishkopf 2000, 2002a), along with rural folk genres (such as *sira*—see Reynolds 1995, 35), and youth-oriented *sha'bi* pop (see Grippo in this volume; Marcus 2007, 160), sold millions of copies, creating huge stars (such as Shaykh Yasin al-Tuhami—see al-Tuhami 1998; Frishkopf 2002b), who received scarcely any radio or television coverage (though their cassettes were generally approved by the censor). In some cases, cassette celebrities, such as Ahmed Adaweya, were actively excluded by the state media establishment as *habit* (vulgar) (Armbrust 1996, 180; Racy 1982, 401; Hammond 2007, 171; see also Abdel-Latif in this volume). As had happened earlier in the 'central domain' of *tarab*, emergence onto cassette also wrought significant social, economic, sonic, and textual changes to these musical traditions, for instance, enabling far greater accumulations of wealth and fame, attracting a different sort of performer, transforming performer image, emphasizing commercialism, adding studio polish, and adapting musical style to new configurations of audiences, listening practices, and contexts (for example, Reynolds 1995, 96ff). In both live performances and cassette recordings, professional Sufi singers of Egypt, for instance, began to insert melodies of *tarab* songs, well-known from radio broadcasts and cassettes, thereby signifying their musical sophistication, and addressing a new audience conditioned by music media.

Numerous Muslim preachers *(khutaba')* contributed to mediated music discourse with popular cassettes fulminating against singing, though when fulminations extended to the government (and many, such as the infamous Shaykh Kishk, inveighed against both), they became political *personae non grata* and their cassettes—ineligible for publication permits—circulated underground (Hirschkind 2006, 59–60; Kepel 2003, 178, 181).

While the economy of cassettes facilitated a wider array of products geared to market niches, production of imitative youth-oriented hits, the most consistently and broadly profitable domain for active singer-stars, was—at least until the recent decline of music cassettes ("Sharikat kasit ittarrat . . . " 2002; "'Uyun" 2002) and relative rise of religious ones—overwhelmingly

dominant. Yet, despite limited industry investment or creativity, listeners have been empowered by the 'cassette revolution.' Unlike the broadcast media and limited range of LPs, cassettes provide much greater listener control. A diverse musical soundscape arose, varying by social situation, region, and neighborhood, and audibly marking place, context, and taste as diverse cassette musics blared from shops, cafés, restaurants, and market stands. Such sounds could even constitute subtle political messaging (Frishkopf 2009). By contrast, until recently radio music has remained homogeneous.

The Arab world moved only slowly toward adoption of CDs in the 1990s, and in poorer countries such as Egypt optical media have never fared well in comparison to cheaper cassettes, for which a broad base of record/playback technology was already available; in 2007 CDs represented only 5 percent of sales in Egypt, compared to 40 percent in Lebanon (Hammond 2007, 177). Only with the spread of inexpensive computers equipped with optical drives did CDs become widespread, and these days one can purchase pirated MP3 compilations on busy street corners. But by this time digital distribution—satellite television, the Internet, mobile phones—had leapfrogged the CD with audio-visual content (much of it free), foreshadowing the decline of product music media in the West today. A shakeout of the cassette industry ensued; smaller firms closed or were acquired, resulting in a reconcentration of product media production in the private sector.[16]

Despite a briefer history, music on television has arguably produced a more profound social effect by absorbing and exploiting visual as well as auditory perception, ensuring more total sensory attention as well as developing the semiotic potential of the visual medium. In the Arab world these considerations are amplified by television's tremendous social importance, stemming from relatively low literacy ("The World Factbook—Field Listing: Literacy" 2010), the largest proportion of young people in the world (38 percent—see Seib 2005), and a growing social conservatism encouraging women to stay at home, where TV has become the principal conduit for information and entertainment.

Since the first Arab broadcasts in the mid 1950s (Amin 2001, 30), television has played an increasingly important role in disseminating and shaping Arab musical culture. This role has been supported by rapid change in both the technological and economic fields. Throughout the 1970s and 1980s the rates of television ownership, number of channels, and diversity of content all increased rapidly. TV has mediated various forms of "visual music" (see

Cestor in this volume), including musical films (see Abdel Aziz, Nassar in this volume), live concerts, studio performances, talk shows, and singing contests (see Meizel in this volume). Combined with the increasing importance of the private home as site for entertainment–consumption (worldwide, but particularly in the Arab-Muslim world), TV music has loomed in importance.

The TV music effect has recently exploded with the advent of satellite television (Sakr 2007b), and its omnipresent *fidiyuklib* ('video clip'—music video), mostly delivered via 24/7 music video channels. Indeed, the most startling developments in mediated music have followed in the wake of transnational satellite broadcasts starting in the early 1990s (Sakr 2001), particularly private-sector free-to-air channels. Any household, restaurant, or café equipped with a dish and decoder box can receive these channels without subscription; using local distribution feeds (common in densely populated areas), even costs of dish and decoder can be shared by adjacent households. Such channels have not been directly driven by state-sponsored political agendas, nor have they been subject to direct government censorship. As Hussein Amin, professor of media studies at the American University in Cairo (AUC) and chairman of the board of the Egyptian Radio and Television Union Space Committee, has remarked ". . . in the new world of television, censorship basically does not exist" (Forrester 2001).

Undoubtedly the direct, fine-grained censorship that characterized state broadcasting for so many years is much less feasible in the new era of private satellite TV. However satellite owners (primarily governments) can nevertheless implement indirect, coarse-grained censorship, by pressuring program producers ("Najla Takes Off Her Pants" 2006), denying satellite bandwidth (Arab Christian channels reportedly unable to obtain bandwidth on Arabsat or Nilesat have broadcast via European Hotbird), or dropping channels (Basma 2008; Campagne 2008). In Egypt, parliamentary calls to ban video clips would primarily affect terrestrial channels (El-Bakry 2004), however a new charter adopted by Arab information ministers on February 12, 2008 threatens to implement uniform principles for censoring satellite television directly (Campagne 2008; Kraidy 2008a). These moves toward censorship seem primarily designed to preclude political opposition, but once the door to satellite censorship has been opened, cultural censorship may follow. Furthermore, one rationale for the charter—evidently intended to preempt Islamist opposition by gathering support from social conservatives—is an implied crackdown on 'pornographic' video clips (Kraidy 2008a). Here is

starkly revealed the inherent contradiction between the state's political and economic interests, since Nilesat is also intended to be a profitable corporation. In fact one of the advantages privatization conferred upon states is the ability to profit (indirectly) from 'objectionable' musical content while keeping it at arm's length (often, controversial music videos disseminated via state-owned satellites are not broadcast on state-owned terrestrial TV; see El Kachab in this volume). But on the whole, while reports of censorship's death may be greatly exaggerated, the satellite era has undoubtedly liberalized the airwaves.

Today, music in the Arab world has arguably shifted from an auditory to a visual medium, what Walid El Khachab calls "video music" (see El Khachab in this volume). Assisted by electronic manipulations, a singer's visual style and physical attractiveness have become more important than his or her vocal capabilities. Linked to global media, star images are increasingly driven both by Westernized transnational fashion and by economic logic. Both forces point toward eroticization, particularly of the female body (as underscored by most of the chapters in this volume). But whereas in much of the world, street culture imitates media fashions (or vice versa), in the Arab world there is an apparently strange disjuncture between television and street, where constraints of poverty and religious conservatism render televised music images phantasmagoric—more 'alternative to' than either a 'model of' or a 'model for' (to paraphrase Clifford Geertz) public life (see El Khachab, Al-Barghouti in this volume). For women especially it is primarily in the domestic sphere where life imitates art, underscoring the reality of the media as modeling a domestic space (more on this below).

A new pan-Arabism?
The centrality of the mass media, driven primarily by capitalism in search of markets, in the development of 'imagined communities' along linguistic contours has been elucidated by Benedict Anderson (1983). Mass media capitalisms (Anderson's argument centers upon print capitalism) generate 'common knowledge' (that which everybody knows, and which everybody knows is common knowledge) (Chwe 2001) within their span. Extending Anderson's arguments, I suggest that mass mediated music is critical in moving beyond the shared *cognitive* content which is 'common knowledge.' Mass mediated music generates 'common *feeling*,' infusing nationalisms with an essential emotional elan (Frishkopf 2008a) undergirding formation of all imagined communities, a modern, secular substitute for that Durkheimian *collective*

effervescence so crucial to the socially constitutive rituals of face-to-face communities (Durkheim 2001, 162–63, 171).

When media span encompasses a linguistic-cultural region—in whole or in part—common knowledge and common feeling support the realization of that region as a self-conscious community, sometimes interpretable as 'nation.' While media are often deliberately manipulated for this purpose by states, the effect is arguably greater when such communities appear as an emergent phenomenon, that is, when the media effect is bottom-up, as is typically the case for free-market systems, rather than top-down, since the former type typically goes unrecognized by media consumers, who accept it as 'natural' rather than imposed.

The difference between pan-Arab broadcasts in the 1950s–1960s and those of the 1990s–2000s is thus highly significant. The earlier period promoted a top-down pan-Arabism using Egyptian state radio services, especially Sawt al-'Arab (Voice of the Arabs, founded in 1953), through unequivocally ideological broadcasts (Boyd 1993, 28). Depending on terrestrial transmission, these were also limited in span. By contrast, satellite broadcasts have triggered a bottom-up effect. Conveniently, the Arab world fits comfortably within a well-positioned geosynchronous satellite footprint (see Figure 3), such as the Arab League's Arabsat, or Egypt's Nilesat. Hundreds of such free-to-air channels are instantly available across the Arab world, offering a common media experience to millions. 1990s pan-Arab broadcasts are increasingly responding to market forces—even on government channels.

A new kind of pan-Arabism has undoubtedly resulted from this phenomenon, though it is premature to evaluate its extent or ramifications. As defined

Nilesat EIRP contours (dBW)

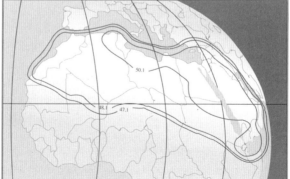

Figure 3. Nilesat's footprint encompasses the entire Arab world.

and promoted by Gamal Abdel Nasser, pan-Arabism was an explicit ideology, defined and promulgated from above, whose decline was marked by military losses in 1967, and the widespread adoption of capitalism in the 1970s. Jon Alterman, Naomi Sakr, and others have suggested that free-market, private sector satellite television, designed for a pan-Arab market and flashing instantaneously across the Arabic-speaking world, may induce a bottom-up, emergent pan-Arabism, drawing together an imagined community of Arabic speakers from Morocco to Arabia through a common media experience (Alterman 2005, 40), allowing Arabic speakers to discover a shared linguistic and cultural heritage, accelerated by the great quantity and speed of information transmitted via satellite television.

Transnational satellite broadcasts, offering diverse, sometimes critical, and even salacious programming, mainly outside the direct control of governments, now provide a free and appealing alternative to the long-established state media fare. Easy profits have driven an explosion of new channels and content, including dedicated Arab music TV channels (most prominently Rotana, Melody, and Mazzika). Besides representing music directly, satellite TV shapes music culture, by driving the socio-cultural and economic transformations within which all music (whether live or broadcast) must now fit. Within the satellite-media capitalism of the Arab world, music appears to play a key, as yet underrecognized, role in the generation of embodied, affective communality.

However, the social effects of satellite-disseminated mass media in the Arab world are complex, particularly in their musical aspect. Applications of Anderson's argument to apparently similar situations, across time, space, culture, and technology, must be inspected carefully. The dissemination of common knowledge throughout a linguistic community does not necessarily give rise to a sense of common identity, particularly when that community exhibits significant dialectical variation. Unified by a common literary language *(fusha)*, the Arab world is also linguistically divided by heterogeneous colloquial languages (sometimes mutually unintelligible), defining a hierarchy of linguistic regions both subdividing and criss-crossing nation states. Less clear, but equally important, are parallel *cultural* differences. Similar complexities of dialect and culture existed in Europe (for example, 'Germany' wasn't speaking a single German). But whereas print capitalism tended to fix and standardize languages (forging 'official' or 'literary' versions), the less formal secondary orality (Ong 2002) of audio-visual media disseminated by satellites is predisposed to express multiple dialects, especially in the Arab

world, with its relatively low literacy rates ("The World Factbook—Field Listing: Literacy" 2010) and high proportion of young people (Seib 2010). Furthermore, while classical Arabic was often sung in the past, colloquial Arabic dialects have enjoyed increasing musical popularity throughout the twentieth century, and enjoy overwhelming predominance today.

Therefore, the social effects of the mass-mediated sung Arabic language are rather ambiguous. Indeed dialect manipulation is an important marketing strategy in contemporary mediated pop music. Egyptian, Lebanese, and Gulf singers frequently adopt each others' dialects (sometimes even mixing them on a single album) to enhance commercial viability across subregions (for example, Lebanese Carole Samaha's recent album in a Gulf accent ("Carole Samaha: The New Face of Fashion" 2005)), though ultimately most pan-Arab popular singers tend to be categorized by subregion, as North African, Egyptian, Levantine, or Gulf, injecting common feeling into regional identities that did not formerly exist as such.

The social impact of mediated musical sound and image is more ambiguous still. Whereas a standard Arabic language (defined by a weighty literary heritage, and the Qur'anic revelation) continues to exist (and is still occasionally sung), Arab music always exhibits a range of subregional styles. Even in the pre-mediated period there was never a single 'classical Arab music.' Like language, Arab musical styles criss-cross national boundaries, and may correlate with class or age. Arab music (considered sonically, linguistically, or visually) therefore inevitably encodes multiple identities; Gulf music contrasts sharply with Lebanese or Moroccan, and each has its own music channels. The new pan-Arab broadcasts have also widened generation gaps that first appeared with the 'cassette revolution' (Usher 2007). Whereas Umm Kulthum and other stars of the mid-twentieth century were beloved by young and old alike, cassettes targeted and nurtured a youth *(shababi)* market, and this trend has continued with video clips. While the youth market dominates, particular programming and channels explicitly target an older demographic, for example, Rotana Tarab, presenting the hits of yesteryear. Televised images—via dance, dress, sets, or landscapes—likewise segment the market; for instance a number of Gulf channels feature traditional folk dances, and the more lascivious clips tend to alienate social conservatives, indirectly delineating an Islamic market.

As a result, mediated Arab music, comprising text, sound, and image, can be socially unifying, or divisive, even when broadcast throughout the region. Pan-Arab music markets do not necessarily serve to unify the Arab world as

a single imagined community, but equally induce a pan-Arab imagination of subcommunities that undermine Arab unity, by underlining subregional differences, generation gaps, religious differences, or national borders. Nationalism may return in force as an economic potential to be exploited by commerical media; this phenomenon is most evident on the singing competition reality shows (for example, SuperStar and Star Academy), associating contestants with countries and pitting them against each other, supported by SMS votes from compatriots back home (Kraidy 2006b; Lynch 2006; MacKenzie 2004; see Meizel and Cestor in this volume). New subregional imagined communities, sharing linguistic and cultural features as well as economic interests (for example, countries comprising the Gulf Cooperation Council, GCC), may emerge, overshadowing national boundaries, without encompassing the entire Arabic-speaking region (see Ulaby in this volume). Pan-Arab broadcasts do not simply unify the Arabic-speaking world by drawing together audiences through free-market processes; while defining a pan-Arab world via communications, they also provide a media space for the negotiation of identities, and differences, even for the formulation of opposition, within that world. Musical globalization (mainly, the inclusion of North American music in pan-Arab broadcasts) also produces ambiguous effects, further discussed below.

Figure 4: Sprouting from every Cairo rooftop: the ubiquitous satellite dish. (Photograph by Michael Frishkopf.)

One may also wonder to what extent pan-Arab channels even generate common knowledge or feeling, simply due to market fragmentation. While satellite broadcasts may be accessible across the Arab world, lack of market research makes it difficult to gauge the extent to which Arabic speakers are actually watching the same channels. Whereas the Arab world is integrated in theory by reception of common channels, it is simultaneously disintegrated in practice by the large number of such channels, increasingly targeting particular population segments. Thus the number of music channels has grown by leaps and bounds—while the four available free-to-air music channels in 2002 consolidated viewer experience, today there are dozens, many specializing in particular music styles and Arabic dialects (for example, Moroccan, Egyptian, Lebanese, Gulf, Sudanese). With market fragmentation, audiovisual musical experience is more divided as well.

Music channels and video clips
In the Arab world, as elsewhere, MTV-style 'video clips' (music videos), watched primarily on free-to-air, privately owned satellite-broadcast dedicated music channels, present a fusion of arts: filmmaking, music, choreography, dance, drama, design (see Abdel Aziz in this volume). Specializations in music production have proliferated apace: directors, cinematographers, and scriptwriters are as important as composers, arrangers, and lyricists. Variable features (dress, folklore, setting, humor, drama, dance, melody, instrumentation, rhythm) may target a particular subregion, age group, or social class. Other features are pan-Arab, or even global, due to common culture, marketing forces, technological resources, and media globalization. Because they are broadcast transnationally, music channel content is not directly regulated by governments, but shaped instead by technology and perceived audience preferences.

The visual dimension of television has become highly appealing, particularly as Arab music TV began to feature increasingly sophisticated, risqué images, based on Western models. As in the West, erotically portrayed female Arab bodies are ubiquitous. But the Arab world, with its stringent standards for public morality and rising religiosity (and sanctimony), has consumed such videos with fiercer debate (see Kubala, Al-Barghouti in this volume). The degree of female eroticism also indexes intra-Arab cultural differences (for example, Lebanon's social liberality versus Gulf conservatism), producing media system synergies (for example, capital from the latter financing production in the former; see Abdel Fattah, Cestor in this

volume). Public debates over morality are crucial to video clip production, because private satellite channel standards are driven by marketing factors (what the audience wants, or will tolerate; see "Najla Takes Off Her Pants" 2006) more than law.

The emergence, over the past ten years, of free satellite music TV in parallel with mobile phone and the Internet has enabled significant synergies to develop among these media. Music production and broadcast costs are borne by advertising and mobile phone revenues. Satellite-delivered 'interactive television' enables viewer participation, via partnerships with mobile phone providers' SMS services. Messaging appears on-screen, or is used to vote in music contests, request clips, or download ringtones. SMS revenues, divided between channel and mobile phone company, cover the costs of many dedicated music clip channels. The synergy between telecom and broadcasting extends to on-screen advertising for mobile phone providers, and mobile phone company sponsorships of live concerts. (See Battah 2008; Khan 2005, 145–46, 263; Kraidy 2008b, 97; Kubala, Grippo, Abdel Aziz, Armbrust in this volume).

Meanwhile, weakening economies throughout much of the Arab world, combined with the availability of free content on TV or the Internet, piracy, and a preference for the visual, has crushed the market for traditional audio product media. Gradually, cassette sales dropped, while in much of the Arab world CDs (and their associated playback devices) were always too expensive for the general populace to afford. By the early 2000s the cassette market was in steep decline, at least for mainstream mass popular music ("Sharikat kasit ittarrat . . . " 2002; "Tawzi' 'al-intirnit' yuhaddid ashab sharikat al-kasit" 2002; "'Uyun" 2002). However, certain niche markets—especially for Islamic sermons (Hirschkind, 2006), Qur'anic recitation (Frishkopf 2009; Nelson 2001), Sufi music (Frishkopf 2002a), and *sha'bi* pop; see Abdel-Latif, Grippo in this volume)—insufficiently served by broadcast media, have managed to thrive nevertheless.

Advertising, self-advertising, and exhibitionism
An advertisement is a symbol in two parts: the first gathers attention; the second redirects it to an object or service for sale. Music and sex are crucial attention-gatherers in most televised advertising today. Video clips— featuring both—are always advertisements, instances of an interstitial category ('advertainment') blurring advertising and entertainment. Clips can be used to sell anything at all as a means of attention gathering, by *sequential* juxtaposition to the commercial proper. *Simultaneous* juxtaposition includes

product placement within the clip, and explicitly commercial clips, featuring product endorsements of singing stars (for example, Amr Diab's advertisements for PepsiCo), often singing songs simultaneously sold as independent musical products (cf. Marcus 2007, 165; see also Cestor, Abdel Aziz, Kubala, Nassar, Grippo in this volume).[17]

More importantly, clips advertise their own content, presenting telephone numbers and codes used to download song media, and pointing to product media as well. Besides every clip's implicit 'buy me' message, product media are also advertised sequentially, via explicit commercials on the same channels. Clips also promote singer–stars directly, along with their other media productions, for instance films in which they play a starring role (and from which video clips are often extracted), or live events. As Hany Darwish observes (in this volume) about Egyptian star Ruby: "In her clip, instead of advertising a product, Ruby herself becomes the product being advertised."[18]

With declining sales, product media, too, have become promotional tools, self-advertisements. Like clips, their importance lies more in their ability to generate symbolic capital (fame) than economic capital (Rizk 2009). Large, highly capitalized, horizontally integrated firms, such as Rotana, can afford to develop exclusive contracts with an entire stable of top singers, whom they promote through their own satellite channels, radio stations, websites, and print media. Resulting symbolic capital is exchanged for cash via live performances at weddings or ticketed events, endorsements, advertisements, or added value in other contexts.

Thus performers and their production companies eagerly produce video clips and provide them to music channels free of charge (Battah 2008), or even pay for broadcast dissemination (Sakr 2007b, 123). With vast distribution, video clips promote singers' careers—and management companies profit from them. Many of these statements may apply worldwide, but take on added significance in a region where the economy and piracy have drastically reduced the profitability of product media.

But music channels are highly profitable, particularly those offering no programming beyond broadcast videos and SMS messages, since aside from an essential layer of human SMS filtration (typically outsourced), channel services can be almost entirely automated, reducing staff to technical operators, yet generating a reported $1 million per channel per month in SMS fees alone, split between channel and mobile phone company. According to Nilesat, approximately sixty music/SMS channels emerged between September 2005 and March 2008 (Battah 2008).

With the gradual victory of capitalist logic over traditional values, explicit eroticism has become an established principle in advertising of all forms, linking the economy to the most reliable of human drives (see Armbrust in this volume). Thus if video clips are auto-adverts, a sexual component is always expected, within audience tolerance.[19] In search of maximal profits, advertisers (music video producers in particular) are continually probing its limits, and thus are guaranteed to provoke public discourse (some of which is captured in this book), particularly in the Arab–Islamic world, with its strong patriarchy and concern for public virtue. Clip eroticism is primarily a visual phenomenon, of bodies and movements, evoking a long history of belly dance in Arab film, yet now incorporating also a more angular, aggressive Western kinesic style (see Darwish in this volume). Unlike Western video clips, with their explicit lyrics, the prevailing light romance of Arab song texts is completely at odds with the erotic video clip imagery they accompany (this phenomenon is particularly clear in Ruby's song "Leh biydari kida"; see Darwish, El Khachab, Elmessiri in this volume), perhaps because verbal limits are more readily defined and enforced than visual ones. As a result music's impact hinges increasingly on its visual aspect; as composer Mounir Al Wassimi states in this volume, "if you close your eyes while hearing a televised song today, you may not feel anything at all."

Criticism of music videos is widespread, but also heterogeneous, critics representing radically different socio-political perspectives, as this volume attests. Clips, and the channels that carry them, have been under heavy fire from social and religious conservatives for illicit public sensuality; from feminist critics, for objectification and commodification of the female body; from nationalist and anti-globalization critics, for cultural imperialism; and from music critics, nostalgic for a romantic audio past, closer to the *tarab* aesthetic, which left more to the imagination (see Kubala, Nassar, Elmessiri, Al Wassimi, Darwish, Abdel Fattah in this volume). Others, including (conveniently) music industry representatives, but also some journalists and academics, uphold video clips as a positive sign of a new liberalism and freedom, even as a secular-liberal antidote to political Islam (Frishkopf 2004a; Khalaf and Wallis 2006; see also Abdel Fattah, Armbrust in this volume). Such critiques resemble those heard in the West. But the socio-political situation in the Arab world is entirely different. Against a backdrop of social conservatism, political repression, and cultural imperialism, eroticism is semantically polarized, carrying strong messages of freedom . . . or of depravity.

Today's video-clip economy is both broad and deep in the Arab world, penetrating public and private spaces via increasingly ubiquitous satellite reception. Cafés that had once displaced live music with phonographs and radio now suspend televisions from ceilings. Predominantly male patrons crane their necks to watch attractive, semi-nude dancing females, rather than look at each another (as they had done when radio or phonograph music provided a sonic backdrop), while fully veiled women pass by in the street. Public standards vary by region, but in Egypt today nearly all women veil in public, *a fortiori* in the more conservative Gulf states, and increasingly among Arab Muslims everywhere. While in Beirut video clip fashion may mirror or model street fashion (as in the West), in most other Arab societies a video clip appears more as an alternative media reality, presenting an escapist, eroticized opulence (see El Khachab, Al-Barghouti in this volume). Public Arab society has thus been filled with ironic contrasts of concealment absent in the West, expressing and shaping the meanings of clips, as well as posing interpretive paradoxes for the observer.

Eroticism and implicit rules against pollution

The central such paradox—how can such a public musical eroticism thrive in conservative societies?—may be superficially understood as a clash of powerful social systems (capitalism versus Islam, global versus local, or 'West' versus 'East'), or, more insightfully, as a swirling manifestation of complex, evolving social dynamics. But how are these clashes and swirls sustained?

Clips are not the only source of paradox. The Arab news media typically discourage female veiling, as a matter of ideological policy as well as profit. Egyptian state television channels have forbidden veiling of female announcers, a means of opposing Islamist currents, though these channels are more conservative with video clips than their private-sector counterparts (see Kubala, El Khachab in this volume). Meanwhile, veiled announcers appear, in Egypt, on *private* sector channels, responding to a market, or expressing other ideologies.

But the ironic contrast between street and media life is more pronounced in music. Despite conservative opposition to sexy clips, they are widely consumed—if not publicly imitated—by the Arab public. There are ironic contrasts between successive channels, one featuring 24/7 music videos with (that ever-titillating cliché) 'scantily clad dancers' in fantastically exotic, luxurious settings (see Al-Barghouti in this volume); the next Islamic, with veiled (or, better, no) women, perhaps even a bearded preacher denouncing

music videos altogether. Sometimes contrastive channels, produced according to a market-segment logic, even form part of the same media empire (for example, Rotana's music, cinema, and Islamic channels[20]).

Not all clips flaunt erotic females, however. Beside a limited number of nationalist, political, or family-values clips are the new 'Islamic video clips,' *al-fann al-hadif* ('art with a purpose') (Kubala 2005), in which sexy female bodies (or even voices) are entirely absent: an Islamic alternative to the Western music video that is nevertheless "like Western pop music, an extremely useful tool for marketing and selling products" (Pond 2006; see also Armbrust and Kubala in this volume). Islamic video clips have proliferated on Islamic channels (themselves proliferating as fast as music channels; see Basma 2008) and even specialized Islamic music channels, such as 4shabab;[21] the biggest star is the British Sami Yusuf, who sings in Arabic as well as English and other languages. Still, as Pond notes, Islamic clips and channels participate in the same techno-economic music system that produces secular pop videos, differing primarily in content. Furthermore, Islamic videos are not bereft of physical beauty—but here it is male beauty, attracting female fans—and once again contrast sharply with unmediated reality, as well as with other media spaces. Yet, a modest *veiled* woman who appeared recently in an unusually realistic music video clip[22]—devoid of anyone 'scantily clad'—stirred more controversy than if she'd been undressed! (see Kubala 2005). One might equally cite the stark contrast between Cairo's lingerie-laden shop windows ("flourishing with panties," as Egyptian poet Iman Mersal has it (2008, 25)) and the street; or the street and the interior of the home. So many paradoxes to unravel!

In all these cases, however, one observes that ironic contrasts appear only *across media boundaries*; in other words the rules of concealment are consistent within each media space. The gyrating dancer does not intrude on the bearded shaykh, nor he on her; they occupy separate but equal domains. Likewise, the clip is utterly unlike real life; it is unmistakably *other.* Here is an unwritten meta-code of symbolic purity, mediating oppositional discursive codes of religion ("thou shalt not . . . ") and capitalism (freedoms of profit and pleasure), by defining disjoint, bounded categories (multiple channels, the street, the home) in each of which different 'codes' apply, with the caveat that such categories *must not overlap*, thus avoiding the dangers of pollution (Douglas 2005). By means of such symbolic compartmentalization is provided a measure of psychic, hence social, stability; indeed, each code ironically *supports* its opposite as a unifying nemesis. The meta-code

protects incompatible categories by forbidding their overlap (which is why the appearance of a veiled woman in a realistic video clip may have caused such a stir). These ironies of contrast can be further resolved on at least two levels: economy, and social space.

From the perspective of economy, contrasting rules for female representations enable highly profitable musical practices to thrive in separate domains, despite Islamic discourses deeply critical of music, *a fortiori* public female singers and dancers (Gribetz 1991; Nelson 2001, 32–51; Shiloah 1997). The media system depends on the maintenance of multiple media worlds, internally consonant, apparently mutually antagonistic, yet ultimately symbiotic. The perception of each such world is cognitively engulfing, stirring a visceral sense of its own rightness, while obliterating the felt truth of any other. Critical faculties thereby disabled, the viewer merely succumbs to the sensory present. The apparent clash of such worlds masks their underlying economic interdependence. While religion and capitalism appear contradictory—the pursuit of profit versus higher principles—their media worlds are mutually reinforcing. Extreme veiling enhances the economic value of the female body, while the unveiled body viscerally legitimizes the social–spiritual value of 'moral virtue.' The apparent visible contradiction between these worlds thus conceals an unacknowledged synergy, by which each world maintains its boundaries (see Al-Barghouti in this volume). A dynamic feedback cycle between the two extremes once again instantiates Bateson's schismogenesis, transposed to the media sphere.

But music videos also penetrate domestic spaces, where they influence a large female audience. Perhaps the cooperative antagonism of apparently contradictory media worlds itself masks their *resolution* in the lived domestic sphere, where life and 'art' are closer than they appear in the street. Conservative Muslim practice only objects to expressions of femininity and sexuality outside of their 'proper' marital boundaries (as interpreted in the *Shari'a*, Islamic law). Thus the contradiction of fully veiled women gazing through "shop windows flourishing with panties" (sometimes inspired by video clip styles!) is only apparent, if such windows are regarded as an economically necessary extrusion of a domestic space into a public one.

Likewise, the apparent contradiction between video clip behaviors and public norms hinges on the assumption that TV is a public medium. However, as television's domestic installed base expanded rapidly from the 1980s onward, penetrating nearly every Arab home, and as satellite receivers have become nearly as ubiquitous, Arab TV has become domesticated as well, all

the more so with the rise of Islamic norms inhibiting public entertainments and female freedom outside the home. While televisions installed in cafés and restaurants broadcast a public semi-nudity to a predominantly male audience, contravening Islamic norms, most TV consumption now takes place in a private domestic space, where the audience is predominantly female. There, in the presence only of close male relations (spouse or *maharim*, those prohibited for marriage) and other females (and sometimes in female-only clubs or even shopping malls), Muslim girls may remove their veils, dress in the fashions of video clips—and dance to their music. Here, females can indeed imitate their favorite singing star, as a domestic intimate, with the virtual reality of video clips coming to life on ever-larger living room screens.

The 'domestication' of televised stars is enhanced by mediated discourse—on TV, radio, in magazines and newspapers—in which music celebrities share intimate details of their lives, rendering the stars as familiar as close friends (see Armbrust in this volume). The ironic intimacy of female media stars, whose private lives are widely exposed, means that these performers—unseeing, but unveiled—come to be accepted as virtual family members, in a domestic space where unveiling and dancing is more acceptable.

The spatial separation of home and street thus provides yet another instance of the 'purity' principle: disjoint, bounded spaces, characterized by contrastive social rules. Indeed the contradiction can be further interpreted in the recognition of the home as a one-way public space, where the entire world is revealed to female inhabitants, as if through a media *mashrabiya*.[23] Formerly known as the *haramlik*, this is a space of one-way visual flow: insiders see out, but no one sees in (see Abdel Fattah in this volume). While unidirectional perception is everywhere a property of broadcast media, in the Arab world, where many women remain at home, it is a particularly significant one. Televised mediation enables even male stars to enter respectably into the home, seen but unseeing, blinded by TV's one-way transmission (just as—in Arab medieval times—blind male musicians were favored in female performance contexts (Touma 1996)). Perhaps the television itself has become a metaphoric veil, its screen analogous to the *sitara* behind which musicians performed in Abbasid times (and in more conservative Arab settings today) (Farag 1976, 204).

Sharper contradictions arise when the female media star is considered as a public figure, broadcast (as she also is) into the public space of the street, violating norms of a different social domain. Here the female singer–dancer invokes another social category—not the intimate friend of the *haramlik*, but

the religiously disreputable persona of female singer or dancer: *qayna, jariya* (Shiloah 1995), *'alma, ghawazi* (Lane 1836), or *raqqasa* (Nieuwkerk 2006), exuding a seductive feminity in total contrast to that of the demure, veiled, virtuous woman (whom she may also entertain), this contrast (in dress, manner, genealogy) serving to ensure the symbolic purity of each category. Threatening, but also titillating and economically valuable, is this performer's implicit challenge to the categorical separation of public and domestic space, simultaneously performing, as she does, in both. Indeed, mediated music stars—public by definition, domesticated by practice—can be distinguished according to the ways in which they mix elements of domestic innocence and public courtesan, for the selected proportions of this mixture are tantamount to a strategy for commercial success.

Whereas the Lebanese singing star Nancy Ajram emphasizes her domestic innocence, with special appeal to younger girls, the Egyptian star Ruby is closer to the public *qayna-raqqasa* figure, appealing to men (and generating considerably more controversy as a result (Comer 2005)). In either case, a categorically threatening admixture of innocence and courtesan, enabled by the sophisticated illusions of media technology, provides a simulated voyeuristic experience of 'ordinary girls singing and dancing,' far more titillating than the gyrations of professional dancers, categorized as such. This fact perhaps helps explain why a professional, such as Lucy, could never compete with a Ruby in the video clip business, the former's far greater dancing talent (and no matter how seductively applied, as in her controversial 2004 clip "Ya imghayyir hali") only serving to classify her all too unambiguously far from the domestic sphere, as observed by Elmessiri in this volume (see also El Khachab, Armbrust, Cestor, Darwish, Kubala, Abdel Fattah, Al-Barghouti in this volume.)

The new synchronousness

With satellites came the resurgence of synchronousness: the communicative condition of distributing and consuming media in lockstep. Before the 1970s, most mediated music was consumed via a few state-owned, free, synchronous broadcast channels (radio, TV), enforcing socio-temporal alignment of listening experiences, as well as state-determined standards of aesthetic quality and moral decency. Asynchronous music media—decoupling distribution and consumption—were limited to phonograms, and relatively less influential, due to cost. Individual media choice was therefore limited, for the most part, to selecting a channel or station from among few options. With

the 'cassette revolution' came a dramatic rise in individual choice, along with widespread asynchronousness.

But choice and asynchronousness could also be decoupled. With the 1990s advent of Arabic channels broadcast, today, from five geosynchronous satellites operated by two Arab satellite organizations—Arabsat (founded in 1976 by the Arab League) with three, and Nilesat (established by Egypt in 1998 as a publicly traded corporation) with two—plus additional channels emanating from European satellites (for example, Hotbird), Arab households can now receive well over seven hundred free-to-air television channels, most of them produced by a market-sensitive private sector, along with dozens of satellite radio channels (Amin 2000; Sakr 2007b; Sakr 2001; Sakr 1999; Hafez 2008).

In Egypt, terrestrial audio has diversified and expanded as well, with the 2003 licensing of two privately managed, privately held commercial stations, Nugum FM (stars FM) and Nile FM, the first such licenses to be issued in sixty-nine years (Sabra 2003; Grippo in this volume). Playing the latest popular hits in search of audience, a government music station (Iza'at al-Aghani, 'Song Radio'), forced to compete, gradually shifted from 'the classics' to similar popular music fare. The new radio content is less determined by censors or taste-arbiters, more driven by commercial considerations. In the mid-1990s Egyptian taxis contained stacks of dusty cassettes, frequently jamming in dusty cassette players. By 2004, cassettes, players, and dust had largely disappeared, as most taxi drivers tuned to the new commercial radio, and participated in a more unified media experience.

However there is a class and religious dimension to the synchronous/asynchronous distinction. First, an active cassette culture has persisted among lower classes, and certain groups of devout Muslims. These include drivers of microbuses—transportation for the masses—whose sonic fare tends to center on *sha'bi* music and taped Islamic sermons not available on synchronous channels (indeed many of these Islamist sermons would never clear the censor).

Second, asynchronousness has developed via the Internet, which has dramatically proliferated among middle and upper classes (and increasingly among lower classes as well) since the late 1990s.[24] But whereas in the West the Internet has enabled a vast and varied indie music scene via Myspace and other 'web 2.0' sites, in the Arab world most online content replicates synchronous channels. A large number of Arab music websites (often linked to channels or production houses) provide MP3s, ringtones, and videos, and Arab youth (as elsewhere) are adept at filesharing as well. Over the past

decade or two, DJs have replaced cover bands (themselves having replaced traditional unmediated music culture only a few decades earlier) at many lower- to middle-class weddings, due to lower cost, and a shift of authenticity (following music media commodification) from 'live performance' to 'original recording.' Only economic elites can afford to hire media stars to perform live, while traditional unmediated ('folk') performers have become increasingly marginalized.[25] But today lower classes in Egypt further economize by loading up a hard drive with downloaded songs, renting a sound system, and deejaying themselves. As was formerly the case for music delivered on cassette or CD, lack of IPR enforcement has contributed to widespread Internet piracy, though many websites formerly distributing illegal free content (for example, mazika.com) have recently begun to comply with copyright laws.

On the whole, however, music consumption has now returned from asynchronous product media back toward synchronous broadcast. Yet the new synchronousness is quite different from that of the old terrestrial radio and TV, in part because the music system has assumed a radically different topology.

New production-consumption topologies

With the advent of satellite television and globalization of the entertainment industry, the topology of the music media system has been transformed. Once governments relinquished full control of music media, and further with the liberalization of many Arab economies, new transnational connections began to link sites across the Arab world in order to optimize financing, recording, and distribution.

Thus whereas up until the 1990s Cairo was the undisputed music and media production center of the Arab world (inducing broad comprehension of the Egyptian dialect), over the past decade or so a networked transnational model has emerged, centered on Saudi Arabian financing and control (Cochrane 2007), production and distribution in the Gulf (especially Dubai), Beirut, and Cairo, and musical talent from everywhere. Egypt, despite its musical riches, is—relatively speaking—materially and technologically poor. While undoubtedly remaining important, Cairo has lost its former political and cultural centrality (see Kubala and Grippo in this volume; Hammond 2007, 13). Lebanon, small but well-educated, well-connected (particularly via an enormous global diaspora), and culturally liberal, has been supplying new musical stars at a rate all out of proportion to its tiny population (see Cestor in this volume). Furthermore Westernized Beirut, ultramodern Dubai, and oil-rich Saudi Arabia are far better connected to the global media economy than Cairo.

There has also been a shift in the topology of consumption. Though most satellite broadcasts are free, advertising and SMS messaging drive content. Egypt provides a large consumer population, but much greater purchasing power is available in the Gulf; most music SMS messages originate in Saudi Arabia and Kuwait (Battah 2008). A consumer sector of growing importance are the populous, prosperous Arab diasporas of Europe, North America, South America, and Australia, many of whom pay high fees to receive retransmitted satellite content via subscription services as a means of staying in touch with the Arab world.

Meanwhile, North Africa, though both receiving and sending pan-Arab broadcasts, is peripheral to pan-Arab music. While North Africans typically know (and may enjoy) the latest Arab Middle Eastern hits just as well as Middle Eastern Arabs, music emanating from North Africa is generally not appreciated in the Arab Middle East due to its unfamiliar dialects and styles.[26] North African singers—such as Warda or Samira Said—have typically relocated to Cairo and sung in Egyptian dialect in order to achieve pan-Arab celebrity. Musically the Arab *Maghrib* is in many ways more closely linked to urban France—through its diaspora, post-colonial connections, and use of French—than to the *Mashriq*.[27] Moroccans, in particular, frequently feel themselves to constitute a distinctive cultural region, more connected, along a north–south axis, to Europe and West Africa, often declaring themselves African but not Middle Eastern. One young Moroccan believes that musical tastes trace "cracks in the pan-Arabic imagery":

> Arabic music is advertised as the music of our brothers and of a dreamed great Arab nation, but when you compare it to Western music, many Moroccans find Arabic music antiquated, full of clichés and, musically speaking, poor. Other Moroccans just don't feel that they are Arab, the majority being of mixed Arab, Berber, and African origins. So they adopt occidental lifestyles more easily and, accordingly, music tastes. (Al-Zubaidi 2006)

The new topology also features integration with global media networks, diffusing non-Arab audio-visual styles (mostly Western, but occasionally from elsewhere too)[28] and productions more widely in the Arab world than ever before. All contemporary Arab pop exhibits strong Western stylistic influence, but several Arab-owned music video channels (such as Melody Hits), present Western video clips themselves, leading to an ambiguous pan-Arab 'common knowledge/feeling' effect: if all Arab speakers watch and

hear the American rapper Baby Bash (currently disseminated on Melody), does this shared media experience reinforce pan-Arabism, or destroy it?

Liberal or conservative?

Undoubtedly the recent liberalized phase of transnational, privatized music media offers many more products than were available in the days of public sector control. However product diversity is not tantamount to anyone's notion of quality, or even improved market satisfaction. More crucially, though productions and stars are unprecedentedly numerous, stylistic diversity is quite limited: music products are exceedingly homogeneous.

Though scientific market research is lacking, countless conversations with Arabs suggest that most adults are not pleased with the range or quality of music productions emanating from the private music sector today—regarding them as trite, uncreative, unmusical, or indecent. There are many songs and stars, people say, but most are crass imitations of one another: they're all singing the same thing. Audiences have little choice, except to listen to older recordings (here Rotana Tarab provides a valuable service). "There are no great singers today," or "what happened to *tarab*?" are commonly voiced complaints. Others appreciate the musical gifts of particular young Arab pop artists (Egyptian musicians frequently commend Sherine Abdel Wahhab and Nancy Ajram as truly talented vocalists), while decrying a music industry that forces them to sing bland pop melodies and flaunt their visual appeal, underutilizing their musical talents and negating the faculty of imagination so critical to earlier romantic song (see Nassar, Elmessiri, Al Wassimi, Darwish in this volume).

Even if the Arab music industry—like music industries elsewhere—centers on profit more than art, why should its productions stir so much discontent? Neoliberalism suggests that free markets should drive the private sector to optimize consumer satisfaction, however lowbrow. Some new media advocates view privatized media in positively Pollyannaish terms. As AUC's Professor Hussein Amin told me, in praise of the liberalized media sector: "the government has to stop forcing people to listen to Umm Kulthum and Qur'an and give them what they want" (Frishkopf 2004a). But while it's quite possible that many people don't want to listen to Umm Kulthum or Qur'an (though many do!), it is illusory for even a neoliberal to conclude that the Arab music system will ultimately give people 'what they want' under the pressure of free market forces, because it's not a liberal system.

I have already discussed many of the factors impeding free market dynamics in music production—piracy, lack of market research, risk aversion, and weak economies. In addition, very few music production companies—even large ones—are publicly traded, precluding shareholder backpressure. Furthermore, most Arab media companies can be established only with the patronage and collusion of political power, whose interests bear heavily on media productions, transcending market pressures (Fandy 2005; Sakr 2007b; Zayani 2004; see Al Wassimi in this volume). Indeed, Mamoun Fandy has argued that the private/public distinction is of limited value in the Arab world (Fandy 2007).

As a result, oligopoly prevails: the four largest music companies control over 80 percent of the market today (Rizk 2009, 343). Powerfully positioned, horizontally and vertically integrated (including production, video clip channels, cassette/CD distribution, radio stations, cinema, endorsements, advertising, live concerts, websites, even music magazines), closely linked to the region's mobile phone companies, and benefiting from resulting synergies, these companies have deep pockets, plenty of star-creation power, and little tolerance for non-exclusive contracts (see Turki 2008).

Saudi-based Rotana—holding vast resources far outstripping those of the competition combined—is the most powerful player of all (Khan 2005, 260–65; Rizk 2009, 345–46). Fueled by massive oil wealth, Rotana is overwhelmingly dominant, with six channels, a record company, a magazine, and roster of top stars (Usher 2007). Specializing at first in Gulf singers, Rotana today has gathered stars from across the Arab world (including 80 percent of Lebanon's Arab repertoire (Harabi 2009, 13))—illustrating a more general Saudi media dominance (Cochrane 2007). Though Rotana is listed on the Saudi stock exchange, its principal is a member of the royal family, and control rests firmly in his hands.

Meanwhile, the Arab 'independent,' 'alternative,' or 'underground' scene, though undoubtedly expanding, is still exceedingly marginal as compared to its Western counterpart, and limited primarily to a narrow elite.[29] While the Web facilitates dissemination of musical alternatives, Internet access is far from universal, and alternative music (particularly heavy metal) is sometimes repressed—for purported moral violations—when politically expedient (Gordon 2008; LeVine 2008; Rizk 2009, 347–48; Tarbush 2007). Amateur music-making has dwindled, due to the power of consumer media, negative attitudes perpetrated by Islam, and a shrinking middle class. For the most part, predictable industry-created stars prevail.

Certainly the erotic images of mediated music are 'liberal' by the stan-
dards of Arab society. Some also see liberalism in the audience empower-
ment enabled by 'interactive television,' allowing viewer SMS feedback in
selection of music videos or voting in music competitions, concluding that
satellite TV has become the Arab world's "virtual Democracy Wall" (Fried-
man 2003). However, such voting is 'democracy-lite,' with most votes cast
chauvinistically (sometimes with state subsidies!) according to identity-
based coalitions (Lynch 2006; see also Meizel in this volume); in so many
ways "voting for a superstar is not the same as voting for an election" (Usher
2007; see also Battah 2008). Indeed, one might easily argue the opposite:
that interactive television delays real democracy with consumerist illusions
of citizen-empowerment that must first be dispelled.

Music's financiers and neo-liberal commentators conveniently inter-
pret lucrative liberalism as an expression of social freedom and progress.
Significantly, two of the region's wealthiest and most powerful communi-
cations media tycoons, Naguib Sawiris (Egyptian) and Prince Alwaleed bin
Talal (Saudi)—both with close connections to ruling regimes—have inde-
pendently justified their business ventures as a tool for promoting social lib-
eralism in the face of religious extremism (Sakr 2007b, 123).

Structurally, however, the underlying music system is profoundly con-
servative, cautious, repetitive; afraid of new musical directions outside the
aesthetic status quo, for the most part even unable to promote artists carry-
ing forward the aesthetics and repertoires of the *turath*, that much-vaunted
repository of the Arab musical heritage. Under such conditions, there can
never be another Umm Kulthum, indeed

The study of the general relation between music and media systems is com-
plex. Such a study includes, centrally, the study of their *intersection*—medi-
ated music, and its multifarious social ramifications. But such a study must
also extend far beyond that intersection to encompass the broader bilateral
interactions between two these two vast, overlapping social systems, consid-
ered in all their cultural, political economic, and technological intricacy.

These interactions include a tremendous range of phenomena. On the one
hand are the general effects of the media (beyond their sonic manifestations) on
music as sound, practice, and discourse: the socio-economic processes of media
system uptake; resulting transformations to musical context, style, form, genre,
timbre, modality, rhythm, poetry, aesthetics, ethics, performance practice, and
criticism; transmutations to creative roles, gender roles, celebrity, norms of

behavior and image, oral traditions, processes of transmission, social networks of artists and listeners; changes to the music economy, the forces and relations of music production, financial flows and concentrations, integrations and synergies, patronage, professionalism, distribution, consumption, and articulations with the global media system; shifts in listening roles and practices, meanings, and experiences; the list is endless.

On the other hand, the relation also entails consideration of the ways in which the music system (mediated or not) has shaped—even driven—the media system and its associated social practices, by embedding music culture within that system (particularly in advertising and cinema) thereby "enticing audiences into unfamiliar terrain" (Armbrust 2002, 233–34), by facilitating intermedia synergies including transfers of celebrity capital, or simply by ensuring profitability, for music channels are among the most lucrative satellite broadcasts (Sakr 2007b, 121).

Beyond the two systems, mediated music powerfully expresses and influences social and material transformation, a key (if often unrecognized) component of formative social practice. While music as a social force—the power of music to shape social relations—is infrequently acknowledged in local discourse, it is demonstrated in practice, all the more powerful for being unrecognized, for "flying under the radar of discourse" (Frishkopf 2009). This much is true everywhere.

But in the Arab world there are special factors modulating (and modulated by) this power: a diversity of musical styles and languages (including multiple Arabic dialects); the recency and complexity of 'Arab identity' (including tensions with religious, national, subregional, and minority ethnic identities—Bedouin, Kurd, Berber, Armenian, Greek, Jew, Filipino, Nubian, South Asian); the lingering effects of divisive colonialism and variable social and linguistic connections to the West; the multileveled role of music (*turath*, rural, or contemporary) in formulating multiple collectivities; a persistent and pervasive patriarchy (Joseph 1996); the quick pace of technological progress (funded by sudden oil wealth); rapid musical change and Westernization clashing with an Arab musical heritage that is symbolically cherished but not always appreciated; a longstanding (and recently intensifying) Islamic opposition to music (Shiloah 1997, Handley 2009); the largest proportion of young people in the world (Seib 2005, 604); relatively low literacy (especially among women); regional political turbulence and instability; widespread authoritarianism (Economist Intelligence Unit 2008); enormous disparities in wealth across class and region; a far-flung and influential diaspora beyond the borders of

the Arab League; and a high level of racism and xenophobia directed against persons of Arab descent, particularly in the aftermath of 9/11.

Thus grappling with music and media in the Arab world is a particularly challenging task. The challenge is not only to gather data over such a large and diverse geo-cultural region (and good data tends to be scarce, well-guarded, or both), but also to intepret that data within multiple fields (social, cultural, religious, economic, political), in a rapidly changing environment. One might argue that the variety of the 'Arab world' and the considerable politics under-lying its conception renders it unsuitably arbitrary as a research domain, except that it has been called into existence—more than ever before—by the media themselves, and by music media in particular.

Nevertheless a number of distinguished scholars of Arab music and culture have successfully taken up the challenge, starting from the earliest media period, the early Arab record industry (Lagrange 1994, 133–214; Racy 1976, 1977, 1978). Much centers on Egypt: Salwa El-Shawan's detailed histories of *al-musiqa al-'arabiya*, in its multiple relations with the media (1980, 1981) and her subsequent study of Egypt's cassette industry (Castelo-Branco 1987); Kristina Nelson's seminal study of Qur'anic recitation (including its mediated forms) (2001); Virginia Danielson's magisterial account of Umm Kulthum's career, including its formulation and dissemination via audiovisual and print media (1997), as well as her insightful look at subsequent popular mediated musical phenomena of Egypt (1996).

Walter Armbrust has provided a compact overview of the media's impact upon music in Egypt (2002), and a number of more extended meditations upon music-media phenomena, especially the careers of two Egyptian musi-cians: *al-musiqa al-'arabiya* singer and composer Mohamed Abdel Wahhab, and *sha'bi* singer Ahmed Adaweya (1996), as well as a piece in the web-based journal, *Transnational Broadcast Studies* (later renamed *Arab Media & Society*), reproduced in this volume. Under Armbrust's editorship, TBS has published a number of other articles centered on contemporary medi-ated music (Grippo 2006; Kraidy 2006a, 2006b; Kubala 2005; Pond 2006). Roberta Dougherty (2000) has provided us with a fascinating glimpse of satirical 1930s print media representations of Egyptian entertainer and impre-saria Badi'a Masabni (c.1880–1972). Scott Marcus highlights media issues in a chapter devoted to contemporary Egyptian pop (Marcus 2007).

Jonathan Shannon discusses music-media issues in Syria, as well as their global projection into 'world music' (2003a, 2003b, 2006), a topic also

covered by Ted Swedenburg (2001, 2002b). Others trace media issues among Arab Jews of Israel (Galit 2006; Swedenburg 1997). David McDonald has analyzed Palestinian rap (2006, 2009), while Oliver and Steinberg examined cassette-based music of the Palestinian intifada (2002), and El-Ghadban has reviewed recordings by important Palestinian artists (2001). Several scholars have inspected music of the North American Arab diaspora, noting the role of the media in maintaining musical connections to the homeland (El-Ghadban 2001; Rasmussen 1996, 2002; Shryock 2000), while others have examined mediated *rai* and rap in constituting Franco-Maghribi cultural identities (Gross et al. 1992). Numerous studies (Armbrust 1996; Asmar and Hood, 2001; Habib 2005; Racy 1982, 2003; Stone 2008; Zuhur 2001) take up issues of music and the media, at least tangentially. Journalist Andrew Hammond's volume on Arab popular culture provides insightful coverage of the Arab popular music scene (Hammond 2007, chapter 6). I have contributed with research on the history of SonoCairo (Frishkopf 2008b), the 'Spanish tinge' in Arab popular music (2003), and mediated Qur'anic recitation (2009).

English-language studies examining music and the media in Iraq and the Gulf region are comparatively scarce. Laith Ulaby has treated music and mass media in the Arab Persian Gulf (2006; 2008, chapter 7), while Neil van der Linden touches on the role of media in the decline of the Iraqi *maqam* tradition (2001), as does Yeheskel Kojaman (2001). The mediation of music in North Africa (Morocco, Algeria, Tunisia) has received better coverage (Davis 1996; Langlois 2009); a Francophone connection has also helped propel musical traditions of this area to world music fame, especially Algerian *rai* (Gross, McMurray, and Swedenburg 1992b; Langlois 1996; Mazouzi 2002; McMurray and Swedenburg 1991; Schade-Poulsen 1999; Swedenburg 2003), Moroccan *gnawa* (Gross et al. 1992; Kapchan 2007; Langlois 1998), and that "four thousand year old rock'n'roll band," Master Musicians of Jajouka (Schuyler 2000).

A number of scholars have attended to issues of music and media relations for ethnic-linguistic minority groups of the Arab world, often nearly invisible to the vast majority of Arabic speakers, including the popular music of Berbers (Goodman 2002, 2005), Nubians (Swedenburg 2002a), Bedouins (Abu-Lughod 1989), and Kurds (Blum and Hassanpour 1996).

Beyond music, scholars in anthropology, religious studies, and political science have begun to study the interaction of media and expressive culture in the Middle East, especially in the wake of the satellite TV revolution (Abu-Lughod 1989, 2005; Hirschkind 2006; Miller 2007). While a large number

of media studies scholars have addressed Arab media systems, particularly satellite television and the Internet (Alterman 1998; *Arab media in the information age* 2005; *Arab Media Survey* 2003; Boyd 1999; Fandy 2005, 2007; Hafez 2008; Sakr 2007a; Zayani 2004, 2005; Zayani and Sahraoui 2007), their research has only occasionally centered on music. Exceptions include Rasha Abdulla's study of music television in Egypt (1996), and substantial attention to music in several books by prolific media scholar Naomi Sakr (2001, 2007b). Recently, two economists have tackled the Arab music industry under rubrics of creative industries and intellectual property, using theoretical models and quantitative techniques suggesting exciting new directions for future work (Harabi 2009; Rizk 2009).

Arab music today is overwhelmingly mediated, with a vast audience. Together with its associated social discourses and practices, this music forms a coherent transnational intermedia world, a 'music media culture' of tremendous significance for well over 200 million native Arabic speakers worldwide. Yet, despite the existence of the aforementioned works, the key relations of music and media in the Arab world remain significantly understudied in relation to their social importance. Arab critics and journalists have provided copious quantities of perspicacious commentary on music and the media, but this body of writing has remained largely inaccessible to readers not fluent in the Arabic language.

Thus, in the fall of 2003 I proposed to Gerry D. Scott, director of the American Research Center in Egypt, that ARCE host a conference entitled "Music and Television in Egypt," as an explicitly bilingual and polyperspectival endeavor. He offered enthusiastic support.

The two-day conference aimed to gather a diverse group, to explore a wide range of themes connected with the social, cultural, political, economic, and technological histories of music and television in Egypt, raising key questions such as: How does TV represent music in Egypt today? How has TV transformed music into a new visual art? What are the meanings and consequences of this transformation? What is the impact of televised music on popular taste? How are gender and sexuality constructed by music videos? How has television transformed the music economy?

Eighteen presenters—including scholars (from ethnomusicology, music criticism, anthropology, and media studies), journalists and critics, creative writers, TV/cinema directors, a filmmaker, a music producer and composer, and an audio engineer—offered insights, in Arabic and English. Many others

attended these sessions as listeners and interlocutors. Most participants were Egyptians, while others were visitors from abroad. Beyond formal paper presentations, issues were further explored in open discussions. Debate was stirred, food consumed, conversations started.

But the conference was limited in several respects. The focus was on Egypt, and on television. And while the Cairo location was ideal for the inclusion of intellectual voices from the Arab world, it also excluded many others who could not travel to Cairo at that time. So afterward I sought to assemble a more permanent published record, expanding on conference themes and participants, in order to document histories, issues, and debates surrounding the relation of music and media in the early twenty-first century.

This book is unusual for combining and balancing multiple perspectives in a complementary fashion, including three discursive modes (historical, analytical, and critical) and two languages (Arabic and English).[30] Most English-language collections about Arab culture and society comprise interpretive essays (analytical or historical) by academics, writing (in English) in what is often presumed to be a neutral, universal metadiscourse of scholarship, marked by a claim (implied or explicit) to 'objectivity' about the target cultural system, as supported by apparent reliance on pure reason and empirical documentation, and avoidance of value judgments. Here, interpretations drawn directly from discursive practices of the culture under consideration are engaged as data, grist for the academic mill. But whatever their claims to neutrality, such essays are nevertheless always theoretically opinionated—sometimes explicitly so—at least within the scholarly metalanguage itself. This scholarship attempts to stand outside the target system, even as it can never succeed in standing outside all such systems. Nevertheless, it typically enters the target system (directly or indirectly), via distribution by transnational media that have undermined bounded discursive systems smaller than the global one.

These historical and analytical essays contrast (to a great extent—no sharp oppositions can ever be drawn) with the style adopted by the public intellectual, the journalist, the essayist. Working in a critical mode, and typically participating fully in the target system, these authors are not reluctant to adopt an explicit axiological stand (aesthetic or ethical) within the cultural world under consideration. While the critical mode appears ethnocentric and even ethically dubious when adopted by those generally regarded as 'outsiders,' it achieves greater authority when adopted by insiders, those viewed as members of the group generating the cultural practices being commented upon, whose critiques are accepted as instances of those practices.

In an attempt to blur boundaries (and de-privilege the 'scholarly'), as well as to introduce Arabic discourse to a broader audience, this collection combines historical and analytical essays (by both Arab and non-Arab scholars, it should be noted, since no facile identification of identity and discourse is possible) with critical ones coming from within the Arab world itself. The latter recursively comment on Arab discourse, while simultaneously entering into it. They are referenced by the former on two levels—as engagable opinion, and as 'data.'

If media have induced a new coherence within Arab music by linking what were formerly more localized musical practices into an interconnected whole, they have done the same at the level of both critical and analytical/historical discourses about music, and for two reasons. First, because the object of such discourses comprises an increasingly mediated world of greater interconnectivity, as the circulatory radii of musical words, images, and sounds are much larger than before. Second, because critical and analytical discourses about music are themselves embedded in the same mediated world, and hence subject to the same processes.

The upshot is a striking coherence among the essays of this volume as they reference common keywords (see Figure 5). Using techniques drawn from social network analysis enables one to grasp the extent of this interconnectivity.

	Keyword	Number of referencing chapters
1	satellite TV	15
2	video clips	14
3	Ruby	8
4	Abdel Halim Hafez	5
5	Mohamed Abdel Wahhab	5
6	Rotana	5
7	Umm Kulthum	5
8	Alwaleed bin Talal	4
9	Haifa Wehbe	4
10	Nancy Ajram	4
11	*sha'bi*	4
12	Armbrust	3
13	Egyptian TV	3
14	Melody	3

15	mobile phone	3
16	Shaaban Abdel Rahim	3
17	song competitions	3
18	Ahmed Adaweya	2
19	Al-Barghouti	2
20	Egyptian Radio	2
21	Elmessiri	2
22	Frishkopf	2
23	LBC	2
24	Mazzika	2
25	Sami Yusuf	2
26	Sayyid Qutb	2

Figure 5: A sample of recurring keywords (including author names), and the number of chapters in which they occur.

Out of this data, I developed a two-mode affiliation network linking each of the fifteen authors to his or her keywords, from which I derived a one-mode network in which the connectivity between two authors is proportional to the number of keywords they share (Scott 2000, 38–49). Such a network can be visualized in two dimensions, using a force-equilibrium algorithm to position authors according to their connectivity: well-connected authors are positioned closer together (Kamada and Kawai 1989). The resulting map (see Figure 6) indicates which chapters are most central

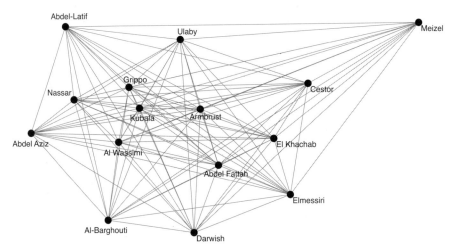

Figure 6: One-mode network of chapter authors, based on a two-mode affiliation network linking authors and keywords.

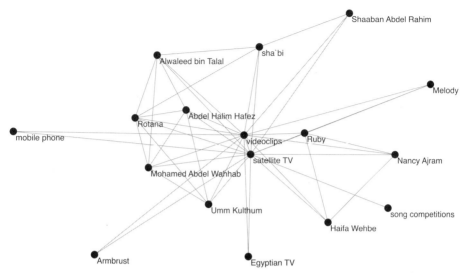

Figure 7: One-mode network of keywords, based on a two-mode affiliation network linking authors and keywords. Weakly connected keywords have been deleted.

to the volume's discourse, with respect to the keywords sample. Conversely, developing a measure of keyword connectivity (proportional to the number of shared authors) enables visualization of keyword centrality (Figure 7). The strong connections among authors and keywords are a manifestation, in microcosm, of the Arab music media scene in general, which is likewise compact. This compactness should not be surprising, since, as I claimed at the outset, *Music and Media in the Arab world* is itself an instance of music and media in the Arab world.

Unfortunately uniform coverage of the Arab world proved impossible for this volume. My research base in Cairo, the site of the conference, and the undeniable influence of Cairo throughout the past century all conspired to bias the results toward Egypt. This bias is not intolerable, since Cairo remains a primary center of the mediated music business, even if it is less central than before.

But country-by-country coverage is decreasingly necessary, because the new Arab music media diminish the importance of national boundaries, by continually crossing them. Rather, they tend to reinforce—or even construct—broader collectivities, along multiple lines of region, class, gender, religion, and other dimensions of identity. The warning once issued in ethnomusicology against reifying 'musical regions' is far less germane today,

when lived reality is to a large extent constituted by media realities of broad scope. Once one shifts attention from live to mediated music, considerable diversity simply collapses.

In any case, the present volume is not offered as an encyclopedic documentation of the relation of music and media systems in the Arab world, but only as an *incipit* for future writing, offering documention, analysis, criticism, queries, and pathways for others—engaged in multiple quests for knowledge, value, explanation, understanding, or social change—to take up. All such writing will find a place both as *discourse about* music media, and as *instance of* music media, blurring the lines between critical and analytical/historical genres, and serving to connect discourses, authors, and readers across linguistic and cultural divides.

References

Abdulla, Rasha. 1996. "The uses and gratifications of music television in Egypt: Why kids want their MTV." Unpublished MA thesis, the American University in Cairo, Cairo.

About Naguib Mahfouz. 2009. http://www.aucpress.com/t-aboutnm. aspx?template=template_naguibmahfouz (April 14, 2009).

Abu-Lughod, Lila. 1989. Bedouins, cassettes and technologies of public culture. *Middle East Report* 159:7–47.

———. 1997. The interpretation of culture(s) after television. *Representations* 59:109–34.

———. 2005. *Dramas of nationhood: The politics of television in Egypt.* Chicago: University of Chicago Press.

Alterman, Jon. 1998. *New media, new politics? From satellite television to the internet in the Arab world.* Washington, D.C: Washington Institute for Near East Policy.

———. 2005. IT comes of age in the Middle East. *Foreign Service Journal,* December, 36–42.

Amin, Hussein. 2000. The current situation of satellite broadcasting in the Middle East. Special issue: The Arab world. *Transnational Broadcasting Studies,* no. 5.

———. 2001. Mass media in the Arab states between diversification and stagnation: An overview. In *Mass media, politics, and society in the Middle East,* ed. Kai Hafez, 23–42. Cresskill, N.J.: Hampton Press.

———. 2008. Arab media audience research: Developments and constraints. In *Arab media: Power and weakness*, ed. Kai Hafez, 69–90. New York: Continuum.

Anderson, Benedict R. O'G. 1983. *Imagined communities: Reflections on the origin and spread of nationalism*. London: Verso.

Arab media in the information age. 2005. 1st ed. Abu Dhabi: Emirates Center for Strategic Studies and Research.

Arab media survey, 2003. 2003. Utica, NY: Zogby International.

Armbrust, Walter. 1996. *Mass culture and modernism in Egypt*. Cambridge: Cambridge University Press.

———. 2002. The impact of the media on Egyptian music. In *The Garland encyclopedia of world music, vol. 6: the Middle East*, eds. Virginia Danielson, Scott Marcus, and Dwight Reynolds, 233–41. New York: Routledge.

Asmar, Sami W., and Kathleen Hood. 2001. Modern Arab music: Portraits of enchantment from the middle generation. In *Colors of enchantment: Theater, dance, music, and the visual arts of the Middle East*, ed. Sherifa Zuhur, 297–320. Cairo: American University in Cairo Press.

Aulas, Marie-Christine. 1982. Sadat's Egypt: A balance sheet. *MERIP Reports* 107:6–18.

El-Bakry, Réhab. 2004. All in favor of Ruby. *Egypt Today*, July.

Barabasi, Alberta-Laszlo, and Bonabeau, Eric. 2003. Scale-free networks. *Scientific American* 288 (5): 60–69.

Basma, Ayat. 2008. Religious broadcasters avoid confrontation. *MEB Journal*, March–April, http://www.mebjournal.com/component/option,com_magazine/func,show_article/id,160/ (October 30, 2008).

Bateson, Gregory. 1972. *Steps to an ecology of mind*. New York: Ballantine Books.

Battah, Habib. 2008. The SMS invasion. *MEB Journal*, March–April. http://www.mebjournal.com/component/option,com_magazine/func,show_article/id,111/ (March 13, 2009).

Beinin, Joel. 1994. Writing class: Workers and modern Egyptian colloquial poetry (zajal). *Poetics Today* 15 (2): 191–215.

Blum, Stephen, and Hassanpour, Amir. 1996. "The Morning of Freedom Rose up": Kurdish Popular Song and the Exigencies of Cultural Survival. *Popular Music* 15 (3): 325–43.

Booth, Marilyn. 1992. Colloquial Arabic poetry, politics, and the press in modern Egypt. *International Journal of Middle East Studies* 24 (3): 419–40.

Bourdieu, Pierre. 1975. The specificity of the scientific field and the social conditions of the progress of reason. *Social Science Information* 14:19–47.

Boyd, Douglas A. 1993. *Broadcasting in the Arab world: A survey of the electronic media in the Middle East*, 2nd ed. Ames: Iowa State University Press.

————. 1999. *Broadcasting in the Arab world: A survey of the electronic media in the Middle East*, 3rd ed. Ames: Iowa State University Press.

Bull, Michael, and Back, Les. 2003. *The auditory culture reader*. Oxford, UK; New York: Berg.

Cachia, Pierre. 2006. Pulp stories in the repertoire of Egyptian folk singers. *British Journal of Middle Eastern Studies* 33 (2): 117–29.

Campagne, Joel. 2008. Pre-empting the Satellite TV Revolution. *CPJ*. http://cpj.org/2009/02/satellite-tv-middle-east.php (June 10, 2010).

Carole Samaha: The new face of fashion. 2005. *Al-Bawaba*, http://albawaba.com/en/entertainment/182394 (May 28, 2010).

Castelo-Branco, Salwa El-Shawan. 1987. Some aspects of the cassette industry in Egypt. *The World of Music* 29:32–48.

Chwe, Michael Suk-Young. 2001. *Rational ritual: Culture, coordination, and common knowledge*. Princeton, N.J.: Princeton University Press.

Cochrane, Paul. 2007. Saudi Arabia's Media Influence. *Arab Media & Society*, no. 3. http://www.arabmediasociety.com/?article=421 (June 5, 2010).

Comer, Brooke. 2005. Ruby: The making of a star. *Transnational Broadcasting Studies*, no. 14. http://www.tbsjournal.com/Archives/Spring05/comer.html (June 7, 2010).

Danielson, Virginia. 1990. "Min al-mashayikh": A view of Egyptian musical tradition. *Asian Music* 22 (1): 113–27.

————. 1996. New nightingales of the Nile: Popular music in Egypt since the 1970s. *Popular Music* 15 (3): 299–312.

————. 1997. *The voice of Egypt: Umm Kulthum, Arabic song, and Egyptian society in the twentieth century*. Chicago: University of Chicago Press.

————. 2002. Stardom in Egyptian music: Four case studies. In *The Garland encyclopedia of world music, vol. 6: The Middle East*, eds. Virginia Danielson, Scott Marcus, and Dwight Reynolds, 597–601. New York: Routledge.

Daoud, Ibrahim. 1997. *al-Qur'an fi Misr*. Cairo: Toot.

Davis, Ruth. 1996. The art/popular music paradigm and the Tunisian ma'luf. *Popular Music* 15 (3): 313–23.

Dougherty, Roberta. 2000. Badi'a Masabni, artiste and modernist: The Egyptian print media's carnival of national identity. In *Mass mediations: New*

approaches to popular culture in the Middle East and beyond, ed. Walter Armbrust, 32–60. Berkeley: University of California Press.

Douglas, Mary. 2005. *Purity and danger: An analysis of concept of pollution and taboo*. London; New York: Routledge.

Durkheim, Emile, Carol Cosman, and Mark Sydney Cladis. 2001. *The elementary forms of religious life*. Oxford and New York: Oxford University Press.

Economist Intelligence Unit. 2008. *The Economist Intelligence Unit's Index of Democracy 2008*. http://graphics.eiu.com/PDF/Democracy%20 Index%202008.pdf (July 17, 2010).

Fandy, Mamoun. 2005. *Arab media: Tools of the governments, tools for the people?* Washington, D.C.: United States Institute of Peace.

———. 2007. *(Un)civil war of words: Media and politics in the Arab world*. Westport, Conn.: Praeger Security International.

Farag, F. Rofail. 1976. The Arabian Nights: A mirror of Islamic culture in the middle ages. *Arabica* 23 (2): 197–211.

Forrester, Chris 2001. High hopes for Egyptian media production city. *Transnational Broadcasting Studies*, no. 7. http://www.tbsjournal.com/ Archives/Fall01/forrester.html (October 21, 2004).

Friedman, Thomas L. 2003. 52 to 48. *The New York Times,* September 3, A19.

Frishkopf, Michael. 2000. Inshad dini and aghani diniyya in twentieth century Egypt: A review of styles, genres, and available recordings. *Middle East Studies Association Bulletin* 34 (2): 167.

———. 2001. Tarab in the mystic Sufi chant of Egypt. In *Colors of enchantment: Visual and performing arts of the Middle East*, ed. Sherifa Zuhur, 233–69. Cairo: American University in Cairo Press.

———. 2002a. Islamic hymnody in Egypt. In *The Garland encyclopedia of world music, vol. 6: the Middle East*, eds. Virginia Danielson, Scott Marcus, and Dwight Reynolds, 165–75. New York: Routledge.

———. 2002b. Shaykh Yasin al-Tuhami: A typical layla performance. In *The Garland encyclopedia of world music, vol. 6: The Middle East*, eds. Virginia Danielson, Scott Marcus, and Dwight Reynolds, 147–51. New York: Routledge.

———. 2003. Some meanings of the Spanish tinge in contemporary Egyptian music. In *Mediterranean mosaic: Popular music and global sounds*, ed. Goffredo Plastino, 143–78. New York: Routledge.

———. 2004a. Interview with Hussein Amin, February 29.

————. 2004b. Interview with Ustaz Fathi at SACERAU, February 25.

————. 2004c. Interview with Ustaz Fathi at SACERAU, March 30.

————. 2008a. Erasing and retracing the nation: Transformations in networks of pan-Arab audio-visual music production, distribution, and consumption. Unpublished manuscript.

————. 2008b. Nationalism, nationalization, and the Egyptian music industry: Muhammad Fawzy, Misrphon, and Sawt al-Qahira (SonoCairo). *Asian Music* 39 (2): 28–58.

————. 2009. Mediated Qur'anic recitation and the contestation of Islam in contemporary Egypt. In *Music and the play of power: Music, politics and ideology in the Middle East, North Africa and Central Asia*, ed. Laudan Nooshin, 75–114. London: Ashgate.

Galit, Saada-Ophir. 2006. Borderland pop: Arab Jewish musicians and the politics of performance. *Cultural Anthropology* 21 (2): 205–33.

Gershoni, Israel. 1992. The evolution of national culture in modern Egypt: Intellectual formation and social diffusion, 1892–1945. *Poetics Today* 13 (2): 325–50.

El-Ghadban, Yara. 2001. Shedding some light on contemporary musicians in Palestine. *Middle East Studies Association Bulletin* 35 (1): 28. http://fp.arizona.edu/mesassoc/bulletin/35-1/35-1al-ghadban.htm (June 10, 2010).

Goodman, Jane E. 2002. Berber popular music. In *The Garland encyclopedia of world music, vol. 6: the Middle East*, eds. Virginia Danielson, Scott Marcus, and Dwight Reynolds, 273–77. New York: Routledge.

————. 2005. *Berber culture on the world stage: From village to video.* Bloomington: Indiana University Press.

Gordon, Lillie S. 2008. Emerging spaces: A Review of nonprofit, nongovernmental music venues in Cairo, Egypt. *Middle East Studies Association Bulletin* 42 (1/2): 62–70.

Gribetz, Arthur. 1991. The sama' controversy: Sufi vs. legalist. *Studia Islamica* 74:43–62.

Grippo, James R. 2006. The fool sings a hero's song: Shaaban Abdel Rahim, Egyptian shaabi, and the video clip phenomenon. *Transnational Broadcasting Studies*, no. 16, http://www.tbsjournal.com/Grippo.html (July 1, 2010).

Gross, Joan, David McMurray, and Ted Swedenburg. 1992. Rai, rap, and Ramadan nights: Franco-Maghribi cultural identities. *Middle East Report*, no. 178:11–24.

Habib, Kenneth Sasin. 2005. The superstar singer Fairouz and the ingenious Rahbani composers Lebanon sounding. Unpublished PhD thesis, University of California, Santa Barbara.

Hafez, Kai. 2008. *Arab media: Power and weakness*. New York: Continuum.

Hammond, Andrew. 2007. *Popular culture in the Arab world: Arts, politics, and the media*. Cairo: American University in Cairo Press.

Handley, Paul. 2009. Saudis reel as clerics say movie show must stop. http://www.google.com/hostednews/afp/article/ALeqM5j5RjnUj_FtoDXeN-b8Z7HTnitkWPQ (June 7, 2010).

Harabi, Najib. 2009. Knowledge intensive industries: Four case studies of creative industries in Arab countries. http://www.google.com/url?sa=t&source=web&cd=1&ved=0CBIQFjAA&url=http%3A%2F%2Finfo.worldbank.org%2Fetools%2Fdocs%2Flibrary%2F251761%2Fday3creative%2520Industry%2520WB_version%25201.pdf&ei=DEINTNDqNoumNq7e0LUE&usg=AFQjCNGKbKwtqacjqgratvKXlcS9LtPskQ&sig2=Ky_hOI69-8CTYrDCMUD_Yw (July 16, 2010).

Hirschkind, Charles. 2006. *The ethical soundscape: Cassette sermons and Islamic counterpublics*. New York: Columbia University Press.

IFPI (International Federation of the Phonographic Industry). 2005. *The recording industry commercial piracy report*. London: International Federation of the Phonographic Industry.

Ismail, Salwa. 1998. Confronting the other: Identity, culture, politics, and conservative Islamism in Egypt. *International Journal of Middle East Studies* 30 (2): 199–225.

Joseph, Suad. 1996. Patriarchy and development in the Arab world. *Gender and Development* 4 (2): 14–19.

Kamada, Tomihisa and Satrou Kawai. 1989. An algorithm for drawing general undirected graphs. *Information Processing Letters* 31 (1): 7–15.

Kapchan, Deborah A. 2007. *Traveling spirit masters: Moroccan gnawa trance and music in the global marketplace*. Middletown, Conn.: Wesleyan University Press.

Kepel, Gilles. 2003. *Muslim extremism in Egypt: The Prophet and pharaoh*. Berkeley: University of California Press.

Khalaf, Roula, and William Wallis. 2006. Egypt billionaire aims to build satellite TV empire. *Financial Times*, May 26, http://www.mail-archive.com/medianews@twiar.org/msg10580.html (July 1, 2010).

Khalafallah, H. 1982. Unofficial cassette culture in the Middle-East. *Index on Censorship* 11 (5): 10–12.

Khalidi, Rashid. 1991. Arab nationalism: Historical problems in the litera-
ture. *The American Historical Review* 96 (5): 1363–73.

Khan, Riz. 2005. *Alwaleed: Businessman, billionaire, prince.* 1st ed. New
York: William Morrow.

Kojaman, Yeheskel. 2001. *The maqam music tradition of Iraq.* London: Y.
Kojaman.

Kraidy, Marwan M. 2006a. Reality television and politics in the Arab world:
Preliminary observations. *Transnational Broadcasting Studies*, no. 15, http://
www.tbsjournal.com/Archives/Fall05/Kraidy.html (August 20, 2006).

———. 2006b. Popular culture as a political barometer: Lebanese-Syrian
relations and superstar. *Transnational Broadcasting Studies*, no. 16.

——— 2008a. Emerging consensus to muzzle media. Arab Reform Bulletin.
http://www.carnegieendowment.org/arb/?fa=show&article=20619#conta
inerComments (March 13, 2008).

———. 2008b. From activity to interactivity: The Arab audience. In
Arab media: Power and weakness, ed. Kai Hafez, 91–102. New York:
Continuum.

Kubala, Patricia. 2005. The Other Face of the Video Clip: Sami Yusuf and the
Call for al-Fann al-Hadif. *Transnational Broadcasting Studies*, no. 14, http://
www.tbsjournal.com/Archives/Spring05/kubala.html (September 27, 2009).

Lagrange, Frederic. 1994. Musiciens et poetes en Egypte au temps de la
nahda. Unpublished PhD thesis, University of Paris VIII.

Lane, Edward William. 1836. *Manners and customs of the modern Egyp-
tians.* The Hague: East-West Publications.

Langlois, Tony. 1998. The gnawa of Oujda: Music at the margins in Morocco.
World of Music 40 (1): 135–56.

———. 1996. The local and global in North African popular music. *Popular
music* 15 (3): 259.

———. 2009. Pirates of the Mediterranean: Moroccan music video and tech-
nology. *Music, sound, and the moving image* 3 (1): 71–85.

LeVine, Mark. 2008. *Heavy metal Islam: Rock, resistance, and the struggle
for the soul of Islam.* New York: Three Rivers Press.

Lynch, Marc. 2006. 'Reality is Not Enough': The Politics of Arab Reality TV.
Transnational Broadcasting Studies, no. 15, http://www.tbsjournal.com/
lynch.html (July 1, 2010).

MacKenzie, Tyler. 2004. The best hope for democracy in the Arab world:
A crooning TV "idol"? *Transnational Broadcasting Studies*, no. 13, http://
www.tbsjournal.com/Archives/Fall04/mackenzie.html (July 1, 2010).

Mahfouz, Naguib. 1984. *Midaq alley*. Trans. Trevor Le Gassick. Cairo: American University in Cairo Press.

Manuel, Peter Lamarche. 1993. *Cassette culture: Popular music and technology in north India*. Chicago: University of Chicago Press.

Marcus, Scott Lloyd. 2007. *Music in Egypt: Experiencing music, expressing culture*. New York: Oxford University Press.

Mazouzi, Bezza. 2002. Rai. In *The Garland encyclopedia of world music, vol. 6: the Middle East*, eds. Virginia Danielson, Scott Marcus, and Dwight Reynolds, 269–72. New York: Routledge.

McDonald, David. 2006. My voice is my weapon: Music, nationalism, and the poetics of Palestinian resistance. Unpublished PhD thesis, Unversity of Illinois, Urbana-Champaign.

———. 2009. Carrying words like weapons: Hip-Hop and the poetics of Palestinian identities in Israel. *Min-Ad: Israel Studies in Musicology* 7 (2), http://www.biu.ac.il/hu/mu/min-ad/ (July 1, 2010).

McMurray, David, and Ted Swedenburg. 1991. Rai tide rising. *Middle East Report* 169:39–42.

Mersal, Iman, and Khaled Mattawa. 2008. *These are not oranges, my love: Selected poems*. Riverdale-On-Hudson, N.Y.: Sheep Meadow Press.

Miller, Flagg. 2007. *The moral resonance of Arab media: Audiocassette poetry and culture in Yemen*. Cambridge, Mass.: Harvard University Press.

Miller, W. Flagg. 2002. Metaphors of commerce: Trans-valuing tribalism in Yemeni audiocassette poetry. *International Journal of Middle East Studies* 34 (1): 29–57.

Mitchell, Tim. 1989. Culture across borders. *Middle East Report* 159:4–47.

Najla takes off her pants. 2006. *Al Bawaba*, February 21, 2006, http://www.freerepublic.com/focus/f-chat/1583402/posts (June 10, 2010).

Nancy Ajram quenches her thirst with Coca Cola. 2005. *Al Bawaba*, http://www.albawaba.com/en/entertainment,latest_news/179033 (May 26, 2010).

Nelson, Kristina. 2001. *The art of reciting the Qur'an*. Cairo: American University in Cairo Press.

Nieuwkerk, Karin van. 2006. A trade like any other: Female singers and dancers in Egypt. Austin: University of Texas Press.

Oliver, Anne Marie, and Paul Steinberg. 2002. Popular music of the intifāda. In *The Garland encyclopedia of world music, vol. 6: the Middle East*, eds. Virginia Danielson, Scott Marcus, and Dwight Reynolds, 635–40. New York: Routledge.

58 Michael Frishkopf

Ong, Walter J. 2002. *Orality and literacy: The technologizing of the word.* London: Routledge.

Pond, Christian. 2006. The appeal of Sami Yusuf and the search for Islamic authenticity. *Transnational Broadcasting Studies,* no. 16, http://www. tbsjournal.com/Pond.html (January 31, 2009).

Racy, Ali Jihad. 1976. Record industry and Egyptian traditional music: 1904–1932. *Ethnomusicology* 20 (1): 23–48.

———. 1977. Musical change and commercial recording in Egypt, 1904–1932. Unpublished PhD thesis, University of Illinois, Champagne-Urbana.

———. 1978. Arabian music and the effects of commercial recording. *The World of Music* 20 (1): 47–58.

———. 1981. Music in contemporary Cairo: A comparative overview. *Asian Music* 13 (1): 4–26.

———. 1982. Musical aesthetics in present-day Cairo. *Ethnomusicology* 26 (3): 391–406.

———. 1985. Music in nineteenth-century Egypt: An historical sketch. *Selected Reports in Ethnomusicology* 4:157–79.

———. 2003. *Making music in the Arab world: The culture and artistry of tarab.* Cambridge: Cambridge University Press.

Rasmussen, Anne K. 1996. Theory and practice at the 'Arabic Org': Digital technology in contemporary Arab music performance. *Popular Music* 15 (3): 345–65.

———. 2002. The popular music of Arab Detroit. In *The Garland encyclopedia of world music, vol. 6: the Middle East,* eds. Virginia Danielson, Scott Marcus, and Dwight Reynolds, 279–86. New York: Routledge.

Reynolds, Dwight Fletcher. 1995. *Heroic poets, poetic heroes: The ethnography of performance in an Arabic oral epic tradition.* Ithaca, N.Y.: Cornell University Press.

Rizk, Nagla. 2009. Arab musiconomics, culture, copyright, and the commons. In *The development agenda: Global intellectual property and developing countries,* ed. Neil Netanel, 341–62. Oxford: Oxford University Press.

Saada-Ophir, Galit. 2007. Mizrahi subaltern counterpoints: Sderot's alternative bands. *Anthropological Quarterly* 80 (3): 711–36.

Sabra, Hanan. 2003. Public-private waves. *Al-Ahram Weekly Online* 26 (2), http://weekly.ahram.org.eg/2003/644/eg9.htm (July 1, 2010).

Sakr, Naomi. 1999. Satellite television and development in the Middle East. *Middle East Report,* no. 210:6–8.

―――. 2001. *Satellite realms: Transnational television, globalization and the Middle East*. London: I.B. Tauris.

―――. 2007a. *Arab media and political renewal: Community, legitimacy and public life*. London: I.B. Tauris.

―――. 2007b. *Arab television today*. London: I.B. Tauris.

Sawa, George D. 1981. The survival of some aspects of medieval Arabic performance practice. *Ethnomusicology* 25 (1): 73–86.

Schade-Poulsen, Marc. 1999. *Men and popular music in Algeria: The social significance of rai*, 1st ed. Austin: University of Texas Press.

Schuyler, Philip. 2000. Joujouka/Jajouka/Zahjoukah—Moroccan music and Euro-American imagination. In *Mass mediations: New approaches to popular culture in the Middle East and beyond*, ed. Walter Armbrust, 146–60. Berkeley: University of California Press.

Scott, John. 2000. *Social network analysis: A handbook*, 2nd ed. London; Thousands Oaks, Calif.: SAGE Publications.

Seeger, Charles. 1961. Semantic, logical and political considerations bearing upon research in ethnomusicology. *Ethnomusicology* 5:77–80.

Seib, Philip. 2005. Hegemonic no more: Western media, the rise of Al Jazeera, and the influence of diverse voices. *International Studies Review* 7 (4): 601–15.

Shannon, Jonathan Holt. 2003a. Emotion, performance, and temporality in Arab music: Reflections on *tarab*. *Cultural Anthropology* 18 (1): 72–98.

―――. 2003b. Sultans of Spin: Syrian Sacred Music on the World Stage. *American Anthropologist* 105 (2): 266–77.

―――. 2006. *Among the jasmine trees: Music and modernity in contemporary Syria*. Middletown, Conn.: Wesleyan University Press.

Sharikat kasit ittarrat 2002. *al-Qahira*, May 7, 11.

Sharp, Heather. 2005. Sexy stars push limits in Egypt, August 4. http://news.bbc.co.uk/2/hi/middle_east/4722945.stm (June 7, 2010).

El-Shawan, Salwa. 1980. The socio-political context of al-musika al-arabiyya in Cairo, Egypt: Policies, patronage, institutions, and musical change (1927–77). *Asian Music* 12 (1): 86–128.

―――. 1981. al-Musika al-'arabiyyah: A category of urban music in Cairo, Egypt, 1927–1977. Unpublished PhD thesis, Columbia University, New York.

Shechter, Relli. 2005. Reading advertisements in a colonial/development context: Cigarette advertising and identity politics in Egypt, c. 1919–1939. *Journal of Social History* 39 (2): 483–503.

Shiloah, Amnon. 1995. *Music in the world of Islam: A socio-cultural study*. Detroit: Wayne State University Press.

———. 1997. Music and religion in Islam. *Acta Musicologica* 69 (2): 143–55.

Shryock, Andrew. 2000. Public culture in Arab Detroit: Creating Arab-American identities in a transnational domain. In *Mass mediations: New approaches to popular culture in the Middle East and beyond*, ed. Walter Armbrust, 32–60. Berkeley: University of California Press.

Sreberny-Mohammadi, Annabelle. 1990. Small media for a big revolution: Iran. *International Journal of Politics, Culture, and Society* 3 (3): 341–71.

Starrett, Gregory. 1995. The political economy of religious commodities in Cairo. *American Anthropologist* 97 (1): 51–68.

Stein, Rebecca L., and Ted Swedenburg. 2004. Popular culture, relational history, and the question of power in Palestine and Israel. *Journal of Palestine Studies* 33 (4): 5–20.

Stone, Christopher Reed. 2008. *Popular culture and nationalism in Lebanon: The Fairouz and Rahbani nation*. London: Routledge.

Swedenburg, Ted. 1997. Saida Sultan/Danna International: Transgender pop and the polysemiotics of sex, nation, and ethnicity on the Israeli–Egyptian border. *The Musical Quarterly* 81 (1): 81–108.

———. 2001. Arab "World Music" in the US. *Middle East Report* 219:34–40.

———. 2002a. Nubian music in Cairo. In *The Garland encyclopedia of world music, vol. 6: the Middle East,* eds. Virginia Danielson, Scott Marcus, and Dwight Reynolds, 641–45. New York: Routledge.

———. 2002b. The post-September 11 Arab wave in world music. *Middle East Report* 224:44–48.

———. 2003. Rai's travels. *Middle East Studies Association Bulletin* 36 (2): 190.

Tarbush, Susannah. 2007. Freemuse and the Lebanese music underground. http://thetanjara.blogspot.com/2007/02/freemuse-and-lebanese-music-underground.html (June 7, 2010).

Tawzi' "al-intirnit" yuhaddid ashab sharikat al-kasit. 2002. *al-Misa'*, May 17.

al-Tuhami, Yasin. 1998. The magic of the Sufi inshad (notes by M. Frishkopf). Montreuil, France: Long Distance.

Touma, Habib. 1996. *The music of the Arabs*, new expanded ed. Portland, Or.: Amadeus Press.

Tucker, Judith E. 1983. Problems in the historiography of women in the Middle East: The case of nineteenth-century Egypt. *International Journal of Middle East Studies* 15 (3): 321–36.

Turki, Elie. 2008. Record companies in the middle east: A shift that changed the music industry. *Ayna*, http://pulse.ayna.com/en/3/ (April 10, 2009).

Ulaby, Laith. 2006. Music and mass media in the Arab Persian Gulf. *Middle East Studies Association Bulletin* 40 (2): 213.

————. 2008. Performing the past: Sea music in the Arab gulf states. Unpublished PhD thesis, UCLA, Los Angeles.

UNdata. 2010. http://unstats.un.org (June 10, 2010).

Usher, Sebastian. 2007. Arab youth revel in pop revolution, http://news.bbc.co.uk/2/hi/europe/6666725.stm (June 5, 2010).

'Uyun. 2002. *Hadith al-Madina,* May 15, 10.

van der Linden, Neil. 2001. The classical Iraqi *maqam* and its survival. In *Colors of enchantment: Theater, dance, music, and the visual arts of the Middle East,* ed. Sherifa Zuhur, 321–35. Cairo: American University in Cairo Press.

Waterbury, John. 1983. *The Egypt of Nasser and Sadat: The political economy of two regimes.* Princeton, N.J.: Princeton University Press.

Wedeen, Lisa. 2002. Conceptualizing culture: Possibilities for political science. *The American Political Science Review* 96 (4): 713–28.

The world factbook—field listing: Literacy. 2010. https://www.cia.gov/library/publications/the-world-factbook/fields/2103.html (June 5, 2010).

Zayani, Mohamed. 2004. *Arab satellite television and politics in the Middle East.* Abu Dhabi: Emirates Center for Strategic Studies and Research.

————. 2005. *The Al Jazeera phenomenon: Critical perspectives on new Arab media.* Boulder: Paradigm Publishers.

Zayani, Mohamed, and Sofiane Sahraoui. 2007. *The culture of Al Jazeera: Inside an Arab media giant.* Jefferson, N.C.: McFarland & Co.

Al-Zubaidi, Layla. 2006. Shouting for change. http://www.qantara.de/webcom/show_article.php/_c-310/_nr-326/_p-1/i.html (June 7, 2010).

Zuhur, Sherifa. 2001. Musical stardom and male romance: Farid al-Atrash. In *Colors of enchantment: Theater, dance, music, and the visual arts of the Middle East,* ed. Sherifa Zuhur, 321–35. Cairo: American University in Cairo Press.

Notes

1 "No universally accepted definition of 'the Arab world' exists, but it is generally assumed to include the twenty-two countries belonging to the Arab League that have a combined population of about 280 million" (Seib 2005, 604). For the purposes of this introduction, this territorial definition is combined with a linguistic one (use of the Arabic language, or its recognition as critical to identity), and

thereby extended into multiple diasporas, especially in the Americas, Europe, Southeast Asia, West Africa, and Australia.

2 Furthermore, AUC Press, publishing literature and scholarship across a wide array of subjects in the social sciences and humanities, and dedicated to local, regional, as well as international distribution, occupies a critical interstitial position in contemporary Arab discourse and culture. One need only recall the Press's unprecedented decision to translate and publish Naguib Mahfouz, leading to his 1989 Nobel prize in literature: "In December 1985, the AUC Press signed a comprehensive publishing agreement with Naguib Mahfouz, thus becoming his primary English-language publisher as well as his worldwide agent for all translation rights; prior to the award of the Nobel prize in 1988 the Press had already published nine Mahfouz novels in English and licensed numerous editions in other languages. As Mahfouz wrote after receiving the Nobel prize, 'it was through the translation of these novels into English . . . that other publishers became aware of them and requested their translation into other foreign languages, and I believe that these translations were among the foremost reasons for my being awarded the Nobel prize.'" (Naguib Mahfouz in "About Naguib Mahfouz" 2009).

3 See Aulas (1982) and Waterbury (1983).

4 For a sophisticated analysis of parallel cassette phenomena in India, see Manuel (1993).

5 Membership of the Popular Music Section of the Society for Ethnomusicology currently exceeds 500, around 20 percent of the full society (see http://pmssem. tamu.edu/, http://fsearch-sandbox.jstor.org/journals/sem.html).

6 This visual preference, in turn, stems from semiotic problems (corresponding to what Charles Seeger termed the "linguo-centric predicament" (1961, 78)), reinforced (in practice) by semiotic strategies (required by the academic field) for converting the symbolic capital of research into the economic capital of academic advancement (cf. Bourdieu 1975).

7 Thus for instance the repertoire of Egypt's national Arab music ensemble, Firqat al-Musiqa al-'Arabiya, performing in Cairo's venerable Opera House as an 'art music' ensemble, has gradually expanded its aesthetic boundaries, from the nineteenth-century repertoire of *adwar, muwashshahat,* and *qasa'id* for whose revival it was established in 1967 (and for which it was still famed when I first encountered the group in 1990), to include works made famous by principal Arab stars of the middle twentieth century, starting with Umm Kulthum and Mohamed Abdel Wahhab, and including such contemporary figures as Hani Shaker (b. 1952) or Sherine Abdel Wahhab (b. 1980) today. (See El-Shawan 1980, 86ff.)

8 On the historicity of the social construction of Arab music *(al-musiqa al-'arabiya)*, see my forthcoming article "The emergence of 'Arab music.'"

9 As Kirsha, café proprietor in Naguib Mahfouz's *Midaq Alley*, tells the local poet-singer (who has been entertaining his patrons for years): "People today don't want a poet. They keep asking me for a radio and there's one over there being installed now. So go away and leave us alone and may God provide for you" (Mahfouz 1984).

10 As the BBC's Heather Sharp correctly assessed, "stars used to make video clips—now video clips make stars" (Sharp 2005).

11 Umm Kulthum's early training centered on Islamic genres (Danielson 1997) but even celebrated Lebanese diva, Fairouz, a Christian, learned to chant Qur'anic verses early in her career.

12 Saudi Prince Alwaleed bin Talal owns the Rotana family of video channels (see http://www.rotana.net/Video), including music, cinema, and a relatively liberal Islamic channel, Al Resalah, whose preachers do not condemn music and which even features Islamic song. At the other extreme, however, is Al Majd, an Islamic satellite network broadcasting no music whatsoever; background sound is drawn from the natural environment (for example, wind) (Basma 2008).

13 For instance, a 1974 study found that a third of Kuwaitis listened to Egyptian radio at least weekly (Boyd 1993).

14 "Some of the most heavily guarded sites in the Arab world are state television and radio buildings." (Campagne 2008).

15 Qur'anic recitation was first recorded on cassette by Shaykh Muhammad al-Tablawi (Nelson 2001, 197).

16 According to recent research by economists, large Egyptian firms account for 70–80 percent of production, while another 20 small firms account for an additional 20–30 percent (Harabi 2009, 13).

17 See http://www.amrdiab.net as well as http://youtube.com (for example, http://www.youtube.com/watch?v=OI-6YsW8QoU) for multiple instances. Nancy Ajram recently completed a television commercial for Coca Cola, for a reported record $2 million. Connections to music videos are explicit in Arab print media: "The singer has revealed that she was very interested in doing the commercial especially due to the fact that the idea of it is very similar to a music video" ("Nancy Ajram Quenches Her Thirst with Coca Cola" 2005).

18 The best example of such auto-advertising is Ruby's video clip, "Leh biydari kida." Ruby is discussed in a number of the following chapters; see especially those by Darwish, Abdel Fattah, and Elmessiri.

19 Beyond this tolerance the clip may backfire; witness, for instance, the public outcry over the Tunisian singer Najla, leading to the ban of her video clips even on private transnational satellite TV ("Najla Takes Off Her Pants" 2006).

20 All six appear on http://www.rotana.net/Video/ (July 17, 2010).

21 http://4shbab.tv/ (July 17, 2010).

22 "Humma malhum bina ya leel" (What Have They To Do with Us?), starring Haytham Said, and directed, ironically enough, by Sherif Sabri (who also created Ruby's controversial clips; see Darwish in this volume).

23 Wooden lattice panels that screened the windows of traditional Arab homes.

24 Estimated Internet access in Egypt increased by a factor of 125 during one decade (1998 to 2008), from 100,000 to over 12.5 million users. During the same period Internet access in the USA increased by only 2.6 times (UNdata 2010).

25 In 2009, the top Lebanese singer was earning USD$40,000 per wedding (Rizk 2009).

26 Exceptions include notable male-female rai duets of late, for example, "Einak" by the Lebanese Amal Hegazy and the Algerian-French Cheb Faudel, which appear designed to introduce rai music (ironically both North African, and global) to a broader Arab listenership.

27 From Paris, North African music stars such as Khaled and Cheb Mami have become far better known in 'world music' circles than their Middle Eastern Arab counterparts, having thus come to represent Arab popular music to the world (Langlois 1996; McMurray and Swedenburg 1991; Hammond 2007, 176).

28 Hisham Abbas's 2001 hit "Nari narayn" (in collaboration with the Carnatic singer Jayashri) featured Indian musical sounds and images, Kathakali dancers, and Hindi lyrics.

29 Lillie Gordon explores Cairo's alternative spaces in a recent article (2008); an Egyptian alternative music label is 100 copies (http://www.100copies.com/), whose name derives from the limited print-run of each new release. Both attract a predominantly Westernized, educated, elite crowd, exceedingly marginal by comparison to Egypt's population. In smaller, wealthier Arab societies (for example, Beirut) alternative music enjoys a proportionately broader audience. (See Al-Zubaidi 2006; Tarbush 2007.)

30 For assistance with this daunting task, I am grateful to the American Research Center in Egypt for financial support, and to the distinguished novelist and translator Somaya Ramadan (whose work has also been published by AUC Press). Likewise, I thank *Al-Ahram Weekly* for providing their translation of Dr. Abdel-Wahab Elmessiri's piece, and Marwa Zein Nassar, for translating her father's essay.

Historical
Reflection

1

A History of Music and Singing on Egyptian Radio and Television

Zein Nassar

I n Egypt, radio and subsequently television have played an essential role in disseminating music and singing to the public. Local radio existed in Egypt at least since a royal decree issued on May 10, 1926, which allowed for the establishment of local radio stations in Cairo and Alexandria. In the late 1920s, Egyptians and foreigners established numerous private radio stations in Cairo, Alexandria, and Port Said, following radio's widespread popularity in Europe and America. Finally, on July 21, 1932, the Egyptian government decided to establish Egyptian Radio (al-Idha'a al-Lasilkiya li-l-Idha'a al-Misriya). By the end of December 1933, at least eight private radio stations were operating in Cairo (Fu'ad, Faruq, Fiyula (Viola), Sabu, Wadi al-Muluk (Valley of the Kings), Ramsis, Misr al-Jadida (New Egypt), and Sayigh), while Alexandria boasted four (Majistik (Majestic), Farid, Radiyu Fuwis, and Radiyu Bafir) (Fathy 1984, 32–33).

Radio provided musical entertainment, and generated profits through product advertisements. Cafés competed with one another, raising the volume of their radio sets to fill the air with songs and advertisements broadcast from various stations (Fathy 1984, 33–34), and during the early period, each station was broadcasting freely. To put an end to this chaos, the government established the national Egyptian Radio station as a radio monopoly, shutting down the competition.

On May 31, 1934, the government's earlier decision to establish a radio station was realized and Egyptian Radio began its broadcasts. Music and song occupied a large part of its airtime. At that time, Egyptian Radio presented its programs live. Among the musical programs were songs and solo performances on a variety of instruments. In the following decades, the station broadcast many songs, presented by the greatest composers and performed by the greatest singers, such as Umm Kulthum, Mohamed Abdel Wahhab, and Riyad al-Sunbati. Radio thus played an essential role in musical dissemination, next to phonodiscs, which were also widely circulated at that time. The first musical director at Egyptian Radio was Medhat Assem, who had been recommended by Mustafa Rida, head of the Oriental Music Institute, to fill this post (Ibrahim 2004, 28).

The newly founded *Majallat al-radiyu* (Radio Magazine) noted on March 19, 1935, that "Oriental music [on Egyptian Radio] dominated other broadcasting materials presented on the radio as the whole duration of morning transmission (75 minutes, from 10:45 to 12:00) was devoted to music only." Articles about musical radio programs published in 1936 indicate that long songs predominated. Critics objected to the degraded level of recorded monologues,[1] and observed that singers were glorified at the expense of lyricists and composers (Shalaby 1995, 76–77)

From 1935 to 1937, Egyptian Radio offered a new opportunity for Syrians, Lebanese, and other Arabs to present their musical works and ideas to a broader audience. For example, it introduced the Syrian composer Yahya al-Libabidi and the monologist Yusuf Hosni to the public. By the beginning of the third year of the station's operation, Muhammad Sa'id Lutfi mentions that radio had begun to influence Egyptian daily life more than anything else.[2] For the first time, people were able to listen to famous Qur'an reciters, musicians, and singers from the comfort of their homes (Shalaby 1995, 80–81).

Egyptian Radio was very much concerned to stir artistic movements and foster star formation in the fields of music and singing. It broadcast live concerts, concentrating on the songs of Umm Kulthum. It also presented theatrical pieces, such as the audio of the film *Yahya al-hubb* (Long Live Love), starring Mohamed Abdel Wahhab and Layla Murad, in February 1938.[3]

The station contributed tremendously to the advancement of artistic movements in Egyptian music, singing, theater, and cinema. It was no longer only the upper classes who were concerned with the artistic field, as critics and the general public began to pay great attention to it as well. Thanks to Egyptian

Radio and its first musical director, Egyptian singing passed through several stages of development.

Music and singing on Egyptian Radio

At the time that Egyptian Radio was established, music in Egypt was dominated by two schools, the conservatives *(muhafizun)* and the progressives *(mujaddidun)*. The conservatives—a group of amateurs and connoisseurs well acquainted with the old musical tradition *(turath)*, which they tried to preserve by careful observation of its rules and methods—were the leaders of the Oriental Music Institute. The progressives, who also developed the traditional framework of Oriental music, were led by such pioneers as Zakariya Ahmad, Muhammad al-Qasabgi, and Riyad al-Sunbati. These musicians had mastered compositional methods and techniques and actively composed songs for the singers of their age, such as Umm Kulthum, Fathiya Ahmad, Salih 'Abd al-Hayy, Nagat 'Ali, and Layla Murad. Mohamed Abdel Wahhab represented a distinctive school of his own, from which later singers and composers, such as Farid al-Atrash, Abdel Halim Hafez, and Mohamed Fawzy, learned a great deal (Fathy 1984, 129).

Egyptian Radio founded a musical group called the Oriental Radio Ensemble (Firqat al-Radiyu al-Sharqiya), conducted by the distinguished musician 'Aziz Sadiq. At first, this orchestra relied on Oriental instruments, but after a while European stringed instruments were introduced. Beginning with a short weekly segment, the orchestra's weekly airtime was extended, and listeners became familiar with its performances and repertoire, selecting their favorite pieces. Thus, the general public's artistic taste began to develop.

With time, many other ensembles appeared on Egyptian Radio, featuring soloists, quartets, and quintets. Musical entertainment on the station was not limited to songs with lyrics, as instrumental music was often featured. In addition, numerous orchestras, named for their conductors, including 'Abd al-'Aziz Muhammad, Muhammad Hasan al-Shuga'i, Husayn Ginayd, 'Ali Farag, 'Atiya Sharara, 'Abd al-Halim 'Ali, Mahmud Abdel Rahman, and 'Abd al-Hamid 'Abd al-Rahman, presented different kinds of music and songs. This promotion of orchestral music was not left to chance, but rather followed a deliberate plan based on weekly statistics.

Egyptian Radio also established a huge symphonic orchestra composed of a group of Egyptians and foreigners residing in Egypt, conducted by the well-known Czech composer, Joseph Hüttel (1893–1951). The foreigners in the orchestra were mostly from Egypt's Italian community. The orchestra's

weekly concerts were widely anticipated events. Jazz music was also very popular, so Egyptian Radio established a jazz band. The symphonic orchestra and the jazz band were highly appreciated by those who listened to the station's European program.

Those who were infatuated with Western music were fortunate, not only because of the music performed in their country but also because of works produced by visiting groups. Contracting with those groups, Egyptian Radio acquired the rights to present their recordings. For instance, the station's programs included operas performed in the renowned La Scala opera house of Milan (Fathy 1984, 132–34).

Cinema flourished during this period and began to influence the music presented on radio. Cinema attracted a great number of singers, generating a sense of competition between radio and cinema, and indicating the popularity of music in Egypt.

Placed under national administration in May 1944, Egyptian Radio came to view itself as a partner in the task of preserving tradition *(turath)*, as well as ensuring the progress of art in general. Arab music has a great history that distinguishes it from other musical styles. Many luminaries helped create this tradition, such as 'Abdu al-Hamuli, Muhammad 'Uthman, Salama Hegazi, Yusuf al-Manyalawi, 'Abd al-Hayy Hilmi, Sayed Darwish, Abu al-'illa Muhammad, Kamil al-Khula'i, Dawud Husni, Darwish al-Hariri, and 'Ali Mahmud, as well as great instrumentalists such as al-'Aqqad, Bizri, and Sahlun. The first step in musical progress was the maintenance of the tradition of these geniuses.

After the Second World War, Egyptian Radio was dominated by enthusiastic tendencies toward developing and linking these improvements to nationalistic and patriotic considerations. Henceforth, radio played a remarkable role in Egyptian politics, art, literature, and Egyptian society in general.

Realizing this important role, prominent figures in these fields began to resort to radio as a means to communicate developments in the arts, literature, science, and other fields to the public. As soon as Egypt's King Faruq announced the cessation of war in Europe, live concerts returned to the radio (Fathy 1984, 140). Radio began to concern itself with artistic renewal of singing and music (among other fields), shouldering the responsibility of raising the arts to a higher level. Lyricists were implored to present nationalistic songs or songs characterized by Egyptian style and spirit, taking up Egyptian topics such as cotton and the daily life of peasants and workers (Fathy 1984, 172).

After the decline of musical theater and the proliferation of musical films, the heads of Egyptian Radio invented the genre of 'dramatic musical radio program' *(al-barnamij al-diramiya al-idha'iya al-ghina'iya)*, in which a story was presented in twenty minutes, interspersed with songs composed by great composers and performed by prominent singers. My own research in the records of Egyptian Radio[4] reveals that at least 231 programs of this type were produced.

After the revolution of July 23, 1952, the Egyptian state supported all kinds of arts, especially music and singing. In late 1953, Muhammad Hasan al-Shuga'i (1903–63), a musical composer and orchestra conductor, was appointed artistic consultant to Egyptian Radio and occupied this position until his death. Al-Shuga'i's main aims were to develop Arab song, and to present its different genres: romantic, dance, national, and descriptive. He also worked hard to improve the quality of lyrics and encouraged talented young composers, such as Muhammad al-Mugi, Fu'ad Hilmi, Muhammad 'Umar, and Baligh Hamdi.

Al-Shuga'i was also concerned to preserve the heritage of Egyptian musical theater as created by Sayed Darwish, Zakariya Ahmad, Dawud Husni, and many others. In order to prevent its loss, he relied upon trusted narrators of the tradition of music and singing. At the same time, he provided opportunities for Egyptian composers working in European musical styles, such as 'Atiya Sharara, Rif'at Garana, and 'Ali Isma'il, to present their works. Thus, Egyptian music came to know the symphonic poem, suite, rhapsody, concerto, symphony, and other European musical forms. During this period, al-Shuga'i relied on the Radio Orchestra, conducted by Ahmad 'Ibayd (al-Masri 1983).

Another key figure at Egyptian Radio was the great music critic Ahmad al-Masri (1920–2000). Responsible for absolute music on Egyptian Radio,[5] al-Masri played a crucial role in shaping radio music in Egypt by developing musical tastes in the masses, through his artistic views and his preparation of a great number of musical programs (Nassar 1990, 61, 63, 85).

In 1987, Egyptian Radio formed an ensemble conducted by Ahmad Fu'ad Hasan that presented instrumental works—Egyptian musical compositions, or music from famous songs featuring some of the country's most skillful musicians as soloists. The ensemble presented only two concerts (in 1987 and 1988) before disbanding because the station refused to pay each musician the requested monthly salary of 1,000 Egyptian pounds, according to its contrabass player, 'Abd al-Hakim 'Abd al-Rahman (pers. comm.).

What helped the station maintain a high artistic level in its broadcasts were the committees, composed of specialists in music and poetry, that guided musical production. These committees were responsible, first of all, for choosing singers, composers, and lyricists at a sufficient artistic level. Songs were developed in stages, beginning with the selection of lyrics and of a suitable composer to set them to music. Thereafter, a singer performed the song, accompanied by a Radio ensemble and recorded by Radio engineers. Finally, a committee of musical specialists would audition the recording before it was presented on the radio in order to ascertain the quality of its composition, musical performance, and audio engineering (indeed, the engineers were themselves great musicians, even if their names are not preserved in history).

While rules and restrictions were designed to ensure that songs maintained a high artistic level, talented musicians nevertheless enjoyed the freedom to be creative. In addition, the great singers of the period had beautiful voices, possessing the ability to express a text's inner meanings and emotions, as well as a good grasp of the elements of Arabic singing, including the ability to improvise and to move smoothly between different melodic modes *(maqamat)*.

Music and singing on Egyptian television and cassettes

The establishment of Egyptian Television in 1960 was a momentous event in the lives of all Egyptians. It was as if the cinema had been transferred into the home. Now, many more Egyptians were able to watch movies, including musical films starring famous singers such as Umm Kulthum, Asmahan, Layla Murad, Sabah, Hoda Sultan, Shadia, Mohamed Abdel Wahhab, Farid al-Atrash, Mohamed Fawzi, 'Abd al-'Aziz Mahmud, Karim Mahmud, and Abdel Halim Hafez. As cinema became more broadly influential, composers like Fu'ad al-Zahiri, 'Abd al-Halim Nuwayra, Ibrahim Haggag, 'Atiya Sharara, and 'Ali Isma'il began to write film music. The television station broadcast live concerts featuring the greatest singers. It also recorded concerts (such as *Adwa' al-madina*) for subsequent broadcast, presenting them to a mass audience.[6] The first Egyptian television orchestra was founded in 1960 and conducted by the well-known Egyptian composer, Rif'at Garana, though it only lasted a few years.

What were the differences between music and singing on Egyptian Radio and on Egyptian Television? To maintain artistic standards, Egyptian TV had its own listening committees, just like Egyptian Radio, as well as its own music ensembles. Television concentrated on the songs of the great singer-stars, however, paying little attention to other kinds of music, while Radio presented a greater musical variety (traditional, folk, light, and orchestral), continuing

its role as a pioneer in presenting musical programs and contributing to the spread of musical awareness among the general public.

Of course television's visual aspect exerted a great effect in drawing viewers. The audience was attracted to television through the pictures they saw on the screen. They watched the ensemble playing the music, and watched the singer moving in front of them. Even for songs recorded in the studio, elements of decor and lighting came to play an important role in attracting an audience. In addition, people began to identify the instruments and performers in the band, and to acknowledge the role of the conductor. Conversely, radio focused attention on the sound of music played by the band and the voice of the singer. On the radio, every listener imagined the singer and the band as he or she wished them to be.

During the 1970s, the private sector cassette trade invaded Egypt and quickly proliferated because of its enormous profitability. Cassettes provided a way around the official song production process, which was monitored by government committees concerned with maintaining social values and high musical standards. From the cassette era onward, absurd lyrics began to appear in songs. As time passed, the melodic character of popular music shifted from the Egyptian style, to which all Egyptians were accustomed, toward an imitation of Western popular music. New songs began to make use of electric instruments like guitar and synthesizer, which often spoiled the traditional Egyptian musical style.

In order to produce a cassette tape, it was still necessary to obtain approval from the official censor. However, while Egyptian Radio's committees were composed of specialists in poetry and music who evaluated artistic works in an attempt to maintain standards, the censor was concerned only with blocking lyrics on taboo subjects, not with evaluating the artistic quality of musical works.[7]

In January 1975, a number of regular educational musical programs began to air on state television. These included *Barnamij al-musiqa al-'arabiya* (Arab Music Program, presented by Dr. Ratiba al-Hefny from 1975 to 2001), *Barnamij sawt al-musiqa* (Sound of Music Program, presented by Dr. Samha al-Kholy from 1975 to 2001, followed by others to the present), *Barnamij fann al-balih* (The Art of Ballet Program, from 1975 to the present), *Barnamij al-musiqa 'abr al-'usur* (Music Through the Ages Program, presented by Dr. Zein Nassar from 1990 to 1991), and *Barnamij musiqana al-misriya* (Our Egyptian Music Program, presented by Dr. Zein Nassar in 2000, followed by others to the present).[8]

Satellite television channels, many in the private sector, began transmission in the 1990s. Enjoying enormous financial support, these channels could afford to sponsor musical groups and invite famous music specialists from different fields. Satellite TV features variety programs (that include songs) and other programs centered on music. I have participated in satellite television programs broadcast on privately owned channels such as Orbit, ART, and Rotana, as well as on Egyptian state TV channels, including cultural channels, variety channels, and the Tanwir channel. Many of these channels are owned by the private sector and virtually unregulated. Each one presents musical material according to its own standards, even sponsoring singing competitions.

The enormous number of satellite channels, broadcasting from many locations, allows the audience to become acquainted with different cultures and societies on a much broader level than before, and, naturally, this experience has had a great social impact. However, standards have been affected as well. For instance, Egyptian TV permits anyone to prepare a program about music, regardless of qualifications (most are journalists). The music program announcers who appear on satellite television are rarely well informed about their subject, and thus are unable to carry on a beneficial dialogue with their musician guests. Indeed, such programs often present erroneous information. Radio in Egypt is more disciplined and organized than television. This difference can be traced to Egyptian Radio's well-established traditions.

Songs on TV are nearly uncontrollable, as they are dominated by the commercial purposes of that medium, especially in advertisements. Television typically emphasizes music's visual aspects, featuring song with dance and presenting influential models for youth regarding fashion and physical beauty, as well as singing style. With the emergence of music videos, or 'video clips,' it has become common to see a male singer with beautiful, nearly naked girls dancing around him in order to attract the attention of the audience. Female singers tend to wear clothes that display their beauty and their bodily charms. Naturally, this strategy does not encourage the audience to listen carefully to the song or to the singer's voice, or to know his or her artistic abilities.

Following a long period when viewing was sharply limited by the small number of state-controlled terrestrial channels, the recent proliferation of satellite dishes and free satellite TV music channels has deepened and broadened the influence of video clips, providing many more young people with the opportunity to watch many more clips. State TV listening committees continue to regulate words, voice, and melodic composition for some songs.

When a song is transformed into a video clip, however, it becomes a kind of TV show, subject to the limits of TV censorship but outside the jurisdiction of the listening committees.

Nevertheless, Egyptian state television—both its satellite and terrestrial channels—is still considered an important means of presenting different kinds of songs, including via concerts and video clips. In 1995, Egyptian TV initiated two new concert series, *Layali al-tilifiziyun* (TV Nights) and *Hafalat al-tilifiziyun* (TV Concerts). Channel officials are responsible for choosing which singers participate in these concerts and which bands accompany them, despite the fact that such officials are typically not musicians or music specialists. Egyptian state TV has broadcast many summer concerts from the Mediterranean beach resort Marina.[9] Lately, TV officials have also held concerts in Upper Egypt, for instance in Sohag and Asyut. Such concerts are recorded live and broadcast to the television audience on special occasions. Channel Two has been broadcasting live Cairo Symphony Orchestra concerts every Saturday. The Cairo Opera House supports Arab music and has encouraged great singers to perform in its concerts, particularly on the occasion of the annual Arab Music Festival (Mahrajan al-Musiqa al-'Arabiya), held each November. However, exclusive broadcast rights to this festival were recently sold to Saudi-owned ART (Arab Radio and Television), a private pay-TV satellite network, depriving most Egyptians of the opportunity to watch music presented in their own country. Critics of the move were told that the festival is expensive and that Egyptian TV does not pay even a penny for broadcast rights.

Egyptian state TV has played an effective role in preserving folk music traditions by presenting programs featuring skilled musicians performing on Egyptian folk instruments, as well as famous folk singers presenting examples of various Egyptian folk music genres. Radio also presents these kinds of programs. But it is important to mention the difference between radio and television announcers. Most radio announcers are cultured, while such announcers rarely appear on TV (though, naturally, exceptions can be found). The reason for this is that Egyptian Radio chooses its announcers carefully, taking into consideration their talents and abilities. For television, an announcer's physical beauty is the prime criterion for selection, so that he or she can attract a larger audience and hold its attention.

Finally, looking to the future, I believe that musical production will shortly be controlled by vast production companies seeking to monopolize Egypt's great singers. Egyptian state TV and radio will have no control over the words and topics in songs produced in Egypt. State broadcasters will

resort to presenting songs of the golden age, in addition to songs produced by large production companies. Unfortunately, Egyptian television and radio have not maintained their responsibilities and have left everything to the private sector, which has resulted in the chaos that currently prevails in the field of singing and video clips.

References

Fathy, Mohamed. 1984. *al-Idha'a al-misriya fi nisf qarn, 1934–1984*. Cairo: Dar al-Kutub.

Ibrahim, Ahmad Kamal Amr. 2004. *al-Idha'a al-misriya: saba'un 'aman, 1934–2004: shahid 'ala al-'asr*. Matabi' al-Jumhuriya li-l-Sahafa.

al-Masri, Ahmad. 1983. Ahmad 'Ibayd. *Majallat al-funun* 17.

Nassar, Zein. 1990. *al-Musiqa al-misriya al-mutatawwira*. Cairo: General Book Association.

Shalaby, Helmy Ahmad. 1995. *Tarikh al-idha'a al-misriya: dirasat tarikhiya, 1934–1952*. Cairo: General Book Association.

Notes

1 [The monologue (Arabic: *munuluj*) was a vocal genre of through-composed expressive poetry popular in early to mid-twentieth-century Egypt. –Ed.]

2 Muhammad Sa'id Lutfi was Egyptian Radio's first consultant *(mustashar)*.

3 [See http://www.youtube.com/watch?v=kxczSFvitDQ&NR=1 (July 6, 2010) –Ed.]

4 *Sijillat al-idha'a al-misriya.*

5 "Instrumental music not intended to represent or illustrate something else." (Oxford Reference Online)

6 [The concerts known as *Adwa' al-madina* (City Lights) were initiated in the 1950s. One concert in this series, held in the Andalus Gardens on the banks of the Nile, marked Abdel Halim Hafez's first official concert appearance, and also represented the first major musical celebration of the establishment of the Egyptian Republic. –Ed.]

7 [In Egypt, the state Censor for Artistic Products *(al-raqaba 'ala al-musannafat al-fanniya)* carefully monitors three key domains: religion, sexuality, and politics. –Ed.]

8 [All three named presenters are well-known scholars of Arab music. –Ed.]

9 [Marina, located about 100 km west of Alexandria, is a seaside touristic village catering to Egypt's elites. –Ed.]

2
Arab Music Videos and Their Implications for Arab Music and Media

Moataz Abdel Aziz

Visual representations of music:
Roles of theater, radio, film, and television

The late 1800s witnessed the beginnings of theater production in the Arab region, at a time when theater involved the use of audiovisual aids that complemented stage drama. The advancement of theater arts gave more weight to the visual and musical dimensions of stage production. In the early 1900s, music played an important role in Arab theater. Exposure to Western cultural sensibilities led to the utilization of some Western musical elements. As musical theater developed, new formats were adopted, such as the operetta (a miniature opera production) and the musical play. Many stage productions were accompanied by music groups, singers, and dancers, who performed special songs and dances associated with the subject of the play (Dr. Mahmoud El Lozy, pers. comm., 2002).

With the advent of Arab cinema, the theater became a venue combining dramatic talent and technology. Following the introduction of recorded sound, the film industry became more dependent on audio aids. Many cinematic productions included music and dance shows involving singers, dancers, and huge sets. The film industry offered its audience sentimental content via music that incorporated its favorite performers. Celebrated artists composed for and performed in films especially tailored for them to present their songs

and dances. Such shows present a kind of visual story, told and shaped as a stage production in front of the camera.

Films in the 1940s and 1950s featured a leading star, usually a singer. This type of movie included what was called the 'music sketch,' comprising a song coupled with a dance routine. Here, the song's subject provided the main idea for the performance. This type of entertainment gathered growing support from audiences. Mohamed Abdel Wahhab, Umm Kulthum, Farid al-Atrash, Mohamed Fawzi, and Abdel Halim Hafez were the most famous Arab singers starring in films involving singing and visual representation of music.

Musical production for the theater, and later for film, facilitated the acceptance of a new format of music as audiovisual entertainment. Hollywood exerted a strong influence, especially through musical films. Generally, the Arab film industry drew upon international film production as a source of new techniques and subjects. Hollywood musicals offered a barometer for the industry. Hollywood and European films distributed in the Arab world provided Arab artists with new techniques and ideas for their productions, while familiarizing Arab audiences with the same. As a result, audiences were prepared to accept similar techniques in locally produced films, including the visual representation of music.

Musical film production came into being following the Arab world's radio revolution. Starting in the 1920s, radio was the principal medium for musical broadcasts, entertaining audiences throughout the region. The introduction of radio in the Arab world created the audience base that would later govern patterns of modern music production. The broadcast of musical entertainment on radio programs created attachments between audiences and certain kinds of music. These radio audiences expanded through the introduction of the transistor radio, which is small and inexpensive. The use of batteries also widened the scope of users, many of whom could not afford electricity (Saad Labib, pers. comm., 2001).[1] To fill airtime with suitable material, it was necessary to locate more talent.

The introduction of television in the Arab world, starting in the late 1950s, further encouraged the visual representation of music as a means of attracting larger audiences and filling airtime. The richness of theater and film productions in the Arab world facilitated the creation of additional televisual representations of music genres, resulting from a steady supply of talent, as well as traditions accumulated over decades of artistic production. Singers were eager to adopt new visual musical techniques in order to broaden their reputations among audiences.

Television channels used to broadcast live music concerts, later rebroadcasting concert segments during daily programming. Such concerts involved singing, often accompanied by scenes of acting or background dancing (Dr. Ashraf Fuad, pers. comm., 2002). The relation between state radio and TV broadcasts and the audience admitted only limited listener feedback. According to Dr. Hussein Amin, chair of the Department of Journalism and Mass Communication at the American University in Cairo, radio and TV broadcasters were mainly concerned with presenting enough material to fill airtime (pers. comm., 2001). Government officials who supervised the daily operation of stations and channels selected material to be broadcast. As a result, the idea of metering the audience and exploring its preferences was never of concern to senior officials.

Audio- and videocassettes gained popularity in the Arab world starting in the late 1970s. The fact that audience preferences had not been matched to broadcasting selections tended to enhance the market for such media products. Audiocassettes produced for Arab markets offered a wide variety of music genres. Each production targeted a particular social segment. According to Saad Labib, the development of the audiocassette industry resulted in the localization of musical preferences (pers. comm., 2001). The release of music cassettes provided a large number of local talents with the opportunity to distribute their artistic output. As a result, more musical productions were available to audiences, enabling members of each market segment to listen to their favorite music in their own dialect and to project shared beliefs and traditions upon it. The introduction of audiocassettes also boosted the rate of music production. As the cost of producing audiocassettes declined, there was a surge in the number of artists available to audiences.

Unlike state radio and TV, audience acceptance determines a cassette's success or failure. Some songs can survive for years, while others may not complete a month. Sales, not talent, are the primary requirement. Political songs may remain at the top of the charts for a long time; songs dealing with certain social moods may survive even longer. Thus, recordings of Umm Kulthum and Abdel Halim continue to maintain their positions within Arab music markets. Their songs represent the tastes of an older generation, but younger audiences also find emotional refuge in them.

The same considerations apply to the field of video production. Producers of visual media products sought to match audience preferences in order to guarantee success in Arab markets (Saad Labib, pers. comm., 2001). Gradually, the visual representation of music became an independent art produced

for special occasions, such as music concerts broadcast live via television and music videos. Theater, radio, film, and television formed the basis for introducing this musical trend in the Arab world.

The beginnings of modern Arab music videos

The late 1970s witnessed the emergence of modern Arab music production. The private sector was by now deeply involved in the field of music entertainment. The demands placed upon music as a resource for both entertainment and financial success increased (Dohny 1993). Under the spotlight of Arab media, the new musical style known as *shababi* (youth) music gained in appeal. Media producers, concentrating on musical patterns that were becoming fashionable around the globe, devoted more of their attention to youth. The rush to satisfy the demand of the youth market for more liberal music encouraged television channels to devote more airtime to music programming.

During this period, Egyptian national television broadcast a weekly program on Channel One that incorporated staged songs, accompanied by dancers. This program included the songs of famous Egyptian singers, pressed into the television show mold. These programs can be identified as the predecessors of the modern music videos, or 'video clips,' through which *shababi* music would spread rapidly.

The rise of modern youth music was a sign of openness to the west, and of growing wealth. The economic boom of the late 1970s provided Arab societies with the means to acquire state-of-the-art music facilities. Greater access to Western musical productions (via records) inspired artists to modernize their music, projecting it to their audiences using new formats that ensured public interest. Accumulation of wealth also resulted in new social classes that demanded a higher level of musical and visual arts, commensurate with their economic status. These classes established new standards for private media production and sought new musical products. In order to maintain audiences and generate profits, producers combined local music with an international flavor: the secret formula for modern youth music.

This formula was applied most strongly in Egypt, Lebanon, and Algeria— the three countries most responsible for the modernization of Arab music. Egyptian artists introduced popular music within Western pop formats: short, fast songs drawing on traditional music styles but filled with Western and Latin rhythms. This format was particularly popular among youth, and inspired musicians throughout the Arab world to construct music following this Egyptian model. The Lebanese model drew heavily on Western

polyphony and harmony, along with Arabic lyrics, while the Algerian model centered on modern *rai* music. These models were the main precursors to the establishment of contemporary Arab pop music, *shababi*.

Because *shababi* songs are short, they are more suitable for televised video clips than the longer songs of older Arab music. Visual and musical style has rendered *shababi* music immensely popular among Arab audiences, most of which are young. Increasing the youth audience has generated greater profits through advertising revenue.

As a result of these trends, the Arab music landscape has come to feature two main streams. The first stream adheres to older formats of Arab music. The second stream promotes the new *shababi* music, which features Western influences.

Modern music production versus classical music

National television channels have tended to prefer the stream of classical Arab music. Arab state television remains conservative regarding the broadcast of modern forms of Arab music. The state's use of older Arab music as a primary source for entertainment programming is a method to 'preserve' culture, counterbalancing the effect of private television stations that target youth with music they find more appealing.

Classical Arab music is constructed upon long-standing performance techniques and styles. Lyrics address a specific theme and are performed in a static manner. The primary singer is accompanied by an instrumental group and back-up vocalists. The audience interacts with the performers by reacting to them, vocally or gesturally, sometimes even asking the singer to repeat parts of a song. Umm Kulthum, the great diva of Arab music, helped create this genre and its sensibilities with her live concerts. For instance, her famous song, "Inta 'umri" (You Are My Life), was frequently greeted by audience calls for repetition.

Conversely, modern Arabic songs are short, fast, and noninteractive. For the most part, younger audiences do not tolerate the repetitions of classical song. Despite the contrast, the newer generations have not completely discarded classical Arab music. Today's Arab youth often resort to classical music for particular genres, especially for love songs. Furthermore, music producers may blend old and new, recruiting younger singers to perform and record covers of classic songs with modern musical arrangements. They attempt to reinvent the classics, making them more appealing to the youth.

For example, the famous song, "Wahashtini" (I Miss You), originally performed by the renowned female classical singer, Soad Mohamed, was recently sung by a young vocalist accompanied by modern instrumental arrangements and harmonies. This modern version remained at the top of the charts for a long time and, indeed, youth preferred it to the original. The song's video clip was broadcast virtually nonstop on several television channels. Many other classical songs have likewise been adopted by music producers and adapted to match the new modern style of Arab music in the hope of appealing to the youth, while establishing in them a taste for classical music.

Technology and the development of the 'video clip'

The video clip category falls under the heading of corporate media production and can be divided into two main parts: audio and video. These two parts are the products of years of experimentation. Over the years, a series of media products has been developed in order to reach a higher standard of broadcast quality (Richardson 1992).

In order to understand the phenomenon of the video clip industry in the Arab world, it is necessary to introduce its technology. Three main fields have contributed to the development of this new visual representation of music: a) audio production, b) video production, and c) satellite television broadcasting.

Audio production

The emergence of radio service in the Arab world was a principal factor in the development of modern audio facilities in the region. Radio required musical programming in order to increase audiences. For this reason, many Arab radio services constructed enormous soundproof studios equipped with large-diaphragm microphones and multiple platforms that allowed full orchestra set-ups. At first, music was performed live, and musicians had to rehearse extensively in order to be prepared for on-air performances. During this period, producing music for radio broadcast was difficult and very expensive.

The requirements of film soundtracks helped establish music recording for the broadcast industry. As has already been discussed, the movie industry demanded large quantities of music. In some cases, musical performances were filmed live. More commonly, music was recorded separately and combined with visuals during the editing phase. The production process

involved rehearsing the vocalist and the orchestra and led to the final stage of recording, with the final product mastered onto four-inch reel tapes. Later, the introduction of eight-track reel-to-reel tapes enabled multitracking. Using this technology, producers could record multiple music tracks separately and then mix them to create the final product.

Television also drove the development of audio technology. Starting in the early 1980s, Arab television channels took full advantage of emerging digital audio technologies, such as digital audiotape (DAT). The efficiencies of digital technology meant that channels now required less investment to establish up-to-date facilities. Arab broadcasters and private producers were thus able to raise their audio production to Western standards (Hamid al-Shaari, pers. comm., 2001). This new technology included digital multitrackers, vocal enhancement devices, music software, and digital musical instruments. Arab musicians quickly became familiar with these musical tools, and a new generation of technicians and artists trained on the new technology began to use it to create a wide variety of musical formats, enriching radio and television production.

Musicians, composers, and technicians became acquainted with digital audio technology and its associated techniques via Western music media products. Naturally, exposure to these products influenced their musical and production styles, imparting a Western flavor. Thus, the importation of technology itself created a musical effect: exposure to new technology via Western popular music was an essential factor in the creation of modern Arab pop music, fusing Arab and Western musical concepts.

Today, Arab music television channels have their own audio production facilities, specializing mainly in audio editing and treatment for broadcast. Moreover, they are increasingly interested in maintaining players and recorders that handle multiple media formats and thus allow broadcast of different musical products. For instance, two music television channels, ART Aghany and Tarab, maintain playback equipment for long-play records, reel-to-reel tapes, quarter-inch tape, four-track, eight-track, DAT, and compact disc in order to match their record library (Mohamed Kamal, pers. comm., 2001).

Currently, most broadcast music is recorded in private professional studios, using the latest digital recording technologies to produce albums for major labels. This audio is later used to produce video clips that are eventually broadcast on television channels (Dr. Salma al-Shamaa, pers. comm., 2001). The development of audio production has thus been a principal factor in the advancement of the video clip industry.

Video production
In its early years, video technology was very expensive and produced low-quality output. Television channels were ready to accept it, however, in order to facilitate the broadcast of recorded material and to expand visual production to its maximum extent (Eastman, Head, and Klein 1989). The appropriation of modern video technology in the Arab world can be traced to the advent of television in the late 1950s. The introduction of video tape recorders (VTRs) was a crucial step toward the current digital video age. Following major investments during the late 1970s, new generations of VTRs and video postproduction equipment appeared in the Arab world, with emphasis on quality rather than value (Boyd 1993). Many television networks invested heavily in such equipment, regardless of the financial burden. Speed and cost were the main obstacles in visual production, and overcoming these obstacles prepared the way for more creative visual production (Lewis 2000).

The 1990s brought the revolution of digital video and its applications, providing several magnificent features: affordability, ease of use, speed, and sophisticated, high-quality results. The new digital technology put creative video tools directly in the hands of the artists themselves. Arab countries, such as Egypt and Lebanon, set the standards of digital video. Technological advancement encouraged the establishment of private production facilities, resulting in the creation of specialized production and postproduction houses capable of meeting the industry's growing demands at modest prices, when compared to the costs for equivalent services in the 1960s (Dr. Salma al-Shamaa, pers. comm., 2001).

Satellite television broadcasting
Satellite technology was deployed to serve several media fields, including newspapers, radio, and television, and is rapidly becoming the main resource for media distribution. In the field of visual media, satellites ignited a revolution that has had a lasting effect on the television industry, enabling television channels to increase bandwidth and terrestrial coverage drastically. Since media profits are mainly generated through advertising and sponsorships (Eastman, Head, and Klein 1989), larger audience numbers for satellite television generate greater revenue.

In the past decade, the Arab world has enjoyed its share of advancement in satellite technology, beginning with Arabsat (launched in 1985) and followed by Nilesat (launched in 1998). As Arab satellite usage grows, especially

in the field of television broadcasting, channels featuring a variety of programming (from news to entertainment) are gaining influence (Sakr 1999). Lower broadcast costs enable more services and profits, enticing more broadcasters to obtain up-to-date technology.

The rapid growth of Arab satellite channels is the direct result of the need to increase audiences, export local culture, and link emigrants to their indigenous societies (Kennedy 1999). Arab development in this field has led to a pan-Arab media that targets all Arabs, irrespective of their cultural or geographical positions. Channels in the ART and Orbit networks exemplify this trend.

In the past, owning a satellite and broadcasting equipment required a large television channel that could cover operational costs (Boyd 1999). Modern satellite technology is making television broadcasting affordable to broadcasters with limited budgets and technological capabilities (Lewis 2000). Technology also plays an important role in expanding television production in order to cover airtime costs for several Arab television channels. This situation is exemplified by the Arab music industry's expansion into the satellite broadcast of video clips.

Western effects on Arab music production for television

The introduction of free-to-air direct broadcast satellite has dramatically increased the viewer base for video clips. Arab media producers have adopted Western formats, production patterns, and technical presentation standards. However, Arab audiences desire entertainment in their local dialects that matches regional preferences. Thus, producers and artists have sought to balance Western musical production techniques with local musical flavors. As a result, viewers were introduced to new concepts that incorporate novel subjects, movements, and attitudes.

This new content could be socially divisive. Robbin Crabtree and Sheena Mahlhotra's remarks on the commercialization of television in India are relevant to the Arab world:

> The "communication effects gap," indifferent to the diffusion of positive or negative effects of television programming, may reveal an increasing cultural divide between those who identify with Western/consumerist values and lifestyles, and those who adhere to traditional beliefs and values. This chasm is likely to reflect—and exacerbate—divisions in class . . . as well as the urban/rural dichotomy that is already striking in India. (Crabtree and Malhotra 2000, 379)

Even more striking in the Arab world are the generation gaps opened by the new content, much of which is directed at urban youth.

Generally speaking, the younger generations of the Arab world feel less constrained by the deep social foundations that govern their society and are more tolerant of foreign ideas and norms than older generations, especially in urban areas. For instance, some contemporary video clips featuring dancers dressed in a manner widely viewed as violating traditional dress codes have been a major source of controversy. These music videos are completely rejected by certain sectors of the Arab audience. One recent clip contained scenes of foreign women dressed in swimsuits dancing with the star singer on an island. Some considered such imagery to be extremely provocative. This and similar video clips have often triggered angry responses and accusations that the media are planting Western ideas in the minds of Arab youth.

Typically, Arab state television channels exercise more restraint in their entertainment programming, especially with video clips, while profit-oriented private Arab television networks are more tolerant of such content, being less strict in their censure of visual representation of musical production.

Production of video clips: From quality to societal acceptance

Numerous Western multinational firms consider the Arab world a growing market for consumer goods. These firms depend on advertising on Arab television to introduce Arab consumers to new products, focusing on young audiences as a target group that possesses tremendous influence on general market preferences for consumable commodities. Advertising campaigners strive to attract the attention of youth in order to expand their consumption bases.

In order to achieve this goal, advertisers are increasingly relying on channels that broadcast video clips. Multinational corporations market their products to young Arab audiences via popular music on music television. These channels are consequently providing rising financial support for Arab television. One direct result of this emphasis on youth-targeted music programming is the rapid spread of new trends in modern Arab music and visual production (Hussein Amin, pers. comm., 2001).

Hence, close reciprocal relationships have developed between multinational manufacturers of consumer products and Arab music producers, artists, and broadcasters. Some multinational corporations sponsor singers to endorse their products. The corporation declares the singer to be an official product representative, develops media campaigns featuring his or her image

and music, and sponsors the singer's live concerts. In this way, PepsiCo contracted pop stars Amr Diab (Egypt) and Nawal Al Zoghbi (Lebanon) to be representatives for its products in the Arab world, thus boosting its advertising visibility.

The continuous advancement of modern trends of televised Arab music has generated fusions between classical Arab music and contemporary pop music, such as *shababi*. Such crossover music is immensely popular, despite its perceived threat to the preservation of traditional Arab music performance. The Egyptian classical composer Mohamed Abdel Wahhab (d. 1991) viewed the Western pop influences in *shababi* music (Western harmony and rhythms) and the *rai* music of North Africa (reggae and other Western sounds) as a distressing trend, stating,

> The new wave singers have damaged the music scene with their songs. . . . In Europe, they are not attempting to replace the "old with the new," or classical with modern, as is happening now in Egypt. (Motavalli 2002, 37)

The displacement of the classical by the modern is particularly evident in the case of Arab video clips. The strong influence exerted by Arab music television channels on Arab societies, particularly among youth, is part of a corporate strategy to shape consumer behavior, indicating the economic incentives behind the industry.

According to Ann Kaplan, the video clip is a format that boosts the selling of an artist to a large audience base (Kaplan 1988). In the Arab world today, music production companies finance video clips, offering them to satellite music television channels free of charge in order to produce a sweeping effect on audiences across the Arab world. Many Arab singers also produce video clips for their songs, donating them for broadcast on music channels in order to broaden their fan bases. Music television channels link the clip to an audience in order to gain more revenue by marketing airtime to advertisers (Kaplan 1988). Mobile phone technology has rendered airtime even more profitable for broadcasters through interactive television, with which viewers request songs, vote for singers, or send text messages to on-screen tickers. Profits from this technology are shared by the channels and mobile phone companies. The link to mobile phone technology has increased both revenue and youth viewership (Battah 2008). Adopted by Arab producers and broadcasters as a method for increasing marginal profits, the approach tends to expand the broadcasting business as a whole.

The Arab world has been exposed to audiovisual technology from the West on several levels. Such exposure has resulted in the introduction of novel techniques of music composition and performance that have assisted in modernizing traditional Arab music. Television and modern audio recording techniques facilitate the incorporation of Western styles into music videos and have transformed a large proportion of modern Arab music into the *shababi* genre. While the video clip has triggered much resistance in some Arab societies, it continues to flourish.

Advertising profits have enabled television networks to produce these video clips in a manner that is appealing to youth and their aspirations. Doing so has successfully raised the level of tolerance among youth for the stylistic and consumerist suggestions that accompany such clips. Conversely, older generations in Arab societies continue to maintain some resistance to this type of audiovisual production.

Despite the intergenerational conflicts highlighted by the rise of the video clip industry, visual representations of modern Arab music—driving the technical dimension of music production—have become essential to the establishment and success of Arab television channels, as well as to the broader culture of Arab popular music throughout the region.

References

Battah, Habib. 2008. The SMS invasion. *MEB Journal*, http://www.meb-journal.com/component/option,com_magazine/func,show_article/id,111/ (May 5, 2009).

Boyd, Douglas A. 1993. *Broadcasting in the Arab world: A survey of the electronic media in the Middle East*. Ames, Iowa: Iowa State University Press.

——. 1999. The impact of satellite television broadcasting on electronic media policy in the Arab world. Paper presented at the Article 19 International Seminar, Cairo, Egypt, February 20–21.

Crabtree, Robbin D., and Sheena Malhotra. 2000. A case study of commercial television in India: Assessing the organizational mechanisms of cultural imperialism. *Journal of Broadcasting and Electronic Media* 44 (3): 364.

Dohny, Samer. 1993. *Qadaya al-sinima wa-l-talfaza fi-l-watan al-'arabi*. Damascus: Ittihad al-Kuttab al-'Arab.

Eastman, Susan T., Sydney W. Head, and Lewis Klein. 1989. *Broadcast/cable programming: Strategies and practices*. 3rd ed. Belmont, Calif.: Wadsworth.

Kaplan, E. Ann. 1988. *Rocking around the clock: Music television, postmodernism, and consumer culture.* New York: Routledge.

Kennedy, Susannah. 1999. Navigating the satellite sky: Watching Arabic language television in Europe. Paper presented at the Article 19 International Seminar, Cairo, Egypt, February 20–21.

Lewis, Ian. 2000. *Guerrilla TV: Low budget programme making.* Oxford: Focal Press.

Motavalli, Jim. 2002. The light for the heart. *Nation*, January 28.

Richardson, Alan R. 1992. *Corporate and organizational video.* New York: McGraw-Hill.

Sakr, Naomi. 1999. The emergence and development of satellite broadcasting in the MENA region: Structures and actors. Paper presented at the Article 19 International Seminar, Cairo, Egypt, February 20–21.

Notes

1 Dr. Saad Labib Makkawi (1921–2009), Egyptian broadcasting expert, was one of the most influential figures in Egyptian radio and television from the 1950s onward. More recently, he played a critical role in shaping Egyptian satellite broadcasting.

3

Arab Music and Changes in the Arab Media

Mounir Al Wassimi

Enormous changes have taken place in the field of Arab music, due to the phenomenal developments brought about by satellite channels and new modes of recording and telecommunications media. In this chapter I shall try to address the impact of these changes on musical composition and song recording, from the standpoint of an observer and active participant in the music field, in the periods before and after the advent of new communication technology.

In the past, state radio and television were responsible for most musical production in Egypt, and remained so until the end of the 1970s. State-owned radio and television were the only venues for broadcasting music and song, and they were both representative of the 'official' political viewpoint. A few privately-owned record companies also produced music during this period. The largest of these was SonoCairo (Sawt al-Qahira), but in the early 1960s it was seized and nationalized[1] and hence toed the political line as well. Sawt al-Qahira monopolized the works of Umm Kulthum, as well as the work produced by Egyptian Radio (some of which they issued on records and tapes). Private record companies also existed, but they were of lesser importance due to their smaller size. These included Murifun (owned by Maurice Iskander), which produced songs by Warda, Fatma Eid and Fayza Ahmad, Shadia, and other singers of that caliber. Other companies included Sawt al-Sharq,

Abdullah, Sonar, and Sawt al-Fann (owned by singers Mohamed Abdel Wahhab and Abdel Halim Hafez, in partnership with Magdy al-Amroussi), which produced albums for Shadia, Nagat, and Abdel Halim himself. There were also companies that operated outside Cairo, many of which produced the work of popular folk singers, 'singers of the streets.' Though such singers were generally not widely known, their albums could generate extremely high sales in the provinces and countryside. Such was the general picture of music production during this era. The song during that period was very much influenced by the social, political, and economic order of the day. Production venues aligned with the politics of the regime and worked within its directives in most cases. Thus, the principal channels for musical production were dominated by social norms: songs did not contain off-color language, but rather delivered a message reflecting social values, usually meant to encourage behavior condoned by society that people could readily champion.

Some stations, such as Middle East Broadcast,[2] were somewhat less restricted, departing from the prevailing norms to a limited degree, but these too remained within the precincts of what was 'permitted. All complied with expected norms in word choice, in accord with perceptions of public morality, and were subject to the standards of official government listening committees responsible for reviewing and defining what was permissible to broadcast. Video clips had not entered the scene yet at that stage, though musical films were common. Such films underscored romantic aesthetics, and were executed artistically, their songs springing from internal dramatic logic, not superimposed, but rather flowing from the story's natural development.

Until the 1960s, the most current songs were those broadcast on radio. When Fayza sang "Yamma al-amar 'al-bab" (Mother, the Moon is at the Door), for instance, people saw—in their mind's eye—a beautiful and romantic setting for the song. Then television appeared in the sixties[3] and songs began to acquire a particular visual form. Initially television carried live concerts, so the picture would be simply that of a band accompanying a singer such as Umm Kulthum, without negating the song's potential for individual interpretation (as occurred later with the televised video clip).

Different media forms, operating in different socio-political contexts, gave rise to two kinds of song production. I have witnessed both. In the earlier epoch a production company would often commission a composer to create the songs. Thus I was commissioned to create cassette tapes for Ali El Haggar, Hassan Al Asmar, Omar Fathy, Mohamed El Helw, or Fatma Eid. Or if I liked a singer, I could introduce him or her to a production

company, which might then decide to undertake a production, giving me an advance to start working with a lyricist. After that, we would record the song live, in the studios of Egyptian Radio on two tracks, and if there were mistakes the recording process often had to be repeated from scratch, though we also had what we called 'scissors editing'—very different from what exists now.[4]

In this earlier epoch the lyrics of many songs remained a repository of a humane, social, linguistic, educational, and intellectual heritage; even the simple corn vendor would sing in the streets the poems sung by Umm Kulthum and Abdel Wahhab. But many songs produced in the wake of the 1967 defeat were completely different, often absurd, wordy travesties, or strings of disconnected gibberish, that nevertheless expressed prevailing social, political, and economic conditions. For instance, in the 1970s Ahmed Adaweya appeared, singing texts criticized by society as uncouth, though also recognized as criticism of social conditions.[5] One of his most famous lines goes: "You who are up there, why don't you take a look at those who are down here below." Singing began to borrow purposefully from the popular heritage in order to comment on current political and social matters.[6] These songs were extremely popular because they addressed some of the issues that people could not voice themselves.

During the heyday of Arab music, songs—such as those of Umm Kulthum and Abdel Halim Hafez[7]—were quite long. However, during the 1970s a new generation appeared that shortened song duration. The score and the musical refrains, the beat and rhythm became more open to innovation and different styles of musical and orchestral arrangement. The form of the song began to take a different shape.

Transformations to song production resulted from changes in studio technology. The first multitrack studio (eight tracks) was set up by Tarek al-Kashef in Maadi. Studios then developed capacities ranging from eight to twenty-four and thirty-two tracks, moving on to forty-eight track capacity until digital technology appeared. With such technology, the relation between the singer and the band started to be severed, because each performer recorded his or her part separately, synchronized by a 'click track.'

In the past, when I recorded songs, a singer such as Ali El Haggar would sing while I led the orchestra and another person would be taking care of recording. Whether the work was of my composition, or that of Sayed Mekkawi and of my arrangement (as was the case with *Ruba'iyat*)[8] that was the style we adopted.

Today, the relation between singer and band, as a result of the click track, is being lost. A recorded musical guide, composed of this one 'instrument,' now suffices to tune the singer into the whole. Thus Eastern music has lost one of its most beautiful and grand aspects.

There is an immense difference between traditional European and Eastern *(sharqi)* musical disciplines. Traditional Eastern music is primarily ornamental and aesthetic, while European music is largely dramatic, depending on a struggle between two ideas. The symphony, the sonata, and the concerto all demonstrate this predilection for the dramatic in Western music.

In traditional Eastern music the relation between the singer, the orchestra, and the audience is one of camaraderie and mutual enjoyment. Singers such as Umm Kulthum or Abdel Wahhab would repeat a musical phrase again and again, simply because the audience had voiced their appreciation by calling out 'Allah.'[9] This special quality of Eastern music is now lost. Arab music has now taken a turn toward a form influenced by the technology introduced of late, causing it to become more rigid, and to lose its emotion and its indigenous aesthetics.

More critical musical transformations came with the advent of the televised music video, or 'video clip.' The radio song of the past addressed the sense of hearing only, allowing each listener to imagine an image pleasing to himself. At that time, a song's impact depended upon its musical merits. But today a state of ignorance is widespread among many song producers, who limit the song as artistic work by imposing an audio-visual format. The visual.aspect has therefore become increasingly prominent in Arab song, to the extent that if you close your eyes while hearing a televised song today, you may not feel anything at all.

Furthermore, the new visual interpretation of Arab song contains many undesirable and dubious elements. There is an ongoing struggle regarding nudity and lewd dancing in Arab video clips. This 'singing with the body' has entered television, and hence has entered people's homes, without their permission. Such vulgarity is allowed in the new world of profit-driven private sector satellite television due to misguided interpretations by those who lack an appreciation of the social and moral value systems that have always regulated Egyptian society.

State television channels remain respectable and serious, presenting committed, clean art, since these channels are not driven primarily by financial concerns. Most private channels, however, seek financial gain, not merely from songs, but from other communication media as well, such as mobile

phone services[10] as well as from advertising. These channels gather money from simple folk for trivial material that is presented to them in the form of nudity, to induce them to watch advertisements paid for by the things they buy, all for the sake of profit

Other private channels are suspect precisely because they do not seem to operate simply for financial gain. One such music channel is Rotana, owned by the nephew of the Saudi king,[11] the king in charge of the Ka'ba at Mecca. On official Saudi television you may watch a broadcast of communal prayer, followed by the news, but when a Saudi channel presents nudity (whether in Western or Arabic songs) and when this channel is considered along with a music channel such as Melody, whose owner is Gamal Abdel Nasser's grandson,[12] the questions must surely arise: What does this mean? Are these phenomena planned? And who is behind such matters?

Private channels seek financial gain, or possibly to effect a change in behavioral patterns in Egypt, the Arab countries, and the Middle East as a whole, in order to counteract other currents, orientations, and attitudes. For these songs subvert the culture and heritage of the region. When we listen to Ruby's song "Leh biydari kida" (Why Does He Hide His Feelings Like That?), we find that the words in and of themselves are ordinary—even romantic.[13] But the visual interpretation of this text, as presented by the song's music video, combines these words with movements producing an unmistakably sexual interpretation, one designed to counteract opposing media currents carrying decidedly different attitudes.

Many aspects of Eastern music have thus been lost as a result of mis-understanding and misapplication. Development in Eastern music should preferably have occurred without severance from its roots. This music should have been allowed to develop organically from its own precedents. Today, unfortunately, a state of ignorance has clearly developed among so many who limit the notion of song to the audio-visual, canceling out the imaginative.

Notes

1 [State-owned Sawt al-Qahira derived from a private company founded by singer-composer-actor Mohamed Fawzy, which the Egyptian government acquired and absorbed in 1964, during a wave of nationalizations. –Ed.]

2 [The radio station Idha'at al-Sharq al-Awsat, founded in 1964. –Ed.]

3 [Egyptian Television was founded in 1960. –Ed.]

4 [The author is comparing older practices of editing by cutting and splicing the magnetic tape to present-day digital editing techniques. –Ed.]

5 [The songs referred to here scandalized the critics. Adaweya remained for long a *persona non grata* in every 'respectable' medium—except the cinema and gossip columns. –Tr.]

6 ["You who are up there" could be viewed as directly inspired by the traditional love songs of the chivalrous ages when the woman is sequestered 'up there' in her terrace behind wooden *mashrabiya* screens, while the forlorn lover is begging for attention from below. –Tr.]

7 [Some critics will say that Abdel Halim Hafez was one of that generation who reduced the length of songs, the pioneer of that movement being the great Mohamed Abdel Wahhab. –Tr.]

8 [A reference to Egyptian singer Ali El Haggar's 1978 album *Ruba'iyyat Salah Jahin* (Quatrains of Salah Jahin), on a text by poet Salah Jahin, composed by Sayed Mekkawi, and arranged by Mounir Al Wassimi. –Ed.]

9 [Besides designating the Deity, the word 'Allah' denotes as well the attribute of Beauty. Hence it is perfectly within order to say 'Allah' to indicate pleasure stirred by an aesthetic experience, whether related to the arts or even to the culinary, as an expression of appreciation. –Tr.]

10 [Interactive television allows viewers to select music videos, vote for singers, or place text on-screen by sending SMS messages from mobile phones; SMS fees are shared between television channels and mobile phone companies. –Ed.]

11 [This nephew is Prince Alwaleed bin Talal bin Abdul Aziz Al Saud (b. 1955), entrepreneur and international investor. With diverse holdings ranging from banking to communications, Prince Alwaleed (nicknamed 'The Arabian Warren Buffet') is among the world's most powerful business figures. He dominates the contemporary Arab popular music industry through his production and broadcast company, Rotana. –Ed.]

12 [The grandson is Egyptian businessman Gamal Marwan, whose maternal grandfather was Egyptian President Gamal Abdel Nasser. –Ed.]

13 [The song begins: "For many nights I've been calling my darling, but he did not come" On this video clip, see chapters by Elmessiri, Kubala, Darwish, El Khachab, and Abdel Fattah, in this volume. –Ed.]

4

Music and Television in Lebanon

Elisabeth Cestor

This chapter examines various forms of interaction between television and professional musicians in Lebanon. By following recent historical events, primarily from the 1960s until the present, we can better understand the present situation and the effects of the relationship between music and the moving image on contemporary Arab societies. In particular, I focus on the important role Lebanese women singers have played in social life and the media world since the end of the civil war and the development of satellite channels.

The fifties and sixties: cinema and the first television channels

Lebanon's first television channel, the Compagnie Libanaise de Télévision (CLT), began broadcasting in 1959.[1] This channel was financed by private funds, in particular from France, unlike the first Egyptian channel, established in 1960, which was public. Another Lebanese channel was created in 1962—Télévision du Liban et de l'Orient (Télé Orient)—with backing from the American Broadcasting Company (ABC) (Moussallem, undated web source; Dajani 2001; Kassir 2003, 458–59; Dajani 2006).

Cinema preceded television as a mass medium for visual music and as an industry promoting musical careers. During the 1950s and 1960s, Arab musicians could reach international popularity through cinema (in addition

to radio). In the 1960s, cinema productions were more popular than television productions in Lebanon. While TV presented programs removed from modern life, concentrating on rural settings (Kassir 2003, 459–60), cinema offered the attractions of Arab stars and dance routines, as well as engagement with contemporary social problems. The participation of famous singers and musicians, such as Samira Toufic (Bedouin songs), Farid al-Atrash, Umm Kulthum, and Sabah (Egyptian songs), and Fairuz (Lebanese songs), guaranteed commercial success. The screenplay at times was less important than the names of the singers cum actors. Not counting Western films, most of the movies shown in Lebanon (and other Arab countries) were Egyptian, and Cairo was widely considered the cultural center of the Arab world. The world of cinema and music was complex, however, and it would be reductive to categorize Arab cinema as coming from only one country. Filmmaking was quite often a collaboration among Egyptian, Lebanese, and Syrian professionals, and scenes could be shot in various countries.

Fairuz,[2] who was to become the most popular singer in Lebanon, got her start in the Lebanese national radio station choir. Her career as a soloist began in the 1950s, when she became known for singing in Lebanese dialect about Lebanese culture (celebrating the mountains, for instance) at a time when most singers used Egyptian dialect and cultural references. Fairuz took roles in *Bayya' al-khawatim* (The Ring Seller), directed by Youssef Chahine in 1965, and two films directed by Henri Barakat, *Safar barlek* (Exile)[3] in 1967 and *Bint al-haris* (The Guardian's Daughter) in 1968. These three films were a platform for some of her most famous songs,[4] which contributed to building her international reputation.

Fairuz refused to perform in Lebanon during the civil war (1975–1990), as she feared she might heighten sectarian tensions.[5] As Christopher Reed Stone explains, Fairuz's main composers, Assi and Mansour Rahbani, used Maronite folklore of the hills to represent Lebanese life from the late 1940s to the 1970s, thus not representing the cultural diversity of Lebanon (Stone 2002, 298). Fairuz thought that her songs' Maronite focus might anger those who opposed the Maronites, and she did not want to participate in activities that could further damage her country. She also did not want to leave Lebanon, despite its dangers.

Nevertheless, Fairuz managed to maintain a media presence in Lebanon throughout the war thanks to television. *Safar barlek*, in which she starred, was broadcast on public Lebanese television each Independence Day. The film depicts the solidarity among the Lebanese against the Ottoman enemy

Figure 4.1. Shown on television every Independence Day throughout the civil war, *Safar barlek* has become part of the Lebanese collective memory. The film features Fairuz, the most popular singer in Lebanon.

in 1914. As a result of its theme of Lebanese unity, transcending ethnic differences, the film became extremely popular, and television viewers looked forward to its screening every year.

According to Hady Zaccak (pers. comm., 2005), a specialist in Lebanese cinema,[6] *Safar barlek* has become part of the Lebanese collective memory. In one scene, the men are singing about their hunger, and how the Ottomans leave them with so little to eat. Fairuz gives them strength, displaying generosity, like her country, dear to her heart. She sings,

> Meek neighbor, don't be so cruel.
> What is done is done.
> What is done is done and life goes on.
> Your love is dear to my heart, my home.
> Charming hosts, our friends are here.
> Hearts are on fire and beauty is blooming.
> Your love is dear to my heart, my home. (Rahbani brothers)

The seventies and eighties:
TV programs that launched singers' careers

The Lebanese Television Company, or Télé Liban, was a fusion of the first Lebanese private channels, CLT and Télé Orient. Civil war had taken its toll on these two channels; for example, advertising revenues were significantly reduced (Dajani 2001). In order to save them, the Lebanese government bought and merged them in 1977.

At the end of the 1970s and in the early 1980s in Lebanon, the range of TV programs was limited. By the mid-1980s, only one official channel existed; the rest was pirate television. Given the limited choice of TV channels, and the dangers of venturing outside after dark during the civil war, a TV show appearance was a great opportunity for a singer to reach a wide national audience. Certain well-known programs launched musicians' careers.

At the beginning of the Lebanese civil war, Assi Rahbani and Fairuz split both personally and artistically. This marked a shift in the composition style of the Rahbani brothers toward a stronger variety style. With other songwriters, the brothers produced a series of thirteen shows with Jordanian TV entitled *Sa'a ou ghenniyé* (One Hour, One Song),[7] presenting musical sets and variety and humor sketches performed by professional Lebanese artists.

Figure 4.2. An LP cover from the *Rahbaniyat* series.

Fadia Tomb[8] and her two sisters, Aida and Ronza, became popular singers thanks to these broadcasts. In the 1980s, the Voix de l'Orient label recorded some of the show's songs on a long-play record as *Rahbaniyat*.

Another successful program, *Studio El Fann*, was shown on Télé Liban starting in the 1970s, before being taken over in the 1990s by the Lebanese Broadcasting Corporation. The program provided young Lebanese singers with the opportunity to become professionals after passing a series of difficult tests. Talented musicians, such as Zaki Nassif,[9] participated in the judging committee. The competition started with local events in different regions of Lebanon and ended with the final competition in the studio, followed by a closing award ceremony in the style of a sporting event.

This rigorous selection process appears to have been highly effective, as many of today's best Lebanese singers first appeared on the program. For instance, Majida El Roumi[10] launched her career in 1974 when she won first prize on the show, singing "'Am bihlamak ya hilm ya Lubnan" (I Dream of You, Oh Lebanon). In 1992, at the age of eighteen, Michel Emile Kfoury, better known as Wael Kfoury,[11] kick-started his career by winning the gold medal on the same program with the song "Mawa'attik binjom al-lail" (I Didn't Promise You the Night Stars). In 1993, Joana Mallah won a *Studio El Fann* gold medal in the folk music competition, thereby launching her career.[12] Other winners have included singing stars Nawal Al Zoghbi, Elissa, and Maya Nasri.[13]

Lebanese TV developed in the 1980s with the creation of new private channels. The most important of these were the Lebanese Broadcasting Corporation (LBC),[14] founded by the Lebanese Forces in 1985, and Future Television, established in 1993[15] and owned by former Prime Minister Rafik Hariri. All the private Lebanese television channels were officially licensed by the government in 1994. Murr Television (MTV) and the National Broadcasting Network (NBN) were founded in 1996.

When highly regarded TV producer Simon Asmar[16] left Télé Liban to join the newly created LBC, he took with him his program, *Studio El Fann*, and was able to use this transition as a turning point for the show. The culture of 'show biz' was introduced to create potential stars on a wider basis than just musical talent. The body became as crucial as music for success in performance, with emphasis being placed on dress, hair, looks, and movement. Asmar was behind a major change in the music world in the mid- to late 1990s, through the creation of Lebanese satellite channels and the development of entertainment programs.

The development of satellite channels, music videos, and music programs

The first satellite channels appeared in Lebanon during the 1990s. Future Television began in 1994, LBC-Sat in 1996, and MTV, al-Manar, Télé Liban, and NBN in 2000. This spectacular rise can be attributed, as Gaëlle Le Potier has pointed out, to entertainment shows (Le Potier 2003). Le Potier analyzes how professional Lebanese TV staff contributed to the success of the medium, which parallels the transformation of the music industry. The particular position of Lebanon, where elements of Western and Arab cultures fuse, has given the Lebanese a creativity and liberty that contrasts with conservative Arab culture. Here, Western innovation that would shock Arabs if reproduced directly could be introduced in a more acceptable, transculturated form. International cooperation has given the Lebanese an opportunity to develop facilities, despite a small and problematic national market.[17] Oil-producing Arab countries, too culturally conservative to produce the same musical programming themselves, have provided financial investments instead. International cooperation also has enabled liberty because responsibilities are shared and thus criticism can be evaded.

LBC-Sat became the most popular channel in Saudi Arabia thanks to its attractive female presenters, even if such presentation is completely prohibited by the conservative Islamic culture that dominates in that country (Guaaybess 2005, 69). The influence of Lebanon's democracy and greater tolerance, as compared to other Arab countries, on the production of TV programs is worth noting. For instance, the reality show *al-Rais*, an Arabic adaptation of Big Brother, a reality TV series that originated in the Netherlands, was cancelled after only one week (Hakem 2004). *Al-Rais* was produced by MBC, based in Dubai, and filmed in Bahrain. The strong opposition of many Bahrainis to unmarried men and women living together in a house led to the show's demise. Critics have also complained about the rules underlying the success of a similar Arab reality program, Star Academy, which nevertheless continues successfully to this day on Lebanon's LBC. In this way, one of the smallest countries of the Arab world, despite its civil war and small market, has become one of the major forces driving Arab televised musical entertainment.

The cultural revolution of Lebanese pop singers

Satellite channels have become an essential medium for anyone who wants to become a successful singer of Arab pop songs, the most prevalent music

style in Lebanon and in Arab countries generally. Satellite channels can be seen in the twenty-two Arab countries, and their audience can reach millions. Music videos have developed exponentially through satellite channels and have been successfully exploited by Lebanese women singers.

The current success of music videos, which emerged from televised musical films and plays and the Internet (as cinema was supported by radio in the first half of the last century), has made television more important than cinema in establishing musical popularity. According to Hady Zaccak, "We used to make films in order to see a musical interlude. Now the thought is why should we make a complete film just for a song? That is why music videos are in full development in Lebanon" (pers. comm., 2005). The professional world has evolved accordingly. For instance, Lebanon's Nadine Labaki, who launched her career in the 1990s via *Studio El Fann*, where she won a prize in the 'directing' category, directed a series of highly successful, provocative music videos before having the opportunity to direct a film. As for many film school graduates, making music videos proved an easier way of practicing her directorial skills.

The role models for the new generation of Arab pop singers are mostly Lebanese women, such as Elissa,[18] Haifa Wehbe,[19] Nawal Al Zoghbi,[20] and Nancy Ajram,[21] many of whom achieved stardom through televised music videos and music competitions, including *Studio El Fann* and Future TV's *Nujum al-mustaqbal*. These singers have attracted a wide pan-Arab audience and have given to the Lebanese a musical place hitherto held by Egyptians.

Lebanon has always enjoyed good relationships with the west, and its culture is less conservative than that of other Arab countries. This is why unusually sexually provocative behavior can most easily be introduced by Lebanese women. In his history of Beirut, Samir Kassir stressed how the emancipation of Lebanese women was more audacious and popular than in other Arab countries:

> While the tendency towards wearing less undoubtedly appeared for certain groups of the population to be a subversive stripping down, its rapid spread had the paradoxical effect of normalizing the gesture and thereby reducing its perceived shock-factor amongst city-dwellers. But, for those who came from outside the city, it remained one of the most visible marks of Beirutian difference, unthinkable anywhere else in the region, including in Cairo, as we can see from Egyptian cinema, despite its tradition of not being particularly uptight. And possibly it was also for

the Beirutian mini-skirt that Egyptian films now began to take a frequent detour via Lebanon. (Kassir 2003, 448; translation by Victoria Reid)

The most striking example of such behavior is Nancy Ajram. In 2003, her popularity grew spectacularly and internationally thanks to a video clip, directed by Nadine Labaki, of her song "Akhasmak ah" (I'll Taunt You) in which she identified herself with Hind Rostom, the "Marilyn Monroe of Egyptian cinema."[22] Her look (a black tight-fitting dress) and the film location (an Egyptian café) helped the Lebanese singer to win over an Egyptian audience, which was happy to see a reincarnation of Rostom, its beloved star of the 1950s and 1960s. The video was controversial because of its sexual innuendo. Nancy Ajram shocked many people with her explicitly erotic dancing and sexual appeal. Certainly, the social context in which eroticism is played out has changed since the days of Hind Rostom.

The manner of musical criticism has also changed. In the 1970s, popular singers were typically criticized for the vulgarity of their lyrics (Armbrust 1996), whereas criticism today primarily targets the singers' image, style, and performance behavior. Behavior perceived as vulgar is no longer acceptable because, in the view of many, it is no longer accompanied by artistic quality. Conversely, aesthetic composition has become less important to success than the manner in which singers present new songs. In an article in the Lebanese *Daily Star* newspaper, Palestinian poet Tamim Al-Barghouti criticized music videos and Arab pop singers.[23] According to him, music videos reveal the desire of Arabs to submit to Western style, undermining the achievements of Arab music, which for a long time remained relatively immune to Occidental acculturation (Al-Barghouti 2004).

For many Arabs, most of the music broadcast in the media is now more a commercial than an artistic product. For example, Nancy Ajram represented Coca-Cola in its 2005 advertising campaign in the Arab world, while Elissa became the official female star for Pepsi in 2003, taking over from Nawal Al Zoghbi, who was featured in 2001. Elissa was succeeded by Haifa Wehbe in 2005. These close relationships with business seem to take priority over the artistic aspects of the music industry, contributing to a growing confusion about the artistic and sociocultural value of Lebanese women singers.

Today, the rise of a conservative wave in every Arab country is interfering with the reception of music videos. The radicalization of a section of the population widens the gap between conservatives and liberals and leads to harsher criticism than before. But, at the same time, the new generation of

singers is very popular, and many female singers are so rich that they have gained considerable power.

Haifa Wehbe is the most popular and controversial singer from Lebanon. She is the subject of crude jokes as a result of her participation in private concerts for Saudi princes. She has also become an idol for the young and the leading trendsetter for Arab pop singers, who value physical beauty and the right behavior and style above artistic qualities. She is rich and powerful, like other Lebanese women singers, who enjoy a rising social status in public life in a society where such recognition is unusual for women.

Music competitions on Lebanese satellite channels

Although music videos are the shortest path to fame, televised singing contests continue to be the best means of launching a musical career. Lebanon excels in producing pan-Arab reality show competitions of this type. Since 2003, competition shows like *Star Academy, Super Star,* and *Song Number 1,* featuring contestants from around the Arab world, have been extremely successful on Lebanese TV. They are broadcast, via satellite, to enormous audiences throughout the region, who can also participate by voting via mobile phone. The popularity of these programs is enhanced by the participation of Arab pop celebrities as guests or judges. The study of these mass-mediated music competitions contributes to our understanding of how Lebanese music television conditions social transformations in the Arabic-speaking world.

The most influential of these competitions is the Arabic version of *Star Academy. Star Academy* first appeared in France, and was later adapted by LBC for an Arab market. The idea is to put eight young men and eight young women from different Arab countries together to learn music and dance, and to compete. Over the course of sixteen weeks, all contestants (even the unmarried) live in the same house—an arrangement that contradicts the customary Arab way of life. Rules differ from Western versions of the show. Flirting is not permitted, and sexually provocative behavior is less explicit. Men and women have separate rooms and may not have sexual relations with each other. There is no camera in the bathroom.

The tremendous success of *Star Academy* can be gauged from the large public participation in the vote for the most talented artist. In the first week of its release, the first compact disc of *Star Academy* reached the top of the charts, according to the artistic manager of EMI in Lebanon, Pascall Gaillot, who collaborated with LBC staff to bring the adaptation to the TV screen (pers. comm., 2005).

The same success was enjoyed by *Super Star*, an Arabic version of the British show, *Pop Idol*, produced by Lebanon's Future TV. On *Super Star*, the TV audience votes via mobile phone text messages, whose fees, plus advertising revenues, provide producers with a return on their investments. In 2003, thirty million people watched Jordanian Diana Karazon win the *Super Star* finale (Maalouf 2004). In 2004, forty thousand people auditioned to appear on *Super Star*, up from ten thousand the year before (Fadia Tomb el-Hage, pers. comm., 2005; Kraidy 2006). In the last weekly contest of 2003, 4.8 million votes were cast, and for the equivalent week in 2004, votes increased to ten million, and to fifteen million in 2005 (Sakr 2007, 113).

Unlike the Arab version of *Star Academy, Super Star* values artistic talent (voice, timbre, technique) over singers' attitude and behavior, although charismatic competitors are nevertheless more likely to win. The jury comprises famous songwriters and singers, including, in its 2004 second season, Elias Rahbani (the youngest brother of the celebrated Assi and Mansour Rahbani), Fadia Tomb, and 'Abdallah al-Kuhd, a Kuwaiti composer. Fadia Tomb el-Hage, who, as previously mentioned, started her career by means of the Rahbani brothers' TV show, has given strong credibility to the artistic selection of *Super Star*. Indeed, after appearances on TV variety shows, she won a scholarship to study music in Germany and pursued an international career as a singer-songwriter and a performer of medieval songs from the West as well as the Arab-Andalusian *muwashshahat* (a classical Arabic music genre of sung strophic poetry).

Janane Mallat, the executive producer of the Lebanese TV production company IProd successfully adapted the French karaoke program *La fureur du samedi soir* (Saturday Night Fury) into an Arabic program for LBC-Sat. In September 2003, Mallat proposed a new concept entitled *Song Number 1*. In this program, broadcast every year since 2003, young singers who are, in the main, former winners of *Super Star* (this was especially so in 2004 and 2005) perform traditional popular Arabic songs. The season comprises sixteen episodes, each of which pays tribute to a famous Lebanese singer, such as Zaki Nassif, Fairuz, Sabah, or Wadi El Safi. Other times, episodes have a theme, such as Valentine's Day, patriotism, or duets.

All these broadcasts were created to match the impressive growth in satellite TV and to attract a wide and varied audience. They influence the transformation of cultural behavior in contemporary Arab life, particularly when they introduce subjects normally considered taboo.

Conclusion

The growing emancipation of women and young people from traditional stric-tures is due, in part, to the mass dissemination of new role models, embodied by popular singers, especially when their music videos and performances are broadcast on satellite channels. The commercial empire of music and the moving image has emerged from complementary profiles of different Arab countries, artistic ability, and cultural and political environments. Lebanon plays a key role in this evolution, despite being a small country with an unstable political situation.

At the same time, religious radicalization is growing in Arab countries, and two different worlds have emerged, one conservative, the other liberal. Confrontations between radically different visions of social life may create a new environment. The success of Lebanese women singers and Lebanese channels is already well established, and the resultant financial benefits would not be easy to relinquish. We can nevertheless ponder how things might change if the political crisis in Lebanon worsens. Could, for example, Lebanon, like Bahrain, experience the censure of its TV reality shows? That would be a sign of a highly significant change in the Middle East.

References

Armbrust, Walter. 1996. *Mass culture and modernism in Egypt*. Cambridge: Cambridge University Press.

Asmar, Sami. 2004. Remembering Zaki Nasif: A Lebanese musical odyssey. *al-Jadid* 10 (46/47), http://www.aljadid.com/features/RememberingZaki-Nasif.html (October 19, 2007).

Al-Barghouti, Tamim. 2004. Video clips and the masses: 2 worlds apart. *Daily Star*, June 10.

Dajani, Nabil. 2001. The changing scene of Lebanese television. *Transna-tional Broadcasting Studies*, no. 7, http://www.tbsjournal.com/Archives/Fall01/dajani.html (July 6, 2010).

———. 2006. The re-feudalization of the public sphere: Lebanese television news coverage and the Lebanese political process. *Transnational Broad-casting Studies*, no. 16, http:/www.tbsjournal.com/dajanipf.htm.

Guaaybess, Tourya. 2005. Télévisions arabes sur orbite: Un système média-tique en mutation, 1960–2004. Paris: CNRS Editions.

Hakem, Tewfik. 2004. Le succès de la télé-réalité dans les pays arabes pro-voque la colère des islamistes. *Le Monde*, March 14.

108 Elisabeth Cestor

International Federation of the Phonographic Industry (IFPI). 2005. *The recording industry 2005: Commercial piracy report 2005*. London: IFPI.

Kassir, Samir. 2003. *Histoire de Beyrouth*. Paris: Fayard.

Kraidy, Marwan. 2006. Reality television and politics in the Arab world: Preliminary observations. *Transnational Broadcasting Studies*, no. 15, http://www.tbsjournal.com/Archives/Fall05/Kraidy.html (July 6, 2010).

Le Potier, Gaëlle. 2003. Le monde de la télévision satellitaire au Moyen-Orient et le rôle des Libanais dans son développement. In *Mondialisation et nouveaux médias dans l'espace arabe*, ed. Franck Mermier, 43–72. Paris: Maisonneuve et Larose.

Maalouf, Lynn. 2004. Western television craze makes assured debut on region's networks. *Daily Star*, January 14.

Mitterand, Frederic. 2006. Fairouz (documentary film). DVD produced by Arte naïve.

Moussallem, Anis. 2007. La radio et la télévision au Liban, http://opuslibani.org.lb/liban/dos0026.htm (July 2007).

Saïd, Khalida. 1998. Glad tidings: Fairuz. In the program of the twenty-first Baalbeck International Festival, July–August, 1998, Lebanon, 124–25.

Sakr, Naomi. 2007. *Arab television today*. London: I.B. Tauris.

Stone, Christopher R. 2002. The Rahbani nation: Musical theater and nationalism in contemporary Lebanon. PhD dissertation, Princeton University.

Notes

1 In the Arab world, Iraq and Algeria established television channels before Lebanon, in 1956. (See Guaaybess 2005, 48).

2 Fairuz was born Nuhad Haddad in 1935, at Jabal al-Arz. Her career began in 1947, when she worked for radio. There Fairuz was discovered by Halim El Roumi, who composed for her and also introduced her to the Rahbani brothers, Assi and Mansour. Through musical collaboration with the Rahbani brothers she became an icon in Lebanon (she married Assi Rahbani in 1954). Their concerts at the International Festival of Baalbeck, as well as their theater plays, films, and records, are well known throughout the Arab world. Umm Kulthum recognized in Fairuz her successor (Mitterand 2006).

3 [*Safar barlek* ('exile') is a Turkish word that was used locally in Lebanon during the Ottoman period. It refers to the exile imposed by the Ottomans on locals who disobeyed their orders, particularly rebels. –Ed.]

4 For instance: "Ya tayr" in *Safar barlek*, "Nassam 'alayna al-hawa" in *Bint el-haris*, "Ya mirsal al-marasil" in *Bayya' al-khawatim*.

5 After the war, Fairuz's first concert appearance in Lebanon was held in September 1994 in Martyr's Square in the center of Beirut, and her first reappearance at the International Baalbeck festival was in 1998, after twenty-five years of absence. Khalida Saïd wrote in the Festival program: "Fairuz is back in Baalbeck, Fairuz that unique phenomenon who became a symbol, who broadened the meaning of song and gave it a new history. We welcome this comeback as a glad tiding" (Saïd 1998).

6 Since 1998, Zaccak has taught at IESAV, University Saint Joseph, Beirut. He gives courses on film directing, Lebanese and Arab cinema history, and film analysis. He is also a filmmaker.

7 During the civil war, there were more opportunities with foreign than with Lebanese channels, and Jordanian programs could be seen in Lebanon.

8 From 1979 to 1981, Fadia Tomb was widely admired for her solos in various musicals composed by the Rahbani brothers.

9 Zaki Nassif (1916–2004), alongside Nasri Shamseddine and Wadi El Safi, was one of the most famous Lebanese folk singers. (See Asmar 2004)

10 Born in 1956, Majida El Roumi is one of the most popular singers in Lebanon, known for her political songs and her love of the country. Her father is the famous Lebanese musician, Halim El Roumi, who discovered Fairuz.

11 Born in 1974 in Zahlé, Kfoury has become one of the most popular Arab variety singers.

12 See http://www.joanamallah.com/joana/about.html (July 6, 2010).

13 See http://www.studioelfan.com/English/index.asp (July 2007).

14 See http://www.lbcgroup.tv/LBC/Templates/AboutUs.aspx (July 6, 2010).

15 See http://www.futureTVnetwork.com/Default.aspx?page=aboutus (July 6, 2010).

16 Asmar was born in 1943 and is a producer and director of television and radio arts programs. See http://www.studioelfan.com/.

17 As the International Federation of the Phonographic Industry (IFPI) reported in 2005: "Lebanon remains the country with the highest level of piracy in the Middle East at 75 percent, followed by Kuwait at 59 percent and Saudi Arabia at 43 percent" (IFPI 2005, 18).

18 Born in 1972 in Deir al-Ahmar, a mostly Christian village in the Bekaa region, Elissa launched her career in 1998 with the song "Badi doub" (I Want to Melt). She won the World Music Award for best-selling artist in the Middle East in 2005 and 2006.

19 Born in Mahrouna (South Lebanon) in 1976 to a Shiite father and a Coptic mother, Haifa was a model (Miss Lebanon 1995) before becoming a singer and then also an actress. Her first release, *Huwa al-zaman* (That's Time) (2002) was the beginning of a successful career.

20 Nawal Al Zoghbi was born in 1972. Her musical career started with her participation in Studio El Fan in 1988. Her first album, *Wihyati 'andak* (For My Sake), was released in 1992.

21 Born in Ashrafiyeh, a Christian Lebanese suburb, in 1983, Nancy Ajram started her career at the age twelve, as she won a gold medal in the "Traditional Lebanese" category, when she sang an Umm Kulthum song on a Future TV show, *Nujum al-mustaqbal* (Stars of the Future).

22 See http://www.youtube.com/watch?v=rQQsQTGcWLE (July 6, 2010).

23 [See Tamim Al-Barghouti's chapter, "Critique: Caliphs and Clips," in the present volume. –Ed.]

5
Mass Media and Music in the Arab Persian Gulf

Laith Ulaby

he advent of recording and broadcast technologies had a profound impact on music making in the Arab Persian Gulf.[1] Unlike many other parts of the world, however, the arrival of mass-mediated music accompanied a period of dramatic economic, social, and political transformation in the region. This chapter presents an overview of mass media technologies, their musical ramifications, and the interplay of music mass media with concurrent societal developments from the early twentieth century to the present. Throughout, I focus on local Gulf musical genres. Collectively, these genres are sometimes known as *sha'bi* (literally, 'folk' or 'popular,' from *sha'b*, or 'people').[2] More specifically, most of the music traditions involved in mass-mediated music in the Gulf are either urban traditions or urban versions of maritime or Bedouin music.

Before oil and mass media
Although today the Gulf has become synonymous with oil and wealth, the region was very different at the beginning of the twentieth century, when pearling, date farming, and long-distance trade dominated the local economy. At that time, many regional and world powers had a keen interest in controlling the Gulf, not because of its natural resources but rather because of its strategic location on trade routes. Life was difficult for most Gulf residents—

both indentured servitude and slavery were common for workers on date plantations or on pearling ships.

At this time, most *sha'bi* music traditions were associated with either the Bedouin or the maritime lifestyles. Much *sha'bi* music consisted of work songs, such as those sung by a Bedouin camel caravan leader, or songs sung by the crew of a pearling ship as they were pulling up the anchor. Another important context for maritime music making was the *dar* (literally, 'house'), a meeting place where sailors and divers could socialize and perform music while on shore.[3] Only two main classes of professional musician existed, the *nahham* and the *imkabbis*, both of which were associated with maritime traditions. The *nahham* was a specialized singer associated with the pearling boats. He led the singing of work songs at sea and a devotional song cycle known as the *fijri* when onshore in the *dar*. The *imkabbis* was a singer and *'ud* (Middle Eastern lute) player who provided entertainment on long-distance trading ships (see al-Taee 2005).

In urban areas, meanwhile, the main venue for music making was the sitting room *(majlis)* common in Gulf homes. These gender-segregated venues provided a space not only for social interaction but also for music making. When used in this context, *majlis* refers both to the room and to the social and artistic meetings it contains (in much the same way as the *salon* of the French Enlightenment describes not just the room but also the meeting). The *dar* and the *majlis* provided fertile ground that would produce the talent for the early days of the recording industry in the twentieth century.

One of the most popular genres performed in the *majlis* was the *sawt*, a genre of sung poetry developed by the Kuwaiti 'Abdullah al-Faraj, while he was living in India in the mid-nineteenth century.[4] Traditionally, the *sawt* would feature a singer accompanying himself on the *'ud* and one percussionist accompanying him on the *mirwas*, a hand-held cylindrical double-sided drum. As with many Gulf genres, it is common for a large chorus to accompany the singer with singing and rhythmic hand clapping. Many contemporary performances of the *sawt* feature multiple *mirwas* players and a violin or *qanun* (plucked zither).

Seven types of *sawt* are available, although the differences among them are not pronounced. They can be divided into six-beat rhythmic cycles *('arabi, khatm, khyali)* and four-beat cycles *(mruba', shami, san'ani, hijazi)* and usually feature lyrical poems no longer than ten verses. A *sawt* performance typically ends with a different section, often a quatrain or two in length, called the *tawshiha*, which introduces changes in both form and tune. *Sawt* is sung

in both literary and colloquial Arabic.[5] As a result of the genre's popularity, the early history of commercial recordings in the Gulf is almost synonymous with the development of *sawt* during the early twentieth century.

The discovery of oil and the development of mass media: Phonograms

While life had long been difficult in the Gulf, the combination of the Great Depression (starting in 1929) and the development of cultured pearls in Japan (from about 1916) devastated the Gulf economy. However, two major developments began to reshape Gulf society dramatically around the same time: the discovery of oil and the introduction of mass media.

Gulf oil was first discovered in Bahrain in 1932, signaling the coming of a new age in the region.[6] Because of the increasing importance of oil in the world economy at this time, the new oil fields also raised global strategic interest in the Gulf, whose protostates (most of which were nominally independent protectorates of the British Empire) began to reap tremendous revenue from oil. Although the advent of mass media in the region predates the oil boom, the great wealth generated by the latter greatly accelerated the former's development.

In the early twentieth century, many large record companies sought to expand into other countries in search of new markets. In the Arab world, some of the most prominent were Baidaphone (based in Lebanon), His Master's Voice (HMV, in England), and Odeon (in Germany). In the 1920s, these companies sent representatives to Iraq and the Gulf to find prospective artists so that they could tap into local markets.[7]

In 1927, a representative from Baidaphone, Hasan Darsah, convinced 'Abd al-Latif al-Kuwayti, then one of the best-known Gulf singers, to record in Baghdad. Al-Kuwayti recorded ten songs, with Salih al-Kuwayti on violin, Dawud al-Kuwayti on 'ud, and Sa'ud al-Mukaytah, a student of Dhahi bin Walid (a legendary Bahraini *sawt* performer), on percussion (Habib 2003, 9).[8] Shortly thereafter, Salih and Dawud recorded two songs on their own, also in the Gulf style (Shlomo Elkivity, pers. comm., 2006). These recordings sold so well that record companies increased their interest in recording Gulf music and opened up opportunities to other artists.[9]

As a result of his positive experiences with the company on the first trip, 'Abd al-Latif al-Kuwayti made a second trip to Baghdad and again recorded for Baidaphone in 1928. In the 1930s, he made recordings for other companies, including Odeon in Cairo, where he met legendary Egyptian singers Umm

Kulthum and Mohamed Abdel Wahhab, who were also recording for Odeon at the time. Because of these recordings, al-Kuwayti's fame spread, and he became one of the best known and respected musicians in the Gulf region.

While al-Kuwayti's Egyptian recordings were commercially successful, he chose to make all subsequent recordings either in Baghdad or in India. Not only were his primary markets in the Gulf (and its South Asian diaspora), but al-Kuwayti also had difficulty finding musicians in Cairo who were familiar with Gulf musical styles. During this period, he also made live radio broadcasts in Jerusalem, Baghdad, Delhi, Lebanon, and London. Al-Kuwayti composed hundreds of songs, many of which are still performed, though others have been lost (Habib 2003, 11). Sadly, only a handful of his original recordings survive today. For al-Kuwayti, recordings acted as a double-edged sword, extending his fame while transforming his recorded repertoire into an oral tradition no longer connected to the original artist.

Mass media effected a shift in the musical roles of religious minorities in Kuwait. During the 1920s, the majority of Kuwaitis were Sunni, yet al-Kuwayti was Shiite, while brothers Salih and Dawud al-Kuwayti were Jewish. Many musicians in the Gulf continued to cherish the work of the al-Kuwayti brothers, and the emir of Kuwait even requested that they not migrate to Israel in 1951. Yet their legacy was subsequently obscured. Although still performed by artists to this day, their compositions are often not credited to them when broadcast on the radio or performed in public ("Iraqi Traditional Music Revisited in a War Era" 2005; Schweitzer 2006). While at one time artists from minority communities could become widely popular, the infusion of an 'authentic' Sunni-Bedouin narrative into the process of state formation has dampened the prospects of this happening in the contemporary Gulf.

In Bahrain, early *sawt* recording was dominated by singers Muhammad Faris and Dhahi bin Walid. Born in Muharraq, Bahrain, in 1895, Faris was closely related to the ruling family and was the grandson of a former ruler of Bahrain, Shaykh Muhammad bin Khalifah (r. 1843–68). He spent considerable time in Bombay, India, where he had followed his mentor, 'Abd al-Rahim al-'Asiri (Habib 2003, 21), who had fled Bahrain after running afoul of conservative elements because of his music salons *(majalis al-tarab)*. After returning to Bahrain, Faris became extremely popular. His innovations within the *sawt* genre were widely influential, and many of the most famous *sawt* players were his students, among them Dhahi bin Walid, Muhammad Zuwayyid, and several of the other most prominent musicians of the pre-Second World War era.

Dhahi bin Walid's biography stands in sharp contrast to that of Faris. Bin Walid's father was a slave, probably of East African origin, who lived in Saudi Arabia. While performing the hajj, one of Faris' aunts, also a member of the ruling family, bought bin Walid's father and brought him to Bahrain. Bin Walid was born in Muharraq in 1898 and grew up in a community of slaves and servants. Like Faris, other members of his family were amateur musicians, including his brother and sister. While still relatively young, bin Walid started to accompany Faris on the *mirwas* and eventually taught himself to play the *'ud*. Unlike many of the other famous *sawt* singers, bin Walid had no formal education and relied on his amazing memory to remember song texts. That memory also enabled him to learn other musicians' songs after only one hearing, which led those musicians to accuse him of stealing their work.

Even after the success of the early recordings of 'Abd al-Latif al-Kuwayti, record company agents could not convince Faris or bin Walid to come to Iraq to record. Their student, Muhammad Zuwayyid, did travel to Iraq, where he made a highly successful recording in the winter of 1929 or 1930.[10] After the success of Zuwayyid, Faris and bin Walid were persuaded by Isma'il al-Sa'ati, an HMV agent, to travel to Baghdad and record their compositions in 1932 (al-Dawsari 1992, 21–22).[11]

When they reached Baghdad, HMV's recording machine had not yet arrived, so they had time to prepare for their first recordings. In keeping with their respective dispositions, Faris mostly stayed in his hotel and practiced while bin Walid circulated among the salons and evening musical gatherings of Baghdad and learned about local musical traditions. After a few weeks, the recording apparatus was ready. Faris recorded five discs and bin Walid recorded eleven. In accord with their prearranged contract, Faris was paid one hundred rupees per recording and bin Walid was paid fifty.[12] Salih al-Kuwayti played violin and Kuwaiti drummer Hamd Buhuyidi played the *mirwas* (Habib 2003, 30).

The recordings sold extremely well (primarily in Kuwait and Bahrain) and increased the competition that had developed between the teacher and his former student. This competition spurred Faris and bin Walid to return to Baghdad in later years and make more recordings. As with al-Kuwayti, attempts to record for record companies in other countries, for instance, the Sudwa record company in Syria, were not as successful, because of the lack of competent accompanists fluent in the Gulf style. Like his teachers, Zuwayyid took several trips abroad to make recordings, including one to India for Odeon in 1936 and another to Cairo in 1957 (Habib 2003, 32–35).

Muhammad Faris, Dhahi bin Walid, and Muhammad Zuwayyid were all pioneers in the *sawt* tradition, creating increasingly complex and innovative compositions. Eventually, their developments became known as the Bahraini style, replacing the older Kuwaiti one as the dominant style of mass-mediated *sawt*. As a result of these recordings, the three Bahraini singers and their musical innovations became hugely influential throughout the Gulf. Indeed, most of the famous Kuwaiti musicians of the mid-twentieth century (for example, 'Awad al-Dukhi, Muhammad al-Khalifah, and Salim Fahd) performed *sawt* in the Bahraini style. Bahrain was also home to the first Gulf-based recording studios, which were established after the Second World War. These studios undoubtedly helped to cement the dominance of the Bahraini style in the region.

While the Bahraini style was appealing because of its more complex melodic lines and intricate *'ud* playing, mass media made its ascendancy possible. Furthermore, the emergence of the Bahraini style as the predominant *sawt* style in the Gulf points to the creation of regional, versus local, media markets, which was made possible by mass-mediated music (Ulaby 2006, 219).

Second World War: Radio

Although a recording hiatus occurred during the Second World War as a result of a shortage of raw materials, another important mass media opportunity opened up: radio.[13] Both the Axis powers and the Allies had a tremendous need for oil and recognized the Gulf's strategic importance. While the region saw very little combat,[14] it became the site of a hotly contested propaganda battle that promoted the development of broadcasting.

Although, at this time, most Gulf residents did not have radios at home, they gathered in cafés to listen to news reports. By 1940, at least 511 radio receivers were in operation in Bahrain alone (Ali 1988, 22). At the war's outset, the British had already established a short-wave Arabic-language service in London that broadcast for a few hours each day. As the war expanded, the Germans employed an Iraqi, Yunis Bahri, to broadcast short-wave Arabic-language programming from Germany to the Gulf on Radio Berlin. On this show, Bahri would play popular Egyptian, Iraqi, and Gulf recordings, attracting a large regional audience.[15]

The popularity of this station concerned the British, who started the competing Bahrain Broadcasting Station, based in Bahrain, which began broadcasting on November 4, 1940. Bahrain was chosen because it was the most

developed area in the region in infrastructure and education. Within a short time, the station was staffed by Bahrainis. The early schedule included Qur'anic recitation (by the king, Shaykh Hamad), the Bahraini and Kuwaiti national anthems, and poetry recitation, some of which was probably performed with music in the *sawt* or *rababa* style (Ali 1988, 25).[16] The station was supervised by the British Department of General Relations, which supplied news reports favorable to the British. It was staffed by three Bahrainis, including one poet (Ali 1988, 26). As part of its programming, the station would present evenings of musical performances, featuring artists like Muhammad Faris, Muhammad Zuwayyid, and other prominent Gulf musicians. These musicians were paid for their appearances, usually commensurate with their popularity (Habib 2003, 40). Many of these performances were actually broadcast from outside the station building, which did not contain a proper studio (Ali 1988, 28). In 1945, at the end of the war, the station was closed.

The Gulf did not have local Arabic-language broadcasting again until government stations were established in Kuwait (1951) and Bahrain (1955) several years later. Although not always popular with conservative elements that harbored theological objections to music, these stations played a vital role in forging a national identity and building consensus for independence from the British (Ali 1988, 39). Radio's role in promoting state formation would not have been possible without a mass audience. To a great extent, that audience was attracted by popular music broadcasts.

Media, music, and state formation

As illustrated by Philip Schlesinger in his overview of media, political order, and national identity, "it seems that it is an article of faith that mass media *must* play a role in the construction, articulation, and maintenance of collective identity" (Schlesinger 1991, 303; emphasis in original). Some of the first scholars to problematize and theorize what that role entails were British cultural theorists such as Stuart Hall (1979) and Paul Gilroy (2006). In a similar vein, many scholars have placed media at the center of their analyses of nation-state level communities as 'imagined,' particularly Benedict Anderson (1983) and Lila Abu-Lughod (2005). For many works on this topic, the starting point is Hall's oft-quoted passage:

> [Mass media] have progressively *colonized* the cultural and ideological sphere. As social groups and classes live . . . increasingly fragmented and sectionally differentiated lives, the mass media are more and more responsible

(a) for providing the basis on which groups and classes construct an 'image' of the lives, meanings, practices and values of *other* groups and classes; (b) for providing the images, representations and ideas around which the social totality, composed of all these separate and fragmented pieces, can be coherently grasped as a '*whole*.' (Hall 1979, 340; emphasis in original)

In the Gulf, state-controlled media outlets have played an integral role in the articulation of collective national identity.[17] Music, specifically *sawt*, has attracted listeners to the media outlets that function in the ways that Schlesinger, Hall, Gilroy, Anderson, and Abu-Lughod have outlined in their works. In addition, the narratives promoted in mass-mediated musical performance work to legitimize ruling regimes and privilege an 'authentic' Bedouin heritage. Bedouin traditions like falconry, camel racing, and the music and dance of the *'arda* have now become nearly synonymous with state power.[18] These Bedouin referents commonly appear in a wide range of television programs on terrestrial state television, as well as in Gulf pop music video clips aired on private satellite networks.

Post-Second World War: The transition to independence, and further media developments

After the Second World War, the dramatic economic transformation that had started before the war accelerated as new oil fields were discovered and developed. At the end of the war, the pearling industry was in terminal decline. By 1955, only twenty ships and one thousand men participated in the pearl diving season in Bahrain, down from five hundred ships and twenty thousand men in 1930 ("Pearling: Past and Present" 1955, 17). After India's independence in 1947 and the consequent British transfer of Gulf administrative control from India to London, the move to an independent Gulf gained momentum. By 1971, all the states of the Arabian Peninsula were independent.[19]

The wealth created by the oil boom helped to foster radio broadcasting and the recording industry. As the shaykhdoms emerged as newly independent nation-states, they did so with the financial resources acquired from the hydrocarbon industry. This wealth allowed the Gulf states to undertake relatively ambitious mass media projects—a trend that continues to this day. Wealth also created a class of consumers with the disposable income to buy recordings, or at least to frequent cafés with record players. The result of these developments in mass media was that music was taken out of the relatively private spaces of the *dar* and the *majlis* and into the public domain.

This injection of music into the public sphere was met by resistance from conservative religious elements in many parts of the Gulf. Enough of a backlash occurred in Bahrain that several of the music salons were temporarily closed by government decree in the late 1940s. Music recording in the region blossomed with the advent of new mass-mediated popular styles. The first was *'adani*, which emerged in the 1960s and was based on musical structures from Aden, Yemen, and perhaps resulted from the cultural influence of the large population of Yemeni migrant workers in Kuwait at the time.

In the 1970s, after independence, the Gulf was home to a vibrant popular music scene that included musicians from a wide spectrum of social classes. Local record companies produced new recordings of traditional genres, especially *sawt*, *samri*, *basta*, and *yammani*.[20] Recordings from this period tend to feature a heavy Egyptian musical influence in both style and expanded instrumentation. They are characterized by bigger, more diverse ensembles and almost always include large string sections. The Egyptian influence probably resulted from Gulf musicians returning home after studying in Egypt and the increased availability of Egyptian recordings and films in the region.

By this decade, most of the Gulf states had at least one national terrestrial television station (for example, Kuwait in 1957, Abu Dhabi in 1969, and Qatar in 1970). Although few series were dedicated to local music, national television regularly featured concerts and special presentations of prominent artists. During the 1980s, both television and radio played a significant role in the evolution of local music (Khan 2002, 107).

The 1970s and 1980s also saw the emergence of a number of popular female singers and mixed-sex groups. In the pre-oil boom era, women rarely performed music in front of men, except for a few specific contexts such as weddings and some spirit possession ceremonies (see Khalifa 2006). Mass media created a new set of performance contexts of which female singers have gradually been able to take advantage. An active stage performance culture emerged, featuring performances by women in popular music styles and disseminated via radio and television. Female singers have also achieved star status via recordings and, more recently, music videos.

The phenomenon of women in public performance has produced interesting tensions. On the one hand, the mass media, in search of an audience, seek out (or create) female stars, and can do so without the problems of gender mixing faced in live contexts. On the other hand, the concept of the public female star flies strongly in the face of Gulf tradition and contemporary

social norms. While several female Gulf singers have become well known today, there has been significant push-back by conservative elements to limit public performances by women ("Kuwait Bans Concerts Involving Women Entertainers" 2004; "Kuwait Bans 'Vulgar' Talent Show" 2004; al-A'ali 2004; Kraidy 2006). While conservative religious groups can apply pressure to limit local live performances, they can do little to stop the dissemination of female singers by satellite television, compact disc, and the Internet.

Starting in the 1980s and continuing through the late 1990s, the marginalization of music at home (primarily due to the resurgence of conservative religious interpretations), combined with the increasing accessibility of music from Egypt, Lebanon, and the United States, led to a decline in local popular music. During this period, great demand emerged for the recordings of imported artists, while local musical groups experimented with many foreign styles and started to incorporate electrified and synthesized sounds into their performances. Some scholars argue that some of these changes are due to a generation gap between those who grew up in the pearl diving era and those of the oil boom era (Khan 2002, 107).

Over the last few decades, *sha'bi* music has started to be seen as something from the past, but intellectuals have taken an interest in such traditions and encouraged the government to support them (Khan 2002). Today, radio stations in both Bahrain and Kuwait are dedicated to broadcasting a wide range of *sha'bi* music, and many of the national (and even some of the commercial) television stations regularly feature both contemporary and older performances of *sawt* and other local genres.

It is difficult to overestimate the impact of the exponential growth of satellite TV stations in the Gulf. In 2000, less than a decade after its arrival, this new technology reached 66 percent of the population of the United Arab Emirates, 73 percent of Saudi Arabia, 81 percent of Kuwait, and 98 percent of Oman (Belchi, 2002). While some see the new satellite TV stations as an important conduit through which Gulf state citizens can project their worldview to the broader Arab and international world, others note that the channels have also become an important means for these citizens to represent themselves to themselves (Sakr 2005, 50).

Satellite television enterprises have thus helped to unify the Gulf media markets, and, to a lesser extent, the Arab media markets. Some media outlets in the region are now promoting a nonlocalized contemporary Gulf style of music, rather than the heterogeneous assortment of styles and genres of the past (Ulaby 2006, 219). The satellite-based unification of the Gulf media

market, led by news and serial programming but featuring music as well, has contributed to a broader sense of Gulf regional identity.

Because of the rampant piracy that attends digital technologies, the Gulf recording industry has become fairly stagnant, and many smaller music labels have ceased production. Today, most recordings are used as promotional vehicles rather than for income generation, and the majority of an artist's income is derived from playing at concerts and weddings. Several music storeowners that produced original recordings have been unable to recoup their investment and now simply sell pirated copies themselves. New digital technologies have also worked in concert with the relatively high Internet penetration rates in the region, allowing for new ways of disseminating and consuming music. As in other parts of the world, the Internet has become an important conduit for downloading music and watching music video clips.

While the smaller Gulf music companies whose business models depended on the local sale of Gulf popular music faltered as a result of the advent of low-cost cassette duplication equipment in the 1980s, another business model has proved to be quite successful for larger companies. The development of this media strategy is best exemplified by the Saudi Rotana company, founded in 1987 and fully acquired by Saudi Prince Alwaleed bin Talal in 2003 (Sakr 2007, 174). Originally a record label centered on local artists, Rotana has recently signed many of the most popular music acts from across the Arab world, including a number of the biggest stars in Egypt and Lebanon.

Rotana was also able to obtain the broadcast rights to a significant amount of music, concert footage, and films from the mid-twentieth century. Drawing on its in-house talent and sizable library, Rotana launched a satellite TV network in 2003 that has grown to include six free-to-air channels, according to the company's Web site. In concert with the TV network and record label, Rotana has become a powerful, integrated player in the broader Arab media market.[21] It has been able to leverage its power as a record label and satellite TV network to promote its Gulf artists both within the region and increasingly throughout the Arab world.

Today, numerous satellite TV channels in the Gulf region primarily, or exclusively, broadcast video clips, including Gulf music content. Several channels broadcast Gulf music exclusively. Whereas in earlier decades, Gulf singers sometimes tried to cater to Egyptian or Lebanese audiences, today many singers from other parts of the Arab world try to appeal to the powerful Gulf media market, alongside their home markets.

Conclusions

The oil boom of the early twentieth century had a profound impact on the Gulf, precipitating a restructuring of Gulf society and the role of music in that society. Oil wealth funded the creation of new performance contexts for music, especially through the development of broadcast and recording media. These new mass-mediated contexts generated alternative spaces for consuming and performing music in the public sphere, expanding what had been primarily a private experience.

Mass media in the Gulf has deployed music to attract people to the extralocal nation-state framework it articulates. This feature has made music a particularly important resource for local governments in the process of state formation. While the introduction of analog recording and terrestrial broadcast technologies tended to promote narratives of the modern nation-state, subsequent digital and satellite technologies have provided an effective conduit for broadcasting and promoting a pan-Gulf identity, both within the region and beyond.

The rise of regional popular music and media markets (created in part by satellite channels such as Rotana and Al Jazeera) has worked in concert with political and economic endeavors to increase Gulf regional integration, including plans for a common currency and market. While in the past Kuwait and Bahrain were the main producers of mass-mediated music, Qatar and Dubai, increasingly backed by investors from Saudi Arabia and Abu Dhabi, have made dramatic progress in media infrastructure and expertise, and now appear poised to lead the region's music mass media industries into the next century.

References

al-A'ali, Mohammed. 2004. Star academy concert put off. *Gulf Daily News*, May 23.

Abu-Lughod, Lila. 2005. *Dramas of nationhood: The politics of television in Egypt*. Chicago, Ill.: University of Chicago Press.

Ali, Ahmed Abdulla. 1988. *A historical and descriptive research on radio broadcasting in Bahrain*. Ames, Iowa: Iowa State University Press.

Anderson, Benedict R. O'G. 1983. *Imagined communities: Reflections on the origin and spread of nationalism*. London: Verso.

Belchi, Jean-Marc. 2002. Evolution of TV viewing in the Middle East 1996–2000. Paper presented at the conference "New Media and Change in the Arab World," Amman, United Arab Emirates, February 28–March 1.

Campbell, Kay Hardy. 1996. Recent recordings of traditional music from the Arabian Gulf and Saudi Arabia. *Middle East Studies Association Bulletin* 30:37–40.

Daukhi, Yusuf. 1984. *al-Aghani al-kuwaytiya.* Qatar: Markaz al-Turath al-Sha'bi (GCC: GCC Research Center).

al-Dawsari, Ibrahim. 1992. 'Alam al-tarab al-sha'bi fi-l-Bahrayn. Bahrain:. N.p.

al-Ghanaym, Ya'qub Yusuf. 2000. *al-Aghani fi-l turath al-sha'bi al-Kuwayti.* Kuwait: n.p.

Gilroy, Paul. 2006. British cultural studies and the pitfalls of identity. In *Media and cultural studies: Keyworks,* eds. Meenakshi Gigi Durham and Douglas Kellner, 381–95. Malden, Mass.: Blackwell.

Habib, Ibrahim. 2003. *Ru'ad al-ghana'.* Bahrain: al-Ayyam Publishing.

Hall, Stuart. 1979. Culture, the media and the "ideological effect." In *Mass communication and society,* eds. James Curran, Michael Gurevitch, and Janet Woollacott, 315–48. London: Sage Publications.

Iraqi traditional music revisited in a war era. 2005. *al Jadid* 10 (49), http://www.aljadid.com/music/IraqiTraditionalMusicRevisitedinaWarEra.html.

Khalifa, Aisha Bilkhair. 2006. Spirit possession and its practices in Dubai (UAE), Musiké 1 (2): 43–64.

Khan, Wahid. 2002. *Aghani al-ghaws fi-l-Bahrayn.* Qatar: Markaz al-Turath al-Sha'bi.

Kraidy, Marwan. 2006. Reality television and politics in the Arab world: Preliminary observations. *Transnational Broadcasting Studies,* no. 16, http://www.tbsjournal.com/Archives/Fall05/Kraidy.html (July 6, 2010).

Kuwait bans concerts involving women entertainers. May 25, 2004. Arab News.

Kuwait bans "vulgar" talent show. May 24, 2004. BBC News.

al-Maliki, 'Isa. 1999. *Aghani al-Bahryn al-sha'biya.* Bahrain: Government Publishing.

Muhammad, Khalid. 2003. *al-Fann wa-l-samri fi-l-Kuwayt.* Kuwait: al-Faysal Press.

Olsen, Poul Rovsing. 2002. *Music in Bahrain: Traditional music of the Arabian Gulf.* Moesgaard, Denmark: Jutland Archeological Society.

Pearling: Past and present. 1955. *Bahrain Islander* 17–21.

al-Rifai, Hessa Sayyed Zaid. 1982. *Al-nehmah wal-nahham: A structural, functional, musical and aesthetic study of Kuwaiti sea songs.* Bloomington, Ind.: Indiana University Press.

Sakr, Naomi. 2005. Channels of interaction: The role of Gulf-owned media firms in globalization. In *Monarchies and nations: Globalisation and identity in the Arab states of the Gulf*, eds. Paul Dresch and James P. Piscatori, 34–51. London: I.B. Tauris.

——. 2007. *Arab television today.* London: I.B. Tauris.

Schlesinger, Philip. 1991. Media, the political order and national identity. *Media, Culture and Society* 13 (3): 297–308.

Schweitzer, Erez. 2006. From the king's palace to a 'ghetto' of oriental music. *Ha'aretz,* June 5.

Smally, Ben. 2006. *Middle East media guide 2006.* Dubai: Arab Media Group.

Sulayman, Muhammad. 1992. *Nahham.* Doha: Markaz al-Turath al-Sha'bi.

al-Taee, Nasser. 2005. "Enough, enough, oh ocean": Music of the pearl divers in the Arabian Gulf. *Middle East Studies Association Bulletin* 39 (1): 19–30.

Ulaby, Laith. 2006. Music and mass media in the Arab Persian Gulf. *Middle East Studies Association Bulletin* 40 (2): 214–21.

Notes

1 Although locally known as *al-Khalij al-'arabi* (the Arabian Gulf), this term is contested. Both the U.S. State Department and the United Nations refer to the region as the 'Persian Gulf,' while other organizations, such as National Geographic, use the more neutral term 'the Gulf,' which I have opted to use here. I refrain from using the term Persian Gulf because I feel that this would lead to confusion, as this chapter focuses on the Arab countries in the Gulf, specifically the members of the Gulf Cooperation Council (GCC), and does not include Iran.

2 While in other parts of the Arab world (for example, Morocco, Algeria, or Egypt) the term *sha'bi* refers to specific local traditions, in the Gulf it is used to refer to a wide range of musical styles. Although there is some inconsistency in what falls within the umbrella of *sha'bi*, I use the term to refer to local, non-religious, folk and popular genres. It is important to note that while these genres do not have a religious function like Qur'anic recitation, they commonly incorporate religious themes and references. (For more, see al-Maliki 1999, 15–17; Olsen 2002; al-Ghanaym 2000.)

3 In this usage the term *dar* refers not only to the building, but also to the performance group.

4 For more on the early development of *sawt* see Daukhi (1984, 223–92).

5 There are several genres in the Arab world called *sawt*, including prominent styles of the Abbasid-era minstrels in Baghdad, which some scholars feel is directly connected to the contemporary *sawt* tradition (al-Rifai 1982, 194; Habib 2003, 19). Although early forms of the *mawwal* were called *sawt*, I am skeptical that we know enough about the performance practice of the Abbasid era to argue that there is any connection between historical and contemporary forms bearing the same name. For instance, the *tawshiha* is certainly a fairly recent innovation to the traditional form of the *sawt*. Similarly, the historical *sawt* was never performed in colloquial Arabic, as it is today. Hessa al-Rifai has speculated that the addition of the *tawshiha* might have been adopted from the *muwashshahat* of Andalusia, which became a popular form in the Eastern Mediterranean (Al Rifai 1982, 194). Other scholars trace the heritage of the *sawt* to Yemen's Hadramaut, an area which has exerted tremendous cultural influence on the Gulf (Sulayman 1992, 124).

6 Although all Gulf states have profited from hydrocarbon resources, benefits have not been uniform. For instance, Qatar, whose main wealth lies in natural gas, not oil, has only been reaping large windfalls since the 1990s.

7 While some non-commercial recordings were made in the Gulf as early as 1904, the commercial recording industry did not take off until the 1920s (Campbell 1996).

8 Brothers Salih and Dawud (no relation to 'Abd al-Latif) were influential musicians in Iraq, serving in the Iraqi national orchestra, of which Salih became director, until their emigration to Israel. Although their surname indicates Kuwaiti heritage, they spent most of their lives in Iraq.

9 For more information about prominent Bahraini *sha'bi* singers in the early twentieth century, including their recording careers, see al-Dawsari (1992).

10 Recordings could not be made in the summer in the Gulf at this time because the weather was too hot to make the imprints on the wax masters.

11 Al-Sa'ati, a Persian watch repairer by profession, is also notable because he brought the first recording equipment to Bahrain and his sons would establish some of the early Bahraini record companies.

12 From at least the nineteenth century the Indian rupee was the main form of currency in the Gulf. Even after Indian independence in 1947, most of the Gulf states continued to use the Indian rupee (renamed the Gulf rupee from 1959 to 1966) as their main currency.

13 The first radio stations in the region were the private networks of King 'Abd al-'Aziz and the Arabian American Oil Company (Aramco) in Saudi Arabia and the Bahrain Petroleum Company (Bapco) in Bahrain, all of which were established

in 1932. Official radio stations of the Gulf states were established in the fol-
lowing years: Saudi Arabia in 1948, Kuwait in 1951, Bahrain in 1955, Qatar in
1968, UAE (Abu Dhabi) in 1969, and Oman in 1970 (see Smally 2006).

14 The exception was the Italian Air Force's bombing of the oil fields in Bahrain
and Dahran, Saudi Arabia, in 1940.

15 High-powered radio transmitters with a range up to hundreds of miles, some-
times called 'border-blasters,' were used to broadcast programming—often
propagandistic—from one country into another.

16 *Rababa* music, which is closely associated with the Bedouin traditions, is a form
of sung poetry; the performer accompanies himself on the *rabab*, a bowed spike
fiddle.

17 Ever since the establishment of national radio stations, Gulf governments have
been the exclusive broadcasters of terrestrial radio and television signals (aside
from shortwave radio). Only since 2000 have there been some moves toward
privatization of radio networks, particularly in Bahrain, Kuwait, and the U.A.E.

18 The *'arda* was originally a 'war dance' used to prepare for battles and celebrate
victories. It is now used to celebrate national holidays and diplomatic events.

19 Kuwait achieved independence in 1961, Yemen Aden in 1967, and Bahrain,
Oman, Qatar, and the UAE in 1971. The UAE was formed from a union of
sheikhdoms that was finalized in 1972. Originally, Qatar and Bahrain were
slated to join the UAE, but backed out of the agreement to become independent
countries. Ironically, these moves brought about the end of a common currency,
the Gulf rupee. The Gulf Cooperation Council hopes to reinstate a common
currency (the Gulf dinar) by 2010.

20 Originally the *samri* was a desert genre of sung poetry accompanied by frame
drums *(tar)*. Today, there is an urban *(madani)* form of *samri* that incorporates
the *'ud* (and other melodic instruments) and expanded percussion (see Moham-
mad 2003). *Basta* and *yammani* are popular song forms of Iraqi and Yemeni
origin, respectively.

21 In this instance, for example, Rotana not only produces music videos, concerts,
and magazines, but also operates cafés, a movie production company, TV chan-
nels, and radio stations. This allows them complete control in production, mar-
keting, and content to maximize profit. It is interesting to note that the kinds of
'multiple rights' or '360' now common with companies like Rotana are becom-
ing increasingly popular with American and European record labels as they try
to cope with piracy and declining record sales.

Cultural Critique,
Cultural Analysis

6

Music of the Streets: The Story of a Television Program

Yasser Abdel-Latif

Since its inception in 1998, I have worked for Nile Variety Entertainment (NVE), one of several specialty channels launched around the same time. NVE was based on the model of MTV, offering primarily music and songs. It operates under the aegis of a sector of Egyptian state-owned television known as the 'Nile specialized channels,' today comprising about ten satellite channels in all. Each of these channels concentrates on a particular field, such as news, sports, drama, or culture. The establishment of such a sector within the framework of the state-owned Egyptian media establishment represented one direction in the government's attempt to invest in new media. Indeed, these specialty channels are carried by two new state-owned satellites (Nilesat 101, launched in 1998, and Nilesat 102, launched in 2000), following closely upon the government's 1996 inauguration of its state-of-the-art Media Production City, built on an enormous site just outside Cairo.

As is typically the case for music channels, NVE focused on the main-stream commercial current of Egyptian and Arabic music, a sort of Arabic pop, suitable for the urban middle-class viewer. NVE video clips, and even the stars hosted on various talk shows, present a shallow pomposity that bores one to tears. Whether this Arabic pop focus resulted from a conscious decision on the part of policymakers or from the tastes of channel programmers is a question to ponder. Certainly, the channel excluded all other contemporary

music, regardless of its popularity with audiences. For us, this was a strong indicator that the middle classes were dictating their own tastes and choices, and presenting them as though they were the sole product of all human endeavors in the music area.

Thus, it occurred to me and to Nader Hilal—television director, colleague, and friend—to make an experimental music documentary presenting other modes of singing, in order to interfere with the channel's unremitting transmission of the commercial mode, day in and day out. The program Nader and I decided to make was conceived as a benevolent 'bug' to be introduced within this channel, where we both felt a strong sense of alienation, both from coworkers and from content. Chance alone had led us to work at that place.

We chose to make a documentary about the musical currents prevalent among the working classes. Such music is incorrectly known as 'folk song' *(al-ughniya al-sha'biya)*, when in fact its principal characteristic is low-budget, marginalized production. It is far from the academic category of 'folk,' which implies a collective creation with no known author. The adjective *sha'bi* (meaning 'popular' or 'of the people') was applied because such music is disseminated largely among simple artisans and (via cassette) microbus drivers. The microbus, a typically Cairene mode of transport, is this music's most important channel of distribution. Microbus clientele represent a mixture of various sectors of society, which means that a variety of tastes and value systems intersect inside these vehicles.

Our choice was also derived from my personal admiration of this 'wild' music, whose lyrics challenge the niceties that prevail in the upper echelons of the music industry, which stultified into a set mold of specific aesthetic and moral codes decades ago.

Beginning with Ahmed Adaweya, but by no means ending with Abdel Basset Hamouda, this *sha'bi* music, which first appeared in the 1970s, developed a large popular base within an audience otherwise regarded as vulgar and unworthy by the conventional middle-class arbiters of public taste. The songs in this genre typically open with the folk *mawwal*, including its *layali* prelude,[1] following which the singer takes up the song proper and its core themes, often cursing time—that divisive, destructive factor invariably doing away with human happiness—and treating sensual love in a manner rarely, if ever, found in the big song productions approved by 'respectable' media. With the artistically primitive performance of the singers and their gravelly voices, resonating with the music, the effect presents the din and rhythm of the crowded city interspersed with melodies flirting, here and there, with folk themes.

Such songs are produced by small production companies in Cairo's popular areas, recorded in unknown studios, and published solely on cheap cassette tapes, with enormous distribution. We have not found as yet that any of the singers in that market have published their music through more sophisticated technology, such as the compact disc.

Nader and I decided to film the singers going about their daily lives, and to gain access to their studios and production companies. We wanted to understand their conceptions of art, to interpret what singing means to them. We wanted to come to know the nature of the relation between them and the musicians who accompany them, and to film weddings and 'concerts' that take place in Cairo's alleyways or in the popular night clubs that are their forum and their stage. We wanted to witness as closely as possible their relation with their audience, live and directly. We planned to devote one TV episode to each singer.

At this point, I should mention a precedent that strongly influenced our project. On a program that aired during peak-hour Ramadan programming in 1998,[2] a celebrity female announcer from Egypt's Channel 2 hosted three *sha'bi* singers, Shaaban Abdel Rahim, Abdel Basset Hamouda, and Magdi Tal'at. Her prejudices, and presumptuousness, were more than clear from the start. The announcer behaved as if she were holding a public trial in which the three singers were the culprit representatives of poor, vulgar taste and artistic corruption, and as though television audiences all over the country held the same views. She used every possible rhetorical trick to belittle and embarrass her 'guests' and to portray them as alien and ignorant beings. Abdel Basset Hammouda was the most true to his nature as a self-made man. His responses were confident and reflected awareness of the nature of the place where he was being interviewed. Unabashedly, he announced he had no need for either the radio or the television. He was perfectly happy and satisfied, he said, with his fans who attend his live performances and buy his cassettes, and proudly announced that those could be counted in the millions.

Magdi Tal'at, meanwhile, came across as defensive, weak, and unsure of himself, even frightened in the awesome presence of the lady and her paraphernalia. It is of interest to note that Magdi is the most highly educated of the three: he holds a second-degree diploma in commerce, which qualifies him as a clerk in the lower echelons of the bureaucracy.

In the long run, Shaaban Abdel Rahim was able to turn the tables to his advantage. He did this with masterful cynicism (in the Greek sense of the word). He played the announcer at her game and gave her the answers she so

obviously wanted to hear, and more, countered her sarcasm with self-directed sarcasm she was unable to follow. For example, when she asked him about the secret behind the flashy colors he wears, he replied that he is always careful to match his clothes with the sofa on which he sits! The 'clever' announcer did not understand his humor, and, though somewhat thwarted, she looked at the man disdainfully, surprised by what she called his "strange" logic.

Nader and I viewed ourselves as occupying a different position from that of this announcer. We presented our program concept to the channel's management, which forwarded it to the highest committee in the sector, the body that approves or rejects programming (based on production viability more than censorship). Our program was approved, and we received a relatively good budget, by the 1999 standards of Egyptian television, to shoot thirteen episodes. Each episode, we calculated, would require three days of shooting and sixteen hours of editing in order to produce forty-five minutes of film—something like a low-budget documentary. But we were used to making do with the limited financial resources offered by the program production department in that sector.

Channel management had no censorial objections to the proposed program, television being a more accommodating institution than radio. To the present day, Egyptian Radio refuses even a mention of Ahmed Adaweya's name by means of listening committees that act as a barrier to the broadcast of any singer not in perfect accordance with the station's rules and standards. This is done under the pretext of protecting public taste, whereas in fact such committees merely serve to protect 'official' currents in song and music. Indeed, until recently, singers like Amr Diab and Moustafa Amar, quintessential representatives of popular commercial *shababi* (youth) music, contemporary, and recognized both by the market (as testified by sales) and by the middle classes, were banned from radio, as their voices and musical styles did not conform to the solemn standards of the listening committees.

At any rate, management in the production sector approved our idea and so did the channel, not only because television is more accommodating but also because any system is always both stupid and clever. In this case, it is stupid because it allows its rules and regulations to be infiltrated despite the efforts expended on maintaining its bureaucracy, and it is clever because, from a pragmatic point of view, such a program would present interesting material to television viewers in all cases.

We had to start a search for the artists we wished to interview and decided to begin with Tarek al-Sheikh and Shafiqa as good representatives of what we

were after. Tarek al-Sheikh was at the time a new name in the world of *sha'bi* song. In the season he first appeared, he had been exceptionally successful. One heard him everywhere, in taxis, microbuses, and popular shops. Tarek had produced just one album and was in the process of recording a second. He deserved an episode of our program all to himself. He had about him all the question marks that excited us, making us want to know how he found his way to *sha'bi* song. Tarek's voice—exceptionally wide-ranging and broad— clearly indicates training in the arduous discipline of chanting and reciting the Qur'an. His first album, *Ya eini 'allena* (Woe Be unto Us), demonstrates a musical education and experience with writers and musicians, alongside high-caliber execution.

Shafiqa, on the other hand, comes from Tanta, in the Nile Delta north of Cairo—a large rural town noted for its mystical traditions and the *moulid*[5] of the famed Sufi saint, Ahmad al-Badawi, as well as for its music and songs. Shafiqa earned her fame in the towns of the Delta during the 1980s, using the name Shafiqa Mahmud. She abbreviated her name as she became known among the popular classes of Cairo and, especially, Alexandria. In timbre and pitch, her voice lies somewhere between the masculine and the feminine. To her audiences, she is reminiscent of their favorite, Badriya al-Sayyid, or Badara the Alexandrian, as they called her.

We began our search with Shafiqa. Shafiqa sings the opening *mawwal* expertly, and her songs contain heated feminine emotions. Our only contact was her production company. We phoned and arranged an appointment with the company's owner, visiting him in his office in the center of Tanta. The company was modern, with the right degree of grandeur—fit for a town like Tanta. The producer met us with the warmth of a local businessman, and talked to us about his work and the stars for whom he had produced albums, one of whom was the late 'Abdu al-Iskandarani, "the dean of the *mawwal*," as he is known. From this, we understood that the producer had a fairly strong position in the field of music production, despite his location far from the Cairo metropolis.

We talked about our program and asked for his assistance in putting us in touch with the artists. He showed instant readiness, but as soon as we mentioned Shafiqa, he retreated, becoming evasive and making excuses that her husband was a very conservative man who would not allow his wife to appear on television! We swallowed the paradox, but felt sure there were other reasons for his refusal. Still, the man promised that he would speak to her and get back to us. (He never did.)

So, we postponed Shafiqa and went looking for Tarek al-Sheikh. Tarek was easy to find. We obtained his cell phone number from a young cigarette vendor who owns a kiosk next to the television building in Cairo. This young man happened to be one of Tarek's fans, and even knew him personally, which to us meant that these stars were not far removed from their audiences. We called Tarek and set an appointment in the coffee shop of a three-star hotel of his choice.

As is typical with such artists, he was almost an hour late for our meeting. But he seemed enthusiastic about the project, and we began interviewing him on the spot. We asked about his life and work. He grew up in the impoverished Cairene quarter of Sharabiya. He had been preparing since early childhood to become a Qur'an reciter. As a teenager, he started singing in weddings in his neighborhood, together with the late Ramadan al-Brins. He gave us the names of the places where he sang and even details of his personal life, so we had quite a collection of material with which to go to work on the scenario. He told us he would be singing in a certain nightclub in Alexandria the following week; this was perfect for us, as we wanted to begin shooting our program.

At the appointed time and place, the work team was ready: the director, the writer, the director's assistant, the photographer, and the production manager, together with three assistant technicians and all the necessary equipment. We had located several areas in which to interview him in Alexandria, and planned two more days of shooting in Cairo in his old neighborhood, in his new house, in a live performance, and finally in the recording studio.

We arrived in Alexandria around ten o'clock in the morning and proceeded to shoot the inserts without Tarek al-Sheikh. We thought to call him around noon, in order to meet and start shooting before he began preparations for his evening performance, which was to take place in a 'variety theater' where wedding banquets are often held and where anyone can enter from the street, uninvited, in order to partake of the food and entertainment. At such venues, the program normally comprises a number of popular singers and one or two second-rate belly dancers. Cheap Egyptian-made alcoholic beverages are typically served.

We called Tarek as soon as we finished shooting the parts of our film in which he would not appear, but his cell phone was off. We called dozens of times, always with the same result. Finally, we lost hope. We waited until evening, then went directly to the venue where he said he would be singing in order to shoot his live performance, postponing our interviews with him

until afterward. When we arrived at the venue, we were told that he was not on the program and that he would not be singing that night. Quite simply, he had fooled us. We returned to Cairo around midnight, having squandered a few thousand pounds of our precious budget.

The following day, I called Tarek to find out what had happened and to demystify his behavior. His manager answered the phone and told me up front that Tarek did not show up because he feared we meant to 'expose' him, to publicly shame him, the way the aforementioned announcer had done with Abdel Basset Hamouda and Shaaban Abdel Rahim. Here I was, face to face with the mutual distrust between these artists and the *effendi*s who work in the media.[4] It did not matter that we were trying to present a different image than the usual. The television episode in which the 'big three' had appeared had fed the distrust and contributed further to the schism between the two sides, each one returning to its respective pen.

Only Shaaban Abdel Rahim had emerged victorious from that famous episode. The day after the program was aired, his sales rocketed sky-high and all social classes developed a curiosity about the laundry boy who became a famous singer. Later, he became a host on several television chat shows, where he relentlessly displayed the rigors of his tough journey ending in celebrity, but always with the same cynical manner he used on that first program. Immediately after that, film director Daoud Abdel Sayed picked him for a role in a relatively serious film, *Muwatin we mukhbir we harami* (A Citizen, a Detective, and a Thief, 2001), thus assuring commercial success for what would otherwise have been a noncommercial film. This role opened other doors. Samir Ghanem exploited Shaaban's popularity and success by giving him a principal role in one of his comedies. Shaaban Abdel Rahim became an icon of the popular grotesque.

Paradoxically, all this was detrimental to the musical current that produced him. That whole line in song and music was reduced to the person and art of Shaaban Abdel Rahim, for the benefit of middle-class educated audiences, in the time-honored tradition by which the 'self' fixes and freezes stereotypical images of all that it considers different.

Strangely, that musical current underwent a real regression, even in its own context, after the Abdel Rahim phenomenon. Production fell, and new voices became scarce. Abdel Basset Hamouda, who appeared on the same fateful program with Abdel Rahim, faded away, though he had been expected to fill the shoes and inherit the status of Ahmed Adaweya.

The middle classes have won yet another round.

As for our program, we shot four episodes about several types of folk song, religious chants, and ethnic music—all topics that have frequently been treated in the modern Egyptian media. Indeed, folklore is naturally a field close to the hearts of the perpetrators of totalitarianism. Thus, our program lost its uniqueness, and the vision that inspired it was deflected. It failed to become an artistic and anthropological bridge between two parallel cultures that despise each other.

In the 1970s, Ahmed Adaweya sang scathingly about the *effendi*s and the childish tenacity with which they clutch their official printed forms and their toy stamps: "Coochy coo, baby, you can fill out a form and stamp it too!"

Notes

1 [The *mawwal* is a type of verbal folk art, colloquial poetry employing various rhyme schemes, and generally following a set scanning pattern *(mustaf'ilun, fa'ilun, musta'ilun, fa'ala)*. The *mawwal* is sung *extempore*, usually accompanied by an instrument, often a reed flute. The *layali*, a vocal improvisation on the words "*ya leil ya 'ein*" (oh night, oh eye) introduces the *mawwal*. The *layali* text is said to be an echo from a story in the *Thousand and One Nights*, but otherwise serves merely as a vehicle for improvisation. –Tr. and Ed.]

2 [A month-long Islamic holiday, the month of fasting, and also the occasion for watching tremendous amounts of entertainment TV in the evenings, when the best television productions of the year are eagerly anticipated. -Ed.]

3 [In Egypt, a *mulid* is the celebration held on the assumed birthday of a saint, whether Muslim, Christian, or Jewish. Hence the *mulid* of the Virgin Mary, or the *mulid* of Abu Hassira (a Jewish saint), or the *mulid* of Sayyid al-Badawi (the Muslim Sufi saint mentioned in the article). –Tr.]

4 [*Effendi* (originally a Turkish title of respect) is the title given to an educated Egyptian male who wears urban, Western clothes. *Effendi*s, usually university graduates, typically occupy lower-echelon civil-service positions at the beginning of their careers. In Egypt, the word came into widespread use following modernizations at the beginning of the nineteenth century, when the Egyptian ruler, Muhammad 'Ali Basha (originally a Turkish officer), was pushing for secular education. –Tr.]

7

What's *Not* on Egyptian Television and Radio! Locating the 'Popular' in Egyptian *Sha'bi*

James R. Grippo

My taxi-nomical revelation

There are over fifty thousand taxis operating in greater Cairo (Nafie 2004), their horns beeping incessantly while they stop and start, turn and dart, as if part of a surreal bumper car race. The ubiquitous black-and-white Cairo taxis are something of a cultural icon to Egyptians and foreigners alike. Often decorated according to tastes that range from the ridiculous (faux leopard-print dashboard covers and flashing colored interior lights) to the sublime (ornate Qur'ans, Christian iconography, amulets, and beads), the vehicles say a remarkable amount about the driver.[1]

Adding to this rich texture, taxi drivers are perhaps the most culturally diversified occupational group in Egypt. I have been driven by graduates of medicine, law, computer science, and agriculture, as well as drivers with no higher education whatsoever.[2] In downtown Cairo, you can be picked up by a driver born and raised in Upper Egypt, Alexandria, Giza, a village in the Nile Delta, or any of the myriad urban Cairo suburbs. While some drivers never say a word, others never stop talking. As a researcher of popular culture, the conversations I shared with Egyptian taxi drivers have been enlightening; almost no topic is too mundane, obscure, or controversial.

Most taxis and microbuses contain a radio and cassette player. For an ethnomusicologist, the sounds coming from vehicles' stereos and the ensuing

conversations are priceless. From Qur'anic recitation to the latest Top 10 pop song, these taxi sounds generate an apt soundtrack for experiencing the diversity of drivers and vehicles, as well as places and events. The types of sounds radiating from taxis have, of course, evolved abreast of the development of audiocassette production (early 1970s). Even semiconscious listeners can discern the most popular singers and songs after riding in taxis over the course of a week. After repeated ventures in Cairo taxis and microbuses, I became aware of deeper trends that challenged my understanding of Egyptian popular music.

My knowledge of Middle Eastern music began with undergraduate and graduate studies in ethnomusicology, based largely on available literature. As can be expected from a somewhat new field, ethnomusicological material on Middle Eastern music cultures is developing rapidly.[3] However, the majority of the established literature centers on two domains with a historic precedence in European and North American scholarship: art and folk music.

It was not long before I had a taxi-nomical revelation: the majority of music being played by taxi and microbus drivers was neither art nor folk music! Moreover, by attending countless weddings with musicians, I discovered that much wedding music is similar to one of the strains of Egyptian popular music that I was becoming familiar with in taxis. As I continued to hear these cassette-based popular musics, I realized that extremely pervasive popular music cultures were happening all around me that I knew almost nothing about. By talking to musicians and drivers, I soon discovered that much of what I was hearing is called *sha'bi*. While I was actively engaged in studying the Arab/Egyptian heritage of art music,[4] known as *al-musiqa al-turathiya* (heritage music) and *al-musiqa al-'arabiya* (Arab music), I was also becoming deeply immersed in *sha'bi* music culture.

As Egyptian *sha'bi* music became my research focus, it became clear that the circumstances leading to my own 'discovery' of this music were indicative of its subcultural standing in the face of 'official' popular culture. Despite the fact that nearly every wedding features live or recorded *sha'bi* music, which also appears to function as the soundtrack for taxi and microbus drivers on the streets of Cairo, little evidence of *sha'bi* can be found in the primary forces of Egyptian mass media: television, radio, and satellite channels. This conspicuous absence of *sha'bi* from the broadcast mass media became my impetus to research *sha'bi* music culture.

After the introduction of recording, radio, and television, the production of music, as well as its transmission and consumption, changed dramatically,

following the advancement of new media products and technologies, such as cassettes, compact discs (audio and video), music videos, computers, the Internet, music and video downloading, satellite television channels, and cell phones. Many of the chapters in this volume illuminate ways in which these rapidly developing mass media and associated 'mediascapes' have transformed not only musical expression but also the ways Egyptians experience and react to music.[5]

In this chapter, I examine the role of the new Arab mediascapes in reconfiguring the Arab popular music industry, especially the ways in which Egyptian *sha'bi* is included in or excluded from the new media. The division between the rich and the poor is demarcated, in part, by access to the technological gadgets required to receive popular music disseminated via new and costly technology. Egyptian *sha'bi* music, though extremely popular among the masses, has not been granted access to emerging media equal to that bestowed upon other forms of Egyptian music, such as Arab/Egyptian secular art music *(al-musiqa al-'arabiya)* or Western-influenced pop music (*shababi*, or 'youth music').

Locating the 'popular' in Egyptian music

In Egypt, as in other countries, music can be differentiated into four primary categories: 1) folk music *(al-musiqa al-sha'biya)*, 2) religious music *(al-musiqa al-diniya)*, 3) art music *(al-musiqa al-'arabiya)*, and 4) contemporary popular music (*sha'bi* and *shababi*). Despite the apparent rationality of these distinctions, the four categories tend to meld into multifaceted and intersecting sites of class, tradition, professionalism, cultural policy, and mass mediation. Moreover, distinguishing what constitutes 'popular' raises questions in academia, in popular culture, and within the Egyptian music industry.

Although Middle East music scholars have focused primarily on folk music (*al-musiqa al-sha'biya*, or 'people's music') and *al-musiqa al-'arabiya*, many have discussed what Ali Jihad Racy (1981) terms the 'classical-popular dualism' to highlight issues regarding systematizing and categorizing musical types that are not only widely disseminated and consumed but also fluid and multifarious (see Danielson 1996; Davis 1996; Manuel 1993; Nettl 1972; Powers 1980).

Racy notes that "the classical-popular division, with all its familiar implications, can be particularly misleading," and that the "applicability of the 'art-popular' distinction to Cairo's music is a matter of degree and interpretation." He identifies mass media (disc, film, theater, and radio) as the main

force behind the fact that the modern music culture of Cairo eludes "such a stylistic typology." A single song may include "a conglomeration of contrasting segments whose styles range from being similar to Egypt's Sufi music to having a tango rhythm with accordion accompaniment" (Racy 1981, 6). Highlighting this last point, Virginia Danielson adds that "some widely popular mediated music is located in the *turath*, or heritage of Arabo-Egyptian music. . . . 'Popular' then does not exclude classical or 'folk' or religious music that also draws from sources within the *turath*" (1996, 299).

Because of its culture-specific dynamism and its tendency to evade definition, the study of popular music has generated a wealth of important scholarship within ethnomusicology and popular music and cultural studies (see Bennett, Shank, and Toynbee 2005; Finnegan 2007; Frith 2004; Middleton 2000; Taylor 1997). Although there are many similarities among international musics that are identified as 'popular,' Egyptian popular music defies some of the basic Western understandings of popular music. In the United States, Great Britain, and Western Europe, for example, repertoires that are designated as serious music are rarely categorized as 'popular' and are positioned in contradistinction to popular music. Twentieth-century Egyptian *al-musiqa al-'arabiya*, meanwhile, has enjoyed a widespread following across class, political, and religious lines.

The categorical dynamism of Egyptian music means that the classification 'popular' must be construed as an index of currency and acclaim, as opposed to designating a specific musical genre. As John Baily suggested over a quarter of a century ago, this issue underscores the need for an ethnomusicological approach to problems of categorization, an emic approach that provides labels only "when the society concerned makes such distinctions itself" (1981, 106).

Certain indigenous terminology has been used to mark the development of Egyptian popular music, though some of it is largely limited to academic usage. Salwa El-Shawan notes that within *al-musiqa al-'arabiya*, two subcategories are distinguished—*al-turath* (the heritage) and *al-jadid* (the new)—as well as a third category that overlaps with *al-jadid*, *al-musiqa al-sha'i'a* (widespread music) (1980, 86). Recently, *al-jadid* and *al-sha'i'a* have been used to describe recent trends in popular music, such as *shababi* (discussed below). Adding to the confusion, the *sha'bi* domain is divided by subculture-specific subcategories (depending on whom you talk to), such as *sha'bi shik* (chic), *sha'bi rifi* (rural), and *sha'bi moderne*.[6] Currently, the most thriving and widely disseminated categorization within Egyptian discourse

and popular music distinguishes: 1) *sha'bi*, literally meaning 'folk,' 'traditional,' and 'popular' in Egyptian colloquial Arabic (Badawi and Hinds 1986, 466), and 2) *shababi*, or 'youthful.'[7] These two categories are counterposed to *al-musiqa al-'arabiya*. Before turning to my analysis of *sha'bi*'s absence from broadcast media, I discuss these terms in greater depth.

Al-musiqa al-'arabiya

The pan-Arab art music known today as *al-musiqa al-'arabiya* is rooted in premediated nineteenth-century practice and evolved during the twentieth century by means of new mass media to become *the* primary form of Egyptian popular music.[8]

For most of the twentieth century, Cairo was the entertainment capital of the Arabic-speaking Middle East, producing some of the greatest musicians, actors, writers, and artists in the region. Egyptian legends such as Umm Kulthum, Mohamed Abdel Wahhab, Abdel Halim Hafez, and Farid al-Atrash, produced and reinvigorated *al-musiqa al-'arabiya* and ultimately set the standard by which any newly composed Arab music was to be gauged.

Al-musiqa al-'arabiya is characterized by the sophisticated use of melodic and rhythmic modes (*maqam* and *iqa'*, respectively) within vocal and instrumental forms, and by experimentation with a wide variety of compositional and performative idioms, "provided that these idioms do not transcend the boundaries of Arabic music styles as perceived by native musicians and audiences" (El-Shawan 1980, 86). Such music may also be labeled *tarab*.[9]

From the 1930s onward, the core of *al-musiqa al-'arabiya*'s repertoire was composed using a long song form (*ughniya*, literally 'song'), which incorporated aspects of the older suite form *(wasla)* and the *taqtuqa* genre from the nineteenth century (Marcus 2007, 119–21). The *ughniya* contained enormous timbral and compositional diversity, including numerous sophisticated modal modulations, rhythmic changes, and stylistic colors *(alwan)* in a piece lasting between twenty minutes and an hour. Whereas it was common practice for a singer to perform with a small ensemble *(takht)* of pan-Eastern Arab instruments such as the *'ud* (lute), the *qanun* (plucked zither), the *kaman* (violin, sometimes played vertically on the lap), the *nayy* (end-blown reed flute), and the *riqq* (tambourine), by the mid-twentieth century, this configuration had expanded to become a large orchestra featuring a Western string section (multiple violins, cellos, the double bass) and sometimes accordion, electric guitar, and keyboard.

Ultimately, *al-musiqa al-'arabiya* united the most expert, talented, and popular poets, composers, and musicians of the time. As a widely respected art music, it was commonly associated with elitist cosmopolitan sectors of Egyptian society, but its reach transcended societal boundaries determined by class, ethnicity, and creed. One example of this transcendence is the phenomenal effect Umm Kulthum's singing had on all Egyptians, as well as listeners across the Arab world. As live performances of her songs were radio broadcast on the first Thursday of every month, it was not uncommon to see children, villagers, and uneducated people singing the sophisticated and esteemed poetry written by some of Egypt's greatest poets, such as Bayram al-Tunsi and Ahmad Shawqi. It is well known among Egyptians young and old that her monthly broadcasts were so highly acclaimed that Cairo's bustling streets would empty as "people took their seats in front of radios" (Marcus 2007, 119).

New media that emerged in Egypt at the beginning of the twentieth century contributed to the creation of superstar singers who obtained an unprecedented level of fame. Widespread commercial recording in Egypt on wax cylinders and discs began in the first decade of the twentieth century, bringing about a "significant change in musical life represented by the emergence of the recording artist and by a musical market sustained by a recording-consuming audience" (Racy 1976, 25–26). Wax cylinders, discs, and their mechanical players were costly, and only small pockets of Egypt's upper class enjoyed owning the new media, but recorded music could be heard for the first time in public at select cafés and coffee shops.

In the mid-1920s, a number of privately owned radio stations emerged in Cairo (El-Shawan 1980, 94), continuing until radio was nationalized in 1934 (Wahba 1972, 67). Although still expensive in the late 1930s, radios quickly became ubiquitous in Egyptian society.[10] Radio stations played music collections recorded on wax cylinders and vinyl discs from previous decades, but styles of music were changing almost as rapidly as the media and live performances were broadcast.

Al-musiqa al-'arabiya singers of the mid-twentieth century became massively popular as their music reached a majority of the population through the airwaves. The Egyptian State Radio Broadcast Station (ESB) (inaugurated on May 31, 1934) hired renowned performers such as Salih 'Abd al-Hayy and al-Shaykh Mahmud Subh. Furthermore, ESB promoted several "young solo vocalists who performed 'new' compositions" and went on to become "radio stars," such as Layla Murad, Farid al-Atrash, and 'Abd al-Muttalib

(El-Shawan 1980, 98). El-Shawan maintains that by the late 1930s, ESB was a "central institution in Cairo's musical life" and one of the main sources of patronage for composers and musicians, adding, "ESB was the major vehicle for the dissemination of music, superseding the record and film industries, as well as live performances. Indeed, it became virtually impossible for Cairene composers and performers [of *al-musiqa al-'arabiya*] to carry out a musical career without ESB's patronage" (El-Shawan 1980, 99).

Egyptian cinema, which began in 1917 but did not flourish until after 1924, augmented the iconization of popular singers, especially Umm Kulthum and Mohamed Abdel Wahhab, who played the leading roles and sang several songs in each of their films.[11]

Mass mediated via cylinders and discs, radio, and film, *al-musiqa al-'arabiya* further expanded its reach following the inception of television (1960s) and the audiocassette (1970s). Today, music stores are filled with thousands of audiocassettes of *al-musiqa al-'arabiya*. Recordings of well-known musical films are gradually appearing in these shops, as well. Finally, numerous Web sites highlight information about singers and post long lists of downloadable music files.

Shababi

The music that came to be called *shababi* in the 1980s was a product of several Western pop-influenced bands that were formed in the 1970s, such as *al-Asdiqa'* (the Friends), 4M, the Blackcoats, the Jets, Hany Shenouda Petits Chats, and, later, al-Masriyin (the Egyptians) (Frishkopf 2002, 160; al-Bakry and al-Malky 2004). Shenouda helped 'popularize' the keyboard *(org)*, which became a dominant force in Egyptian popular music. In the mid-1980s, this new strain of Egyptian *bub* (pop) music, eventually labeled *shababi*, was marketed to appeal to younger Egyptians by fusing Western popular music styles (rock, jazz, or disco) and instruments (keyboards, drum kit, electric bass, or guitar) with Arab music characteristics (Arabic language, lyrical meanings, or rhythms) (Frishkopf 2002, 160). While initially it may have been the youth who were primarily interested in this new pop music, by the 1990s it had become the mainstream sound of Egyptian pop.

In addition to fusing Western and Eastern musical idioms, *shababi* music is created in a modern studio and produced on multitrack recording equipment in order to achieve a slick, contemporary sound. Electronic beats and synthesized sounds are the norm on recordings, and singers are often supported by enormous orchestras for live or televised performances. *Shababi*

singers emulate Western pop stars, flaunting their seemingly flawless physical beauty (often enhanced by cosmetic surgery and image professionals) and surrounding themselves with symbols of opulent wealth, often while selling consumer products in million-dollar advertising campaigns.

Perhaps the most famous of all Egyptian *shababi* singers is Amr Diab, who released his first cassette in 1986 *(Ya Tariq)* and who, since the early 1990s, has always had several hits in the Top 10 Arab pop charts. Diab, under the guidance of composers Hany Shenouda and Nasser el Mizdawi, set the *shababi* standard for hundreds of singers by establishing trademark musical and image styles. The best known of these musical styles is the 'Spanish tinge,' an assimilation of Spanish influences (such as the acoustic guitar and "Latin grooves and percussion"), which occurs with some frequency in Arab pop (Frishkopf 2002, 155). Amr Diab has maintained his status as an Egyptian pop culture icon and a force to reckon with in the ever-competitive Arab pop music industry.

Sha'bi[12]

The music that came to be called *sha'bi* emerged out of Cairo's vibrant and crowded working-class neighborhoods, such as Shubra al-Khayma, Imbaba, and Sayyida 'Aysha, among many others, during the late 1970s. This decade witnessed not only the decline of *al-musiqa al-'arabiya*—marked by the passing of its legendary performers, such as Farid al-Atrash (d. 1974), Umm Kulthum (d. 1975), and Abdel Halim Hafez (d. 1976)—but also the beginning of a downward spiral of economic fragmentation and social unrest. Some Egyptians argue that the creation, or popularization, of *sha'bi* was a direct result of the working-class majority desiring "something of our own," something from "our streets instead of the conservatories" (Tarek al-Sheikh, pers. comm., 1998). Others suggest that *sha'bi* was a reaction to the widespread depression, insecurity, or anger caused by several factors, including Egypt's defeat by Israel in the Arab–Israeli war (1967), President Gamal Abdel Nasser's death (1970), the failing economy under President Anwar Sadat's Open Door policies (*infitah*, literally 'opening'), and the exportation of 10 percent of Egypt's most skilled laborers to the burgeoning oil-rich Arab Gulf countries (Wahba 2003, 5). Within this chaotic socioeconomic milieu, the new urban musical style known as *sha'bi* began to flourish as the dominant form of Egyptian popular music.

As mentioned above, *sha'bi* literally means 'traditional,' 'folk,' and 'popular' in Egyptian colloquial Arabic. The last meaning implies mass

mediation—referring to this music's enormous dissemination via the audio-cassette market—while also carrying connotations of the working class, from which the majority of this music's producers and consumers come. The term *sha'bi* evokes a complex cultural formation, one perhaps most easily defined as the antithesis of Egypt's elite cosmopolitanisms; it is associated with working-class neighborhoods, and points to cultural manifestations of working-class style in dress, demeanor, and language. As I have argued elsewhere,

> From the perspective of the cultural elite, the term often serves as an index for what is seen as the cultural backwardness of the uneducated masses. However, *sha'bi* also evokes for many Egyptians a sense of local identity, tradition and heritage, and the aura of authenticity that is referred to as *asil*. Grippo (2007, 259).

Essentially, the category can be considered a quintessential 'music of the people,' as singers convey the pains and joys of life in a vernacular slang that speaks directly to the common folk.

The complexity of *sha'bi* resides not only on a sociocultural level but also on a linguistic one. Arabic requires nominal-adjectival gender agreement. Hence, when *sha'bi* (masculine; feminine form, *sha'biya*) is preceded by *al-musiqa* (music; feminine), it becomes *al-musiqa al-sha'biya*, the primary term for the category of Egyptian folk music.[13] Despite this linguistic relationship, after hundreds of conversations with Egyptian musicians, composers, critics, and music industry professionals, I have not discovered the derivation of the term *sha'bi* or its connection to folk music culture.

The term *sha'bi* pits heritage folk musicians against *sha'bi* musicians in an imaginary battle for authenticity. The battle is imaginary, from my point of view, because this issue is virtually nonexistent for *sha'bi* musicians. Folk musicians, however, lay claim to the term *al-musiqa al-sha'biya*, as well as its natural masculine counterpart *(sha'bi)*, and many have expressed nothing short of disgust that the 'other' genre of the same name is associated with their art. My ethnographic interview progress hit frequent snags because of the name-sharing issue. While interviewing people outside the *sha'bi* domain, the first fifteen to twenty minutes were invariably spent explaining that my interest resides not with folk music but with the contemporary urban phenomenon of *sha'bi*. My clarifications usually provoked surprise and polite chuckling, followed by a genuine concern for my seemingly ludicrous and peculiar research focus.

According to acclaimed folk music singer Fatma Serhan, the confusion is based on the fact that "both come from *al-harat* [narrow dirt roads, traditionally constituting a neighborhood], both come from simple [common] people *(nas busata)*" (pers. comm., 2004). Dr. 'Abd al-Rahman al-Shafi'i, director of Firqat al-Funun al-Sha'biya (Ensemble of the Folk Arts), vehemently denies any equations between Egyptian folk music and *sha'bi*, saying, "these [*sha'bi*] songs have *sha'biya* but they are *not* folklore! Folklore does not die [dramatic pause] but *sha'bi* performers do!" (pers. comm., 2004). Dr. al-Shafi'i thus highlights two important aspects of folk music and *sha'bi*: *sha'bi* uses musical and cultural elements of folklore, and Egyptian folk music is rooted in oral tradition and sustained over time by hereditary musicians.[14] Unlike folk songs, all *sha'bi* songs are newly composed, and the genre's musicians come from widely disparate socioeconomic and educational backgrounds. Some have received musical training in the military or conservatories, while others have very little musical experience.

Furthermore, *sha'bi* music, although erroneously identified with Egyptian folk music and culture, is unquestionably an urban phenomenon. The first *sha'bi* superstar, Ahmed Adaweya, who emerged into public prominence in the 1970s thanks to the new medium of audiocassette, worked his way to the top from the lower rungs of *suq al-musiqiyin* (the musicians' market). According to Nicholas Puig,

> This market of musicians is composed of not only specific urban places but also a system of relationships and interactions that define it professionally, reproducing certain trades, skills and economic interests. It is also an urban culture, or subculture, anchored in urban spaces like Muhammad 'Ali Street, in places where the wedding ceremonies are organized, and on stages where musicians play. (Puig 2006, 514) (See Figure 7.1)

Yet *sha'bi* draws upon musical and cultural elements of folklore. Adaweya, who started his career in the *suq al-musiqiyin* of Muhammad 'Ali Street, carrying instruments for musicians and then eventually playing percussion, mastered the *mawwal* (sung colloquial folk poetry; plural, *mawawil*), often displaying virtuosic improvisations in the *maqamat* (melodic modes). Adaweya recorded several audiocassettes featuring *mawawil* and titled *Mawawil 1, Mawawil 2,* and so on. Sami Hanna describes the *mawwal* as "one of the genuine Arabic cultural elements which expresses the true life of the

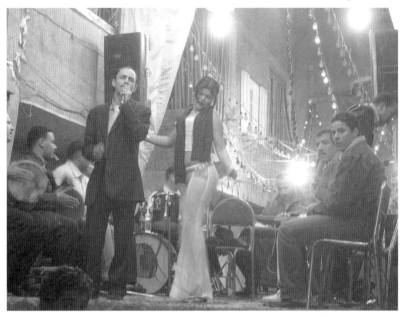

Figure 7.1. A typical *sha'bi* wedding celebration in a *hara* (narrow alleyway typical of *sha'bi* neighborhoods) in Hada'iq al-Ma'adi, Cairo. The singer, Ahmad Shari'i, is virtually unknown in the music industry, but he is a popular performer for families of modest means. (Photograph by James R. Grippo.)

Egyptian masses in their homes, their humble coffee shops, market transactions, and social life" (1967, 184). "I am a *saltangi*," claimed Adaweya. "*Saltana*[15] is my thing—I can sing, and alternate between, different Oriental *maqamat* (melodic modes): from the *rast*, I can slide into *nahawand*, then into *higaz*; I can play with *sika* and move to *bayati*, to *saba*. This is *saltana*—it's all in the *maqam*" (al-Kashef 2001). Adaweya's ability to improvise melodically and poetically won him millions of fans, but perhaps more relevant to the lives of working-class Egyptians was his use of affective devices to convey folk wisdom *(hikmat al-sha'b)*. These devices include "double entendre, indirect metaphor *(kanaya)*, and popular slang to convey commonplace topics, socially charged issues, and innumerable variations of romantic and religious themes" (Grippo 2007, 259).

Adaweya augmented the popularized *mawwal* tradition established by famous singers a generation earlier (in the 1940s and 1950s), such as Anwar al-'Askari and Abu Dira', who were rooted in specific hereditary traditions and performed with indigenous folk instruments such as the *arghul* (double

clarinet made from reed). From approximately 1955 to 1965, Muhammad Taha and 'Abd al-'Aziz Mahmud were significant influences on Adaweya, as well as on the evolving contemporary sound of *mawwal* as a defining feature of modern *sha'bi*. So were Muhammad 'Abd al-Muttalib, Shafiq Galal, Muhammad al-'Izabi, and Mohamed Rushdi, *sha'bi* singers who tirelessly worked the nightclub circuit (Abou Seoud, pers. comm., 2005). In a recent interview, Adaweya stated, "I consider myself an extension of prominent popular singers such as Shafiq Galal, Mohamed Rushdi and Muhammad 'Abd al-Muttalib, who have preserved a kind of traditional singing that could be assimilated by simple, uneducated people" (Mahmoud 2008).

Presently, the overall aural presentation of *sha'bi* is raucous and loud, consisting of short songs with unforgettable refrains. The *sha'bi* sound developed from an acoustic to an amplified orientation, with the addition of musical instruments typical of *al-musiqa al-'arabiya* (such as *'ud*, *qanun*, *nayy*, and accordion) and, over time, foreign instruments such as keyboard,

Figure 7.2. Al-Leil (Night) is one of Cairo's most successful nightclubs, located (along with many others) on Shari' al-Haram (Pyramid Street). The club's entranceway is flanked by life-size cutouts of Sa'd al-Sughayyar (left) and Shaaban Abdel Rahim (right). (Photograph by James R. Grippo.)

Figure 7.3. Flashing lights draw attention to images of al-Leil's current stars. To the right of "Al Gafar Co." are Shaaban Abdel Rahim and Sa'd al-Sughayyar. (Photograph by James R. Grippo.)

brass, and drum kit. The instrumentation of *sha'bi* bands has not changed much from the days of Adaweya, except for increasingly widespread use of the electronic keyboard. Today's bands commonly use one to four acoustic pan-Arab melody instruments, such as *nayy*, *'ud*, violin, or accordion. The majority also include a Western drum kit, keyboards, electric bass, and a brass section comprising trumpets and trombones. Pan-Arab percussion instruments, such as the *tabla* (aluminum or clay goblet-shaped drum), the *dohola* (larger *tabla*, with a louder sound and lower timbre), and the *mazhar* and *daff* (frame drums), are compulsory components of the *sha'bi* band, which relies upon their acoustic power and ability to articulate definitively Egyptian rhythms.

Whereas weddings provided the main performance occasion for the early generation of *sha'bi* singers, by the 1960s, nightclubs had become a lucrative source of income both for musicians and *raqs sharqi* (Eastern or 'Oriental' dance) dancers (see Figures 7.2 and 7.3). Today's *sha'bi* is performed in all varieties of nightclubs, as well as at life-cycle celebrations such as engagements, circumcisions, and especially weddings.

The Arab mediascape since the 1970s

Egypt was once the uncontested entertainment media hub of the Arab Middle East for radio, film, music recording, and television, a status largely secured by Gamal Abdel Nasser's nationalization and centralization of many of Egypt's media industries.[16] Indeed, after Nasser increased the radio broadcasting signal in order to ensure that 'the voice of Egypt,' Umm Kulthum (see Danielson 1997), could be heard by millions more, he was promoting not only national pride but also the potential for a pan-Arab unity rooted in common forms of intellectual and artistic expression.

Succeeding Nasser in 1970, Sadat ended Nasser's nationalist direction in favor of greater Western influence and control. Sadat instituted Open Door policies in the early 1970s, moving Egypt toward American-style free market economics. His push toward decentralization and privatization ultimately destabilized the Egyptian economy and widened the gap between rich and poor (Hamed 1981; Aulas 1982). The Mubarak regime, in power since 1981, has not rectified these problems. The region's power and economic structures have also changed dramatically because of the ascendancy of oil-rich Gulf countries such as Saudi Arabia since the 1970s.

As a result of these changes, as well as advances in technology, especially satellite television, mobile phones, and the Internet, the music and television industries have been reconfigured, leaving Egypt a mere player in a larger regional competition. Today, many Egyptian artists are signing contracts with Rotana Music, a Saudi Arabian company that currently controls over 85 percent of the total Arab music market. Rotana is owned by Prince Alwaleed bin Talal bin Abdul Aziz Al Saud, grandson of the founding king of Saudi Arabia, entrepreneur, and international investor. According to its Web site, Rotana is "the leading producer/distributor of Arabic music and film in the world," owning exclusive rights to the most successful *shababi* singers in the Arab world, including Amr Diab, Kadim Al Sahir, Najwa Karam, George Wassouf, Wael Kfoury, and Abdullah Al-Rowaishid, to name just a few.[17] Thus, entertainment mass media in the Arab world have spread from a centralized national location, Egypt, to a decentralized pan-Arab mediascape, allowing non-Egyptian singers (particularly Lebanese) to dominate the charts.

Satellite television

Egyptian satellite television arose in the early 1990s (Abdel Rahman 1998). While it was quite expensive at first, viewers could access Russian and European satellite channels until the first Arab satellite system, Middle East

Broadcasting Center (MBC), began transmission in September 1991, featuring a free-to-air, twenty-four-hour television network across the Middle East (Schleifer 1998). Egypt's first national satellite, Nilesat 101, was launched on April 28, 1998, carrying twelve transponders, each capable of transmitting eight digital television channels, thus providing up to ninety-six channels, plus over four hundred radio stations (Amin 1998).

This period is considered by many to have been an exciting moment in Arab media broadcasting history, since until then the vast majority of local media outlets were state controlled. With the development of satellite television, private channels and programming proliferated. Such programming includes a large number channels dedicated to music videos and many others that broadcast them on occasion.

Starting around 1990, the Arab music video, or 'video clip' *(fidyu klib)*, became one of the most popular, pervasive, and mass-marketed modes of *shababi* music production. Rotana's most powerful media vehicle is satellite television, offering six free-to-air channels, including four twenty-four-hour music channels (Rotana Musica, Rotana Clip, Rotana Tarab, and Rotana Khalijia) and two channels that feature Arab cinema exclusively.[18] Many other Arab music channels also broadcast Arab music videos twenty-four hours a day, catering to an audience of millions throughout the Arab world.

Nearly all Arab music videos feature mainstream *shababi* singers. The few exceptions are specialty channels that feature *al-musiqa al-'arabiya* or Gulf singers. For instance, Rotana Tarab broadcasts concert and cinematic segments from the legendary singers of *al-musiqa al-'arabiya*, while Rotana Khalijia features music videos from the Khalij, or Gulf region, including performers of art, folk, and Gulf-style *shababi*. None of these channels features Egyptian *sha'bi*.

Mobile phones

Mobile (cell) phones proliferated even faster than the satellite dish in Egypt, in part because of the second of two mobile network operators in Egypt: Vodafone (Mobinil was the first). In 1998, Vodafone (formerly Click GSM) succeeded in penetrating the popular market by offering prepaid mobile phone plans at a time when only the rich could afford to use mobile phones.[19] The introduction of mobile phones in Egypt has not only completely redefined the way people communicate but also established a new medium for musical mediascapes, including ringtones and interactive communications with music video channels like Rotana, Mazzika, and Dream.

Soon after mobile networks were established in Egypt, the ubiquitous billboards of *shababi* superstars were printed with numerical codes that allowed mobile phone users to download the latest ringtones or videos from their favorite new releases. Ringtone codes could be found all over music magazines, and inserts filled with thousands of codes were distributed in new cassettes. The market for ringtones and music videos has proved to be highly profitable.[20]

Mobile phone users can also interact with the many satellite music channels. Individuals send text messages via short message service for a fee. After a short delay, these messages are displayed along the bottom or top of the screen like a news ticker. Curiously, on some programs, multiple crawlers on the top and bottom of the screen crowd out video content itself—a visual testament to the commercial power of this interactive mediascape. Mobile phones are also used to vote for favorite artists, albums, videos, and films, especially in competitive programs where audiences help select new stars.[21] Again, nearly all the singing stars disseminated via mobile phone are *shababi*; *sha'bi* stars are largely absent.

Radio

There are only two private Egyptian-owned music radio stations in Egypt: Nugum FM (100.6 FM) and Nile One (104.2 FM). The independence or private nature of these stations is debatable. According to 'Amr Adib, the stations' managing director, both are privately owned and "completely Egyptian." The stations are managed by the Good News for Me (Gn4me) group, of which Adib is a representative, but ownership is divided among the Gn4me group, Cable Network of Egypt (CNE), and the Egyptian Radio and Television Union (ERTU). Hassan Hamed, director of ERTU, maintains that the stations are only being managed by the private Gn4me group but are in fact state owned (Sabra 2003). According to Sherif Nakhla (2003), however, the stations were launched by the Nile Production Company, a privately owned company.

Nugum FM broadcasts a wide variety of Arab popular music, ranging from legendary art music—the songs of Umm Kulthum, Abdel Halim Hafez, and Layla Murad, for example—to modern *shababi* music—such as the songs of Amr Diab, Sherine, and Nawal Al Zoghbi. It occasionally features classic Egyptian folk songs made famous in films. Nile One broadcasts American and British pop music (classic rock, oldies, and pop) with English-speaking commentators. Both stations were launched in May 2003, and in the

beginning were limited to broadcasting music only (no talk shows or adver-
tisements, and limited commentary) (Nakhla 2003). Today, there is still little
commentary broadcast on these stations, though commercial advertisements
are much more prevalent. Neither station features *sha'bi*.[22]

Locating sha'bi in the Egyptian mediascape

I have discussed several new media trends in Egypt: satellite television,
mobile phones, and radio. The primary forms of popular music featured on
these media are *al-musiqa al-'arabiya* and *shababi* artists. Since the 1970s,
the dominant medium for *sha'bi* music has been the audiocassette *(sharit)*,
though now one can also find MP3 compact discs containing *sha'bi* compi-
lations. The successful dissemination of *sha'bi* via audiocassettes and CDs
seems to compensate for its absence from broadcast media.

Whereas radio and film spurred the popularization of *al-musiqa al-'arabiya*
singers, it was only the birth and proliferation of the audiocassette industry that
propelled *sha'bi* singers to fame, most notably Adaweya, whose first release
sold over a million copies (Bortot 2000; Rais al-Bira, pers. comm., 2004).
Recording companies like Sawt al-Hubb (Sound of Love) became known
for producing *sha'bi* artists such as Adaweya. The low cost of materials and
production made the audiocassette an accessible medium for both recording
companies and consumers. Soon after, this accessibility was enhanced by the
proliferation of underground cassette pirating operations. Although the rate
of inflation in Egypt has been high, the price of underground cassettes has
remained stable and comparatively low.[23]

Illegal music reproduction is one example of many in a widespread infor-
mal market system that exists in *sha'bi* districts throughout Egypt. According
to Diane Singerman, based on research in such districts, "The informal econ-
omy, informal networks, savings associations, informal communal goods,
and black markets have been devised by men and women as a way to provide
for their families, protect their security, and further the collective interests of
the community" (Singerman 1995, 174).

One frequently finds sellers displaying hundreds of *sha'bi* cassettes (legal
or bootleg) on a makeshift table or cloth near crowded outdoor markets and
mass transit stations. In more established informal marketplaces, there may
also be display cases and a large portable stereo to blast music into the crowd,
often to the point of distortion. None of the cassettes is sealed, and the vendor
will play any cassette upon request. Until recently, the audiocassette was the
only way to hear recorded *sha'bi* music. In recent years, as technology has

Figure 7.4. Cassettes for sale in an informal market near the Sayyida Zaynab Metro station, Cairo. (Photograph by Michael Frishkopf.)

developed, *sha'bi* ringtones and compact data discs loaded with MP3s are also available at affordable prices.

Originally propelled by the burgeoning cassette industry as well, *shababi*, with roots in the upper echelons of the Egyptian music industry, quickly penetrated other forms of modern music media, such as magazines, billboards, radio, television, musical films, cell phones, MP3s, compact discs, and—most significantly—big-budget music videos broadcast on local and satellite television stations. *Sha'bi,* by contrast, did not.

When Ahmed Adaweya exploded onto the Egyptian popular music scene in the mid-1970s, many predicted, even prayed, that he was riding a wave that would soon subside. According to Adaweya's longtime accordion player and composer, Hassan Abou Seoud, cultural pundits denounced his music as vulgar and unsophisticated, deeming it unworthy for widespread audiences (pers. comm. 2005). Furthermore, the mainstream press gave no evidence that Egyptian celebrity entertainers such as Abdel Halim Hafez and Adel Imam were attending Adaweya's nightclub performances, and that he was selling millions of cassettes.

The Egyptian Ministry of Culture censored *sha'bi* music because of its "inappropriate influences on the Egyptian youth" (Judge Muhammad Sayyid al-Ashmawi, pers. comm., 2004). When I asked Abou Seoud about *sha'bi*'s alleged vulgarity, he responded, "It's the music of the simple [common] people *(nas busata)*, not the upper classes *(al-hayy)*; the elite had their image to protect" (pers. comm., 2005).

Contrasted with a 1970s–1990s global mediascape replete with violence, sex, and ribaldry, it may be difficult to surmise why Adaweya and his brood were targeted by Egyptian censors. Were their polyester slacks and shirts so garish that they had to be concealed from official media? Of course not, but the 'image' Abou Seoud mentioned runs deep. For the upper class, the *infitahi* (nouveau riche), and the Egyptian intelligentsia, *sha'bi* is

> potentially associated with the crowds of illiterate masses, backwards customs, and even vulgarity of speech and dress. From this point of view, *sha'bi* is in contradistinction to the romanticized and essential-ized ideal of folk culture established by late twentieth century Egyptian nationalism, modernist ideology, and cultural policy. (Grippo 2006)

Ultimately, the distinction is rooted in popular versus official discourse. Walter Armbrust discusses how popular culture is "linguistically impor-tant" as a "vehicle for establishing national identity," as opposed to official discourse (1996, 8), but Egypt's modernist crusade was hindered by what popular culture produced, including *sha'bi*. There was no room for low-brow forms of cheap entertainment in Egypt's "ideology of transformation" from tradition to modernity (1996, 25), especially when these forms did not even fit the molds of imagined authentic folklore. It is these ideological tensions that have led to the official castigation of Egyptian *sha'bi* music, despite offi-cial appropriations of '*sha'bi*-ness' as a marker of authenticity.

A nostalgic present and an invented future

There are exceptions, however. A minority of 'breakthrough' artists have crossed the invisible cultural barrier between *sha'bi* and the new media. *Sha'bi* singers such as Hakim, Shaaban Abdel Rahim, and Sa'd al-Sughayyar have become well-known in the mainstream media. Indeed, these singers are good examples of the different paths *sha'bi* singers of today may take to make it big in a music industry infiltrated by modernist cultural ideals: one based on the art and heritage of a legendary golden past *(al-musiqa al-'arabiya)*, and

the other extolling Arab-Western fusion musics as sung by icons of wealth and beauty *(shababi)*.

Hakim is widely known as a crossover star extraordinaire for presenting *sha'bi* in its typical raw form, as well as in different styles *(alwan)*, such as *sha'bi moderne* or *sha'bi shik* (Atia 2001). These *alwan* describe Hakim's remixing (*Hakim Remix*, 1998) and his duets with foreign stars, including Olga Tañon ("Ya albi" (My Heart) on *Talakik*, 2002) and James Brown ("Lela" on *al-Yomin dol*, 2004). Hakim has also cultivated a marketable image, attracting a large fan base and bringing opportunities to star in advertisements (including a Mobinil television commercial). He has enjoyed Western assistance with tour management (Universal) during his American tours, as well as album production (Arc 21) for albums featuring international guest artists. In a recent interview, he said, "I want to address a new region, namely the west. This is something that has always been a target of mine—to take the popular song to international levels, take it outside the Arab world" (Wahish 2002).

Since his 2001 hit, "Ana bakrah Isra'il" (I Hate Israel), Shaaban Abdel Rahim has strategically crafted a controversial and politically charged identity. From singing about local issues like smoking and taxes to internationally recognized topics like the Israeli occupation of Palestine or the Iraq war, Abdel Rahim constantly tries to outdo himself. While he promulgates political activism in his songs, his public persona is shockingly naïve, often to the point of absurdity. Practically all of Cairo was talking about him after a televised interview in which he claimed that he did not know what he was singing about and, after a sideways compliment about his garish attire, that he had his suit made out of upholstery fabric to match his living room. Comments like these suggest that Abdel Rahim is manipulating the masses in order to maintain "a delicate balance between 'fool' and 'hero'" in order to ensure his safety and longevity in a state-controlled local music industry (Grippo 2006).

Sa'd al-Sughayyar is Egypt's latest *sha'bi* superstar. He is young and handsome, and has worked tirelessly with a near thirty-piece band toward certain stardom. Al-Sughayyar was relatively unknown when I met him in 2004, but following the release of his 2004 cassette "Shokran 'ala al-akhir" (Thanks to the Last Degree), he began to ascend to the top of the Egyptian pop music game. Ever the determined and savvy businessman, al-Sughayyar forced himself into stardom through a relentless campaign of self-promotion, bribery, and barter. To promote his new album, he created spectacles in some of Cairo's

most crowded neighborhoods—Manial and Shubra al-Khayma—by setting up flashing lights, giant balloon figures, posters, and a sound system on which he looped one of the album's main tracks while singing over it to the throngs. His band, together with youth hired from these neighborhoods, created a raucous scene that fed into the energy of his 'appearance.' Al-Sughayyar's first music video was seen on monitors in the underground downtown Metro station, al-Sadat. Afterward, small to medium-sized billboards promoting the singer started popping up around Cairo. Soon after, he started to appear in films and continued producing music videos for almost every song on his album. Besides his sophisticated business sense, al-Sughayyar is a wonderful entertainer. His stage antics, bordering on comedy routines (often including a very small dwarf), have won him fans in almost every venue.

The music and music videos of Hakim, Shaaban Abdel Rahim, and Sa'd al-Sughayyar are broadcast on local and satellite music channels on which audiences vote enthusiastically for their videos to be repeatedly shown. Egyptian radio occasionally plays a Hakim song, but I have never heard the songs of Abdel Rahim or al-Sughayyar being aired on radio, although the latter's music has become more accepted by the mainstream. These three *sha'bi* singers have managed to carve out different niches for themselves by tapping into the collective consciousness of Egyptian popular culture. Whatever their talent, one common thread unites them: their embodiment of the vulgar, downtrodden, curious, sexy, obnoxious, clever, authentic, backward, and hilarious *sha'bi* musician.

The developments, successes, and failures of Egyptian *sha'bi* are embedded in overlapping arcs of history and imagination, each with a different tale to tell. *Sha'bi* can be heard as urbanized folk music or as a celebration of the vernacular and all things truly Egyptian. In a sea of technology and arts heavily peppered with foreign influence, many Egyptians experience a "nostalgia for the present" (Jameson 2003), a present that is already lost, which triggers a search for an invented future.

As *shababi* is pumped through mediascapes at dizzying rates, unapproved *sha'bi* culture adapts and thrives alongside it, making brilliant use of available resources. *Sha'bi* has been relegated to an informal economy, largely outside the media broadcasting establishment, as if confined to the streets whence it is derived. Yet, as a result of its absolutely pervasive presence, *sha'bi* continues to push the boundaries of socioeconomic class acceptability, speaking to and empowering a burgeoning working class eager for a new music that expresses vernacular culture, including folk wisdom and a good laugh.

References

Abdel Rahman, Hala. 1998. Uses and gratifications of satellite TV in Egypt. *Transnational Broadcasting Studies*, no. 1, http://www.tbsjournal.com/Archives/Fall98/Documents1/Uses/uses.html.

Amin, Hussein Y. 1998. Nilesat 101 channels. *Transnational Broadcasting Studies*, no. 1, http://www.tbsjournal.com/Archives/Fall98/Documents1/Nilesat/nilesat.html (July 6, 2010).

Appadurai, Arjun. 1996. *Modernity at large: Cultural dimensions of globalization.* Minneapolis: University of Minnesota Press.

Armbrust, Walter. 1996. *Mass culture and modernism in Egypt.* Cambridge: Cambridge University Press.

Atia, Tarek. 2001. The money *mawwal. Al-Ahram Weekly Online*, February 8–14, http://weekly.ahram.org.eg/2001/520/sc2.htm (July 6, 2010).

Aulas, Marie-Christine. 1982. Sadat's Egypt: A balance sheet. *MERIP Reports* 107:6–18.

Badawi, al-Said, and Martin Hinds. 1986. *A dictionary of Egyptian Arabic.* Beirut: Librairie du Liban.

Baily, John. 1981. Cross-cultural perspectives in popular music: The case of Afghanistan. *Popular Music* 1 (1): 105–22.

El-Bakry, Rehab, and Rania Al Malky. 2004. Pump it up. *Egypt Today*, September, http://www.egypttoday.com/article.aspx?ArticleID=2244 (July 6, 2010).

Bennett, Andy, Barry Shank, and Jason Toynbee. 2005. *The popular music studies reader.* London: Routledge.

Bortot, M. Scott. 2000. Shaabi album misses a couple beats. *Middle East Times*, February 25.

Danielson, Virginia. 1991. *Min al-mashayikh*: A view of Egyptian musical tradition. *Asian Music* 22 (1): 113–28.

———. 1996. New nightingales of the Nile: Popular music in Egypt since the 1970s. *Popular Music* 15 (3): 299–312.

———. 1997. *The voice of Egypt: Umm Kulthum, Arabic song, and Egyptian society in the twentieth century.* Chicago: University of Chicago Press.

Davis, Ruth. 1996. The art/popular music paradigm and the Tunisian *ma'luf* popular music. *Popular Music* (Middle East Issue) 15 (3): 313–23.

Finnegan, Ruth. 2007. *The hidden musicians: Music-making in an English town*, 2nd ed. Middletown, Conn.: Wesleyan University Press.

Frishkopf, Michael. 2002. Some meanings of the Spanish tinge in contemporary Egyptian music. In *Mediterranean Mosaic*, ed. Goffredo Plastino, 143–78. London: Routledge.

Frith, Simon. 2004. Popular music: Critical concepts in media and cultural studies. London: Routledge.

Grippo, James R. 2006. The fool sings a hero's song: Shaaban Abdel Rahim, Egyptian *shaabi*, and the video clip phenomenon. *Transnational Broadcasting Studies*, no. 16, http://www.tbsjournal.com/Grippo.html (July 6, 2010).

———. 2007. I'll tell you why we hate you! Shaaban Abdel Rahim and Middle Eastern reactions to 9/11. In *Music in the post-9/11 world*, ed. Jonathon Ritter and J. Martin Daughtry, 255–75. London: Routledge.

Hamed, Osama. 1981. Egypt's open door economic policy: An attempt at economic integration in the Middle East. *International Journal of Middle East Studies* 13 (1): 1–9.

Hanna, Sami A. 1967. The *mawwal* in Egyptian folklore. *Journal of American Folklore* 80 (316): 182–90.

Jameson, Fredric. 2003. The nostalgia of the present. In *Postmodernism, or the cultural logic of late capitalism*. 2nd ed. Durham, N.C.: Duke University Press.

al-Kashef, Injy. 2001. Ahmed Adawiya: The king is in the house. *Al-Ahram Weekly Online*, February 8–14, http://weekly.ahram.org.eg/2001/520/profile.htm (July 6, 2010).

Mahmoud, Sayed. 2008. Singing in the shadow. *Al-Ahram Weekly* Online, October 16–22, http://weekly.ahram.org.eg/2008/918/sc2.htm (July 6, 2010).

Manuel, Peter. 1993. Cassette culture: Popular music and technology in North India. Chicago: University of Chicago Press.

Marcus, Scott L. 2007. *Music in Egypt: Experiencing music, expressing culture*. Oxford: Oxford University Press.

Middleton, Richard. 2000. *Reading pop: Approaches to textual analysis in popular music*. Oxford: Oxford University Press.

Nafie, Reem. 2004. New cabs for old. *Al-Ahram Weekly Online*, December 2–8, http://weekly.ahram.org.eg/2004/719/eg4.htm (July 6, 2010).

Nakhla, Sherif Iskander. 2003. The radio phenomenon. *Al-Ahram Weekly Online*, June 26–July 2, http://weekly.ahram.org.eg/2003/644/cu6.htm (July 6, 2010).

Nettl, Bruno. 1972. Persian popular music in 1969. *Ethnomusicology* 16 (2): 218–31.

Powers, Harold S. 1980. Classical music, cultural roots, and colonial rule: An Indic musicologist looks at the Muslim world. *Asian Music* 12 (1): 5–39.

Puig, Nicolas. 2006. Egypt's pop-music clashes and the 'world-crossing' destinies of Muhammad 'Ali street musicians. In *Cairo cosmopolitan: Politics, culture, and urban space in the new globalized Middle East*, eds. Diane Singerman and Paul Amar, 513–36. Cairo: American University in Cairo Press.

Racy, Ali Jihad. 1976. Record industry and Egyptian traditional music, 1904–1932. *Ethnomusicology* 20 (1): 23–48.

———. 1977. Musical change and commercial recording in Egypt, 1904–1932. PhD dissertation, University of Illinois at Urbana-Champaign.

———. 1981. Music in contemporary Cairo: A comparative overview. *Asian Music* 13 (1): 4–26.

Sabra, Hanan. 2003. Public-private waves: Are Egypt's newest radio stations really private? *Al-Ahram Weekly Online*, June 26–July 2, http://weekly.ahram.org.eg/2003/644/eg9.htm (July 6, 2010).

Said, Summer. 2005. Rotana making fine music in Egypt. *Arab News*, March 9, http://arabnews.com/?page=9§ion=0&article=60172&d=9&m=3&y=2005 (June 14, 2010).

Schleifer, S. Abdallah. 1998. Media explosion in the Arab world: The pan-Arab satellite broadcasters. *Transnational Broadcasting Studies,* no. 1, http://www.tbsjournal.com/Archives/Fall98/Articles1/Pan-Arab_bcasters/pan-arab_bcasters.html (July 6, 2010).

El-Shawan, Salwa. 1980. The socio-political context of *al-musiqa al-'Arabiyyah* in Cairo, Egypt: Policies, patronage, institutions, and musical change (1927–77). *Asian Music* (Symposium on Art Musics in Muslim Nations) 12 (1): 86–128.

———. 1984. Traditional Arab music ensembles in Egypt since 1967: The continuity of change within a contemporary framework? *Ethnomusicology* 28 (2): 271–88.

Singerman, Diane. 1995. *Avenues of participation: Family, politics, and networks in urban quarters in Cairo*. Cairo: American University in Cairo Press.

Taylor, Timothy Dean. 1997. *Global pop: World music, world markets*. London: Routledge.

Wahba, Jackline. 2003. Does international migration matter? A study of Egyptian return migrants. Paper prepared for the Conference of Arab Migration in a Globalised World, September 2–4, Cairo. Preliminary draft.

Wahba, Magdi. 1972. *Cultural policy in Egypt.* Paris: UNESCO.

Wahish, Niveen. 2002. Hakim: From Mohamed Ali street to Radio City Music Hall: The business of pleasure. *Al-Ahram Weekly Online*, October 10–16, http://weekly.ahram.org.eg/2002/607/profile.htm (July 6, 2010).

Notes

1 Before I enter a taxi I scan the exterior and interior for religious iconography (just as many Egyptians do). I can then greet the driver in an appropriate manner, depending on whether he is Christian or Muslim.

2 Many Egyptian college graduates struggle to make ends meet. Some fields, like medicine and engineering, are flooded by the endless stream of new graduates, but pay rates usually force Egyptians to work multiple jobs. One driver, who is also an electrical engineer, told me the income from his engineering job paid for groceries and a part of rent. He drove a taxi and worked for his cousin to make enough for his family.

3 The Society for Ethnomusicology (SEM) was founded in 1955.

4 I was studying the *'ud* (Arab lute) and *qanun* (Arab plucked zither).

5 'Mediascape' refers to the electronic mediation of information (by newspapers, magazines, television, Internet, and so on) as well as "the images of the world created by these media" (Appadurai 1996, 9). This term is one of five inter-related 'landscapes' outlined by Appadurai in his frequently referenced cultural study of globalization, *Modernity at Large: Cultural Dimensions of Global-ization* (1996). The other four are ethnoscapes, financescapes, idioscapes, and technoscapes (Appadurai 1996, 30).

6 *Sha'bi shik* (chic) is used to describe the appearance of singers, or a sound that is 'cleaned up' and fashionable. Kat Kut al-Amir refers to his music as *sha'bi* chic. *Sha'bi rifi* (rural) is used to describe *sha'bi* that is closer to folk music in terms of performance context, instrumentation, and lyrical content. Such music is commonly performed in villages and hamlets. *Sha'bi moderne* is the most contemporary manifestation of *sha'bi*; Hakim is the primary representative of this style. Such *sha'bi* draws upon Western pop techniques and idioms such as remixing, electronic dance beats, and, in Hakim's case, working with singers from different traditions such as James Brown and Olga Tanon. The use of the French 'moderne' evokes this music's cosmopolitan and international appeal.

7 Not included within these two domains are Egyptian bands that have emerged in recent years, boasting a consistent, if limited, following. These bands, such as Wist al-Balad (Downtown) and Dur al-Awwal (First Floor) perform at down-town venues frequented by upper-middle-class students and young professionals.

Intending to create something new (outside previously named categories), they compose and perform a mixture of styles such as jazz, rock, and Arab music.

8 For more on *al-musiqa al-'arabiya* see El-Shawan (1980 and 1984).

9 The term *tarab* refers to the musical ecstasy created by a gifted and virtuosic singer who is able to create emotional waves in audience members by masterfully expressing the text or the *maqam* system. The singers of *al-musiqa al-'arabiya* are also referred to as *mutribin* (sing. *mutrib*), or creators of *tarab*.

10 Because radio licenses are not required, it is difficult to assess the number of radios in use, but by 1966 it was estimated that there was one radio for every three households (Wahba 1972, 4).

11 The bank of Egypt financed a joint stock company called the Misr Company for Acting and the Cinema in 1924; by 1934 Misr Studios was completed (Wahba 1972, 57).

12 As I will explain below, the term *'sha'bi'* also refers to Egyptian folk music, but my use of the term is limited to the urban popular music phenomenon that emerged in Cairo in the 1970s.

13 Many Egyptians also use an Arabicized version of 'folklore': *fulklur*.

14 'Hereditary musicians' is a term widely used to designate people who have inherited a musical profession from a parent.

15 "*Saltanah*: a creative ecstatic state typically experienced by performers, and usually linked to the melodic modes" (see Ali Jihad Racy, 2003, *Making Music in the Arab World*, Cambridge: Cambridge University Press, p. 228). [The *saltangi* is the producer of *saltana*. –Ed.]

16 Nasser was Egypt's president from June 23, 1956 to September 28, 1970.

17 See http://www.rotana.net/RotanaNew/Rotana/about.aspx?id=About%20Us (accessed February 16, 2008).

18 In 2004, Rotana bought the rights to two-thirds of Egypt's classic film collection, or approximately 3,200 films, some dating back to 1935, along with two hundred recent releases for approximately LE15 million (Said 2005).

19 See www.vodafone.com.eg/db/JSP/personal/dynamic/en/aboutUs/companyProfile/companyProfile.jsp?selectedItem=169 (January 26, 2009).

20 Urban Cairenes are very conscious of ringtones in crowded areas; I've noticed people letting their phones ring for almost a minute before answering to ensure that their ringtone had been heard!

21 [See chapter by Katherine Meizel in this volume. –Ed.]

22 [Nor do the long-established state radio services. –Ed.]

23 I have been purchasing pirated *sha'bi* cassettes since 1998; the price of a cassette has remained between LE3 and LE5.

8

Ruby and the Checkered Heart

Abdel-Wahab Elmessiri

Erotic reductionism

A video clip is a short movie comprising a jingle, a dance, and a dramatic theme. It is a far cry from the world of song as we once knew it, it must be said at the outset, for this is all a video clip contains.

Yet there was a time when listening to a song was a multidimensional experience in which the listener could appreciate lyrics, music, and performance. Not unlike the video clips of today, most were admittedly about romantic love, but some were about mothers, nature, or human relations in general. Singers performed the classical Arabic poems of such giants as Ahmad Shawqi, al-Akhtal al-Saghir, and Ibrahim Nagi. Among my own favorites was "Tislam iden illi ishtara" (Bless the Hands of Him Who Bought) by 'Abd al-Muttalib. I also liked 'Abd al-'Aziz Mahmud's "al-Sabah al-jadid" (New Morning), an Abu al-Qasim al-Shabbi poem made into a song by Medhat Assem. Unfortunately, the latter was lost and is no longer available in the radio archives. Whether we shall ever listen to it again depends on the generosity of collectors. There was Asmahan's "Layali al-uns fi Vienna" (Merry Nights in Vienna). In this connection, one also remembers such Abdel Halim Hafez classics as "La talumni" (Don't Blame Me). This species of music is to be encountered in many Fairuz songs, and it survives in Majida El Roumi.

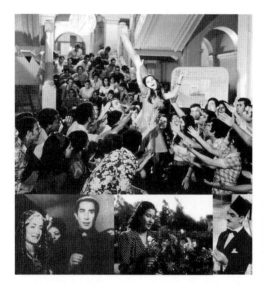

Figure 8.1. Clockwise from top: Soad Hosni in *Khalli balak min Zuzu*; 'Abd al-Muttalib; Umm Kulthum; Asmahan and Youssef Wahby in the movie *Gharam wa intiqam*.

Diversity of subject matter was matched by variety of form: the comic 'monologue' (Ismail Yasseen and Thuraya Helmi); the duet (Mohamed Fawzi); the operetta number (as in "Majnun Layla," or Layla's Madman); the film (*Ghazal al-banat*, or Girls' Dalliance); and the radio drama song ("Auf al-asil," or The Original Auf). And that is not to mention patriotic songs, which were heard throughout the year, not, like now, only once or twice a year, as if in memory of an irrevocably lost past. There were religious songs, too—Fayda Kamel's "Ilahi laysa li illak 'awna" (No Help for Me but You, My God), Asmahan's "'Alayk salat Allah wa salamu" (God's Peace Be upon You). This species, too, has all but disappeared, leaving only the romantic love genre for the video clip to take over.

Yet, in the ubiquitous hands of the video clip, even love songs—a once ambiguous, complex, and delightfully varied genre—have undergone a negative transformation.

The death of subtlety

Take, for example, "Khanni al-hawa" (Love Deceived Me) or "Ghazal turki" (Turkish Gazelle); Mohamed Qandil's "Ahl Iskandariya" (People of Alexandria); 'Abd al-Aziz al-Sayyid's "al-Beed al-amara" (Pretty White Girls); Muhammad al-'Izabi's "'Uyun Bahiya" (Baheya's Eyes); Muhammad Rushdi's "Ulu li ma'zun al-balad" (Call the Town *Ma'zun*); Nagat al-Saghira's "Kallimni 'an bukra" (Tell Me of Tomorrow); Layla Murad's "Bahibb itneyn

Figure 8.2. Ruby, in a scene from her video clip "Leh bi-ydari kida" (2004).

sawa" (I Love Two [People] at the Same Time), "Shuft manam" (I Saw a Dream), and "al-Hubb gamil" (Love is Beautiful); Mohamed Abdel Wahhab's "Gafnuhu 'allam al-ghazal" (His Eyelid Taught Dalliance), "'Ashiq al-ruh" (Lover of the Spirit), and "al-Khataya" (Sins); Abdel Halim Hafez's "Samra" (Dark Girl) and "al-Toba" (Repentance); Asmahan's "Dakhalt marra al-ginayna" (I Once Entered the Garden) and "Ya tuyur" (Birds); Umm Kulthum's "Madam tihibb bitinkir leh?" (Since You're in Love, Why Deny It?), "al-Atlal" (Ruins), and "Hanat al-aqdar" (Destiny's Tavern). The examples are endless.

Being love songs in the true sense of the term, all include erotic insinuations; and I use the word 'insinuations' deliberately, for the erotic is always assimilated into another romantic dimension of the song, be it the images or the narrative background.

Enter the video clip and all is instantaneously reduced to a one-dimensional eroticism, presented in isolation from any other element, with the dancers leaving very little to the viewers' imagination. The image is usually more powerful than the abstract word, for a distance separates the recipient from a text he is reading, giving him time to reflect on meaning and significance.

The image, on the other hand—especially when it is the image of half-naked, beautiful girls jumping up and down and, in the process, moving all that can be moved in their bodies, and in a less than objective way—is an immediate assault on the senses; it leaves no room for reflection or relaxation (imagine a classical song turned into a video clip of the dancing variety—a largely impossible proposition).

Flesh parades

Having reduced singing to a single genre, video clips have also done away with nuances within that genre. Having spent many delicious hours watching video clips, switching between channels, from one scantily dressed dancer to another, I discovered that what has enabled the video clip to penetrate our sensibility is what might be referred to as 'horizontal dancing.' We are all familiar with dancing. We have seen it in movies, five-star hotels, night-clubs, but it was always vertical. In horizontal dancing, the performer lies on the floor instead of standing up, making her movements both dazzling and seductive—a process in which she is aided by high-tech image manipulation and the fast pace of the action. The viewer can only succumb.

Belly dancing, with its explicit erotic dimension, is part of our cultural tradition. It is also an art form that was largely confined to movies and wed-dings. It belonged in a parallel world—one we tended to keep at bay. Before the emergence of video clips, there was one notable attempt to elevate belly dancing into a valid form of expression: Soad Hosni's film *Khalli balak min Zuzu* (Take Care of Zuzu), particularly the scene in which Hosni dances to Shafiq Galal singing "La tibki ya 'en" (Don't Cry, My Eye), a sad song. This was the first and last attempt to divest belly dancing of eroticism.

What video clips are doing with music is the diametrical opposite of this—normalizing otherwise exotic erotic dance, and bringing it into our living rooms all the way from the floorshow. Video clips present dancing as a daily experience—precisely what Sherif Sabri does in his rendering of Ruby's first song "Inta 'arif leh" (You Know Why). The singer is seen walking casually in the street, in a dancing costume. Later, she changes into casual clothing and continues to dance. Her dancing, what is more, is amateur rather than professional—the kind practiced by ordinary girls at home, for fun. This acts to remove the barrier separating daily life from belly dancing—normalization of a risqué activity. (Perhaps this explains why the recent Lucy video clip failed, for, being an expert dancer, the heroine danced as a professional does in a floorshow.)[1]

The *like-this* syndrome

The same tendency continues in Ruby's second song, "Leh biydari kida" (Why Does He Hide His Feelings Like That?). Ruby appears in gym wear, an evening gown, a schoolgirl outfit, and as a widow. The variety of attire notwithstanding, Ruby still moves suggestively—*like this*. The last scene is particularly interesting in that it is reminiscent of a home video. Wearing casual clothes, Ruby is on her way to the hairdresser's, and her face looks extremely innocent (quite *unlike this*). Her smile is pure and childlike, with the barest hint of sensuality—normalization at its effective best. This is how belly dancing is deranged, domesticated, business as usual. Ruby is a dancer and yet she is a role model—or so we are supposed to think.

One explores this in such detail because one is aware of its import: these things affect millions of people, changing our perception of ourselves, our surroundings, the way we perceive sensuality and sexuality. I recall that when we settled in Egypt in the early 1970s, my children knew very little about Egyptian pop culture, having been brought up in the United States. One day, I found my four-year-old boy singing the refrain, "Ya wad ya te'il" (Cool Boy). I remember wanting to know more about this song in order to work out what was going on in his head—and that of the society he was fast becoming part of. So I watched *Khalli balak min Zuzu*, pen and paper to hand, and ended up with an essay that *al-Ahram* published under the title "Pondering the Cool Boy and the Checkered Heart," in which I now remember making reference to the scene in which Hosni, advising women to make things happen for themselves, gestures assertively as she says, "Dreaming will get you nowhere, you get what you want this way."

Two years later, watching the television serial *Adventures of Chief Okasha* resulted in an article for *al-Tali'a* entitled "From Faten Hamama's Sorrows to Chief Okasha's Joys," in which I argued that Faten Hamama's films had set the boundary separating her trademark character (the virgin) from that of film star Mimi Shakib (the whore). The Okasha show had eliminated that boundary. In one scene, for example, Okasha is sitting between a woman journalist and a professional dancer, kissing both. I wonder whether Okasha started a trend that now finds expression in Ruby and other video clip starlets. If such a trend exists, is it inevitable or can we still reverse it? Pop culture, of which video clips are an important instrument, affects the nation as a whole. And we cannot in our right mind let show-business producers decide what is best for us.

Private pleasures

You may be wondering by now if I actually like video clips. I do, and my description of the performers is not, in the end, unbiased. I find the performers beautiful, titillating, and pleasant to watch. They move horizontally and vertically in continuously surprising ways that set my head spinning. I could say a few things about the sets, the makeup, the clothing (or lack thereof), but I am hardly qualified to pronounce judgment on any of these things.

What interests me, rather, is the question of whether the pleasure a video affords is a sufficient reason to speak in its favor? Does not such a line of thinking betray a bias toward individuality—as if individual pleasure is the only purpose of life, as if the individual (the amount of pleasure he gets) is the only, absolute point of reference? What about society and the family, by contrast? Should not the analytical unit be society as a whole, its orientation and interests? Should we not place such considerations above the private pleasures of individuals? Is it not our right as human (hence social) beings to posit questions regarding other aspects of human life? For there is more to video clips than private pleasure, namely their influence on society and family, and, enjoy them as I might, it is to this that my attention must now turn.

Consumerism unbound

Critics of the video clip, I have noticed, tend to focus on the partial nudity it makes available, the erotic, *like this* suggestiveness. And I would agree with them if not for other concerns of my own—the effect on society and the family. Video clips amount to more than a sexy woman dancing and singing. Rather, they provide the public with a role model, promoting a particular lifestyle that, in turn, typifies a worldview, one whose starting point is individual pleasure at any price—a solely carnal pleasure that excludes the possibility of appreciating a good performance, the beauty of an aspect of nature, or a thought, an emotion. By focusing on carnal pleasure in a social setup that makes marriage increasingly difficult as a practical course of action, the video clip contributes to a libidinal voracity we could well do without.

It is a well-known fact that escalating libidinal voracity is a function of consumerism—a fact on which TV advertisers tend to capitalize, resorting to sex to sell commodities. Particularly worrying in this connection is that sexual consumerism disassociates the individual from moral and social values. The viewer is implicitly encouraged to pursue individual pleasures through increased consumption—the unabashed pursuit of narrow self-interest through purchase. This seems like an unwise message to be transmitted to

the masses in a society in which the vast majority of the population continues to live either slightly below or slightly above the poverty line.

Beyond the physical

The video clip reduces both women and men to their respective, sexually charged bodies. The body becomes the sole source of identity, which is significantly narrowed down in the process. This is why video clips are so repetitive. Compare Hosni's assertive *this way* to Ruby's suggestive *like this*: Hosni's *this way* was a declaration of female independence, a refusal to live in the shadow of men. Zuzu, the character Hosni so ably brought to the screen, refuses to be defeated when things go wrong in her love life. She shakes her head and makes fun of her beloved, comparing his coolness to that of a British surgeon, a police sergeant, a diplomat (note how all such characters have both wiliness and power).

Hosni goes on to liken him to Ramesses II and the Mystery Man. The idea is to inflate the macho characteristics of the lover sarcastically, with the object of undermining them. Both the fictional, foreign Mystery Man (an extremely reticent character) and Ramesses II (the pharaoh fond of huge statues)—it is her beloved's gait that evokes the latter—are references to machismo and authoritarianism. Yet the context and the tone act to expose the Egyptian male's allegations about himself, undermining this brand of power. This is why all such references are preceded by sarcastic phrases that undercut them, turning the huge and magnificent male into a small child subject to manipulation by the real female subject. When the mustached male declares that "the whole world is not up to his standards," that he is "the tallest person in the alley," it becomes apparent that he is the victim of a conspiracy to ruin his reputation. The dynamic girl has set him up, leading him to believe that he is a rapacious hunter while reducing him, in reality, to prey. She knows how irresistible she is, notwithstanding her adversary's legendary inflated proportions and the historical weight he carries.

And this is precisely what Ruby does not do. Her message is rather, quite simply, that girls are cute and cuddly, receptive and playful. Ruby's character is sexy, perhaps sweet, but not inspiring. Frankly, I am surprised at the lack of a feminist critique of the implicit affront to women's status that she represents.

The dread of globalization

The video clip embodies a consumerism detached from all ethical, societal, and national affiliations. The songs often have Indian, American, or European

settings; the girls are often blond, or dressed in foreign fashion. Libidinal consumerist man, preoccupied with private pleasures, moves within a tight circumference that does not overlap with any value system, be it social or moral; his societal and familial affiliations are gradually eroded; his sense of belonging to his own country is rudimentary, if not nonexistent.

Now if you look at video clips, you will realize that they take place in no specific country. Even when the story revolves around an Egyptian easily recognizable as such, the sets, the costumes, the whole backdrop have nothing at all to do with the implements of life as we know it. The characters drive fancy cars; they live in mansions—and this not only stimulates the consumerist urge further and further, it acts to weaken the viewers' sense of national or cultural belonging. Video clips are, more than anything else, a symptom of globalization—of a world homogenized, broken down to basic economic units amenable to the laws of supply and demand. Within these units, the individual is materially driven, with no particular traits, no sense of belonging, no historical memory. This is good only insofar as one endorses a world dominated by the movement of capital and commodities. In the end, cultural and ethical traits are impediments to the effective functioning of such a world. And it is in this light that the video clip can be placed in a broader international context.

Ruby's ideology

Globalization is in essence an endeavor to standardize the world, reducing it to identical units, both rationalized and economic, subject to material laws like those of supply and demand. The human being who inhabits the parameters described by these units is economic libidinal man. He has no particular traits and no sense of belonging because his historical memory has been erased—all of which are preconditions for the unhindered flow of capital and commodities. In the absence of belonging, identity, value systems, and ethical and religious points of reference, everyone is the same; everything is relative. It becomes difficult to distinguish between beautiful and ugly, good and bad, justice and injustice; an absolute relativism predominates.

And the ideological expression of globalization is postmodernism, alias antifoundationalism, a movement that rejects points of reference, celebrating the absence of reason. Richard Rorty has said that postmodernism means that man will not sanctify anything, not even himself. Postmodernism is hostile not just to religion and ethics, but also to the accepted norms of humanity. Yet what does this have to do with Ruby? In a postmodern world, the individual lives in a specific, small realm, unhampered by tradition or collective memory.

Humanity is standardized, individuals taught how to rest content with pre-packaged sets of physical goals. Only then can global business thrive.

Outside history

The video clip is disassociated from current events. When Shaykh Ahmed Yassin was assassinated, the entire nation was enraged, yet video clips churned out cheerful songs as if nothing had happened. And this demonstrates that the world they occupy lies outside the parameters of history. It may seem farfetched to attempt to relate Ruby's performance to globalization, but it is good to remember that, while the connection may not be direct or organic, all things are interconnected nonetheless. Jean-François Lyotard has compared the postmodern standpoint on reality to the relation of a naïve man (viewer) to a coquette—he thinks he has got hold of her, but she always manages to escape. The relation of mind to reality is slippery at best.

Friedrich Nietzsche, Roland Barthes, and Jacques Derrida all argued that deconstructing national and linguistic categories is a process that has a sexual dimension: dissolution and fluctuation. Some advocates of postmodernism—the rejection of ultimate points of reference—argue that a woman's body is self-referential. It presents a challenge to the logocentric world (a world with a center, fixed, comprehensible) as understood by man. In her celebrated book, *Against Interpretation* (whose date of publication, 1965, is considered by many to be the birth date of postmodernism), Susan Sontag argues that the most important challenge to absolutes and to reason is the body.

Notice the effect on your mind of watching a dance of the horizontal variety. This physical experience has nothing to do with historical, cultural, or social specificity, and works to erode collective memory. Postmodernism posits, in essence, that each individual lives within what is called a 'small narrative,' his own—an impenetrably individual point of view. The socio-historical grand narrative, which would subsume any such small narratives, is nonexistent; even if it exists, it has no legitimacy or relevance. Therefore all ultimate points of reference fade away, and horizontal dancing appears alongside its horizontal counterpart, together with multinationals working to reduce humanity to a predictable, standardized bundle of economic and libidinal desires—an individual who is readily instrumentalized in the framework of the global market.

At no time was the scandal of the video clip more exposed than on the assassination of Shaykh Ahmed Yassin. While an entire nation raged and mourned, the bodies of the dancers kept appearing, unaffected, as if they

were, in themselves, a beginning and an end—the beginning of individual pleasure; the end, alas, of history.

The satellite takeover

Through satellite stations, video clips reach into our homes, mingle with our dreams, reshape the way we see others and ourselves. Their goal is not to enlighten us or deepen our understanding of our surroundings—it is profit. They are parasitical capitalist enterprises that compete with each other to make more money, and the end result, rather than enhancing our sense of beauty or improving our ability to appreciate the arts, is simply vulgarity and alienation—the flesh parade.

To know in which direction we are heading, one should simply watch MTV and follow how human beings are systematically turned into what I like to call human protein. Some of you may not be aware that there is a nightclub in Cairo called Evolution X. This venue serves a drink called the Blue Lesbian. I see this as another attempt to normalize abnormality, not essentially different from the attempt to normalize horizontal as opposed to vertical dancing and the systematization of sexual stimulation. It is scary, to say the least. But is it possible to stop the forward march of such exponential deterioration?

Some would say that this amounts to interfering with freedom of expression, with art. My contention is that video clips are not an art form at all; they have nothing to do with creativity as such. What they are is a crude commercialization of sex that exploits humanity for the sake of profit. Great art deals with many subjects, including sex, but sex (like violence) is never presented as an end in itself; it is an element among many others. Art (unlike pornography) can use sex, but not in a gratuitous manner. Art can use sex to portray the complexity of the human condition, to help us understand the nuances of the human psyche. If the video clip producers want to produce art, they will have to do two things first. One is to stop seeking material gain. The other is to practice what they preach; that is, to apply the ethics of the video clip to their wives, mothers, daughters, and sons. I have no doubt that this is what they will do, but you never know.

Notes

1 [Lucy is a professional belly dancer, one of the most famous in Egypt, and some-time singer. –Ed.]

9

The Controversy over Satellite Music Television in Contemporary Egypt

Patricia Kubala

A headline in the Egyptian national daily, *al-Ahram*, reads: "The Music Video Clip Is a Heated Cultural Attack that Is Destroying the Family, Ruining [Our] Youth, and Promoting Adultery," and another claims, "Female Video Clip Singers Are Behind an Increase in Divorce!" (Magid, 2004; "Mughanniyat al-fidyu klib wara' ziyadat al-talaq" 2005). In the Egyptian radio and television magazine, *al-Idha'a wa-l-tilifiziyun*, Egyptian pop music superstar Amr Diab declares, "I'm a *fellah* (peasant) . . . and I've forbidden my children from watching video clips" (Nur al-Din 2005). The opposition newspaper *al-Wafd* worries, "In the Age of the Video Clip, When Will We See the Songs of the Greats on the Television Screen?" ("Fi zamaan al-fidyu klib: aghani al-'amaliqa . . . mata naraha 'ala shashat al-tilifiziyun?" 2002).[1] During an interview with a youth magazine for its Ramadan issue, Shaykh al-Azhar Muhammad Sayyid Tantawi advises his young readers: "Keep away from doubtful activities and avoid watching video clips so that the reward for your fasting will not be compromised" ('Abd al-Mun'im 2005). Another Egyptian critic, appalled by the lyrics and visual content of music television, titles her editorial, "Video Clip Channels: From Seductive Housemaids to Insults to Saad Zaghloul!" (Maurice 2005).[2] And the opposition paper *al-Dustur* runs the following headline about SMS messages broadcast on music video channels: "Can You Believe It . . . Egyptians Paid

5 Billion Egyptian Pounds to Insult Officials and Practice Illicit Activities on Satellite Channels!" (Radwan 2005).

Over the past few years, headlines such as the ones cited above have become a familiar sight in the Egyptian and Arab press. Even though Arabic-language and foreign music videos began to be shown on Egyptian state terrestrial television in the early 1990s, the source of all this recent commotion over music television in Egypt is the launching of Egyptian and Arab private satellite channels devoted entirely to the broadcast of foreign and Arabic-language music videos, referred to in the Arab world as *fidyu klib* (video clip).[3] When these satellite channels first appeared in the early 2000s, almost overnight, many restaurants, cafés, and other public venues in Cairo switched from satellite news channels such as Al Jazeera, which began its first transmissions in 1996, to these new sources of 24/7 entertainment. Thus, they quickly became a ubiquitous symbol of the satellite revolution in Egypt and, to some critics, all that is wrong with it.

This chapter contextualizes the gender, class, and moral anxieties articulated by Egyptian critics of the flourishing genre of Arab music videos and satellite music television channels, and demonstrates that the present-day uproar over the Arab music video has a clear genealogy in the history of Egyptian mass-mediated culture. The kinds of criticisms directed at the music video clip are not distinct to the genre as such, but resonate with, on the one hand, the history of national cultural politics in modern Egypt, and, on the other, a Muslim legal discourse on entertainment, morality, and sexuality within which Islamist social reformers since the early twentieth century have grounded their critiques of modern art and mass-mediated entertainment practices.

The aim of the chapter is to illuminate why the video clip is such a controversial cultural artifact in contemporary Egypt, and why it matters so much for people to talk about it. I contend that the music video clip has met with so much ire because it contradicts the vision of a progressive modern society that art in this postcolonial nation is called upon to stand for—but not everyone shares the same vision of what that society, or its art, ought to be.

To illustrate this point, the chapter explores how criticisms of the music video are used by Egyptian critics arguing within the nationalist and Islamist discursive frameworks to publicly assert different idealized visions of politico-ethical subjectivity, public morality, and the place of religion in modern society. As the discussion below of the history of controversies over popular culture and religion in Egypt demonstrates, satellite television and

the video clip have not brought these issues to the fore for the first time. But increased accessibility to satellite programming in Egypt has simultaneously introduced a new source of controversy (the music video) and a new public arena (non-state-controlled television) in which to debate these questions.

Yet the chapter also points to some of the ways in which it is not so easy to map controversies over contemporary popular culture in Egypt onto a neat divide between (secular) nationalist and Islamist positions—a subject that is briefly elaborated in the conclusion. The final section of the chapter discusses some recent Islamist interventions in the field of entertainment production and highlights how popular culture has become a privileged site of social, political, and ethical reform in Egypt during the past decade.

The video clip: *"al-Fann idha hawa"* (Art When It Has Sunk Low)

Private pan-Arab satellite channels devoted to the broadcasting of music videos emerged in the early 2000s. Music videos also occupy a significant portion of the airtime of many variety channels.[4] The number of channels devoted to broadcasting music videos has increased steadily over the past five years. By 2006, at least fifteen private, unscrambled, free-to-air music video channels were available on Nilesat, the Egyptian state-financed satellite, alone. Many more variety channels, both private and government-run, broadcast music videos some of the time (Sadek 2006, 175–76). In addition, audiences with access to multiple satellites (such as Arabsat or the European Hotbird) and subscription-only packages may view even more music video channels.

Although in the eyes of several commentators the video clip now seems to dominate the Arab satellite television landscape, the ubiquitous presence of music videos is not a reliable gauge of their popularity, as Walter Armbrust points out (2005, 18).[5] What the large number of music video channels on Arab satellite television does indicate is that they are a financially appealing investment. Although no reliable sources detail the profits of these channels, it is clear that advertising, as with MTV and VH-1 in the United States, is a major source of revenue. Commercials appear for the products of transnational corporations such as PepsiCo and Coca-Cola, services from regional mobile phone providers such as Vodafone and Mobinil, and food and household products from national companies.[6] Also similar to MTV, album production companies (and singers without production companies) bear the cost of producing the videos and then provide them to the satellite channels as a form

of commercial exposure for their songs (Kaplan 1987, 13; Goodwin 1992, xvi). In addition, some of the most popular music channels, such as Rotana, Melody, and Mazzika, are owned by companies that also produce albums, so many of the videos they air simultaneously serve as advertisements for the companies' other products.[7]

Furthermore, the music video channels are capitalizing on the boom in mobile phone technology that took place in Egypt and the Arab world around the same time as satellite television became more accessible.[8] Transnational cell phone users may access codes from boxes on the edges of the television screen that enable them to request videos to be aired on the channel or to download ringtones, songs, and videos to their cell phones. Some channels offer games such as the "Love Meter," in which, once again via a cell phone, two people send in their names to the channel's meter to determine their romantic compatibility.

If media reports are to be believed, the major source of profits for these companies, and the one that really keeps them in business, is the constant stream of short and multimedia messages sent out by viewers from their cell phones that are then displayed by the channels in continuous tickers that fill the top and bottom margins of the television screen (Radwan 2005).[9] Rarely do these messages bear any overt relation to the music videos. More often than not, they comprise jokes, greetings, and exchanges between friends or family members, comments on recent political events or deaths of public figures, and even initiatives from viewers wishing to engage in live chat with 'hot Cairo babes.' Thus, Arabic satellite music video channels profit not only from advertising revenues and the sale of ringtones and music videos to patrons with cell phones but also from providing a venue for live cell phone chat. In addition, a video clip song certainly functions to promote the sales and patronage of a singer and his or her work, but it is simultaneously an art commodity that can itself be purchased by viewers with the use of mobile phone technology.

The unabashedly commercial nature of the music video is one of the reasons why its Egyptian detractors subject it to so much criticism, as is discussed below. Yet, as the newspaper headlines that begin this chapter indicate, critiques of these videos and the channels that broadcast them are simultaneously moral, religious, political, social, and aesthetic. Critics attack all features of the genre—the music, the song lyrics, the SMS messages that race across the screen, the images and dancing in the video clips, as well as the performers who star in them and the channels that broadcast them.

Criticisms of the kind directed at the music video clip are not unprecedented in the Egyptian public sphere, however. Rather, scholars have documented several similar outcries over popular and mass-mediated entertainment throughout the twentieth century. The current criticism of the music video must be seen in the context of these repeated, publicly aired outcries concerning popular entertainment and moral decline in the national mass media.

Two co-implicated themes emerge out of this history: controversies surrounding the nation's image (who or what may represent Egypt), and contestations over the representation of the ideal, modern citizen-subject. Armbrust argues that, beginning in the early decades of the twentieth century, Egyptian popular culture sought to represent a uniquely Egyptian modernity that "rejects making a break with tradition" (1996, 194). He also points out, however, that "heritage is not simply there but must constantly be sifted and reworked in the cause of progress" (1996, 25).[10] In the years before the 1952 military coup that marks the beginning of an independent Egyptian nation-state, Egyptian mass media disseminated nationalist and modernist popular culture texts with a successful, educated middle class as the focal point of representation. Importantly, nationalists in the early part of the century, many of whom were upper middle class, deployed rhetoric of the nation as a collective family, and as the new model of that nation/family, based on the bourgeois ideals of a companionate marriage and emotional bonds between members of a nuclear family, rather than the ties of extended family kinship or same-sex social worlds (Baron 2005, 5–6; Abu-Lughod 2002, 442–45). Nationalist rhetoric also drew upon notions of family honor, of which women are most often the repository, to formulate a discourse in which the honor of Egypt, gendered as a woman, came to define the identity of the national collective (Baron 2005, 216). Correspondingly, nationalist writers such as Qasim Amin linked the status of Egypt's women to the progress of the nation (Abu-Lughod 2002, 439).

Armbrust (1996) suggests that in mass-mediated representations, the formulation of modern Egyptian national bourgeois identity took place via a synthesis between two worlds of character extremes, each with distinct class-based shortcomings and vices: on the one hand, the overly Westernized, wealthy, culturally inauthentic, corrupt, and immoral elite (*ibn al-zawat*, or 'son of the aristocracy') and, on the other, the good-hearted and authentic but culturally ignorant, crude, and uncouth peasants or working-class residents of urban quarters (*ibn al-balad*, or 'son of the country'). The figure of a

cultured, progressive, and socially conscious middle-class Egyptian—properly socialized through education and embedded in the heteronormative nuclear family structure of a bourgeois companionate marriage—came to embody the desired modernist convergence of these two class extremes, and the ideal national citizen-subject.

Sites of industry, education, and government institutions were the favored symbolic locations of modernity in these popular culture texts, and bureaucrats, governmental officials, army and police officers, and educated professionals such as doctors, lawyers, and teachers were frequently represented as the bearers of morality (Armbrust 1998, 290). Respectable female characters—wives, mothers, students, and middle-class professionals—symbolized the modern home, family, and nation (Franken 1998, 271). The figure of the seductive belly dancer working in a nightclub, long the symbol of a fallen woman in Egyptian popular culture, might be redeemed in these narratives through retirement from her profession and transformation into a bourgeois lady, or by the fact that she was forced to be an entertainer in order to support other members of her family in their social ascent to middle-class security.[11]

In this way, early-twentieth-century Egyptian mass culture texts fashioned middle-class nationalist heroes who could successfully integrate the best aspects of Arab-Islamic heritage with the authentic, 'folkloric' character traits of the *ibn al-balad*, as well as appropriate the advanced scientific and technical resources of the West and cultivate a sophisticated appreciation of the refined offerings of its artistic and cultural heritage. Throughout the twentieth century, popular culture came to be evaluated by the terms set by this trope linking modernity, national pride, and middle-class morality and identity. National establishment critics praised mass-mediated popular culture as 'respectable' *(muhtaram)* and 'civilized' *(mutahaddir)* if it subscribed to the narrative convention that associates morality and progressive social ideals with an educated middle class. They also objected to popular culture representations that failed to achieve the modernist synthesis among 'high' Western, Egyptian, and Arab-Islamic cultural features that had come to represent an honorable and progressive national identity.

In the post-independence era in Egypt, nationalist state-run mass media—radio, television, newspapers, and subsidized cinema—became the mouthpiece for expressing national aspirations framed in the rhetoric of progress, development, and enlightenment. During Gamal Abdel Nasser's presidency in the 1950s and 1960s, the modernist tropes of pre-1952 nationalist cultural ideology became integrated into state policy regarding the arts and

entertainment. Nasser's 1959 presidential decree on Egyptian broadcasting contained such stated goals as "elevating the standards of the arts," "participating in the spread of culture among the masses," "reviving the Arabic literary, scientific and artistic heritage," and "informing the public about the best products of human civilization" (Boyd 1982, 22). The state prioritized public-sector funding of the arts. Hence, artists and artistic expression played a fundamental role in articulating and disseminating these hopes for the building of a modern Egypt that would draw upon "the best products of human civilization" yet remain rooted in authentic Arab and Egyptian cultural heritage.[12] The proper role of the artist and his or her art was not merely to entertain but also to educate and uplift the citizenry and promote the new nation's political aspirations in times of peace as well as times of war.[13]

As a result of the association among art, mass media, and national development promoted under Nasser, by the 1970s, in the field of music, a core group of 'Golden Age' cultural icons—the most prominent among them Umm Kulthum, Mohamed Abdel Wahhab, and Abdel Halim Hafez—had become the standard by which all subsequent singers and composers were measured by the majority of the nationalist cultural intelligentsia.[14] These performers, who also appeared in films, are remembered by contemporary establishment critics as upholding the highest standards of musical artistry while at the same time contributing to the nation's political and social development.[15]

One of the many factors that contribute to contemporary nostalgia for these singers is that after Nasser's death in 1970, President Anwar Sadat implemented significant political and economic changes that were reflected in popular culture. State subsidies for the arts declined, and new classes of nouveaux riches emerged that benefited from Sadat's Open Door, or *infitah*, economic policies.[16] In contrast, the educated middle class found itself entering a period of downward mobility, with its social position and aspirations no longer commensurate with its economic status (Starrett 1998, 221). Also in the 1970s and 1980s, the prosperous economies in the Gulf states encouraged many Egyptians, including uneducated workers, to find employment in these countries and then return to Egypt with their savings. Many secular nationalists blame this migration for the rise of fundamentalist tendencies among Egyptian Muslims.[17] Thus, in the post-*infitah* era, new classes of patrons for the arts arose who did not conform to the old educated, modernist ideal of middle-class identity.

Further, the political, economic, and social disappointments that symbolically began with Egypt's defeat in the 1967 war with Israel and that

continued into the age of *infitah*, as well as the role of state media institutions in circumscribing information available to the public, led many Egyptians to feel wary of and disillusioned not only with the rhetoric of progress and enlightenment but also with the mouthpiece of that discourse—state-run media. The glaring discrepancy between the ideology of establishment culture and the lives of most Egyptians, especially those attempting to gain the elusive benefits of middle-class identity promised by education, led to the emergence of new forms of mass cultural expression—ones that often did not meet with the approbation of the state or conservative establishment critics.

In fact, the current proliferation of satellite television in Egypt invites comparison to the spread of cassette tape technology in the 1970s, which allowed audiences to listen to music and religious sermons at odds with the official modernist ideals and thus not broadcast over state-run radio or television.[18] The rise in popularity in the 1970s of a new tradition of urban, working-class music, known as *sha'bi*, came to epitomize the new era.[19] Egyptian establishment critics labeled the brash new music and lyrics of these 'low-class' singers, such as Ahmed Adaweya and, more recently, Shaaban Abdel Rahim, which did not conform to the artistic standards and modernist ideology of the previous Golden Age singers, as "vulgar," "meaningless," and "all about making money" (Armbrust 1996).[20]

Since the 1970s, artists and intellectuals alarmed by this trend toward 'vulgarity' epitomized by *sha'bi* music have been producing films and television serials that condemn the new classes of nouveaux riches for their lack of education, taste, and appreciation of the arts.[21] In turn, establishment critics in the post-*infitah* era tend to attack cultural production that does not espouse their modernist ideals or conform to the style and standards of the Golden Age as the deplorable byproduct of opening Egypt up to penetration by Western capitalist markets, the influence of Gulf-state 'petrodollars,' and political and economic normalization with Israel.[22] These critics blame the class of *ibn al-balad* nouveaux riches that emerged in the 1970s for corrupting noble cultural ideals and public taste by encouraging the spread of selfish individualism and materialism and promoting what are seen to be the worst aspects of traditional Egyptian and Western culture, and even Islamic fundamentalism (Swedenburg 2000, 95–96).[23] In short, this class and the art they patronize are seen by critics to embody the exact opposite values of the old modernist, middle-class ideal represented by cultural icons such as Umm Kulthum, Mohamed Abdel Wahhab, and Abdel Halim Hafez.

The issue of class has also been at the forefront of controversies over several documentaries and films in the post-*infitah* era, including *Cairo* (Youssef Chahine, 1991), *Marriage Egyptian style* (Joanna Head, 1992), and *Mercedes* (Yusri Nasrallah, 1993). These films have become the subject of heated and polarized debates over Egypt's national honor and 'reputation' (Saad 1998).[24] In an article about the controversy surrounding *Marriage Egyptian style*, Egyptian anthropologist Reem Saad, who participated in the making of the film, suggests that the primarily urban middle-class critics who attack the movie seek to monopolize the right to represent Egypt's on-screen image both at home and abroad. *Marriage Egyptian style* is a British Broadcasting Corporation-produced documentary that centers upon the life of a single, lower-class house cleaner in Cairo and her attempts to find suitable spouses for her children.

Criticisms of the way the film portrays Egypt and Egyptian society, Saad observes, reveal a profound ambivalence toward peasants and the urban poor, as well as a paradoxical relationship to 'Western civilization.' The film has been considered part of a Western campaign to destroy Egypt's reputation precisely because it does not focus on the 'civilized,' 'Westernized' aspects of Egyptian society felt by the middle class to be symbols of national progress and its own social class, such as the Opera House, five-star hotels, and an educated professional woman. As for 'the people,' Saad writes, "[They] are celebrated and used to express the authenticity of this nation; but they are tolerated only in the abstract" (1998, 406). The documentary's portrayal of the life of a poor urban woman in a way that is neither patronizing nor romanticized undermines "a sense of social distinction essential to middle-class identity" (409). In Saad's analysis, then, the attacks on 'vulgarity' that have been a common feature of the national press for decades form part of an urban middle-class attempt to exclude representations of Egypt that do not seek to uphold the symbolic markings of its own class position.

Economic liberalization and privatization accelerated under President Hosni Mubarak with Egypt's signing of International Monetary Fund and World Bank structural adjustment and economic reform agreements in the early 1990s. As a result of these transformations, the majority of Egyptians, including university graduates and middle-class white-collar employees, suffered from higher costs of living, declining real wages, and a decrease in government subsidies and social services. At the same time, the integration of Egypt's economy into global markets led to the rise of a small but highly

visible new class of wealthy and upper-middle-class professionals employed in the upper echelons of the transnationally oriented private sector. If the 1970s and 1980s era of *infitah* nouveaux riches was symbolized by the low-class *ibn al-balad* who used his or her newfound wealth to promote vulgar Egyptian 'street' singers such as Ahmed Adaweya, then the danger that the wealthy *ibn al-zawat* class of the age of globalization seems to pose to national values in the eyes of many establishment critics is that of excessive and morally permissive Westernization and consumption.

Scandals over the vulnerability of the nation's youth, portrayed as being corrupted by money and excessive materialism, erupted throughout the 1990s. In one such incident, a group of young upper-class 'heavy metal' music fans hanging out in front of a McDonald's were rounded up by security forces and accused of Satan worship (Abu-Lughod 2005, 205–206).[25] Critics were particularly scandalized by the mid-1990s popularity among Egyptian youth of a transsexual Israeli Mizrahi singer named Dana International, whose songs and lyrics contain both Arab and Euro-American influences. As Ted Swedenburg points out in his study of the Dana International phenomenon, "anxieties about Israel's aims and power are displaced onto the linked domains of culture and morality, such that the press is constantly churning out inflammatory stories, many of them delusionary, about Israel's efforts to conquer Egypt and the Arab world culturally and to corrupt their morals" (2000, 91–92).[26]

In these critics' eyes, the popularity of Western singers such as Dana International, Madonna, and Michael Jackson among young people not only reflects society's descent into vulgarity but also poses a real threat to the sexual and moral health of Egyptian youth, for whom early marriage is increasingly difficult because of the high cost of living and social expectations for celebrating a wedding and opening a new home (Swedenburg 2000, 94–95). In this discourse, the problem with popular culture—especially 'Western' popular culture or Arab and Egyptian popular culture that is seen as imitating the worst of the west—is that it encourages youth to indulge in excessive consumption to the point of engaging in subversive and illicit activities that undermine heteronormative gender roles, religious practices, and national political loyalties.

The two themes articulated in this discussion of twentieth-century Egyptian mass-media culture—controversies surrounding the nation's image (who or what may represent Egypt), and contestations over the representation of the ideal, modern citizen-subject—are also at the heart of the current wave of

national criticism directed at the music video clip. In the eyes of the majority of Egyptian critics, the kinds of Arabic music video clip predominantly aired on satellite channels, rather than contributing to the realization of a better society, are harmful to viewers and the nation's image.

Some critics accuse the music video of being a product of the kind of excessive consumption practices associated with the new class of professionals that has benefited from Egypt's integration into a globalized economy. Beginning in the late 1990s, a new landscape of exclusive, public leisure sites, including Western-style restaurants, cafés, bars, and malls, has sprouted up in Cairo to meet the social needs of this emerging bourgeois class.[27] Not only are these new symbolic sites of affluence frequently used as locations for the filming of Arab music videos, many of them also sport wide-screen televisions that broadcast popular satellite music television channels such as Melody, Mazzika, and Rotana for patrons to view while sipping their cappuccinos and dining on Caesar salad and crepes.[28]

Other critics declare that earlier forms of post-*infitah* culture, such as the lower-class *sha'bi* music of the 'street,' are responsible for degrading taste to the point that viewers accept the video clip and its artists as the dominant representation of Egyptian and Arab culture in the contemporary age.[29] Using language similar to that directed against other disreputable forms of post-*infitah* mass culture, critics decry the apparent lack of diversity and meaningful messages contained in the genre, for unlike a true form of artistic expression, they say that the video clip is divorced from political and social realities, artistically *tafih* (trite) and *habit* (vulgar), aiming only to generate profit for producers and the satellite television stations that broadcast them.

While a degree of diversity and recognition of social and political realities does in fact exist in the video clip genre, and many establishment voices approve of 'respectable' kinds of videos (a subject which will be treated further in the conclusion), for the most part, when critics speak of the video clip in general terms and seem to condemn the genre as a whole, they and their audiences know exactly what kind of music video they are talking about. The term 'video clip' is collectively understood to refer to the most stereotypical manifestation of the genre, a romantic love song set to a dance rhythm and a catchy tune. The singer is either a seductively dressed female vocalist swaying alluringly to the music or enacting an intimate love scene, or a male vocalist accompanied by a bevy of beautiful model-dancers. Rather than featuring the critics' favored sites of heritage and modernity, the setting is usually a disco, a mansion, a resort beach, or some other location

that represents an exclusive, affluent lifestyle. In this kind of clip, which is sometimes referred to as a *burnu klib* (porno clip), the lyrics, music, and images are interpreted by many critics as an invitation to an illicit, decadent, and socially irresponsible lifestyle.

An exemplary and sophisticated critique of the video clip illustrating most of the commonly encountered criticisms discussed above is found in the essay "Ruby and the Chequered Heart," written by the highly respected Egyptian intellectual and political activist, Dr. Abdel-Wahab Elmessiri. An English professor and author of a seminal encyclopedia on Zionism, Elmessiri, like many of his generation, began his intellectual career in the era of Abdel Nasser as a supporter of Marxist-leftist socio-political visions but later in his life came to regard an engagement with the Islamic tradition as essential for the project of social justice and reform. Up until his death in 2008, he commanded the respect of a wide range of Egyptian and Arab intellectuals and political activists across a broad spectrum of parties and positions, and his article on the video clip has been one of the most lauded and widely discussed editorials on the subject to appear in recent years.[30]

Published in Egypt's most widely circulated daily newspaper, the government-owned *al-Ahram,* Elmessiri's article begins with a definition:

> A video clip is a short movie comprising a jingle, a dance, and a dramatic theme. A far cry from the world of song as we once knew it, it must be said at the outset, for this is *all* a video clip comprises. Yet there was a time when listening to a song was a multidimensional experience in which the listener could appreciate lyrics, music and performance. Not unlike the video clips of today, most were admittedly about romantic love, but some were about mothers, nature or human relations in general. Singers performed the classical Arabic poems of such giants as Ahmed Shawqi, Al-Akhtal Al-Saghir and Ibrahim Nagui. (Elmessiri 2005, 22)

Dr. Elmessiri then recalls some of his favorites from among the old recording artists' repertoire and praises the diversity not only of their subject matter but also of their form, lamenting that "in the ubiquitous hands of the video clip, even love songs—a once ambiguous, complex and delightfully varied genre—have undergone a negative transformation" (Elmessiri 2005, 22).

After introducing his critique of the one-dimensionality of the lyrics and content of the video clip song via these comparisons with early-twentieth-century Arabic music classics, in the next section Dr. Elmessiri turns to the

subject of the pictorial content of the video clip. He argues that the video clip's stereotypical images have reduced the love song to a one-dimensional eroticism, with "the dancers leaving very little to the viewers' imagination" (Elmessiri 2005, 22). Further, they have changed the meaning of Oriental dance itself: from what used to be a 'vertical' dance confined to movie theaters, nightclubs, and weddings "in a parallel world, one we tended to keep at bay," the video clip dazzles the viewer with (quite literally) 'horizontal' dance movements (Elmessiri 2005, 22).[31] Using the singer Ruby's video clips as an example, Dr. Elmessiri writes that, unlike the old form of this cultural tradition, Oriental dancing in video clips takes place on the street and in other daily-life settings, therefore "normalizing otherwise exotic erotic dance, and bringing it into our living rooms all the way from the floorshow" (Elmessiri 2005, 22).[32] The danger of this new kind of video clip dancing is that it acts "to remove the barrier separating daily life from belly dancing—normalization of a risqué activity" (Elmessiri 2005, 22).

Lest the reader find these observations trivial, Dr. Elmessiri insists that "one explores this in such detail because one is aware of its import: these things affect millions of people, changing our perceptions of ourselves, our surroundings, the way we perceive sensuality and sexuality" (Elmessiri 2005, 22). Indeed, Dr. Elmessiri continues, the problem with the video clip is precisely its impact on the social order, for the private pleasure of the individual viewer ought not to be placed above the concerns of family, society, and nation:

> Video clips amount to more than a sexy woman dancing and singing. Rather, they provide the public with a role model, promoting a particular lifestyle that typifies a worldview in turn, one whose starting point is individual pleasure at any price—a solely carnal pleasure that excludes the possibility of appreciating a good performance, the beauty of an aspect of nature or a thought, an emotion. By focussing on carnal pleasure in a social setup that makes marriage increasingly difficult as a practical course of action, the video clip contributes to a libidinal voracity we could well do without. (Elmessiri 2005, 23)

Thus the ideology behind the video clip, in Dr. Elmessiri's reading, is the promotion of a sexual consumerism that encourages the individual's unbridled pursuit of pleasure. On the one hand, this is harmful because the difficult economic conditions that most Egyptians live under make it impossible for many to marry at a young age, let alone purchase the

cosmopolitan commodities and lifestyles that they are urged to consume by the video clip. More significantly, the "libidinal voracity" of the video clip is dangerous because it makes the body "the sole source of identity" by reducing "both women and men to their respective, sexually charged bodies" (Elmessiri 2005, 23). The video clip arouses the sexual appetites of the (male) viewer, and the message of video clip singers such as Ruby is simply that girls are playful love objects. Ruby's character is hardly inspiring, Dr. Elmessiri writes, and he remarks that "Frankly, I am surprised at the lack of feminist critiques of the implicit affront to women's status that she represents" (Elmessiri 2005, 23).

Dr. Elmessiri then proceeds to associate the consumerist urges encouraged by the video clip with a global capitalism that divorces the individual viewer from all moral, social, and national values and affiliations:

Now if you look at the video clips, you will realize that they take place in no specific country. Even when the story revolves around an Egyptian easily recognizable as such, the sets, the costumes, the whole backdrop has nothing at all to do with the implements of life as we know it. The characters drive fancy cars; they live in mansions . . . And this not only stimulates the consumerist urge further and further, it acts to weaken the viewers' sense of national or cultural belonging. Video clips are, to a greater extent than anything else, a symptom of globalisation—of a world homogenised, broken down to basic economic units amenable to the laws of supply and demand. Within these units, the individual is materially driven, with no particular traits, no sense of belonging, no historical memory. (Elmessiri 2005, 23)

Thus, in Dr. Elmessiri's analysis, globalization, underwritten by a postmodern ideology of absolute moral and cultural relativism, creates an ideal, homogenized consumer subject who lives outside of the realm of history, culture, or tradition. As an example of the video clip's disassociation from socio-political realities and its consequent propagation of an amoral, dehistoricized postmodern ideology, Dr. Elmessiri cites the assassination of the Hamas spiritual leader Shaykh Ahmed Yassin as a historical moment during which the Arab nation was enraged, yet the video clip singers danced on as if nothing had happened. He writes, "While an entire nation raged and mourned, the bodies of the dancers kept appearing, unaffected, as if they were, in themselves, a beginning and an end—the beginning of individual pleasure; the end, alas, of history" (Elmessiri 2005, 23).

The conclusion of the article unequivocally condemns the video clip as a dangerous cultural genre that exists solely for the sake of profit, with Dr. Elmessiri warning:

> Through satellite stations, video clips reach into our homes, mingle with our dreams, reshape the way we see others and ourselves. Their goal is not to enlighten us or deepen our understanding of our surroundings—it's profit. They are parasitical capitalist enterprises that compete with each other to make more money, and the end result, rather than enhancing our sense of beauty or improving our ability to appreciate the arts, is simply vulgarity and alienation—the flesh parade. (Elmessiri 2005, 23)

He predicts that society is headed towards the kind of dehumanized world portrayed on MTV. As an example of the kind of undesirable transformations that have already taken place, he cites a nightclub in Cairo that serves a drink known as 'Blue Lesbian.' Linking this with the music video clip, he writes, "I see this as another attempt to normalize abnormality, not essentially different from the attempt to normalize horizontal as opposed to vertical dancing and the systematization of sexual stimulation" (Elmessiri 2005, 23).

Dr. Elmessiri's final thoughts revolve around the nature and purpose of art. Although some may say that attempts to halt the detrimental spread of the video clip are an interference with art and freedom of expression, the video clip, he contends, is not an art form at all but rather "a crude commercialization of sex that exploits humanity for the sake of profit" (Elmessiri 2005, 23). Great art may treat sexuality "to portray the complexity of the human condition, to help us understand the nuances of the human psyche," but in order for producers of the video clip to create art through this medium, they must first, Dr. Elmessiri asserts, stop seeking material gain, and secondly, apply the ideas and ethics embodied in their artistic productions to their own families (Elmessiri 2005, 23). No one among the makers of video clips, he believes, will find in himself or herself the courage to do either of these things.

It is not difficult to discern in Dr. Elmessiri's comments an affinity with postcolonial national discourses of modernization and developmentalism in which the proper role of art is to serve the greater good of the nation rather than to inspire, for example, rebellious dissent against social norms or valorize individualistic freedom of expression. As discussed above, for most of the twentieth century, both the state and the cultural establishment in Egypt

have viewed the mass media as a technology to be used for the formation and enlightenment of modern citizen-subjects. In contrast, the numerous private Arab satellite channels that air video clips alongside commercials for Frito-Lays potato chips and Fanta soda drinks are clearly profit-driven, commercial enterprises operating within the parameters of a global economic system: in other words, they are in the business of broadcasting to a transnational region of potential consumers, rather than a national citizenry.

The danger posed by the video clip in the analysis of Dr. Elmessiri is that it encourages a new kind of subjectivity, one divorced from specific national, religious, and historical affiliations. Rather than cultivate ethical, political, and aesthetic norms that may serve as an enlightened model for the individual, the family, society, and the nation, the video clip instead reduces the subjectivity of men and women to a consuming, pleasure-seeking body. Importantly, Dr. Elmessiri does not in theory object to the portrayal of sex or sexuality, or the performance of dance, in the video clip or in any other art form.[33] Instead, it is the video clip's elevation of sexuality as the defining marker of identity that is the target of his critique. The video clip does not show the viewer an educated female teacher, doctor, or mother, but rather a woman who is nothing but an attractive body that is sexually available. The viewer is not addressed as a citizen concerned with the socio-political realities of his or her society, or as a human being capable of having his or her emotions elevated through appreciation of the arts, but as a consumer driven solely by libidinal instincts.

In this way, the video clip's perversion of gender ideals (the commodification of sexuality and the conversion of vertical to horizontal dancing), of economic conditions (the display of lifestyles and goods utterly unattainable by the majority of Egyptians), and of political issues (the disregard for the assassination of Shaykh Ahmed Yassin) intrudes into the heteronormative sphere of the family home via satellite television and begins to remake the subjectivity of the Egyptian viewer.

If the main concern of Dr. Elmessiri's critique of the video clip is the genre's reduction of the individual to a mere body stripped of the political, social, ethical, and aesthetic sensibilities and identifications that a true work of art aims to cultivate, then other nationalist critiques place greater emphasis on the video clip's degradation of Egypt's national image. One such critic is the sociologist Dr. 'Azza Kurayyim, a researcher at the National Center for the Study of Sociology and Criminality. On April 13, 2005, the Cairo Opera House, the state's most esteemed cultural institution, hosted a special

seminar devoted to the subject of the video clip.[34] The discussion featured the respected Egyptian singer Anoushka and the chair of the Musicians' Association, the composer Hassan Abou Seoud, both of whom discussed the reasons behind the poor artistic quality of the video clip and the decline of respectable music in the Egyptian and Arab market, and called for greater state support of musicians attempting to present dignified art. In turn, Dr. Kurayyim provided the audience with a sociological analysis of the effects of the video clip on Egyptian society, particularly its youth.

Importantly, Dr. Kurayyim began her commentary by rejecting the notion of 'art for art's sake.' The artist, she insisted, is not free to do or say as he or she pleases, but must be held accountable for creating cultural productions that meet the social needs of his or her audience. Here it is important to note that many video clip artists publicly subscribe to the nationalist discourse that art should be socially meaningful, and they join critics in their attacks on certain video clips for their moral excesses and aesthetic triteness and participate in 'campaigns' against 'the porno clip.'[35] During interviews, if confronted with questions concerning the controversy over their videos, singers tend to deny that their work is anything but pleasant entertainment, and female artists often insist that their looks are merely intended to express their femininity, not to offend or cross any red lines.[36] These controversial stars tend to maintain that the motive for what they do is the expression of their individuality and unique style, rather than outright transgression of societal norms.[37]

It is this 'narrow' view of the artist as merely an entertainer expressing his or her individuality that Dr. Kurayyim objected to in her analysis of the video clip phenomenon. Art, and especially music, she insisted, have always played an important social role, inciting the troops to battle in times of war, helping in the treatment of diseases, and assisting in the social upbringing *(tanshi'a)* of youth, who these days, she proclaimed—to much sympathetic audience applause—memorize video clip songs more than their school lessons.[38] Because of the importance of art to social life, artists cannot simply be left free to pursue their creative fancies without limits set by society. Despite all the efforts to improve women's status, for example, video clip producers just represent women as sexualized commodities in order to quickly attain fame and fortune, even if they do not subscribe to the ideology implied in the images that they portray. Further, this degraded state of the video clip, in which artists are simply running after personal gain, Dr. Kurayyim warned, is negatively affecting Egypt's reputation abroad:

> Art is an image for a country. I as an artist and the song that I present, in any
> society that sees it on any satellite channel, [the viewer] will say, "This is an
> Egyptian singer, and that is Egypt and that's Egyptian art." [We have become]
> a big laughing-stock *(mahzala)*! I have [traveled] outside of Egypt to many
> countries, and I look around and find that they talk about Egyptian art in the
> most degrading terms. [They say] that the Egyptian artist and Egyptian art
> are selling because they are only interested in sex and arousing [the sexual
> feelings of] the youth. Egypt's entire reputation is presented by the artist, and
> I [the video clip artist] harm this reputation with these songs.

Dr. Kurayyim then proceeded to describe some of the negative effects of
the video clip on the Egyptian family, home, and society—rising tensions
between husbands and wives; an increase in divorce because each partner
fails to live up to the romantic and physical standards set up by the video
clip; unemployed youth immersing themselves in the illicit pleasures of drugs
and alcohol while watching the clips—before calling on the Egyptian state
to interfere to protect the image of Egypt and its art that Egyptian satellite
stations are broadcasting to the world. She concluded her analysis with the
following plea for respectable art:

> Art is the true foundation for the development of society, and by the way,
> we measure historical phases by way of what [they produce] in terms of
> art. We say in the sixties art and artists were like this, in the seventies
> like this, in the fifties like this, so art represents the history of a society.
> We must respect and maintain it in order to uphold our society in the best
> image possible.[39]

Thus, while Dr. Kurayyim's objections to the Arab music video clip fore-
ground the relationship between a nation's art and its status (in the eyes of
others) as a civilization, they also, as with Dr. Elmessiri's critiques of the
video clip, center upon the detrimental influence of the video clip on family
and society. Importantly, both critics fault video clip artists for not present-
ing works that convey ethical, political, and social standards that they them-
selves would wish to live by; instead, they are simply seeking the quickest
and easiest path to money and fame, with little regard for their effect on the
subjectivities of viewers. As the discussion of the history of Egyptian media
controversies treated previously in this chapter has shown, throughout the
twentieth century, nationalist critics have regarded Egyptian popular culture

not simply as entertainment, devoid of social or political import, but as a crucial technology for the formation of modern citizen-subjects.

Speaking within the nationalist institutions of the Cairo Opera House and the government daily *al-Ahram*, Dr. Kurayyim and Dr. Elmessiri object to the work of video clip artists because they are seen by these critics to display narratives and models of personhood that neither articulate national or community affiliation nor engender in the viewer the moral and political sensibilities necessary for inhabiting a modern, progressive society. The favored institutions and markers of modernity represented in texts of Egyptian popular culture that gain favor with nationalist critics—universities and schools, Pharaonic and Arabo-Islamic architectural heritage, the bourgeois heteronormative family, civic-minded middle-class professionals—are absent, in the eyes of these critics, from the video clip. Instead, they have been replaced by schoolgirls who flirt with their teachers, mansions and other sites of decadent wealth that are seen to promote consumption as the highest social goal, and seductive bodies that encourage the pursuit of unbridled individual pleasure and the neglect of family, social, and political life. The video clip perverts the pedagogical function of the mass media as a tool for the enlightenment of the people, and Egyptian music video artists have abandoned the task of representing Egypt to the world as a modern, developed nation.

In the next section, this chapter turns to an examination of another strand of criticism of the video clip, one that in many ways resonates with the critiques just explored. For like those arguing within an Egyptian nationalist discursive framework, critics of the video clip speaking from an explicitly Islamist perspective also attack the genre for its immorality and seeming indifference to the political and social struggles of the nation (albeit an Arab-Islamic, rather than Egyptian one). Nevertheless, there are Islamist critiques of satellite music television that point to a different understanding of the relationship between art, subjectivity, and politico-ethical reform—and a different history that grounds that understanding—than the one treated in the above discussion. Indeed, throughout the twentieth century, Egypt's thriving national entertainment industry has proven a major source of contestation between the Egyptian state, the secular nationalist intelligentsia, and Islamist social reformers. But as the example of Dr. Elmessiri demonstrates, it is not so easy to map controversies over popular culture in Egypt onto a neat divide between (secular) nationalist and Islamist positions. The conclusion of the chapter will elaborate on this point as well as discuss recent Islamist interventions into the field of satellite entertainment production that highlight some

of the ways in which popular culture has become a privileged site of social, political, and ethical reform in the past decade.

"Rotana Cinema: You will (not) be able to take your eyes off it!"

At the beginning of 2005, Rotana, a major album production company and satellite television network owned by Saudi Prince Alwaleed bin Talal, added a new channel, Rotana Cinema, to its bevy of channels for music video clips, entertainment programs, and concerts. The Rotana channels began to run ads for the new cinema channel featuring one of the company's most famous and controversial music video stars, the voluptuous Lebanese video clip singer Haifa Wehbe. Set to the music of one of Haifa's latest hits, "Hayat qalb,"(Oh, Life of My Heart), the ad juxtaposed scenes of sultry film icons (such as Nadia Lutfi and Hind Rostom) from Egyptian cinematic history with shots of Haifa batting her eyes seductively and pronouncing, "Rotana Cinema: Mish hati'dar tighammid 'enek" (You won't be able to take your eyes off it!). The ad was clearly trying to grab viewers' attention as well as compare Haifa's sultry performances, which many Egyptian critics find scandalous, to those of some of the most famous and beloved stars of the national cinema industry.

Figure 9.1. Student protests at Alexandria University: "You will (not) be able to take your eyes off it!"

In March 2005, students at Alexandria University staged a protest against the spread of risqué music videos and the satellite channels that broadcast them. Some of the demonstrators belonged to Islamic groups, and one sign in particular caught a photographer's eye: Rotana's name and famous green trademark drawn next to Haifa's slogan, "You will not be able to take your eyes off it!" The artist had drawn large x-marks over the name 'Rotana' and the word 'not' (mish), changing the slogan, of course, to "You will be able to take your eyes off it!" At the bottom of the sign, he or she had written the name of the student group whose members were carrying the banner: The Youth of the Islamic Trend (Shabab al-Tayyar al-Islami) ("Protests against Seductive Music Videos Erupt in Egypt," 2005).[40]

Student protesters demonstrating against Rotana's entertainment channels were following in a long line of Muslim reformers in Egypt in their public stance against the immorality of mass-mediated arts and entertainment. The following section discusses Islamist criticisms of the music video that engage with a centuries-long Muslim legal discourse on entertainment, morality, and sexuality that is grounded in a different history and set of discursive knowledges and practices than those that inform the nationalist critiques of the video clip genre. Although the objections of Islamist social reformers to the content of satellite music television in Egypt coincide in significant ways with those of Egyptian critics arguing within national, state-inscribed spaces and frameworks, a point that will be explored further in the conclusion, here the chapter draws attention to some of the reasons why popular culture has become a highly politicized site in Egypt in which secular-nationalist and Islamist visions of social reform are articulated and defined in opposition to each other.

In a recent book, Fiqh al-lahw wa-l-tarwih (The Jurisprudence of Entertainment and Recreation) on Islamic rulings concerning leisure, one of the most prominent Muslim religious authorities alive today, the Egyptian shaykh Dr. Yusuf al-Qaradawi, devotes an entire section to legal opinions on dance, including the kind of dance found in the video clip. After sanctioning most kinds of folk dance that maintain gender segregation, he proceeds in his treatment of the subject to explain why Oriental (belly) dancing is forbidden:

> [The dancer] relies upon [her ability to] sexually arouse the men who watch her and waste their money on her, particularly [because] she is barely clothed, since the kind of cloth that covers her is transparent, as if she is wearing glass. No scholar—or for that matter, an ordinary Muslim—doubts the prohibition

of this kind of dance because of its incitement to sin and its enticement to fornication. (al-Qaradawi 2005, 123–24)

In the next section, Dr. al-Qaradawi turns his attention to the music video clip:

> Of late there has appeared a kind of female dance that is more dangerous, provocative, and effective in arousing the worldly instincts. [This dance] is performed by women working in the professions of singing and dancing (dancers of the video clip), and they excite [the viewer] with their shameless movements more than with their tender voices. They [perform] in this dance some unheard-of arts that are not limited to the well-known vertical dancing, but they have invented horizontal dancing, meaning that they dance standing or sitting or lying down, or what resembles lying down! This has become famous on singing and amusement channels, and it has become a profitable business to those who deem permissible illicit earnings, even if [this money] is gained by dishonoring [*hatk*] inviolable things, and disdaining morals, and degrading ethical virtues, and raising the logic of the body above that of the spirit, and treating the human as if he were an animal!
>
> And if it is forbidden to intend to look at a woman whose body reveals a part that is not permitted to be uncovered, so how is it if, in addition to this, [one finds oneself looking at images whose very purpose is] arousal and seduction." (al-Qaradawi 2005, 23–24)

Like Dr. Elmessiri and Dr. Kurayyim, Dr. al-Qaradawi objects to the singing-dancing girls, their immodest clothing, their voices and movements that are seen to provoke sexual excitement—all things which are seen by the shaykh to take one's mind off God and encourage one to engage in illicit activities. Also similar to Dr. Elmessiri's critique of the video clip as degrading the viewer to a mere consuming subject driven by libidinal instincts, Dr. al-Qaradawi blames the video clip for stripping the human of his spiritual qualities and inciting him to behave as an animal driven purely by worldly desires. Yet unlike Dr. Elmessiri, who does not disapprove of Oriental dancing in and of itself, but in the way it is practiced by video clip singers, Dr. al-Qaradawi (who, it seems, has appreciated the former's observation about the horizontal dancing found in the video clip) declares that Oriental dancing is a forbidden form of dance, and in the section of the book that follows his treatment of the video clip, he discusses the reasons why ballet and ballroom

dancing between men and women are also not permitted by Islam.[41] The Cairo Opera House, the state institution that hosted the seminar on the video clip in which Dr. Kurayyim took part, regularly features ballet performances, and the Golden Age songs and films (such as the kind mentioned by Dr. Elmessiri at the beginning of his article) that nationalist critics hold up as the respectable standard for the arts quite often feature couples dancing.

Recent theorists of secularism argue that formulations of the doctrine of separation between religion and the state have been negotiated quite differently within varying national and historical contexts, and that it is more useful to think of the concept of secularism as a series of state legal and administrative interventions that aim to construct, regulate, and reorder the sites and practices of 'religion' and define its role in social life (Asad 2003; Mahmood 2005; Veer 2001; Jakobsen and Pellegrini 2000; Chatterjee 1998).

In the case of Egypt, the work of Talal Asad, Saba Mahmood, and Charles Hirschkind demonstrates that since the late nineteenth century, the Egyptian state has enacted a series of reforms in its attempts, in Mahmood's words, "to redefine the locations and modalities of proper religious practice as part of the project for creating a modern polity" (Asad 2003; Hirschkind 2004; Mahmood 2005, 77). The general intent of these reforms has been to demarcate a sphere for the *public* appearance of religion within state-sanctioned legal channels (personal status laws), nationalized religious institutions (al-Azhar University and other official mosques), and mass media programming (broadcast on government-run television and radio); simultaneously, these reforms have defined a series of practices, such as clothing styles and leisure activities, as personal matters, and restricted them to the privatized sphere of individual choice (Hirschkind 2001; Asad 2003, chapter 7; Mahmood 2005, chapter 2).

In their ethnographic studies of contemporary Egyptian Islamic reform movements, Mahmood and Hirschkind point to the centrality of the concept of *da'wa* (literally, 'call' or 'summons') as a means by which Islamist pietists "unsettle key assumptions of the secular-liberal imaginary" that the state has attempted to normalize in its project to create modern citizen-subjects (Mahmood 2005, 78). Early-twentieth-century Muslim reformers such as Rashid Rida (d. 1933) and Hasan al-Banna (1906–49), founder of the Muslim Brotherhood, drew upon the wide range of meanings historically associated with the classical notion of *da'wa* to emphasize 'the call' as a duty incumbent on all individual Muslims to exhort fellow members of their community to pursue more pious lives (Hirschkind 2001, 6–7; Mahmood 2005, 61–64).

Despite the government's banning of the Brotherhood and general crackdown on Islamist organizations, the practice of *da'wa* in its myriad manifestations (be it face-to-face or mass mediated, written or spoken, in the form of a discussion, exhortation, or sermon) has expanded throughout the twentieth century to "become a space for the articulation of a contestatory Islamic discourse on state and society," a space in which a "counterpublic" (a public of *da'wa* practitioners) cultivates religious sensibilities and modes of public conduct in tension with those the Egyptian nation-state attempts to inculcate in its citizens (Hirschkind 2001, 7, 17–18). In as much as the regulatory power exercised by the modern state itself has shaped so many aspects of daily life, the *da'wa* public, in its attempts to create the everyday social conditions conducive to the leading of a pious Muslim life, necessarily transgresses secular notions of public and private by rendering public issues that the state tries to circumscribe to the realm of private choice (Hirschkind 2001, 12, 15).

Following these insights from the work of Hirschkind and Mahmood, I explore Islamist criticisms of the video clip in the context of the practice of *da'wa* undertaken by Muslim social reformers since the early twentieth century. The legality of performing and listening to different genres of the musical arts was a disputed subject among medieval Islamic scholars, and since this debate has continued into contemporary times, it has become part of the rhetorical framework within which practitioners of *da'wa* criticize Egyptian popular culture, even that approved of by the national intelligentsia and tolerated by al-Azhar.[42] Of particular relevance is the medieval literature on *al-amr bi-l-ma'ruf wa-l-nahi 'an al-munkar*, or the duty placed upon members of Muslim society to either verbally or physically attempt the commanding of right and the forbidding of wrong in the public sphere. This literature contains frequent references to individuals undertaking this duty by breaking musical instruments or verbally scolding the owners of houses from which music was overheard (Cook 2000, 97, 240).

The reception by Muslim scholars of European forms of mass-mediated and popular culture in the twentieth century reflects the continuation of medieval concerns regarding the potentially harmful influence of music and entertainment on the Muslim subject. Some scholars updated their list of wrongs that a Muslim should endeavor to publicly forbid to include gramophones, photographs of immodestly dressed women, and the cinema (Cook 2000, 186, 509–10). In early-twentieth-century Egypt, Muslim reformers such as Rashid Rida, editor of the journal *al-Manar*, responded to transnational

readers' concerns over such issues as listening to the radio, the taking and display of photographs, and the acting of Muslim women in theater performances (Rida 1970, vol. 6, 2456–57, vol. 3, 1141–44, vol. 4, 1418–20). On this later point, Rida accepted in theory that a Muslim woman may act so long as she appears without make-up, properly dressed, and in socially uplifting roles that do not violate Islamic prohibitions or encourage any kind of indecency. Rida wrote that in practice, however, the reigning immoral conditions of the theatre effectively ban her from participation (Rida 1970, vol. 4, 1420).

An attitude similar to Rida's toward European-introduced arts seems to have informed major figures of the Muslim Brotherhood. Hasan al-Banna, the movement's founder, certainly called for the banning of gambling clubs, establishments that served alcohol, dance halls, and other aspects of European life in flagrant violation of Islamic norms that flourished under British colonial rule, and he called for the strict regulation of films and plays (Banna and Wendell 1978, 127). He recognized, however, the central role that modern mass media could play in disseminating the Brotherhood's message of social reform:

> [T]he methods of propaganda [al-da'wa] today are not those of yesterday. The propaganda of yesterday consisted of a verbal message given out in a speech or at a meeting, or one written in a tract or letter. Today, it consists of publications, magazines, newspapers, articles, plays, films, and radio broadcasting. All these have made it easy to influence the minds of all mankind, women as well as men, in their homes, places of business, factories, and fields. Therefore it has become necessary that propagandists [du'ah] perfect all these means so that their efforts may yield the desired results. (Banna and Wendell 1978, 46)

In this vein, the Brotherhood's magazines included columns on Islamic art and cinema, and the organization even had a theater troupe devoted to the production of Islamic drama (Mitchell 1969, 292–93). Similarly, in his *Manhaj al-fann al-islami* (Manifesto on Islamic Art) from the early 1960s, Muhammad Qutb (brother of Sayyid Qutb) expressed his view of contemporary Egyptian cinema in the following terms:

> As for cinema, in my estimation it is the last art that might enter into the purview of Islamic art, not because cinema in itself is forbidden, but because it is, in its present vulgar, pornographic, and dissolute state, very far from an

> Islamic atmosphere. However, it, like all other art, can become Islamic if it
> follows the principles of Islamic art that we have clarified in previous chapters
> of the book. (Qutb 1973, 203)

Thus, similar to Rida's attitude toward the theater, Qutb does not object to cinema in and of itself, but rather to the kinds of cinematic texts and images found in the movies of his day.

Charles Hirschkind argues that Islamist criticism of secular-nationalist culture "is not simply a case of political criticisms being reflected onto the safer realm of culture" (Hirschkind 2001, 16). Rather, pious audiences feel that "most of the programs presented on the state-controlled television engage and direct the senses toward moral dispositions—states of the soul—incompatible with the virtues on which an Islamic society rests." (Hirschkind 2001, 16) It is for this reason, Hirschkind writes, that media entertainment and star performers are frequent targets of popular *da'wa* preachers.

Shaykh 'Abd al-Hamid Kishk became famous for his sermons criticizing beloved national icons previously mentioned in this chapter, such as Umm Kulthum and Mohamed Abdel Wahhab, and Shaykh Muhammad Mitwalli al-Sha'rawi and Dr. 'Umar 'Abd al-Kafi are remembered for their role in a wave of 'conversions' of film, television, and music stars in the early 1990s (Hirschkind 2001, 16). The majority of these repentant female (and sometimes male) stars retired from performing and publicly expressed regret for their involvement in the entertainment industry, and the female performers donned the veil.[43]

As Egypt's entertainment industry is a source of considerable national pride, these conversions stirred a national controversy in the Egyptian press, and some critics of the phenomenon accused the repentant performers of accepting bribes from Saudi sources (Abu-Lughod 2005, 243). These conversions were received by nationalist critics not as a sign of piety, which the performers and those who supported them insisted they were, but instead as a sign of the ascendancy of fundamentalism that was in large part attributed by nationalist critics to the negative influence of Saudi Arabian Wahhabi Islam on Egyptian society (Abu-Rabi 2004, chapter 6).[44]

Along with conversions of these performers, nationalist critics were also concerned about other Gulf influences on Egyptian society during this period due to the economic changes brought on by the *infitah*. As the economies of the Gulf states grew stronger in the 1970s and 1980s, tourists from the Gulf began to spend summers in Cairo and became notorious visitors at

belly-dancing nightclubs, where they ostentatiously lavished excessive amounts of money on the dancers (Nieuwkerk 1995, 87, 125). Hence, many Egyptian films and television serials of the 1980s and 1990s associated Islamist characters not only with religious extremism, but also with sexual immorality and greedy materialism—in short, an Islamist 'petrodollar' version of the post-*infitah* villain—and pitted them against enlightened, modernist heroes with the nation's best interest at heart.[45]

Thus, while the video clip has become part of a longstanding debate between Egyptian Islamists and nationalists over the proper relationship between art and public morality, nationalist critics' post-*infitah* responses to both the growing presence of Islamism in Egyptian society and the criticisms that the Islamists direct against the national entertainment industry cannot be understood without taking into consideration regional power shifts since the 1970s that lessened Egypt's economic, political, and cultural dominance in the Middle East.

With the emergence of multiple regional economic powers, including post–civil war Lebanon, Dubai, and Saudi Arabia, the Arab world's entertainment industry is now no longer dominated by Egyptian financial backers, producers, and artists. Nowhere has this been clearer than in the realm of Arab satellite television, in which Egyptian government and privately-owned channels are a small minority, and although the Egyptian dialect is still widespread, it is certainly no longer hegemonic, with pan-Arab audiences now tuning in to music, talk shows, and television serials in Lebanese, Syrian, and Gulf dialects. Gulf-owned channels are numerous, and to some Egyptian commentators, the dominance of these *batrufada'iyat* (petro satellite channels) spells out the clear end of Egyptian leadership in the region, embodied in the Nasserist vision of (Egyptian-led) pan-Arab unity in the 1950s and 1960s.[46]

Similarly, in the field of music production, unlike in the past, when non-Egyptians contracted with Egyptian companies to reach regional audiences, it is now common for Egyptians to contract with Gulf-owned companies, in particular Saudi Prince Alwaleed bin Talal's company Rotana. Thus, to some Egyptian nationalist critics, the rise of the video clip, of which some of the most famous symbols are Lebanese women whose contracts are with Gulf-owned music and satellite production companies, represents a deliberate attempt to corrupt the high artistic values represented by the Golden Age of Egyptian artists who flourished in the Nasser years. Just as Saudi money was ultimately seen to be behind the 'conversions' of Egyptian actresses in

the early 1990s, it is also seen by many nationalist critics to be responsible for the corruption of Egyptian music over the past decade.[47]

In 2005, one of the prominent Islamic satellite channels, Iqra', part of the Arab Radio and Television (ART) network owned by the Saudi businessman Shaykh Saleh Kamel, devoted a series of episodes on its program *Qabl an tuhasabu* (Before You are Judged) to the issue of the Arab music video clip.[48] This weekly show was devoted to exploring current social issues—such as drug addiction among youth and increased rates of divorce—in a way that emphasized the threat they pose to the Arab-Islamic *umma* (nation) as well as the role of Islam in speaking to the problems at hand. As such, the program can be seen as a kind of televisual form of *da'wa* that complements other forms of mass media put to use in the Islamist movement, such as cassette sermons and Internet sites, all of which aim toward improving the moral condition of the Muslim community.

In the episodes devoted to the controversy over the video clips, which were referred to on the show as *aghani al-'ura* (songs of nakedness), the show's veiled Egyptian host, Basma Wahbi, herself a repentant former model and actress, conducted a series of taped interviews with video clip singers and directors, intellectuals, young people, and children in Egypt and other Arab countries.[49] The program thus took the position that the video clip posed a moral threat to the Islamic and Arab *umma* as a whole, and not to one particular country. However, the program also taped a debate about the issue in which a group of public figures, all of them Egyptian, discussed the controversy òver the video clip in the presence of a small group of Egyptian audience members.[50] Hence, although the debate took place on a transnational satellite channel, it nevertheless reflected the specifically national tensions and concerns of its Egyptian participants.

In my discussion of the program in the following pages, I focus on this debate in order to illustrate the different modes of reasoning and deliberation that mark secular nationalist and Islamist positions toward the video clip in Egypt. Islamist critics of the video clip invited on the Iqra' channel insisted on publicly grounding their critique in an Islamic discursive tradition that state institutional spaces of debate (such as the Cairo Opera House or Egyptian radio and television programming) attempt to exclude or marginalize. As Talal Asad argues, "the public sphere is a space *necessarily* (not just contingently) articulated by power," and hence "the domain of free speech is always shaped by preestablished limits" (Asad 2003, 184). The debate on the talk show *Qabl an tuhasabu* turned into a dispute over the nature of the

agreed-upon limits necessary to engage in public discussion about the video clip, with the eventual result that the two secular nationalist journalists silently withdrew from the debate in implied protest.

The debate took place on the grounds of a fancy villa outside of Cairo, in front of the garden's swimming pool. On one side of the pool, four participants were seated—a director of video clips, a female video clip singer, and two journalists with secular nationalist outlooks toward the video clip. On the other side of the venue sat the Islamist-identified participants—a lawyer bringing a court case against the Egyptian government for broadcasting video clips on its channels, a journalist, a composer, and a sociologist. The program host, Basma Wahbi, sat in the middle, and to her right, on the side of the Islamist participants, sat Dr. 'Abd Allah Barakat, an Azhari-trained shaykh. Although points of agreement did exist between participants on both sides, in the following discussion, I stress the disagreements between the two journalists placed on the side of 'supporters' of the video clip, and the 'detractors' on the other side, in order to illustrate how these differences revolved around the issue of the role of Islam in determining public morality and the kind of ethical and political subject that needed to be cultivated in order to protect against the perceived dangers of the video clip.

The Egyptian journalist Wael Abdel Fattah,[51] known for his articles in Egyptian opposition papers such as *Sawt al-umma* and *al-Fajr*, wrote about his participation in the program on the side of *ahl al-nar* ('the people of the fire,' that is, those destined for hell), as he sarcastically remarked in his article about this experience. A left-leaning oppositional figure critical of the ruling government party, Abdel Fattah is one of the few Egyptian intellectuals who, rather than condemn the video clip outright, has attempted to analyze why this new form of artistic expression has become the site of such controversy.

According to Abdel Fattah, disagreement between the participants on the program began even before the start of the taping of the episode, as soon as Dr. 'Abd Allah Barakat, the Azhari shaykh, appeared on the set. Apparently not all the participants had been properly informed as to the details of the program and its guests, so Abdel Fattah requested that some ground rules for the discussion be laid. In his article, he writes about the following exchange between himself and the shaykh:

> I requested to speak. I said, "I hope that all accept that [this is] a dialogue. No one here possesses the ultimate truth. And I hope that no one speaks in the name of God."

Here the shaykh became indignant, "God forbid! It is necessary for all of us to speak in the name of God."
I said to him, "In a dialogue, no one is in a position to speak in the name of God."
He said, "We speak in the name of God."
I lost my temper a bit, saying, "This is not suitable in a dialogue. Do you have an authorization *(tawkil)* from God [to represent Him]?"
So he said with alarming confidence, "This is clear disbelief if [only] you knew." (Abdel Fattah 2004)

This disagreement between Dr. 'Abd Allah Barakat and Abdel Fattah over the meaning and purpose of 'dialogue' exemplifies Charles Hirschkind's observation that even though public argumentation and deliberation figure prominently in the practice of *da'wa,* this does not imply a shift toward the embracing of secular-liberal values, as *da'wa* "is not geared toward securing the freedom of individuals to pursue their own interests, but, rather, their conformity with a divine model of moral conduct" (Hirschkind 2001, 27). Dr. Barakat's assertion that "It is necessary for all of us to speak in the name of God" set the parameters for a kind of 'dialogue' that neither Abdel Fattah nor the other secular nationalist journalist invited on the program, Maha Matbuli, considered appropriate for a discussion of the video clip. After his exchange with the shaykh, Abdel Fattah reports in his article that he deliberately remained silent for most of the taping, only speaking when called upon to give an opinion, and eventually leaving the session before it ended after the proceedings dragged on far into the night.

As for Matbuli, who at first actively participated in the discussion, numerous points of disagreement arose between her and the host and other participants on the Islamist side of the debate. One of the most salient differences concerned the perceived source of the video clip threat, with Basma Wahbi and most of the Islamist participants and audience members regarding it as the west's latest tactic in its 'clash of civilizations' campaign to destroy Muslim society, this time through the corruption of its moral foundation; indeed, the program sometimes referred to the video clip as a 'weapon of mass destruction.' In contrast, Matbuli regarded the spread of the video clip as due in part to an (implied Gulf-Lebanese) conspiracy *(mu'amara)* against Egyptian art.

This particular point of disagreement reflected a more fundamental difference between Matbuli and the video clip artists, on the one hand, and

the Islamist participants and audience members, on the other, over whether discussion of the video clip should revolve around the subject of art and its pedagogical role in developing society, or around the threat that the video clip and other forms of popular entertainment pose to the ability of the Arab Muslim *umma* to cultivate virtuous communities and selves. Video clip singer Hanan 'Atiya attempted to defend her work by comparing it with the films of beloved Egyptian national singer/actress icons, such as Shadia, whom she admired as a child. Dr. Barakat seized upon her comments to illustrate how the wrongdoings of previous generations of artists negatively impacted the moral character of young people such as Hanan, and he warned that artists bear an enormous responsibility *(wizr)* before God for what they present because millions of viewers imitate them and regard them as role models.[52] Similarly, great opposition was directed by the Islamists at Matbuli, who throughout the debate repeatedly insisted that she had not appeared on the show to talk about the video clip in terms of *halal* (religiously permissible) or *haram* (forbidden), but rather in terms of good or bad art. Objections to this position came both from audience members, who responded by saying that at the end of the day, the youth need to know whether or not watching video clips is right or wrong, and from Islamist-affiliated participants in the debate, such as the sociologist Dr. Ahmad al-Magdub and the host Basma Wahbi herself, who both insisted that knowledge *(al-'ilm)* cannot be separated from religion *(al-din)*.

This issue of the 'secularization' of knowledge revealed itself most clearly in discussions of the threat posed by video clips to the moral well-being of viewers. Matbuli suggested that parents take advantage of the presence of the video clip to educate *(yurabbi)* their children as to proper sexual mores and explain why certain video clips are inappropriate; the proper domain of this education *(tarbiya)*, in her view, lies in the privatized realm of the home. A person raised in this proper way, under the tutelage of the family, would be affected by the negative aspects of the video clip, especially its sexually explicit images, only if he or she were in some way mentally unbalanced. For Matbuli, then, watching or not watching certain kinds of video clips was a private matter of individual choice that in large part depended on the kind of cultural awareness and moral upbringing that one might have.

Audience participants, as well as Dr. Barakat, strongly disagreed with Matbuli's position. Throughout the program, the shaykh (Dr. Barakat) reminded viewers and participants in the debate that it is the duty of a Muslim to attempt to prevent any kind of wrongdoing within the community before

it takes place; anyone who shirks this duty also shares in some part in the committing of the sin and will be punished for it.[53] The shaykh and audience members agreed that the video clip incites normal, healthy people to engage in illicit activities; hence, it cannot be considered a matter of personal choice, as Matbuli would have it, but poses a threat to the well-being of the community as a whole. To illustrate this truth, the shaykh narrated a long story about how the prophet Musa (Moses) nearly lost a battle due to the fornication of one soldier in his army; the wrong doing of one member of the community almost resulted in the corruption of the collective as a whole.[54] During this sermon, Matbuli left the debate without explanation and did not return, which the host Basma Wahbi interpreted as an objection to the shaykh's, and the program's, insistence that any discussion of the video clip must be grounded in the authority of the Qur'an and the Prophet's Sunna (sayings and doings).

Thus, as with the cassette-sermon listeners who are the subject of Hirschkind's ethnography on the da'wa movement, these Islamist critics of the video clip on the Iqra' satellite program *Qabl an tuhasabu* objected to music videos because they "engender emotions and character attributes incompatible with those that in their view enable one to live as a Muslim" (Hirschkind 2001, 16). What is at stake in this debate for the Islamist participants is not merely the question of good or bad art, a subject on which the program also takes a position by promoting an example of the kind of artistic expression desirable for the Muslim community to produce and consume—a song performed by schoolchildren and Basma Wahbi about the plight of the Palestinians. Rather, the points of disagreement between the Islamist and secular nationalist participants in the program revolve around the question of how certain knowledge traditions, moral sensibilities, and ethical modes of personal and public conduct shape the kind of subjectivity and community one inhabits.

Broadcast over a transnational Islamic satellite channel, the discussion between different participants and audience members on the program *Qabl an tuhasabu* illustrates the discrepancies in the various subject positions and assumptions that animate the debate taking place over the music video clip in the Egyptian public sphere. Whereas in the public spaces for dialogue structured by state institutions such as the Cairo Opera House or the government-owned daily *al-Ahram*, Islamist positions are marginalized, in the public arena created by the private Islamic satellite channel Iqra', advocates of secular nationalist points of view are effectively silenced. Part of a long series of conflicts between Egyptian Islamists and secular nationalists over

the content of twentieth-century popular entertainment, current debates over the music video clip thus illustrate Talal Asad's point that

> The public sphere is not an empty space for carrying out debates. It is constituted by the sensibilities—memories and aspirations, fears and hopes—of speakers and listeners. . . . Thus the introduction of new discourses may result in the disruption of established assumptions structuring debates in the public sphere. (Asad 2003, 185)

Popular culture has been and continues to be such a contentious issue between Islamists and secular nationalists in Egypt precisely because each position, in order to enter into this debate over art and cultural production on its own terms, must disrupt and threaten the authority of the existing assumptions held by the other.

This example of a debate over the video clip from the program *Qabl an tuhasabu* also illustrates that the spread of private transnational Arab satellite television in the past decade is enabling the emergence of new spaces for the expression not only of different opinions or viewpoints in the Egyptian public sphere, but of new kinds of debates as well. These new spaces are not necessarily more secular, liberal, or democratic than their government-controlled counterparts, but they are founded upon different power structures and discursive traditions than those assumed by state-mediated, national forums for public argumentation. In addition, the program *Qabl an tuhasabu* also points to new developments in Islamic media. Just as the spread of cassette technology in the 1970s made available to Egyptian audiences new forms of music and religious sermons, artists and producers are utilizing the medium of satellite television to create alternative forms of pious entertainment, including religious video clips. In the final section of the chapter, I explore the phenomenal success in Egypt of one such video—"al-Mu'allim" (The Teacher), sung by British Muslim Sami Yusuf—and its role in the cultural politics of the music video clip in contemporary Egypt.

Sami Yusuf and *al-fann al-hadif* (art with a purpose)

As discussed in the previous section, major twentieth-century Egyptian Islamic intellectuals and reformers such as Rashid Rida, Hasan al-Banna, and Yusuf al-Qaradawi devoted their attention to the question of Islam and the forms of popular entertainment introduced by the European colonial powers. Certainly all of these figures, regardless of their opinions as to the

theoretical relationship between Islam and the arts, have been highly critical of the twentieth-century Egyptian culture industry in both the colonial and postcolonial periods. They claim that it has blindly and misguidedly imitated Western cultural themes and forms, thus rendering the majority of Egyptian cultural productions not only unsuitable, but detrimental, to the cultivation of ethical Muslim individuals and societies. In the 1980s and 1990s, cassette sermon preachers called upon performers to repent and retire from their professional activities, and the Egyptian national press sensationalized cases of these 'conversions' and attributed them to the spread of extremism and corrupting Gulf influences on Egyptian society. Although some 'repentant' artists, such as Hoda Sultan, continued to work under conditions acceptable to their new sense of religiosity, most in fact did retire from public life.

These artists overwhelmingly attributed their retirement to their new-found piety, but an additional reason might perhaps have been the unavailability of suitable work. The Egyptian Radio-Television Union does not allow veiled female broadcasters to appear on its channels, and Egyptian films and serials shown on state television channels tend to marginalize or satirize Islamist characters.[55]

But the advent of transnational satellite television broadcasting in the Arab world has been accompanied by an explosion in private, commercial television productions with Islamic themes, and much of it, like the debate on the program *Qabl an tuhasabu*, is produced with Egyptian shaykhs, preachers *(du'ah)*, and male and (usually veiled) female announcers, intellectuals, and performers.[56] The growth of religious satellite television programming in the 2000s is providing numerous opportunities for pious female media personalities to utilize their talents, but this time appearing in Islamic-appropriate dress as hosts of talk show programs or actresses in television serials with suitably pious roles. The past few years have witnessed the return of many formally retired female performers to the screen, including Suhayr al-Babli, Sabrin, and 'Abir Sabri, or the veiling of actresses, such as Hanan Turk, who do not retire but choose to continue performing under new conditions.[57]

In the Egyptian cinema industry, a growing number of filmmakers and actresses, veiled and unveiled, refuse to portray sexually explicit scenes visually, appear in immodest clothing, or depict immoral characters. The new regime of morally disciplined representations in the 'clean cinema' trend, as Egyptian critics have dubbed it, marks a shift in the post-1967 Islamic Revival toward regarding the entertainment industry as an arena for refashioning religio-ethical norms, particularly ones surrounding the female body

and sexuality. In this newly revitalized site of social reform, as Karim Tartoussieh notes in a perceptive recent analysis of clean cinema, "the sinfulness of art—a discourse that was prevalent in the 1980s and resulted in many female actors renouncing their artistic careers and veiling—is replaced by a different discourse that is amicable to popular culture as an arena of social purity and morality" (Tartoussieh 2007, 41). This alternative discourse of "*al-fann al-hadif*" (purposeful art) stresses the responsibility of the artist to serve as a model of moral decency and to convey socially constructive messages in his or her work.

In addition, some of the most popular satellite television religious preachers in Egypt consistently promote the arts as an essential aspect of Islamic *tarbiya* (moral/educational upbringing) and civilization. They may regard many kinds of popular entertainment, including the stereotypically risqué video clips or even certain romantic songs of the great Umm Kulthum, as unsuitable popular entertainment for Muslim viewers, but they encourage artists to cultivate Islamic-appropriate cultural productions, rather than retire from their work.

One such preacher is Amr Khaled, famous for his conversational presentations in Egyptian colloquial. Khaled devoted an entire episode to the subject of culture and the arts on his recent show *Sunna' al-hayah* (Lifemakers).[58] Each week on this program, Khaled discussed a different aspect of social reform and encouraged viewers to participate in development projects to help bring about a *nahda* (revival or renaissance) in their local communities, countries, and ultimately, the Islamic *umma* (nation) as a whole. In an episode entitled "Culture, Art, Media . . . and Making Life," Khaled called upon "gifted young artists to participate with us in the project of *Sunna' al-hayah*, and in the project of progress. There will be no rise of our nation or progress without you and your contribution; your role, help and support is very important for the implementation of this progress" (Khaled 2009).[59] Khaled's official Web site contains advertisements and web links for Islamic-appropriate music and songs, and in another episode of the *Sunna' al-hayah* program, he introduced the music of a young British Muslim recording artist of Azeri origin, Sami Yusuf, to his audiences as a model of the kind of exemplary art to be undertaken by Muslim youth.

A trained musician and composer but not a native Arabic speaker, Yusuf, in his albums, blends primarily English lyrics with Arabic, Turkish, and Hindi vocals and refrains, and his compositions employ a range of Middle Eastern and Western instruments, rhythms, and melodic themes. The singer's

first album, entitled "al-Muʻallim" (The Teacher)—referring, of course, to the Prophet Muhammad—was released in 2003, and a music video of the title track was shot in Egypt using an Egyptian director (Hani Usama) and production team. It was aired for the first time on the popular music satellite television station Melody during Ramadan 2004, around the same time that Yusuf appeared on Amr Khaled's show.

The video clip "al-Muʻallim" juxtaposes English and Arabic lyrics in praise of the Prophet Muhammad with images of a chic young photographer going about his daily life; working in his studio in his large, well-appointed suburban Cairo home; behaving kindly to his veiled old mother and the people in his community; and teaching religious lessons to children amidst the splendor of Islamic Cairo's medieval architectural heritage. At the end of the clip, he drives off in an SUV to undertake a solo photography shoot in the desert, and in the darkness, he captures on film the image of a glowing, Kaʻba-like structure radiating light, probably meant to symbolize *al-nur al-muhammadi* (the Light of Muhammad).[60] Thus, the video emphasizes the special role that the artist, in this case a photographer, plays in devoting his talents to expressing the beauty of God's creation and the truth of the Prophet's message. At the same time, he leads an exemplary and pious life in his community, all the while enjoying the technological amenities and comforts of a modern, cosmopolitan lifestyle.

Sami Yusuf's own art thus blends a religious worldview with a mainstream form of entertainment, and in doing so, Yusuf communicates a personable, accessible expression of the Islamic faith that is in harmony with the modern world and incorporated into the mundane activities of daily life. Similarly, the singer's own public statements indicate that he regards his art as a means of engaging in the kind of Muslim community development encouraged by Amr Khaled. Yusuf's production company is named Awakening (another common English translation for the word *nahda*), and his official Web site describes him as "a devout Muslim who sees songs as a means of promoting the message of love, mercy, peace and tolerance and encouraging the youth to be proud of their religion and identity" (Sami Yusuf: Biography 2009).[61] The website's notes for the album "al-Muʻallim" express similar ideas about the convergence of religious piety, art, and the technological trappings of modernity:

> Awakening and Sami Yusuf were greatly motivated to produce this project from
> the outset, and this motivation stemmed from a shared deep conviction that we

have a duty to provide an Islamic alternative for the Muslim youth that is vibrant and enjoyable to listen to and is produced to the highest standards of composition, singing, harmonies, sound production and engineering, being in all these aspects a match for any albums produced by the Western music industry, and yet containing the beautiful teachings of Prophet Muhammad (pbuh). (Sami Yusuf: al-Mu'allim 2009)[62]

In this way, Sami Yusuf seems to share in Amr Khaled's philosophy regarding the special role of art in preserving cultural identity and cultivating the Muslim community's spiritual progress and well-being.

Yusuf is fast becoming one of the most popular religious singers among Muslims worldwide; he became an instant success in Egypt among a wide cross-section of audience members, Islamist-identified or otherwise, and the particular reasons for his popularity in Egypt are many. Islamic religious singing, called *inshad*, has a distinct cassette market, set of stars, and performance spaces of its own in Egypt. However, with very few exceptions, recent generations of Egyptian pop singers, before the appearance of Yusuf, rarely presented religious material. Nor did *inshad* singers make hip video clips.[63] Sami Yusuf successfully bridges this gap by deliberately avoiding the label of an *inshad* singer, preferring to speak of himself as an artist creating quality work. In addition, he chooses to present his videos to mainstream Arabic satellite music channels, rather than explicitly religious satellite channels such as Iqra', in order to reach out to the youth and remind them, through music, of the relevance of the Prophetic message to their everyday lives.

Indeed, what Egyptian audiences seemed to like about the "al-Mu'allim" music video was its merging of the representations of Islamic piety with stereotypical video clip images of a sophisticated, cosmopolitan, and modern upper-middle-class lifestyle, a theme that was repeatedly brought up in interviews with Yusuf and in critics' reviews of the song.[64] The video's carefully crafted images of Egypt and Islam met with approval not only from Islamist-affiliated critics and audiences, but also from secular nationalists, who welcomed the singer's voice, message, and lyrics for their inspirational religious qualities and artistic merit, which earned him an invitation to sing at the Cairo Opera House on the occasion of the Prophet's Birthday in April 2005.

Holding the video up as an example of *al-fann al-hadif* (art with a purpose), the Egyptian press almost universally embraced Yusuf's music as a welcome alternative to the increasingly scandalous, insipid videos broadcast on the Arab satellite television music channels. The popular, youth-oriented

Egyptian entertainment weekly *'Ayn*, for example, featured the singer on its front page a week before the start of Ramadan in 2004 with the headline, "Sami Yusuf's Operation against the 'Porno Clip' Devils." The corresponding article by Muhammad Faruq inside the newspaper described Yusuf's "al-Mu'allim" video, irrespective of its religious content, as an *'amaliya fida'iya* (heroic resistance operation) against the kind of performers and songs that usually fill the screens of Arab satellite music channels. Despite his dislike of censorship, the author wrote, "I can't deny the role of Maria, Tina, Najla, Ruby, and Jad Shwery in insulting art as a message and a means for promoting society's morals . . . so the coming days (of Ramadan) have become the prerogative of stars whose art has a purpose *(al-fann al-hadif)*, wholesome songs, and Sami Yusuf!" (Faruq 2004).[65]

Yusuf's "al-Mu'allim" video, which has been followed by several other videos from both his first album and a second one, *My Ummah* (released in fall 2005), seems to have started a trend among Egyptian pop singers, as if once it were proven that a market did indeed exist for *al-fann al-hadif*, others were inspired by (or more cynically, perhaps, decided to capitalize on) his success. More and more 'family-values' style music videos appeared on music satellite channels in 2005, as well as music videos with explicitly Islamic themes, and these are broadcast not only during the month of Ramadan or around the time of other major religious holidays, but throughout the year.[66]

In March of 2009, the first pan-Arab satellite channel devoted entirely to Islamic music videos and entertainment programs began transmission on satellites in Europe and the Middle East. Called 4Shbab (For Youth) and created by Ahmad Abu Hayba, an Egyptian producer who has worked closely with the preacher Amr Khaled, the channel advertises itself as "Islam's Own MTV," and a press release for its launch outlined its mission in the following terms:

> Mainstream pop videos are bombarded with lewd imagery that blatantly contradicts the values of most people in the Middle East. It is precisely this phenomenon that led to the launch of 4Shbab, competing for the hearts and minds of young Muslims all over the world and proving once and for all that it [Islam] can embrace the technologies of the 21st century.

This trend toward transnational Islamic cultural and entertainment production broadcast on Arabic satellite television—epitomized by the success of Sami Yusuf's "al-Mu'allim" music video in Egypt, encouraged by popular preachers such as Amr Khaled, and distributed by both 'secular' channels

such as Melody and 'religious' ones such as 4Shbab—seems to mark a new phase in the post-1967 Islamic revival. Although previous generations of Islamic intellectuals, such as Rashid Rida, Hasan al-Banna, and Muhammad Qutb theoretically approved of the Islamization of European-imported media and performing arts, the venues for such experiments were circumscribed by the Egyptian state's control of the mass media and other spaces of cultural production. Now that this control has been mitigated by the opportunities opened by satellite television and a shift toward pan-Arab, regional-based entertainment production, transnational financers, artists, producers, and religious figures are participating in the creation and circulation of Islamic cultural and entertainment productions that are not subject to the direct censorship of the Egyptian state, yet that still contain a strong sense of Egyptian, Arab, and Islamic identity.

Notably, as with state-produced cultural programming, these Islamic-appropriate mass-mediated cultural productions are evaluated by producers, preachers, and audiences on the basis of a distinction between, on the one hand, art that works in the service of reviving the nation (the Arab and Islamic *umma*) and, on the other hand, art that arrests or deters the *umma*'s development. Similarly, the above discussion of Sami Yusuf illustrates that the current discourse of *al-fann al-hadif* points to a space of convergence in contemporary Egypt between nationalist and Islamist visions of the role of art-making in building society and the responsibility of artists toward the project of social reform.[67]

It is not difficult to understand, then, why the arguments of a critic such as Dr. Elmessiri are intelligible and well-received across a broad spectrum of intellectual and political commitments, and why Egyptian audiences and critics almost universally approved of "al-Mu'allim's" neat convergence of pious religiosity, respect for parents, community and cultural heritage, and wholesale participation in a bourgeois, modern lifestyle—in short, a variation on the old cultured, civic-minded middle-class professional hero of twentieth-century nationalist popular culture texts.

The current moment of *al-fann al-hadif* thus highlights the need for further scholarly attention to the range of arguments and positions among Islamists and nationalists as well as attention to those discourses and practices that do not map easily onto either category; likewise, it asks us to rethink the ways in which Islamist and secular nationalist discourses have informed each other, not only in the current moment, but throughout the twentieth century, as responses to similar conditions and transformations in the structures of

modern life that the highly politicized discursive formation of 'nationalist versus Islamist' obscures.

Yet one could also argue that Yusuf's "al-Mu'allim" video, as well as other mainstream mass-mediated Islamist entertainment productions that fall under the rubric of *al-fann al-hadif*, have so far avoided images and narratives that might raise the kinds of contested issues that the secular nationalist and Islamic participants on *Qabl an tuhasabu* argued about. Whether set on the streets of London, Istanbul, or Cairo, Yusuf's videos depict no conflict between leading a good Muslim life and participating in the everyday social conditions articulated by the power structures of modern, secularized nation-states.

While this harmonious portrayal of co-existence between Muslim piety and a secular-liberal public sphere may perhaps account for Yusuf's widespread popularity, it remains to be seen whether Islamic satellite television channels in the Arab world will offer artistic depictions, in video clip form or otherwise, that point to the more radical questions concerning the relevance of the Islamic discursive tradition to public life and personal politico-ethical subjectivity that were posed by twentieth-century Islamic *da'wa* reformers such as Rida, al-Banna, and Qutb, and that continue to be discussed on satellite talk show programs such as *Qabl an tuhasabu*. As long as the importance of these questions persists for critics, audiences, and performers alike, contestations over mass-mediated, popular culture genres such as the music video will continue to figure prominently in the cultural and religious politics of postcolonial Egyptian society.

References

Abaza, Mona. 2006. Egyptianizing the American dream: Nasr City's shopping malls, public order, and the privatized military. In *Cairo cosmopolitan: Politics, culture, and urban space in the new globalized Middle East*, eds. D. Singerman and P. Amar, 193–220. Cairo: American University in Cairo Press.

'Abd al-Mun'im, Amira. 2005. al-Halal wa-l-haram . . . fi hiwar shaykh al-Azhar wa qurra' al-shabab. *al-Shabab*, October 1, 8.

Abdel Fattah, Wael. 2004. Hikayat 'an al-tahawwulat al-mudhisha. *Sawt al-umma*, October 11, 12.

Abdo, Geneive. 2000. *No God but God: Egypt and the triumph of Islam*. New York: Oxford University Press.

Abu-Lughod, Lila. 1993. Finding a place for Islam. *Public Culture* 5:493–513.

———. 2002. The marriage of feminism and Islamism in Egypt: Selective repudiation as a dynamic of postcolonial culture politics. In *The anthropology of globalization: a reader*, eds. J. X. Inda and R. Rosaldo, 428–52. Malden, Mass.: Blackwell Publishers.

———. 2005. *Dramas of nationhood: The politics of television in Egypt.* Chicago: University of Chicago Press.

Abu al-Naga, Nagla'. 2005. Hurub umara' al-naft wa rijal al-a'mal 'ala suq al-sinima wa-l-ghina'. *al-Fajr*, December 26, 22.

Abu-Rabi, Ibrahim M. 2004. *Contemporary Arab thought: Studies in post-1967 Arab intellectual history.* London and Sterling, Va.: Pluto Press.

Ahmad, Nadir. 2003. Jasadi la yughanni wa ada'i fi-l-fidyu klib fi hudud al-unutha. *al-Jumhuriya*, July 2, 13.

Armbrust, Walter. 1996. *Mass culture and modernism in Egypt.* Cambridge and New York: Cambridge University Press.

———. 1998. Terrorism and kabab: A Capraesque view of modern Egypt. In *Images of enchantment: Visual and performing arts of the Middle East*, ed. S. Zuhur, 283–300. Cairo: American University in Cairo Press.

———. 2005. What would Sayyid Qutb say? Some reflections on video clips. *Transnational Broadcasting Studies*, no. 13, http://www.tbsjournal.com/Archives/Spring05/armbrust.html (July 6, 2010).

Asad, Talal. 2003. *Formations of the secular: Christianity, Islam, modernity, cultural memory in the present.* Stanford, Calif.: Stanford University Press.

Asmar, Sami W., and Kathleen Hood. 2001. Modern Arab music: Portraits of enchantment from the middle generation. In *Colors of enchantment: Theater, dance, and the visual arts of the Middle East*, ed. S. Zuhur, 297–320. Cairo: American University in Cairo Press.

'Azazi, 'Ali 'Azazi. 2004. Dimuqratiyat al-burnu al-fada'i. *Sutur*, 40–43.

al-Banna, Hasan, and Charles Wendell. 1978. *Five tracts of Hasan al-Banna (1906–1949): A selection from the* Majmu'at rasa'il al-imam al-shahid Hasan al-Banna. Berkeley: University of California Press.

Baron, Beth. 2005. *Egypt as a woman: Nationalism, gender, and politics.* Berkeley: University of California Press.

Boyd, Douglas A. 1982. *Broadcasting in the Arab world: A survey of radio and television in the Middle East.* Philadelphia: Temple University Press.

Chatterjee, Partha. 1998. Secularism and tolerance. In *Secularism and its critics*, ed. R. Bhargava, 345–79. Delhi and New York: Oxford University Press.

214 Patricia Kubala

Comer, Brooke. 2005. Ruby: The making of a star. *Transnational Broadcasting Studies*, no. 14:33–37.

Cook, M. A. 2000. *Commanding right and forbidding wrong in Islamic thought*. Cambridge and New York: Cambridge University Press.

Danielson, Virginia. 1996. New nightingales of the Nile: popular music in Egypt since the 1970s. *Popular Music* 15 (3): 299–312.

———. 1997. *The voice of Egypt: Umm Kulthum, Arabic song, and Egyptian society in the twentieth century*. Chicago Studies in Ethnomusicology. Chicago: University of Chicago Press.

———. 1998. Performance, political identity, and memory: Umm Kulthum and Gamal 'Abd al-Nasir. In *Images of enchantment: Visual and performing arts of the Middle East*, ed. S. Zuhur, 109–22. Cairo: American University in Cairo Press.

De Koning, Anouk. 2006. Café latte and caesar salad: Cosmopolitan belonging in Cairo's coffee shops. In *Cairo cosmopolitan: Politics, culture, and urban space in the new globalized Middle East*, eds. D. Singerman and P. Amar, 221–33. Cairo: American University in Cairo Press.

Elmessiri, Abdel-Wahab. 2005. Ruby and the chequered heart. *Al-Ahram Weekly*, March 17–23, 22–23.

Farmer, Henry George. 1967. *A history of Arabian music to the XIIIth century*. London: Luzac.

Faruq, Muhammad. 2004. 'Amaliyyat Sami Yusuf didd najamat al-burnu klib. *'Ayn*, October 7, 14.

———. 2005. al-Mashahir yasrukhun la li-l-burnu klib. *'Ayn*, January 27, 11.

al-Faruqi, Lois Ibsen. 1985. Music, musicians, and Muslim law. *Asian Music* 17 (1): 3–36.

———. 2005. al-Mashahir yasrukhun la li-l-burnu klib. *'Ayn*, January 27, 11.

Fayiq, Ahmad. 2005. Hikayat inhiyar al-mutribin fi dawlat al-shaykh wa-l-amir. *al-Fajr*, September 3, 19.

Fi zaman al-fidyu klib: aghani al-'amaliqa . . . mata naraha 'ala shashat al-tilifiziyun? 2002. *al-Wafd*, December 11, 12.

Franken, Marjorie. 1998. Farida Fahmy and the dancer's image in Egyptian film. In *Images of enchantment: Visual and performing arts of the Middle East*, ed. S. Zuhur, 71–80. Cairo: American University in Cairo Press.

Frishkopf, Michael. 2001. *Tarab* ("enchantment") in the mystic Sufi chant of Egypt. In *Colors of enchantment: Theater, dance, music, and the visual arts of the Middle East*, ed. S. Zuhur, 233–69. Cairo: American University in Cairo Press.

Ghannam, Farha. 2006. Keeping him connected: Globalization and the production of locality in Cairo. In *Cairo cosmopolitan: Politics, culture, and urban space in the new globalized Middle East*, eds. D. Singerman and P. Amar, 251–66. Cairo: American University in Cairo Press.

Ghoussoub, Mai. 2000. Chewing gum, insatiable women, and foreign enemies: Male fears and the Arab media. In *Imagined masculinities: Male identity and culture in the modern Middle East*, eds. M. Ghassub and E. Sinclair-Webb, 227–35. London: Saqi.

Goodwin, Andrew. 1992. Dancing in the distraction factory: Music television and popular culture. Minneapolis: University of Minnesota Press.

Gordon, Joel. 2002. *Revolutionary melodrama: Popular film and civic identity in Nasser's Egypt*. Chicago studies on the Middle East. Chicago: Middle East Documentation Center.

Hani, Muhammad. 2003. al-Burnu klib wa-l-baytari klib: al-fann idha hawa. *Rose al-Youssef*, March 21, 15.

Hirschkind, Charles. 2001. Civic virtue and religious reason: An Islamic counterpublic. *Cultural Anthropology* 16:3–34.

———. 2004. Hearing modernity: Egypt, Islam, and the pious ear. In *Hearing cultures: Essays on sound, listening, and modernity*, ed. V. Erlmann. Oxford and New York: Berg.

Jakobsen, Janet R., and Ann Pellegrini. 2000. World secularisms at the millennium: Introduction. *Social Text* 18 (3): 1–27.

Kaplan, E. Ann. 1987. *Rocking around the clock: Music television, postmodernism, and consumer culture*. New York: Methuen.

Karkuti, 'Ala'. 2005. Klibat 'ala yad al-ma'dhun. *al-Dustur*, May 11, 14.

Khaled, Amr. 2009. Episode 28: Culture, art, media and making life. Sunna' al-Hayah, Amr Khaled, http://www.amrkhaled.net/articles/articles406.html (July 6, 2010).

Magid, Amani. 2004. al-Fidyu klib ghazw thaqafi mahmum. *al-Ahram*, July 4, 33.

Mahmood, Saba. 2005. *Politics of piety: The Islamic revival and the feminist subject*. Princeton, N.J.: Princeton University Press.

Maurice, Magda. 2005. Qanawat al-klibat min ighwa' al-khadimat . . . ila al-isa'a li-Sa'd Zaghlul. *al-Jumhuriya*, January 6, 27.

Mitchell, Richard P. 1969. *The Society of the Muslim Brothers,* Middle Eastern Monographs, 9. London: Oxford University Press.

Mughanniyat al-fidyu klib wara' ziyadat al-talaq. 2005. *al-Ahram al-masa'i*, April 16, 10.

Nieuwkerk, Karin van. 1995. *A trade like any other: Female singers and dancers in Egypt*. Austin: University of Texas Press.

Nur al-Din, Ayman. 2005. Amr Diab: ana fallah . . . wa mana'tu awladi min mushahadat al-fidyu klib. *al-'Idha'a wa-l-tilifiziyun*, November 5, 30.

Protests against seductive music videos erupt in Egypt. 2005, http://www.albawaba.com/en/main/180979/ (July 6, 2010).

Puig, Nicolas. 2006. Egypt's pop-music clashes and the 'world-crossing' destinies of Muhammad 'Ali Street musicians. In *Cairo cosmopolitan: Politics, culture, and urban space in the new globalized Middle East*, eds. D. Singerman and P. Amar, 513–36. Cairo: American University in Cairo Press.

al-Qaradawi, Yusuf. 2005. *Fiqh al-lahu wa-l-tarwih*. Cairo: Maktabat wahba.

Qutb, Muhammad. 1973. *Manhaj al-fann al-islami*. Cairo: Dar al-shuruq.

Radwan, Adam. 2005. "Tusaddiq . . . al-misriyun dafa'u khamsat milyarat ginay li-yashtimu al-mas'ulin . . . wa yumarisu 'adatahum al-muharrama 'ala al-fada'iyyat." *al-Dustur*, June 1, 12.

Rashed, Dena. 2004. For the love of God. *Al-Ahram Weekly*, November 4–10.

Rashid, Marwa. 2006. Shurut al-mumaththilat al-muhajjibat li-la'b butulat al-aflam wa-l-musalsalat. *Sawt al-umma*, January 9, 13.

Rida, Rashid. 1970. *Fatawa al-imam Muhammad Rashid Rida*. Ed. S. a.-D. a.-M. a. Y. Khuri. Beirut: Dar al-Kitab al-Jadid.

Ryzova, Lucie. 2005. "I am a whore but I will be a good mother": On the production and consumption of the female body in modern Egypt. *Arab Studies Journal* 12 (2): 80–122.

Saad, Reem. 1998. Shame, reputation and Egypt's lovers: A controversy over the nation's image. *Visual Anthropology Quarterly* 10 (2/4): 401–12.

Sadek, Said. 2006. Cairo as global/regional cultural capital? In *Cairo cosmopolitan: Politics, culture, and urban space in the new globalized Middle East*, eds. D. Singerman and P. Amar, 153–90. Cairo: American University in Cairo Press.

Sakr, Naomi. 2001. *Satellite realms: Transnational television, globalization and the Middle East*. London: I.B. Tauris.

———. 2007. *Arab television today*. London and New York: I.B. Tauris.

Sami Yusuf: al-Mu'allim. 2009, http://www.samiyusuf.com/albums/album01_almuallim.htm (April 10, 2009).

Sami Yusuf: Biography. 2009, http://www.awakening.org/samiyusuf/biography/index.htm (April 10, 2009).

Sawa, George Dimitri. 1985. The status and roles of the secular musicians in the *Kitab al-aghani* (Book of Songs) of Abu al-Faraj al-Isfahani (356 AH/967 AD). *Asian Music* 17 (1): 69–82.

Schimmel, Annemarie. 1975. *Mystical dimensions of Islam.* Chapel Hill: University of North Carolina Press.

Shafik, V. 2001. Prostitute for a good reason: Stars and morality in Egypt. *Women's Studies International Forum* 24 (6): 711–25.

al-Sharif, Sami. 2004. *al-Fada'iyyat al-'arabiya: ru'ya naqdiya.* Cairo: Dar al-Nahda al-'Arabiya.

Shehadi, Fadlou. 1995. *Philosophies of music in medieval Islam.* Brill's Studies in Intellectual History, 67. Leiden and New York: E.J. Brill.

Shiloah, Amnon. 1995. *Music in the world of Islam: A socio-cultural study.* Detroit: Wayne State University Press.

Starrett, Gregory. 1998. *Putting Islam to work: Education, politics, and religious transformation in Egypt.* Berkeley: University of California Press.

Swedenburg, Ted. 2000. Sa'ida Sultan/Dana International: Transgender pop and the polysemiotics of sex, nation, and ethnicity on the Israeli-Egyptian Border. In *Mass mediations: New approaches to popular culture in the Middle East and beyond,* ed. W. Armbrust, 88–119. Berkeley: University of California Press.

Tartoussieh, Karim. 2007. Pious stardom: Cinema and the Islamic revival in Egypt. *Arab Studies Journal* 15 (1): 30–43.

Veer, Peter van der. 2001. *Imperial encounters: Religion and modernity in India and Britain.* Princeton, N.J.: Princeton University Press.

Wheeler, Brannon M. 2002. *Prophets in the Quran: An introduction to the Quran and Muslim exegesis.* Comparative Islamic Studies. London; New York: Continuum.

Winegar, Jessica. 2008. Purposeful art between television preachers and the state. *ISIM Review* 22:28–29.

Wise, Lindsay. 2004. Amr Khaled: Broadcasting the *nahda. Transnational Broadcasting Studies,* no. 13, http://www.tbsjournal.com/Archives/Fall04/wise-amrkhaled.html.

Zuhur, Sherifa. 1998. Victims or actors? Centering women in Egyptian commercial film. In *Images of enchantment: Visual and performing arts of the Middle East,* ed. S. Zuhur, 211–28. Cairo: American University in Cairo Press.

Notes

1 Underneath the headline are pictures of "the greats" the article has in mind: Egyptian singers Umm Kulthum, Mohamed Abdel Wahhab, and Abdel Halim Hafez, all of whom will be discussed below.

2 Saad Zaghloul was an Egyptian nationalist hero from the early twentieth century.

3 Throughout the chapter, I refer to music videos using both the common English-language term as well as the Arabic one, 'video clip.' Further, as it is not uncommon for Egyptian and Arab commentators to refer to particularly racy music videos by the term '*burnu klib*' (porno clip), I also use this latter term when describing criticisms of such music videos.

4 For further discussion of the pan-Arab transnational satellite industry and the place of music video channels within it, refer to Sakr (2001, 2007), al-Sharif (2004), and Sadek (2006).

5 [Armbrust's article is reproduced in the present volume. –Ed.]

6 Occasionally, as with Lebanese singer Nancy Ajram's recent series of commercials for Coca-Cola, a commercial sponsor will fund in full or in part the production of a music video. An ad featuring part of the new music video will appear, then the entire video will be aired a few weeks later. Some advertisers prefer product placement, an advertising technique used in videos such as Ragheb Alama's "al-Hubb al-kabir" (The Great Love), whereby a product, in this instance the first-class services of Malaysia Airlines, will conspicuously appear in the video, and the sponsor will be listed in the video's credits. This trend entrenches the already common perception that video clips are not art, but merely advertisements.

7 [See www.rotana.net, www.melodyhits.tv, and www.mazzika.tv. Rotana (founded in 1987, and fully owned by the Saudi billionaire Prince Alwaleed bin Talal since 2003) includes four music channels, as well as the region's largest record label. Melody Music (owned by Egyptian billionaire Naguib Sawiris) broadcasts two channels as well as producing albums, while the Mazzika channel is linked to the historic Egyptian music production company Alam El Phan, founded by Mohsen Gaber in 1976. –Ed.]

8 This trend is reflected in the recent purchase of the popular music video channel Melody by Naguib Sawiris, the Egyptian owner of Orascom Telecom, which operates one of Egypt's three mobile phone service providers, Mobinil. The original owner of Melody, Gamal Marwan, retains administrative control of the channel (Abu al-Naga 2005).

9 SMS stands for text-only 'short message service,' and MMS stands for 'multimedia message service' that enables the sending of pictures and other graphics as well as text.

10 See also Abu-Lughod (2002) for an extended discussion of the occlusions entailed in the rhetorical claims to authentic cultural heritage made by different groups of social and political actors in contemporary Egypt.

11 See further discussions of these virgin/whore tropes in Franken (1998), Shafik (2001), and Ryzova (2005). The social status of female dancers and entertainers in contemporary Egypt is complex, and public opinion of these women has varied considerably over time. A number of factors influence people's opinions, including the venue, the patrons, and reasons for which they dance. In general, the dance is considered by middle-class nationalists to be part of the Egyptian cultural heritage, but its proper place for respectable public viewing is in a film, at a wedding, and, if tastefully done, during an entertainment show at a five-star hotel. Dancing at a nightclub is associated with the twin vices of alcohol and prostitution. The most comprehensive analysis of female dancers and entertainers in Egypt is Karin van Nieuwkerk's *A Trade Like Any Other* (Nieuwkerk 1995). I will further discuss the status of performers in Egypt in the next section, on Islamist critiques of the video clip and Egyptian pop culture in general.

12 For further analysis of the legacy of the nationalist cultural policy of the Abdel Nasser period and the music industry, see Danielson (1996, 1997, 1998); for television serials, see Abu-Lughod (2005); for film, see Gordon (2002).

13 See Abu-Lughod (2005, 231–33) for a discussion of television artists' perceptions of themselves as engaged citizens. For a discussion of the role that Umm Kulthum played in adding legitimacy to Abdel Nasser's regime, see Danielson (1998). For treatments of Abdel Halim Hafez's association with the 1952 Revolution and Egyptian nationalism during the Abdel Nasser era, see Gordon (2002, 117–29) and Asmar and Hood (2001, 301–303).

14 See Danielson (1996) for further discussion of this nostalgia and the negotiations of post-Golden Age generations of Egyptian musicians to achieve both critical and audience acclaim. For treatments of the nationalist legacies of these singers, including analysis of how they have changed over time, see, for Abdel Wahhab, Armbrust (1996); for Umm Kulthum, Danielson (1997, 1998); and for Abdel Halim Hafez, Gordon (2002) and Asmar and Hood (2001). Significantly, all of these figures were also the subject of moral and aesthetic criticisms at different points in their careers.

15 Umm Kulthum, for example, toured the Arab world after Egypt's defeat in the 1967 war with Israel and donated the proceeds of these concerts to the Egyptian government (Danielson 1997, 184–86).

16 The *infitah*, or opening, refers to the reversal of Abdel Nasser's socialist economic policies and the shift toward the economic liberalization and structural

adjustment policies that began under Sadat and that have continued and intensi-fied under President Hosni Mubarak.

17 Refer to Abu-Rabi (2004, chapter 6) for further analysis of the relationship between economic conditions in the 1970s and 1980s and the rise of Islamism in Egypt. See also Abdo (2000, chapter 4) for a discussion of the role of migration to the Gulf in exposing Egyptians to different notions of Islam's place in public life and the participation of economically disenfranchised Egyptian middle-class professionals in the Islamic Revival. For an excellent ethnographic analysis of Egyptian emigration to the Gulf that examines social mobility, consumption practices, and the production of locality, see Ghannam (2006).

18 See Hirschkind (2001) for a discussion of the cassette sermons of oppositional Islamic preachers and their audiences in *infitah*-era and contemporary Cairo.

19 [See chapters by Abdel-Latif and Grippo in the present volume. –Ed.]

20 See also Puig (2006) for his treatment of the cultural establishment's criticisms of *sha'bi* music.

21 For film, see Zuhur (1998) and Armbrust (1996, 1998). For television serials, see Abu-Lughod (1993, 2005) and Armbrust (1996).

22 This official 'normalization,' of course, began with Sadat's signing of the Camp David Accords in 1978.

23 For excellent discussions of the perceived class conflict between the cultural vanguard of the 1950s and 1960s and the *infitah* nouveaux riches, see the analy-sis of the television serial *The White Flag* in Abu-Lughod (1993) and Armbrust (1996, chapter 2). See also Shafik (2001) and Abu-Lughod (2005) for discus-sions of the *infitah* villain as Islamic fundamentalist, a subject the chapter will explore further in the next section.

24 As with many contemporary cinematic productions in Egypt that attempt to treat social issues in serious dramatic form, the production of these three films involved non-Egyptian artists and financers.

25 McDonald's is patronized primarily by upper-middle- and upper-class people in Cairo.

26 For a gender analysis of one such inflammatory episode, a series of articles that appeared in the Egyptian press in the mid-1990s about an Israeli-made chewing gum that supposedly caused impotence in men and uncontrollable sexual excite-ment in women, see Ghoussoub (2000).

27 See De Koning (2006) and Abaza (2006) for further discussion of these new public leisure sites.

28 Some cafés in Egypt have an agreement with one of the major music televi-sion satellite channels, such as Melody or Mazzika, to broadcast only its

programming; in return, the channel broadcasts the name and location of the café during advertisement breaks. Other cafés base their television settings on the perceived preferences of their clientele, who may or may not, of course, be paying much attention to what is flashing across the television screen.

29 An exemplary critique of this kind is Muhammad Hani's "'The 'Porno Clip' and 'The Veterinary Clip': Art When It Has Sunk Low" (Hani 2003). The author says that it is no wonder that Lebanese video clip stars like Nancy Ajram and Haifa Wehbe (examples of 'the porno clip' genre) have achieved such popularity when Egyptian musical life is dominated by the likes of *sha'bi* sensation Shaaban Abdel Rahim, whose songs reference aspects of lower-class life, including animals, thus earning him the label of a singer of the 'veterinary clip.' The author contrasts the 'low' nature of contemporary popular culture, with its twin features of animality and sexuality, with "great" moments from the Golden Age of Egyptian film, including Mohamed Abdel Wahhab's appearance in the classic 1949 film *Ghazal al-banat* (The Flirtation of Girls).

30 First published on April 8, 2004 in the Arabic daily under the title "The Video Clip, the Body, and Globalization," the essay was translated and published in the English weekly *Al-Ahram Weekly* soon after (March 17–23, 2005, Issue no. 734), from which all quotes here are taken. The full text of this piece may be read at http://weekly.ahram.org.eg/2005/734/feature.htm. The piece was very well received; several Egyptian friends who knew about my project told me I must read it carefully, and the well-known talk show host Nagwa Ibrahim claimed that it inspired her to shoot an episode of her program *Life* about the socio-cultural implications of the video clip in May 2005. [The author kindly agreed to allow his essay to be reproduced in the present volume. –Ed.]

31 When Oriental dance is performed live in Egypt, or in dance sequences in Egyptian films, performers usually remain upright except for an occasional backbend or bow, and they almost never engage in moves that would require them to be on their knees, stomach, or back, or touch the floor with any part of their body other than their feet. In the video clip, however, female singers and dancing models sometimes are pictured in reclining 'horizontal' positions, where they perform the same movements that one would find in a performance of 'vertical' dance.

32 Elmessiri is referring in particular here to Ruby's first music video, entitled "Inta 'arif leh" (You Know Why). Directed by Sherif Sabri and released in 2003, the song's simple love lyrics and electronic synthesizer-enhanced music are typical of the Arab pop music genre. The images, however, were received as something quite new and scandalous. The video alternates shots of the star wearing a

series of revealing belly-dancing costumes while walking through the streets of a crowded European capital, dancing in a park and a public square, reclining on a couch, and lying on her back gyrating on the pavement of a street. The music video may be viewed on-line at www.melodyhits.tv.

33 In this perspective, Dr. Elmessiri differs from other Islamist critics, as will be discussed further on in the chapter.

34 The Cairo Opera House library provided me a copy of this seminar.

35 The weekly entertainment newspaper *'Ayn*, for example, enlisted the help of several young Egyptian pop stars for its campaign in 2005 to stop the broadcasting of songs by 'nude' video clip singers (Faruq 2005).

36 For example, Lebanese singer Nancy Ajram, one of the most popular video clip artists and a frequent target of critics, declared to an Egyptian newspaper: "My body does not do the singing and my performances in the video clip remain within the limits of femininity *(al-unutha)*" (Ahmad 2003, 13).

37 Such was director Sherif Sabri's explanation, for example, as to why his protégée Ruby is controversial. In an interview with an English-language journal, Sabri said that "what she's revealing is her individuality, not her sexuality." This was controversial, in his opinion, because "this culture doesn't tolerate people who are different. If you don't fit a mold, you get criticized" (Comer 2005).

38 This is not the only criticism viewers have of the negative impact of the video clip on the institution of education. Another favorite target of Egyptian critics is the Lebanese singer Maria, one of whose clips, "Tikdib 'alaya" (You're Lying to Me), depicts a schoolgirl flirting with her teacher, then taking revenge on him when she realizes that she is not the only object of his attention.

39 My description of Dr. Kurayyim's comments is based on a videotape of the seminar obtained from the Cairo Opera library archives.

40 The religious meaning of the new slogan would have been clearly understood by pious Muslims: In a series of verses on modesty and proper interactions between men and women not related through kinship or marriage, the Qur'an *(Surat al-nur*, 30–31) admonishes both male and female believers to "lower their gaze" *(yaghuddu min absarihim and yaghdudna min absarihinna)* when they come into contact with one another.

41 In his discussion of these forms of dance, Dr. al-Qaradawi invokes the Qur'anic verses *(Surat al-nur*, 30–31) cited in the previous note concerning modesty and lowering the gaze.

42 Several English-language references treat the status of music and musicians in Islamic law and medieval society (see Farmer 1967; Shiloah 1995; Shehadi 1995; Sawa 1985; al-Faruqi 1985).

43 Some eventually returned to the screen unveiled (such as Sawsan Badr), a few continued to perform veiled (Hoda Sultan), and others began careers as program hosts on satellite television channels (such as Muna 'Abd al-Ghani). New generations of satellite preachers seem to be encouraging the latter two trends, rather than retirement, a subject I will explore further in the conclusion.

44 An eighteenth-century alliance between the fundamentalist religious reformer Muhammad bin 'Abd al-Wahhab and the Sa'ud family eventually led to the foundation of the modern country of Saudi Arabia in 1932. Many Egyptian youth emigrated to Saudi Arabia in the 1970s and 1980s in search of work, then returned home influenced by the conservative form of Wahhabi Islam that they encountered there.

45 See Abu-Lughod (1993, 2005), Armbrust (1996, 1998) and Shafik (2001) for discussions of these negative depictions of Islamists associating them with *infitah* materialistic values.

46 For an example of an article expressing this line of thinking see 'Azazi (2004, 43)

47 See, for example, Fayiq (2005), who examines the slow infiltration of Gulf money into the Egyptian cassette market and its subsequent demise.

48 These episodes of *Qabl an tuhasabu*, with host Basma Wahbi, were broadcast on the Iqra' satellite channel on March 31, April 7, and April 14, 2005.

49 Journalist Wael Abdel Fattah, one of the guests who took part in the show, reports that she is a former video clip model and actress (Abdel Fattah 2004). The Egyptian press reported in 2008 that Basma Wahbi has since removed the veil and no longer works in the field of Islamic television production.

50 Abdel Fattah writes that these audience members were paid extras, a common feature of Arab satellite television talk show programs. All of the audience members were, in effect, proponents of the Islamist 'side.'

51 [Wael Abdel Fattah is a contributor to the present volume. –Ed.]

52 Shadia in fact was among the performers who retired and donned the veil in the early 1990s.

53 The shaykh does not specifically use the phrase *al-amr bi-l-ma'ruf wa-l-nahi 'an al-munkar*, but it is clear that he is drawing upon this tradition in his disagreement with those who would leave the matter of watching video clips to individual choice. As discussed earlier in the chapter, this is the legal term used to describe the duty placed upon the members of a Muslim society to attempt, either verbally or physically, the commanding of right and the forbidding of wrong in the public sphere, which historically was (and continues to be) invoked by those who object to certain kinds of music-making.

54 The shaykh says that this incident took place during a war between Musa and the Amalekites *(al-'Amaliq)*. The medieval scholar Ibn Kathir makes reference to this war in a commentary on the Qur'anic verse 5:20 (see Wheeler 2002, 210), but I was unable to locate a specific textual source for this particular story.

55 Refer to Shafik (2001), Armbrust (1998), and Abu-Lughod (1993, 2005) for further discussions of popular culture depictions of Islamists.

56 Some of this programming appears on satellite variety channels, such as Dream or Al Jazeera, and some of it on channels devoted to explicitly Islamic content, such as Iqra'. A variety of subjects and programs exists; there are, for example, numerous shows devoted to hosting different shaykhs who respond to audience requests for *fatawa* (non-binding legal opinions) on specific matters concerning everyday life transactions and ritual practices. Still other programs, such as *Qabl an tuhasabu,* follow a talk-show format and explore current issues faced by the Muslim *umma* (nation). A small but growing genre is also developing for Islamic-appropriate cultural and entertainment programming.

57 The Egyptian press is fond of writing about these conditions. See, for example Rashid (2006).

58 For further discussion of Amr Khaled, refer to Lindsay Wise's article (2004).

59 The Arabic recordings of these lectures are posted on Amr Khaled's Web site, www.amrkhaled.net, along with translations into English and several other languages.

60 I thank Professor Juan Campo for this last observation regarding the Light of Muhammad, a Sufi concept of the Prophet as a primordial light that was the first entity created by God. For discussion of this idea, refer to Schimmel (1975, 214–16, 224).

61 Sami Yusuf's official Web site is www.samiyusuf.com.

62 The acronym 'pbuh' is short for 'peace be upon him' and is said by pious Muslims after mentioning the name of the Prophet Muhammad.

63 For a discussion of *inshad* in contemporary Egypt, refer to Frishkopf (2001).

64 See, for example, Dena Rashed's *Al-Ahram Weekly* article (Rashed 2004).

65 All of the other singers mentioned by the author are favorite targets of video clip critics.

66 One observer labeled this new trend "Clips [made with the help] of the Marriage Shaykh" (Karkuti 2005).

67 For further discussion of these convergences see Winegar (2008).

10
Caliphs and Clips

Tamim Al-Barghouti

n the summer of 2004 I came to Cairo, back to the good old satellite receiver, only to feel the same misrepresentation, disempowerment, and humiliation I felt watching Fox News and MSNBC. But this is not an essay about American news channels; rather, it is about video clips on Arab entertainment channels!

It is almost impossible to find one square millimeter of contemporary Arab life where defeat has not expressed itself. By defeat I mean the sum of native-colonial interaction over the last two centuries. Music was traditionally seen as a domain more immune to colonial redefinition and appropriation than other domains of native culture. In one of his essays, Bernard Lewis wrote, with a grin, that European costumes, architecture, bureaucracy, and cuisine were adopted by the conquered societies of the Middle East, but not European music. Lord Cromer of Egypt frowned at the Egyptian's fascination with Oriental music, which to him sounded monotonous and altogether meaningless.

Of course, Cromer never spoke Arabic. If he had, he would have understood that the repetitive melodies in classical Arabic and Turkish music were designed as carriers of poetry. The listener's attention is supposed to be drawn to the poetry, and he will reach ecstasy when the poem, not the melody, reaches its peak. Throughout its fifteen centuries of history, Arabic music

225

never existed without poetry. *Taqasim*, improvisations, most commonly on instruments like *qanun* (zither) and *'ud* (fretless lute), were preludes to singing a poem or part of a poem.

I have discussed, in more than one article, how poetry formed the Arab collective in imagination.[1] Through poetry, the tribe would express itself, in a collective memory of times, places, and events; the poem became the embodiment of the "imagined community," to use Benedict Anderson's expression (Anderson, 1991). The compilation of metaphoric and highly poetic religious texts and secular poetry thus became the container of Arab identity, the system of symbols corresponding to the national flag, anthem, map, and history textbooks of contemporary states.

The word *umma*, usually translated as 'nation,' and the word *qasida* (poem), stem, respectively, from the synonymous Arabic roots *a-m-m* and *q-s-d*, implying meanings of 'seeking' or 'aiming.' Both are idealized representations whose creators, as well as audience, aspire to become. Singers, as conductors of poetry, were thus makers of identity, treated with the same respect and dignity as poets. Some of the medieval Arab princes and even some of the caliphs were singers: Prince Ibrahim (779–839), son of the Caliph al-Mahdi (r. 775–785), and brother of the famous Caliph Harun Al-Rashid (r. 786–809), was one of the finest singers of his time. According to some accounts, as the civil war between his two nephews, Amin and Ma'mun, was approaching its end, after Amin was defeated and before Ma'mun entered Baghdad, people came to Ibrahim and decided to make him a caliph. While Amin and Ma'mun paid enormous sums of money to form their armies, the people of Baghdad, the story goes, elected Ibrahim on one condition . . . that he should sing to them!

But this is not an essay on pre-colonial Arabic music; rather, it is about video clips on Arab entertainment satellite channels! Most critics of Arab satellite channels focus on the impropriety and vulgarity of so-called singers and dancers from a religious or a strictly moral point of view. I will not make that point here. Rather, I think there is a socio-political point to make.

Video clips are full of half-naked, well-sculpted women, and rich, handsome young men in convertibles, chasing and flirting with one another against backgrounds of European green, or extravagant mansions. Poor streets and simple clothes appear as relics, folklore, or exotic eye-catchers; the music, the choreography, and the lyrics are as foreign to such backgrounds as a Victorian Orientalist is to a mosque.

Of course, the vast majority of Arab women do not look like those women on TV, nor do they dress, walk, talk, live, and die like them. Nor do the vast majority of Arab men own those kinds of cars and mansions; the green background is something Arabs hear about rather than live in. The culture produced by television is that of the young Arab elite, a depoliticized, disengaged elite that seems to be coming from outer space.

It could be argued, however, that elites can still produce good art. This is true, but not in the case of the Arab elite, which has been suffering from schizophrenia for the last 150 years. A love-hate relationship with the west, the typical relationship between colonized elites and their colonial masters, expresses itself in every form of art they produce. Unlike many critics of Arab video clips, I won't argue that they are a blind imitation of Western music videos, especially American video clips on MTV. Rather, I think that they are quite genuine. These clips honestly describe the mental and emotional condition of their producers, but that exactly is the problem: their producers belong to the non-genuine, psychologically damaged Arab elite.

Video clip images focus on the use of the female body for marketing purposes, while lyrics focus almost solely on the subject of man-woman relations. Everything about the video clips has sexual suggestions, which is perhaps acceptable in a Western society where the relations between men and women are significantly more liberal than is the case among even the most Europeanized of Arab elites. The very same channels and companies that produce and broadcast such clips also sponsor hours of religious programming, teaching about abstinence, the veil, and good Islamic behavior. The very same company, owned and managed by members of the elite, feeds two contradictory movements in society: an obsession with sex, and an outright condemnation of it.

This situation corresponds to the wider, and paradoxical, love-hate relation between those elites and their colonial creators; an obsession with a Western pattern of life and an outright condemnation of it. Commercially, however it only makes sense to feed both orientations, for they feed on one another; the more sex becomes a taboo, the more it becomes an obsession, and vice versa. The producers are sure to make profits if they sell semi-pornographic material that passes as a song or a tape for a preacher who condemns it. Moreover, they know that the very same individual can buy both tapes. This crowd of obsessions, moral, commercial, and biological, leaves little space for the only obsession an artist should have: the aesthetic one. The quality of the music, the lyrics, the voice, and the clips is therefore secondary to the minds of those

who sell and those who buy. As the market keeps this business growing, a culture of utter vulgarity and ugliness, coupled with self-despising and guilt, is perpetuated among the elite.

On the other hand, the social effect on the non-elites, the majority of the Arab audience, is much more painful and dangerous. While the elites may have the choice to practice what a video clip suggests—that is, driving a Ferrari and having relations with seductive belly dancers from Russia, while openly condemning all of that—the poor majority is prevented from doing either. They cannot, economically, afford either Ferraris or blonde girlfriends, and politically, if they condemn the Ferraris and the blondes anywhere outside their homes, they run the risk of being arrested as Islamic extremists, fanatics, and terrorists.

The average Arab young woman living in the crammed districts of Cairo or Marrakech would watch the young man with a convertible Porsche and a gothic mansion with great admiration; she would identify with the model he is courting, though she knows that the model is everything she is not and vice versa. Similarly, the Syrian or Sudanese man, sitting in a coffee shop, too poor to get married, a man who was perhaps unable to hold a woman's hand in the street until the age of forty, would identify with the guy singing in the middle of a dozen half-naked belly dancers, though he knows he will never be able to be like him. And the man will not be able to be like him precisely because the handsome singer represents a socio-political system that oppresses and deprives his amazed spectator.

Here the reader should be reminded of the meaning of the words *qasida* (poem) and *umma* (nation), the image expressed in poetry and sought after by the audience. Similar to medieval songs, today's Arabic entertainment channels express an image sought after by the collective. However, unlike the medieval songs, this image contains an inherent contradiction that makes it a social burden, rather than an asset: it is a skewed, ugly mirror casting a spell on those who gaze at it, condemning them to spend their lives looking until they die of hunger, thirst, or lack of movement.

In essence the elite's culture, produced by our media, attempts to perform the same colonial function as that of the cowboy comics given to Caribbean children, about which Frantz Fanon wrote his thesis *Black Skin, White Masks* (2008). In glorifying the white cowboys, the comics cause the black Caribbean children to identify with a hero they can never become. Moreover, they are identifying with their colonial master, with their enslaver, with the cowboy who stands at the root of their historical crisis. While the masses

try hopelessly to imitate the elite and become it, despite the socio-economic barriers precluding that dream, the elite is hopelessly trying to imitate the American model and become it.

It is the essence of the colonial scheme to make the African want to become white while at the same time preventing him from being so. The French wanted the Algerians to embrace French culture, but not enjoy French rights. The Americans would be happy to see Iraqis queuing at the doors of McDonalds and dancing to American music, but they feel alarmed when the Iraqis demand self-determination and the immediate end of occupation.

While current Arab television culture makes men and women desire fancy cars and mansions, it attempts to depoliticize their minds, and prevents them from asking questions about their misery and impotence. A teenager watching an entertainment channel instead of a news channel will not make a connection between the Iraqi death shown on the news channel and the Arab version of the American MTV culture produced by the entertainment channel. While America mentally and emotionally occupies the Arab elites, those elites are colonizing their own peoples and using all the resources at hand to occupy them mentally, emotionally, and even physically.

But, like everything colonial, such policy is backfiring. While these video clips succeed, to various extents, in creating a completely depoliticized elite, they aggravate the political polarization among those who are already politicized, who are not few in the Arab world. Besides the fact that the masculinity of men, and the femininity of women, are not expressed, due to socio-economic constraints in the Arab world, especially among the middle class, (standing next in line behind the elite and with an attempt to overthrow it), the attack on Islam and culture, stemming from forces that start in Washington and end in the Arab governments and their TV channels, make the majority of people even more sensitive toward sensual expression. The fact that America and Europe are hated in the Arab world for political reasons results in condemning their culture as well. Dancers and singers of the video clips are seen as if in league with a colonial cultural invasion.

It is here where things get even nastier. Not only are female video clip singers like Ruby seen as immoral opportunists making money by showing poor Arabs that which they cannot obtain, they are also seen, to various degrees, as traitors, anti-Islamic agents of an invading culture. In the most extreme cases Islamic groups may declare such women to be infidels and treat them as enemies; in less extreme cases people buy the women's clips, gaze lustfully at their bodies, but nevertheless condemn them just as easily and cruelly.

Attacks on cabarets, night clubs, and even music cassette stores were part of the second *intifada* in Gaza. If one looks at the history of popular rebellions against occupation one will find this to be a pattern: from Napoleon's invasion of Egypt in 1798 (the first colonial attack on the Arabs in the modern era) up until the second *intifada*! Now why, if not for the reasons mentioned above, would the men and women considered to be heroes of the resistance be so violent against their own artists for the last two hundred years?

It is true that the men and women watching TV in Arab slums seldom make a conscious causal connection between their own poverty and the singers' extravagance. This connection is usually covered in a gown of moral and religious condemnation. While such condemnation, as mentioned above, takes a docile, self-excusing tone among the elites, among the middle class and the majority of the poor population it is fueled by a real interest in overthrowing the system. The man in the slum won't talk about dependency theory, but he will definitely make the link between the half-naked singer, the president, the White House, Israel, the United States, and Mr. Bush's crusade, all of which bring him poverty, death, and humiliation; to him, they are all against Islam. And, to the man in the slum, or to his middle class cell-leader sitting in a cheap street side café in Cairo, Islam is but a collection of broken medieval images, bits and pieces of the grand poem made of texts and stories. This image presents its own problems and contradictions as well, but in contrast to the image produced in video clips, it has a huge potential to mobilize and to produce violence. The rare reconciliation between musical instrument and the Caliph's turban seems to have vanished. With the bombs in Baghdad, whether American bombs, delivered by the half-naked, belly dancing, Iraqi government, and falling from above, or Iraqi bombs, coming from the slums, full of all kinds of turbans, and exploding from below, the sounds of Ibrahim al-Mahdi are utterly inaudible.

References

Anderson, Benedict R. O'G. 1991. *Imagined communities: Reflections on the origin and spread of nationalism*. London: Verso.

Fanon, Frantz. 2008. *Black Skin, White Masks*. New York : Grove Press.

Notes

1 [*The Umma and the Dawla: The Nation State and the Arab Middle East,* by Tamim Al-Barghouti (London: Pluto Press, 2008) –Ed.]

11

What Would Sayyid Qutb Say?
Some Reflections on Video Clips

Walter Armbrust

I n quantitative terms one could say that video clips dominate Arab satellite television. At any given time as many as a fifth of the free-to-air channels on Nilesat may be broadcasting video clips. Other programming categories that preoccupy observers of Arab satellite television—specifically news, religion, and dramatic serials—are broadcast by fewer specialized channels, and probably receive a smaller proportion of airtime on variety channels.[1]

But the ubiquity of video clips may overstate their popularity. Video clips are free content in an economically troubled business, paid for substantially not by the networks that broadcast them, but by mobile phone service providers and music producers. Mobile phone service companies underwrite the production of video clips because the text messages flowing constantly on the margins of the screen during songs advertise their business, and because they can sell ring tones. The same goes for music producers—video clips advertise cassettes and CDs, and they create stars who can command high fees for live performance. Because video clips are quasi-advertising for a limited set of businesses rather than a simple response to demand, their conspicuous presence among the free-to-air satellite channels is an unreliable gauge of how many people watch them.

While the size of the audience is in question, it cannot be denied that they are a significant component of satellite broadcasting in the Arab world.

The music at least must be popular. If it were not, the mobile phone service providers and music producers would surely not go on producing video clips. This type of music is both commodity and culture, and must therefore be understood as both. However, the commercialism of video clips is so much a part of the art form that to look at one side of the phenomenon without acknowledging the other defies both common sense and critical sense. The intrinsic commercialism of videos inevitably invites scorn from cultural gate-keepers, who almost uniformly condemn them for lack of artistic merit.

Everything you wanted to know about sex

Other factors shape attitudes about video clips. One is that the video clip is an art form that revolves around sex. There are exceptions to this rule, and some of them are important. Nonetheless, those who condemn video clips do so on the grounds that they feature excessive display of women's bodies, in a narrative or lyric structure that they take as an invitation to break social conventions that prohibit sex outside of marriage. Worse, video clips seem to sell unsanctioned sexual behavior. That they give a whiff of salesmanship

Figure 11.1: "The future of the fine arts: dancing on the hands after the legs get tired." From *al-Fukaha*, no. 61 (January 25, 1928).

is unsurprising. Video clips are, after all, quasi-advertisements for mobile phones and recorded music. Sex and advertising go together like spaghetti and tomato sauce. Selling with sex is as predictable and common in the Arab world as it is in France.

Nor is it new. For example, a 1926 cover of the Egyptian magazine *al-Fukaha* revels in sex (Figure 11.1). It shows an ink drawing of two couples who appear to be three sheets to the wind at a party, dancing on their hands. The caption says, "The future of the fine arts: dancing on the hands after the legs get tired." One couple is modern and chic; the other is more homely, and the man is a caricatured African drawn in golliwog style. The image foreshadows some of the conventions of the video clip and other forms of audiovisual culture that were still in the future in the 1920s. One is simply selling the product through sexualized imagery. Sexy women sold the magazine, just as the sexy women in video clips now sell music and ring tones.

The appeal of sex could be made more directly, as a cigarette advertisement from a 1933 issue of the magazine *al-Sarih* shows (Figure 11.2). It sells Amun Cigarettes with a drawing of a topless dark-skinned but

Figure 11.2: Advertisement in *al-Sarih* magazine for *Amun* cigarettes. From the July 6, 1933 issue.

Figure 11.3: Hairdresser: "Cutting your hair won't tire me out even if I stand doing it for an hour. If only you had a beard." *Al-Fukaha*, no. 21 (April 20, 1927).

European-looking woman wearing an evening gown (below her exposed breasts). Breasts sold cigarettes, or so the Amun company hoped. In the case of the *al-Fukaha* image, the operative principle is literally to sell the book itself (or magazine) by its cover. The publisher encouraged just the opposite of the saying "Don't buy a book for its cover." The maxim made no sense before books were mass marketed in the print age, and the same principle applies to other new media. Music and ring tones are sold in video clips "for their cover."

Another premonition of the video clip suggested by the *al-Fukaha* cover depicting drunken dancers doing handstands is the rather ambiguous appearance of one of the women. In the foreground of the drawing we see a European-looking woman in a flapper dress (which the law of gravity dictates ought to be falling off). Or is she meant to be Egyptian? Perhaps she is. On another front cover from the same period (Figure 11.3) a lecherous hairdresser addresses a European-looking customer, again in flapper dress and with a shocking expanse of leg exposed, murmuring in her ear: "Cutting your hair won't tire me out even if I stand doing it for an hour. If only you had a beard!" But though the sexy customer dresses like a flapper, shows leg and décolleté like a European, and appears to be quite unconcerned at the hairdresser's

Figure 11.4: Frame from "Kull al-shawq," by Maysam Nahas. From the Melody channel, recorded in 2003.

improper advances, we know she is Egyptian. She is drawn on the cover of *al-Fukaha* sitting in the hairdresser's chair reading none other than *al-Fukaha*, which she could only do if she were Egyptian, or at least Arabic-speaking.

Anyone who has watched Arabic-language films or television can confirm that the same convention transfers across different forms of mass media. The salience of actresses and models who sport a carefully cultivated European look is so marked that one cannot help noticing those who do not fit the pattern. Roughly the same is true of men. Of course, roles in film or television often call for much more localized imagery—not every character in a film or *musalsal* (TV serial) can be shown dressed like a European. But almost without exception, the persona of stars elaborated through secondary media (magazines, television interviews, public appearances), as opposed to roles in films or television serials, is European. The convention of favoring European looks—in clothes, hair style, and to some extent skin color—extends seamlessly into the video clip.

Consider, for example, Maysam Nahas. Nahas is no superstar, but she does typify much of the rhetoric on video clips. She is a Lebanese singer who appeared two or three years ago as a sultry blond in a video clip titled "Kull al-shawq" (All Desire—Figure 11.4). The clip is both narrative and lyrical. The narrative part is simple: it is about a lovers' quarrel. They break up in the beginning, and get back together in the end. Visually it is about men desiring the singer. The video could easily be labeled a 'porno clip,' as Egyptian detractors of the genre sometimes call the video songs they object to most strenuously. "Kull al-shawq" even hints at some borrowing from the pornography genre (Figure 11.5). The camera certainly focuses on body parts fetishistically. At one point,

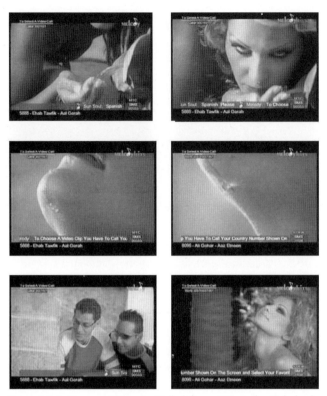

Figure 11.5. Maysam Nahas in "Kull al-shawq." From the Melody channel, recorded in 2003.

she drinks from an open faucet, bending over, camera lingering on the breasts a moment, luscious lips drinking the water. She raises her head and a drop rolls suggestively down her neck, while a group of voyeuristic men look on.

However, the salience of sexualized European looks as an ideal of female beauty occurs in every decade from *al-Fukaha* in the 1920s to Maysam Nahas in the 2000s. But while the prominence of European appearance has been a stable convention in mass-mediated visual culture, it is nonetheless one of the aspects of video clips that draws scrutiny and invites comment. Of course, the availability of visual mass media—illustrated magazines, films, television—is historically uneven. Cairenes have had access to these visual conventions since the 1920s; Yemeni tribesmen may have only encountered them in recent decades with the advent of television and labor migration to more cosmopolitan parts of the Arab world and beyond. Nonetheless those who promote the notion that such images are new and potentially disturbing

Figure 11.6: Frame from "Kull al-shawq," by Maysam Nahas. From the Melody Hits channel, recorded in 2003. Compare with cover from al-Fukaha, no. 6 (January 5, 1927). Conductor: "Why all this crowding? They're all one lot over there, and she's another lot all by herself!"

implicate the entire Arab world—urban Cairo as much as an isolated village in the Yemeni highlands. In the end it may be the idea of novelty rather than novelty itself that invites attention.

In one sequence of Maysam Nahas's "Kull al-shawq" video, she is ogled in the street by a crowd of relatively dark men (she ends the video in the arms of a blond lover) (Figure 11.6). The gist of it is identical to another *al-Fukaha* cover from the 1920s, in which men on a tram are astonished to see a woman exposing her legs. They sit on one side of the tram so that they can all get a good look at the woman, who sits alone on the other side. The conductor enters, saying, "Why all this crowding? They're all one lot over there, and she's another lot all by herself!" Plus ça change, one might say. The men on the tram and the men ogling Maysam Nahas are cut from the same cloth.

But of course things do change. The point is that it pays to bear in mind that novelty in 'new media' must be held to a high standard. Video clips may be more remarkable for their brute accessibility compared to previous 'new media,' for the ways people consume them, and for the places in which they

consume them, than for the nature of their content. And yet whether or not one likes them or respects them as an art form, the ways they create meaning must also be taken seriously if one wants to understand them.

This brings us to youth

One might expect opposition by cultural conservatives to the use of sex as a marketing tool in any society. In the Arab world, this opposition is shaped by the fact that video clips are made for youths. Though we may not have precise quantitative data on viewing habits, this we can be sure of. Everyone knows it. From the style of the music, the text messages constantly flashing across the screen, and the age of the performers, video clips scream 'youth.' As a category, youth is quintessentially modern. It exists because mass education creates a stage in life between childhood and adulthood. Without mass education, the boundary between children and adults would be marked by marriage. Since transition to sexual maturity takes place during the years of education—the defining feature of youth in a modern society—school years are a potentially uncomfortable stage in life. This is a generic feature of all societies with mass education, but it is a particularly acute problem when marriage is the only sanctioned outlet for sexual behavior, as is the case in Arab society.

There are all sorts of strategies for controlling youth. School, of course, is the main 'work' of youth and hence the primary means of structuring their lives. For the increasing number of students who do not work after school hours in family trades, agriculture, or businesses, various extracurricular activities have been devised over the years to structure the 'free time' of youth—scouting (once a significant movement in many parts of the Middle East, and much emulated organizationally by more politically minded movements) and sports, for example. But the problem of leisure remains. Arab society gives almost no social sanction to sex for unmarried youths, particularly girls and young women.

This is the reason that the insistent marketing of products through sex is the primary lens through which video clips are viewed—it rubs salt in a particularly sore spot. Consequently, the dominant attitude expressed toward video clips in public is hostility or scorn. Even the youthful patrons of video clips are often inclined to mirror the dominant hostility. Survey research on attitudes toward video clips rarely captures the ambivalence of opinions, because to state an opinion openly requires respondents to make choices about how to position themselves vis-à-vis patriarchal values. Furthermore,

depending on the respondents' class background, people almost everywhere disavow an interest in television to the degree that they want to be associated with elite taste. Consequently, surveys tend to show that youths are as sceptical about video clips as their elders, inevitably leading to the conclusion that whoever likes video clips, it is not these youths (that is, whichever ones were asked the survey questions). And yet the music industry and mobile phone companies go on churning out new video clips at a furious pace.

The oblique nature of video clip fandom came home more forcefully with my first encounter with Nancy Ajram, who is one of the dominant stars in the video clip business. On the first night of Ramadan of 2003 (AH 1424), I attended an *iftar* at the home of a family in Cairo I had known for almost two decades. After the meal, the television came on, as it almost always does, and the first program my friends tuned in was a nightly televised popular music concert. The first singer presented in the program was none other than Nancy Ajram, who appeared singing on top of an open bus by a seashore. She was wearing leather trousers and a skin-tight tube shirt. Her movements, her song, and her interviews between numbers all proclaimed sex. But I had not followed Arab popular music during several years of an overworked first teaching job, and had never heard of Nancy Ajram. When I asked who she was, the twenty-two-year-old daughter of the family, who I had known since she was five, was incredulous: "You've never heard of Nancy Ajram?"

With unfeigned enthusiasm she told me the Nancy Ajram story. Nancy was Lebanese. She began singing at the age of eight. She started off singing in children's contests until she broke into the big time, and now she was the biggest star in the whole Arab world. And here she was singing on top of a bus in leather trousers and a tube top, as my *muhaggaba* (veiled) interlocutor, who lived in a lower-middle-class neighborhood dominated culturally by Islamists, told me in no uncertain terms that I was an idiot for not knowing who Nancy Ajram was. This young woman bore all the signs of social conservatism. And she is socially conservative. Despite her obvious enthusiasm for Nancy Ajram, and extensive knowledge of the singer's biography, it took nothing to get her to switch into the register of social disapproval. One moment a fan; the next moment an opponent.

Hostility to video clips is ubiquitous. As Palestinian poet Tamim Al-Barghouti put it, "Video clips are full of half-naked, lovely women, and rich, young, handsome men driving convertibles, flirting in backgrounds of European green, or extravagant mansions." For him, video clips are a form of cultural imperialism:

Instead of forming and reforming identity and imagination, and redefining
what beauty means, the video clips on Arab channels make Arab youth want
to become what they can never be, and make them want to become an image
of their colonial masters. While the masses try hopelessly to imitate the elite
and become it, despite the socio-economic barriers that would insure the
impossibility of that dream, the elite is hopelessly trying to imitate the Ameri-
can model and become it. (Al-Barghouti 2004)[2]

English professor and cultural critic Abdel-Wahab Elmessiri focuses more
directly on the capacity of video clips to undermine the foundations of patri-
archal society:

Critics of the video clip, I've noticed, tend to focus on the partial nudity
it makes available, the erotic, *like-this* suggestiveness. And I would agree
with them if not for other concerns of my own—the effect on society and
the family. . . . By focussing on carnal pleasure in a social setup that
makes marriage increasingly difficult as a practical course of action, the
video clip contributes to a libidinal voracity we could well do without.
(Elmessiri 2005)[3]

These are normative positions in the press and in most public discussions of
video clips. In this formulation, video clips are a form of Western cultural
hegemony that "make Arab youth want to become what they can never be,"
and they undermine patriarchal society through the marketing of sex, which
"makes marriage increasingly difficult as a practical course of action." One
has to search fairly hard for a contrarian position. In fact, one has to go out-
side the Arab world.

If there is an alternative to the video-clip-as-cultural-threat position, it
may be a 'video-clip-as-discourse-of-liberation' argument. If one were to
do an ethnography of the video clip, one would surely want to ask video-
clip producers if this is what they see themselves as doing. I have not done
video-clip ethnography, so I can shed no light on the matter. I do know that I
would be surprised to hear the argument made very insistently in the public
sphere outside of the video-clip industry. Al-Barghouti's and Elmessiri's
views are very common (though of course expressed in different forms and
degrees of sophistication).

But Arab video clips have been championed outside the Arab world.
Charles Paul Freund, a senior editor of *Reason* magazine,[4] argues vociferously

that "there is a revolution going on in Arab popular music," and that the political implications of this revolution are huge:

> What this low, "vulgar" genre is offering, in sum, is a glimpse of a latent Arab world that is both liberal and "modernized." Why? Because the foundation of cultural modernity is the freedom to achieve a self-fashioned and fluid identity, the freedom to imagine yourself on your own terms, and the videos offer a route to that process. By contrast, much of Arab culture remains a place of constricted, traditional, and narrowly defined identities, often subsumed in group identities that hinge on differences with, and antagonism toward, other groups. (Freund 2003)[5]

Freund's take on video clips sounds eerily like the reception that initially greeted the Al Jazeera network in the West before the September 11, 2001, terrorist attack on New York. In numerous academic conferences between the establishment of Al Jazeera in 1996 and the 9/11 attack, Al Jazeera was the Great White Hope for civil society in the Arab world. It was going to bring real debate. It would be independent. It was the thin end of a democratic wedge. Of course, then 9/11 happened, and shortly thereafter Al Jazeera was vilified in the American press when it began contradicting the American line on the invasions of Afghanistan and Iraq.

Freund's article has the same breathless quality as the early discussions in the West of Al Jazeera. The civil society promised by Al Jazeera didn't quite work out (in the estimate of the American press). But Freund says don't worry, the Arab world will be revolutionized through sex! He ends his article by contrasting the 'liberated' sex of the latest video clip hit, by a singer named Elissa, who is shown having a liaison with a man in a Paris hotel, with the puritanical outlook of Islamist thinker Sayyid Qutb, whose sojourn in the United States turned him into a fierce opponent of decadent music and dance.

> It isn't hard to imagine [Sayyid Qutb's] reaction to the sight of Elissa's substantial cleavage looming out of her bustier. . . . Yet Elissa in her hotel room . . . could hardly be [a] more apt response . . . to the Islamist moral constrictions that have been advanced, in part, as a result of Qutb's work.

Sayyid Qutb might well have been outraged at Elissa. But he might have tried to get even rather than to get mad. Believing Muslims—possibly not in the Sayyid Qutb mold, but believing nonetheless—can also pursue their vision through this genre.

What would Sayyid Qutb say?

One of the impediments to a better understanding of the significance of video clips is the tendency of observers to see only what they want to see. The most common fixations of all commentators are women and sex. It is perfectly true that some aspect of sex features in the majority of video clips. But despite frequent claims that video clips feature nothing but 'partial nudity' and 'substantial cleavage' looming out of bustiers, sex is handled differently from one video clip to another. Some are about controlling women. For example, there is a small number of honor-killing videos. Some video clips feature married couples with children. Others are narrative videos about meeting, falling in love, getting married, and having children. Despite the obsessive concern by critics with 'libidinal voracity,' there are in fact a number of different models of sexuality on offer in Arab video clips. There are even a few video clips to which even a hardliner like Sayyid Qutb might give at least qualified approval.

Figure 11.7: Ali Gohar, in "A'azz ithnayn" on the Melody Hits channel, 2003. The singer is awakened by his mother, greets his father, and goes off to work.

"A'azz ithnayn" (The Dearest Two) by Ali Gohar is a good example. It is virtually an anthem to patriarchal values. The singer, an unshaven (though not quite bearded) thirty-something, is shown being awakened by his mother (Figure 11.7). He gets up, kisses his father, and goes off to work teaching at an elementary school for girls. One sequence in the song shows a mother in *hijab* (rare on most Arab television) dropping her daughter off at school (Figure 11.8). While at play, the girl slightly skins her knee. So strong is the maternal instinct that the mother, far away preparing food in her kitchen, feels a pang of sympathetic pain from her child's minor injury. The song is essentially a lesson to teach kids a lesson in filial respect. Gohar drives the lesson home throughout the song, telling his young charges and the viewers that their parents "sold everything for their sake." In one sequence, he is shown asking a question explicitly (Figure 11.9). He holds his hand up, on the point of calling on a student who will answer his question. We see the eager students with

Figure 11.8: Mother in "A'azz ithnayn" feeling her daughter's pain from afar.

Figure 11.9: Ali Gohar in "A'azz ithnayn." First 5 frames: He asks, "who are the dearest two?" The girl knows the answer (father and mother) and writes it on the board. In the final scene of the clip Gohar is put to bed by his father.

hands raised. He calls on the little girl who skinned her knee on the slide. She writes on a whiteboard. The answer? "Baba wa Mama." The question? "Who are the dearest two?" Of course the viewer knew the answer from the beginning, since the thoroughly adult singer is shown very much in the care of his parents. His mother wakes him up. The final scene shows his father putting him to bed. Sayyid Qutb might not have exactly approved of the song, but he surely would have found it preferable to Maysam Nahas's 'porno-clip.'

The great Islamist thinker was no Sufi, but he might nonetheless have given qualified approval to Sami Yusuf's "al-Mu'allim" (The Teacher). Yusuf is a British Muslim whose family is of Azeri origin. Though not a native Arabic speaker, he has become a global star through singing *anashid* (devotional songs, sing. *nashid*).[6] *Anashid* are conventionally associated with Sufism. In much of the Arab world, particularly Egypt, Sufi musical performers occupy a kind of parallel universe, completely separate from the circuits of both

Figure 11.10: Sami Yusuf in his Egyptian suburban mansion, kissing his mother's hand. From "al-Mu'allim" on the Melody Hits channel, 2004.

officially sponsored and commercial popular music. "Al-Mu'allim" con-spicuously crossed over to the popular music universe. It was broadcast right alongside Nancy Ajram, Elissa, and Maysam Nahas. Just as Yusuf crosses into the commercial musical world, his video clip crosses into the urban space of commercial music (Figure 11.10). He is depicted living in a modernist suburban villa—a mansion really.

Cairo is increasingly surrounded by such housing. Developments carry names such as European Countryside (al-Rif al-Urubbi), Dreamland, and Beverly Hills. When conventional video clips represent urban space, they lean very heavily toward these areas, and they conspicuously abandon the urban center of Cairo that was once the seat of political and economic power. There is no Arab analogue to the American hip-hop 'keeping it real' aesthetic, which often uses gritty urban streets as a backdrop in music videos.

Figure 11.11: Yusuf goes to his Jeep, and while loading it notices a blind man crossing the street. It looks like he's headed for trouble, as he can't see the stone in his path. "Al-Mu'allim" on the Melody Hits channel, 2004.

In Egypt (where "al-Mu'allim" was filmed) almost all location shooting in video clips is done in the new suburbs. Lebanese and Arab video clips follow the same convention. Many video clips use exotic foreign locales. By contrast, nearly all 'traditional' imagery is fabricated in studios, and the 'old modern' Cairo is simply ignored, or filmed only at night and from a distance. "Al-Mu'allim" is no exception. It asserts an Islamic presence in precisely the same imagined space as many 'porno clips.'

In "al-Mu'allim," Sami Yusuf is shown kissing his mother's hand while she sits on the stairway landing in his 'Beverly Hills' modern mansion reading the Qur'an. (Figure 11.11) He then goes to his Jeep outside in the street. As he loads the Jeep, he spots a blind man crossing the street. The man is about to stumble over an unseen stone in his path, but Yusuf rushes to help him, saving him just before he trips (Figure 11.12). Another sequence shows him going to a mosque to pray (Figure 11.13). He goes to an old mosque, but is filmed

Figure 11.12: Yes! Sami Yusuf makes the save. The blind man beams in gratitude. "Al-Mu'allim" on Melody Hits channel, 2004.

very tightly against the exterior of the building, and in all-male crowds, so that the urban space around the mosque (probably the Mamluk-era Sultan Hasan mosque is used for the exterior shots) is invisible (Figure 11,14). At the mosque, he is shown teaching a group of boys how to pray—an obviously fitting image for a video clip entitled "al-Mu'allim" (The Teacher). But in this sequence he also actually follows an Arab video-clip convention. Children appear in many clips, including many of the sexual ones. Even Maysam Nahas at one point in "Kull al-shawq" is shown casting a motherly eye on some boys playing basketball (they in turn stand and stare at her in exactly the same lascivious manner as the dark adult men ogling her on the street).

"Al-Mu'allim" differs from conventional video clips in that it refrains from running text messages in the margins (bottom and sometimes top as well) throughout the song (Figure 11.15). The text messages, sent in both English and Arabic (and sometimes Arabic written in English characters), are personal

Figure 11.13: Sami Yusuf going to the Sultan Hasan mosque to pray. "Al-Mu'allim" on the Melody Hits channel, 2004.

correspondence in a very public venue. The senders of course are anonymous except to each other, and the content of the messages is often about love and relationships, real, imagined, or perhaps incipient. But that does not happen in "al-Mu'allim." Religion is kept firmly separated from profane love. It is not, however, kept separate from corporate sponsorship. Periodically throughout the video clip Coca-Cola advertisements appear, the logo on the upper left, and on the lower right a red bottle cap that metamorphoses into red female lips mouthing silently at the viewer (saying, perhaps, "Buy Coke").

"Al-Mu'allim" is a strongly narrative video clip. It tells the story of a pious nature photographer trying to capture images of God's creation (Figure 11.16). Yusuf drives his Jeep into the desert, perhaps to Wadi Digla just outside of Cairo, and quite close to some of the new bourgeois suburban developments. There he takes out his camera and photographs nature.

Nature photography is often used in the imagery of televised calls to prayer. God created the universe; hence, depictions of nature are inherently

Figure 11.14: Sami Yusuf teaching children how to pray. "Al-Mu'allim" on the Melody Hits channel, 2004.

consistent with belief. They also get programmers out of potentially thorny dilemmas of social representation—no need to choose whom or where to show; no need to worry about class; no need to worry about whether or not women need be represented.

"Al-Mu'allim" also does not delve into such difficult areas as how to show the handsome Sami Yusuf interacting with women (many of whom are alleged to be fans in a way that confuses his stardom with his message). And it must be said that "al-Mu'allim" is, in the end, a hyper-patriarchal document. Its Islamic message, however, is in some ways contrary to the social trends that have been labeled 'Islamist' over the past few decades.

In the video clip, Yusuf goes on photographing into the night (Figure 11.17). When it is completely dark, he spies a light shining at the top of a rocky cliff. After climbing the cliff, he finds himself facing a glowing image of the Ka'ba, the symbolic heart of the Muslim world. He stares in astonishment, but does not fail to take pictures (Figure 11.18). Later he is shown in his darkroom

Figure 11.15: "Al-Mu'allim," unlike almost all other video clips, does not run text messages along the margins of the screen. It does, however, receive corporate sponsorship, which appears as Coca-Cola "bottle cap lips," the only female imagery other than the singer's diegetic mother. "Al-Mu'allim" on the Melody Hits channel, 2004.

Figure 11.16: Sami Yusuf Drives his Jeep to the desert on a nature photography expedition. While in the desert he sees a vision up on a craggy outcrop.

developing the pictures. It is a crucial part of the video clip's narrative that the glowing Ka'ba be shown not as a vision or a fantasy, but as completely real. The material lens, a creation of science, picked up the image of the glowing Ka'ba just as much as the human eye. Hence al-Mu'allim neatly ties together spirituality and science, a maneuver certainly more consistent with Sufism than with the sort of Salafist tendencies associated with someone like Sayyid Qutb (or, more importantly, with the broader Islamist movement as it would have been understood not much more than a decade ago) (Figure 11.19). The final frame in "al-Mu'allim," complete with the Coca-Cola advertisement and the Melody Hits logo, summarizes the paradoxical nature of this artifact.

However, paradoxical though it may be, "al-Mu'allim" is not an anomaly. It is, rather, an instance of a niche in the video clip market. Video clips are not as simple as either their proponents or their detractors claim.

Figure 11.17: Yusuf climbs to the top of the outcrop and finds a glowing image of the Ka'ba. "Al-Mu'allim" on the Melody Hits channel, 2004.

Figure 11.18: Science and the human senses are in agreement: the image is real, not illusion. God exists. "Al-Mu'allim" on the Melody Hits channel, 2004.

Figure 11.19: The final frame of "al-Mu'allim" on the Melody Hits channel, 2004.

Conclusion

In conclusion, I would like to reiterate two points. First, video clips are far more interesting in historical context than they are as putatively unprecedented 'new media.' Even the rhetoric of dismissing them as vulgar and cheap resonates with the past hundred years of Egyptian history. It is an inevitable consequence of canons of taste, which are historically changeable, quintessentially modern, and still emerging. Video clips will not undermine the foundations of society, but they are part of longstanding tensions over the status of youth in a patriarchal culture. Nor will video clips liberate the individual and usher in a blossoming of democracy, though there is no question that they are a powerful palette for sketching out ideas about sexuality and the body. It is, however, crucial to recognize that some of these ideas have historical roots. One must be on guard against overstating the novelty of new media.

My second point is simply that one must not ever take for granted claims that 'all video clips' are anything. Basic reservations about analytical conflations apply as much here as anywhere else. Video clips are all made in a structured economic and social system, as is any form of expressive culture. The system itself is of interest, but so are the products of the system. Even if one grants that video clips are about sex—which they certainly are in a quantitative sense—there are, one must be compelled to admit, many different things that can be said about sex. Video clips are both the agents and the products of important social currents. They should therefore be taken seriously.

References

About Reason. http://reason.com/aboutreason.shtml May 9, 2005.

Armbrust, Walter. 2005. What would Sayyid Qutb say? Some reflections on video clips. *Transnational Broadcasting Studies*, no. 14, 18–29, http://www.tbsjournal.com/Archives/Spring05/armbrust.html (July 6, 2010).

Al-Barghouti, Tamim. 2004. Video clips and the masses: 2 worlds apart. *The Daily Star*, Beirut, June 10. http://web.archive.org/web/20050523024435/http://dailystar.com.lb/article.asp?edition_id=10&categ_id=4&Article_id=5043 (April 9, 2009).

Elmessiri, Abdel-Wahab. 2005. Ruby and the chequered heart. *Al-Ahram Weekly*, March 17–23, 22–23, http://weekly.ahram.org.eg/2005/734/feature.htm (July 6, 2010).

Freund, Charles Paul. 2003. Look who's rocking the casbah: The revolutionary implications of Arab music videos. *Reason*, June, http://www.reason.com/news/show/28802.html (May 9, 2005).

Kubala, Patricia. 2005. The other face of the video clip: Sami Yusuf and the call for *al-fann al-hadif*. *Transnational Broadcasting Studies*, no. 14, http://www.tbsjournal.com/Archives/Spring05/kubala.html (May 9, 2005).

Notes

1 My estimates of air time allocated to video clips and other thematic categories on free-to-air Nilesat broadcasts is impressionistic. In the year 2005 there were ten to twelve channels (new channels are added and old ones subtracted constantly) that specialize in video clips out of a free-to-air package of around 90 channels. Many other channels, such as the private Dream TV, and national channels, broadcast video clips as a part of their program. News, religion, and dramatic serials have fewer specialized channels. Their proportion of the total content of Nilesat free-to-air broadcasts is similarly difficult to pin down precisely because of the shifting content of variety channels.

2 [See also the chapter by Tamim Al-Barghouti in this volume. –Ed.]

3 [The article is also reproduced in this volume. –Ed.]

4 *Reason* is published by the Reason Foundation. It styles itself as "a refreshing alternative to right-wing and left-wing opinion magazines by making a principled case for liberty and individual choice in all areas of human activity." (About Reason)

5 All subsequent Freund quotes are from this source.

6 See Patricia Kubala (2005) [and her chapter in this volume. –Ed.]

12
Images of Women in Advertisements and Video Clips: A Case Study of Sherif Sabri

Hany Darwish

Introduction

From its outset, the third millennium promised to be the era of media *par excellence*. Satellite television, journals published by various political parties, and network technology pushed communication toward more democratic channels, creating a larger demography of those who have the right to choose.

On the other hand, this change has also exposed the attitudes of cultures in the developing world that have until recently remained hostage to their own perceptions of themselves and others, without revision for a long time. Such societies have found themselves drawn into a global system without having prepared themselves to develop their own images about themselves and others. These societies are now in the uncomfortable position of being hooked to global production and marketing while their superstructures remain culturally and epistemologically tied to a pre-globalized system.

Politically, democracy continues to be a central and essential question for these societies. However, culturally these societies are still confused as to whether to join the global system, or to protect their own cultural systems, with their admittedly positive and negative aspects. While economics and politics hurry to catch up with the global system, culture and knowledge remain subject to meandering and criticism.

Meanwhile, the controversies surrounding human rights, the absence of civil society, and the status of women remain unresolved within current discourses of identity, now being reviewed under American pressure. It is increasingly impossible to avoid discussion of these issues of national portent.

Yet initiatives undertaken by regimes that harbor, exploit, and contribute to an oppressive social and cultural atmosphere cannot help in scrutinizing these issues through 'elitist' mechanisms, especially with the manifestations of social and cultural regression that have infiltrated the lower strata of society and its dominant relations. What is required is a radical initiative that would come from the base, which is exactly what those regimes fear most. The obstacle preventing this weak structure—comprising both state regimes and their citizens—from joining the new global system is its inability to address its most urgent cultural issues. Women's issues are at the top of the list.

This chapter aims to understand the role of the media in underscoring negative concepts related to gender issues. What I am discussing here is the image of women presented in television advertising by the controversial director Sherif Sabri.[1]

Even though Sherif Sabri provides a distinctive model of adventurousness and daring, he is only reflecting the prevalent vulgarity of stereotypical attitudes toward women. At the roots of his representations stands everything that connects his advocates to his calumniators. Both camps hold up an ambivalent duality in their attitudes to the subject. Hence, the nature of the deformed prejudices of one camp will not help in discussing Sabri's work as a 'product,' because of the complicity between both sides regarding women's issues, even when they disagree about everything else. Sabri has simply and inadvertently caught the prevailing hypocrisy in one of its weakest and most critical moments.

The media image of women in Egypt is largely negative. We need only recall the din and clamor that surrounded *al-Hajj Metwalli*, a recent television serial that idealized a chauvinistic worldview in the framework of drama. In this serial women are divided once again (like their historical ancestors) into free women and kept women. This recipe came accompanied by religious sanctions, giving Muslim males the right to more than one wife. The fantastic stereotype at the heart of the drama is the woman whose only concern is to marry the affluent, handsome, god-fearing Hajj. The result is a portrayal of women as a homogeneous group, in which differences in socio-cultural background, education, or economic status are of little consequence. For all that the woman seeks is a just man. Since the just man is rare, the

women of *al-Hajj Metwalli* are quite willing to share. This model has even deeper implications in the history of film and, in our case, in the field of commercial advertising.

It was not Sherif Sabri who smacked the kiss on Tarek Nour's famous Gravena campaign in the 1980s,[2] when people were told to "blow up their old bathroom." Sabri's controversial impact on the advertising scene was also preceded by Tarek Nour's Beefy ads, released in the early 1990s, which so disturbed the Muslim Brothers members of Egypt's Peoples' Assembly![3] The disreputable heritage of representing women in advertising continues, and Sherif Sabri is only its latest manifestation.[4]

Here, I deal with Sabri as a phenomenon which, when analyzed within its cultural context, bears on the development in tastes of both producer and consumer in the wider sense. The Egyptian advertising market is an offshoot of the international one and continues to operate from within it. Still, Sabri has willfully insisted on choosing a deformed treatment of his subject matter.

Advertising as a virtual and enforcing 'reality'

Apart from direct awareness-raising campaigns—usually boring on account of their poor execution—the commercial is one of the media items most attractive to spectators. The commercial introduces the spectator to all that is new in the world of consumer goods, but also to other worlds that seep through the advertisement and for which people develop empathy.

An advertisement is a message from a producer to a consumer, through an audio-visual medium. As such, it is a message that contains several intersecting signifiers. The most obvious signifier is the value attached to consumption behavior, which is the advertisement's first target. While the advertisement usually enforces certain values, it also underscores the importance of changing others. It represents a parallel virtual 'reality' which carries implications of how life 'ought to be.'

As such it is not concerned either to present or to question reality. Rather, it seeks to reinforce reality by making it look better and by defining an aesthetics of life through the use of the advertised product. The basic marketing aim carries within its folds more important metaphorical aims, responsible for adding an artificial glitter to life through a certain commodity. The symbolic meanings hidden within the advertisement thus create, through continuous accumulation, a virtual 'other world' related to the visual image more than to real life. Hence the ideal advertisement is one which freezes reality,

beautifying it through empathy with the extant moral code of the viewer, on one hand, and through its effects upon his subconscious, on the other.

In the case of a society oriented toward a conservative moral system, advertising deepens the schism between a virtual media reality and real social life. The rectangular screen serves as a thin partition between the viewer (with his or her coherent, real-world moral system), on the one hand, and a completely different—yet desired—virtual world, on the other. The viewer's alienation increases as a result of a tampering with his or her assumed opposite position. The unsuspecting passive viewer sitting in his or her chair is under the illusion of having freely chosen what to watch, when in fact he or she is a hostage to what has been chosen for him *a priori*. These choices determine consumption patterns, moral systems, and ideal images. One of these predetermined images is women.

An audience lacking the capacity for critical thinking provides an easy target for advertisers. In such cases advertising plays a central role in unifying the experience of wide sectors of society. Advertising reflects the moral system used by the producer to market his products, and the significance of advertising images lies in their capacity to reproduce moral values in an extreme form. More than any other visual art, advertising in Egypt has always endorsed negative representations of women, as seductive, flirtatious, or oppressively masculine. All of these images depict women as nothing more than sexual objects.

Sherif Sabri and the local cloning of an international market
Sherif Sabri is an Egyptian director of commercial advertisements. His advertising career began in the late 1980s at Tarek Nour's advertising agency, Americana. Later, he left for England, where he had the opportunity to develop his techniques working with smaller agencies. He returned to Egypt in the mid-1990s with a new vision, cloned from the advertising industry in European and American media.

Sabri's return to Egypt coincided with the disintegration of the Egyptian advertising market, a period when monopolistic agencies were subdividing into smaller units, beginning their new operations within an economic environment of large capital investments (at least when judged by Egyptian standards of the time). This was also the period when services and commodities strongly connected to the global market (such as communication services) were being introduced, and when investors wanted to increase marketing efficiency.

All this naturally provided enormous resources to advertisers, who, however, had to compete on an international level due to the revolution in media and communications inaugurated by the era of satellite television. The competition resulted in a quantum leap in commercial production, both artistically and technically.

At this time Sabri came up with his first promising campaign, for Birell (a non-alcoholic beer). His vision can be summarized by enumerating the following features:

- Novelty in the use of color: pale metallic hues imprinting a different visual memory at a time when consumers were used to highly contrasting loud colors (as promoted by Tarek Nour)
- New lighting techniques: internal lighting closer to soft box unit photography, concentrating on faces and products, before dark backgrounds.
- Low camera angles, and the use of a wide lens to emphasize the center of the frame.
- A rapid succession of visual shots, superimposed on a terse audio track, shocking in its linguistic suggestiveness, that plays upon the double-entendres of colloquial metaphor, conveying the physical pleasures of consumption.
- Models featuring an Afro-Latino physiognomy, yet compatible with international standards of beauty (as globally disseminated via fashion magazines and satellite television)—unlike the predilection for European-looking models that prevailed during the 1980s and early 1990s.
- Playing with sexual insinuations—both visual and verbal.
- The use of jazz, blues, and Afro-Latino music, quite different from the Arabic musical styles that had formerly predominated in local advertising.

Sabri thus completed the model for a special product in a market seeking connections and interactions with the global market. Having cloned the foreign and injected it with an Egyptian spirit, advertisers ran to Sabri, who exploited the situation and fixed his fee at 5,000 pounds sterling per day.

It may be that what gave Sabri his advantage as a director was his reliance on the professional team who had worked with him in London, especially his director of photography, his art directors, and his stylists. The fact that he distributed the work professionally, according to his vision as director, was likewise an important factor in his success.

The most important factor in his success story, however, was the exotic image of women in his work and the sexual innuendos produced by female

models who are made to belly dance, not using the traditional soft undulations most familiar to Egyptians, but aggressively, using a more angular choreography reminiscent of Western belly dancers (as, for example, in his music video for Amr Diab's song "Amarain" (Two Moons).[5] It is almost as though Sabri is trying to remold the Orientalist image of Oriental women by producing European clones similar to the clone of a product that he is marketing.

Two advertising campaigns: Fayrouz, and Ruby's video clip

The female body is fundamental to Sabri's treatment of the commercial. This is not just because of the high statistical presence of women in each frame, but through constant and clever connections between the body of the woman and the product. Sabri exploits all that is possible, in the nuance of the spoken word or the scenic sequence, alongside parallel montaging of the product and the body of the model. It is obvious that he is out to excite sexually. Intextually, he reproduces the image of the 'hot' bimbo: a product to taste (here a soda drink called Fayrouz, featuring flavors of seasonal fruits such as mangoes and strawberries), and the female body, exposed in such a way as to be desired.

Let us note here the insinuations of the voiceover, drawn out and sultry: "Fayrouz . . . press on the drum oh the drum, the violin, Fayrouz pineapple—press on I love it, Fayrouz press on." These words here are loaded, in the popular imagination, with the meaning of coitus. This meaning is visually rendered using parallel cuts containing hot tropical colors and clothes in provocative styles, whereby the area between the bust and the shape and arrangement of the seasonal mango refer to one another directly. Add to this the tone in which the words are spoken and you get the picture.

In his second ad campaign for Fayrouz, Sabri deploys music and image without any spoken word. A model, appearing in a medium shot, turns as if she sees something which is hidden from the viewer. The movement of her lips indicates her sexual excitement, stirring the viewer's expectations. She extends her arm horizontally, then brings back a cup filled with Fayrouz, and begins to drink it with great pleasure. This ad reproduces the theme of the sexually excited woman, making the product into a subject for male sexuality, and thus reproduces the cliché that women are the source of instinct, always searching for sexual satisfaction.

The crassness of such pornographic acting is even clearer in a third campaign devised to market a bigger and thus supposedly more economic container. Sabri 'borrows' the music of a song from a Soad Hosni film, "Ya wad

ya te'il" (Cool Boy) to suggest a relation between the product and the sexual, through verbal and visual signifiers as follows: "Oh oh oh big liter . . . how economical . . . new from Fayrouz, new and I like it, oh. Oh, oh."[6]

These signifiers intertwined a visual sequence that concentrates on the fluid pouring out of the larger bottle, photographed from a low angle, creating a visually pornographic effect, loading the bottle with the properties of a phallus. Note that the word for 'phallus' in Egyptian colloquial language is close in sound to the word 'liter.' The bottle and the model's body are thus connected through image and sound in praise of the new container, which has come to hold more liquid for more glasses. The product is made to embody sexual connotations as the model speaks about the size of the liter.

Ruby: A commercial campaign for a starlet who sings

Before Ruby, Sherif Sabri had directed music video clips without seeming to ruffle many feathers. This may be because of his successful beginnings with the popular, well-loved male superstar of the recent musical era, Amr Diab, for whom he has directed several hits, including "Amarain," "Habibi walla 'ala balu" (My Beloved is Unaware of My Love), and "Tamally maak" (I'm Always with You).

In these clips, Sabri introduced new variations to serve the making of a young star, manipulating Oriental show dance ingredients using the same methods he used with another male singer, Ragheb Alama, in a song called "Tab leh" (Then Why?) in which female models appeared in the form of three genies who surround the singer in a manner reminiscent of gangsta rap songs.[7] Controversy only emerged with his video for Cheb Mami and Samira Said's duet "Yom warra yom" (Day after Day);[8] some television channels cut out certain scenes in which Said appears.

Sabri, notwithstanding, returned to surprise everyone with the Egyptian singer Ruby, whom he filmed as an Oriental belly dancer moving through the streets of Paris, in a stark reproduction of Orientalist imagery, in which the colors of her dress contrast sharply with the gray, crowded city streets, while the dancer sings a song called "Inta 'arif leh" (You Know Why), in monotone.[9] Sabri participated in the making of a porn star who compensates for lack of vocal talent with her physical presence. Things did not stop there, but continued with an innovative commercial campaign, similar to television advertisements for telephone sex. Ruby appears smiling seductively, asking the viewer to call a certain number in order to watch and hear her new song, which for the first time is not included in an album.

That campaign was met with denunciation in the media and was the sub-
ject of a heated controversy. Nevertheless, Sabri went on, presenting Ruby
in a second video clip with a song called "Leh biydari kida?" (Why Does
He Hide His Feelings Like That?).[10] The clip is devoid of dramatic effect or
narrative. All we get is Ruby showing off her near-pornographic acting and
taking on a series of postures where the camera concentrates totally on the
body of the model-singer against a backdrop featuring only her name, thus
giving the clip its advertising nature.

Four scenes recur in rotation, with minimal variation: Ruby as a belly-
dancing teenager; working out in a gym (using a reversed male metaphor)
with cuts highlighting her sexuality; in a classic pattern of winking, and
drinking out of a glass; and finally in a low-cut red dress. It is to be noted that
in all four scenes Ruby is dancing in a rural-popular style, and that the direc-
tor is obviously flirting with the pornographic folk *imaginaire*. The refrain
is repeated alongside snapshots of buttocks and breasts, producing a verbal
confusion through juxtaposition with the story of a lovesick girl who stays up
nights waiting for a lover who hides his true feelings. Sabri here effectively
kills off the imagination of the viewer by presenting him with all the known
dramatic ploys of pornography.

Conclusion

For Sabri the female body becomes, unabashedly and frankly, the ideal mar-
ketable product. In her clip, instead of advertising a product, Ruby herself
becomes the product advertised. By dialing a telephone number, one can even
watch a new clip being filmed. The customer of this 'Rubian service' can now
watch a sample beyond abstract sound and image. Sabri has imprisoned women
in the pattern of Ruby by killing the imagination of the image completely.

In the end, Sabri goes as far as he possibly can to address an imagined
male audience holding stereotypes degrading to women. As he does that he
presents us with a final statement. He marks the end of the era when the
sexual hid behind visual and verbal innuendo and insinuative metaphor. What
Sabri leaves behind is an image reducible to the idea that women are the bear-
ers of all evil, in a chauvinistic, consumer-centered society. And he is daring
enough to target the unconscious of social conservatives for the purposes of
marketing and consumption.

Notes

1 [Sherif Sabri holds a PhD in Material Engineering from King's College, London, and has taught in the University of Calgary in Canada. He was the director of one of the most effective public awareness campaigns on Egyptian television during the Year of the Egyptian Female Child. Due to the Ruby clips mentioned in this chapter the Council for Women and Children has reportedly taken him off its project. –Tr.]

2 [Gravena is an Egyptian bathroom fixtures manufacturer; see http://www.gravenaegypt.com (July 6, 2010) –Ed.]

3 [According to his Web site, Tarek Nour founded the first private Egyptian advertising agency in 1979; see http://www.tareknour.com. The Muslim Brothers (al-Ikhwan al-Muslimun) is an Islamic opposition party, officially banned by the government. The People's Assembly (Majlis al-Sha'b) constitutes one of two legislative chambers of the Egyptian government. –Ed.]

4 Tarek Nour's Gravena advertisement depicted a beautiful woman in a bathrobe, seductively kissing the air, along with the slogan "Blow up your old bathroom." His commercials for Beefy sausages featured a beautiful girl rolling a sausage (with its sexual suggestiveness) into a loaf of bread, then consuming it with erotic sensuality. The Brothers responded by presenting an interpellation to the minister of information, in which they charged the advertisement with "propagating licentiousness."

5 [Originally from Port Said (Egypt), Amr Diab (b. 1961) is regarded as one of the Arab world's most popular singers; "Amarain" (Two Moons) was released in 1999 on an album of the same name. See http://www.youtube.com/watch?v=lD9xXRm3Jpw (July 6, 2010) –Ed.]

6 [From the 1960s to the 1980s Soad Hosni (1942–2001) was one of the most renowned female stars of Egyptian cinema. The Soad Hosni song, "Ya wad ya te'il" (Cool Boy) is also mentioned by Abdel-Wahab Elmessiri in his chapter. –Ed.]

7 [See http://www.youtube.com/watch?v=DzRwy8dKusw (July 6, 2010) –Ed.]

8 [See http://www.youtube.com/watch?v=gnwWia9qmC0 (July 6, 2010) –Ed.]

9 [See http://www.youtube.com/watch?v=LsD-i7tckvk (July 6, 2010) –Ed.]

10 [See http://www.youtube.com/watch?v=e966wklzBfM&NR=1 (July 6, 2010) –Ed.]

13

Arab Video Music: Imagined Territories and the Liberation of Desire (or: Sex Lies in Video (Clip))

Walid El Khachab

The purpose of this chapter is to investigate the way music video—what I prefer to call video music—in the Arab world has become an imagined territory, where the weight of censorship on desire and its manifestations is lightened. New media bring new freedoms: this is especially the case for satellite television (and particularly its encrypted pay-TV channels), where the investment of Capital entitles the consumer to more sex and more unorthodox expressions of fantasy, gender identity, and subjectivity than allowed in other Arab audiovisual products. My preference for 'video music' over 'music video' stems from the predominance of the visual aspect in these media products.

The debate over pros and cons of censoring video music in the Arab world reveals more than the reshaping of (absence of) media control by the nation-state. It is the whole politics of discourse that is remapped. The state is no longer the ultimate authority regulating discourse in the public sphere, as Capital has become a major player in the regulatory process—a status evidenced by Capital's agency in satellite channels. State-controlled TV channels endure more restrictive content control than satellite TV networks, but with progress in the global circulation of cultural products, censored material typically has a backdoor, for example, downloaded from the Internet on computers located in the restricted territory.

I will not discuss here the situation where the privileges of the state are put into question. I will rather address the way video music—better known as 'video clips' in Arab cultures—is becoming a discourse on its own, regardless of content. Arabic video clip programs are the space of liberation of desire *per se*, where new identities, new sexualities, new discourses producing subjectivities—autoreferential discourses about one's self—are circulating.

Video clip as discourse

The importance of studying the video music phenomenon rests upon the tremendously important place video music holds in people's everyday lives, and the ways video music challenges assumptions about Arab social conservatism, particularly in the domain of female sexuality. Daily, video music is the object of recurrent references in the public space. Video clips are the subject of gossip in homes, schools, and cafés; they are featured in newspaper gossip columns and on front pages; they are even discussed in parliamentary debates. In 2005, the rear of an Arab video clip icon was at the center of a controversy sparked by a Kuwaiti parliamentarian.[1]

A comparison with the place held by MTV in our North American and European public spaces makes the case for the existence of a 'cultural divide' between societies (for example, Arab) which give audiovisual entertainment a central importance in everyday politics, endowing them with a powerful symbolic value, and those which view video music and other entertainment as an element of the spare-time play sphere of popular culture.

The moral debate surrounding video clips in Arab societies is usually about how permissive their content has become, regarding this form of entertainment as an emblem of 'cultural invasion,' that is, cultural imperialism. In fact, rather than permissive, video clips are becoming the realm where traditional models of identities are questioned, even in the products that are most respectful of conservative dress codes, *bienséance* requirements, and traditional values in general. Video clips in the Arab world— regardless of the lyrics or the type of music presented—are the imaginative territory of 'postmodern' identities. Andrew Hammond quotes an Arab scholar on that issue: "In his critique of a video by Lebanese pop star Nawal Al Zoghbi, Egyptian academic Ashraf Galal noted that there is 'the absence of Arab identity and positive values, and a clear approval of Western values, and there is no presence for the Arab environment, and there is a complete cancellation of higher meanings and values' (*al-Hayat*, April 20, 2004)" (Hammond 2005, 151).

If postmodernism is about the hybridization or contamination of modern cultural codes, and about the undermining of the nation-state structure as a vehicle of modern identity and as the central organization of modern society, then video music is indeed the realm of the Arab postmodern.

Virtual and imaginary

According to Pierre Lévy, the process of the virtualization of knowledge and information is the essence of our globalized electronic age. Lévy defines this virtualization as "undoing ties with a particular here and now, acceding to the public and especially heterogenesis" (Lévy 1995, 55). The virtual is hence a material, yet imaginary, space where the Self is deterritorialized through interaction with media while being produced by those media, including terrestrial and satellite TV, Internet, radio, cinema, and other forms.

Traveling all over Arabic-speaking societies and diasporic communities, Arab video music has no ties with a territorialized here and now. Its genesis is particularly heterogeneous, involving different nationalities some of which are non-Arab and diverse media, including music, video, and computer graphics, as well as numerous transmission stations, some based in Europe. Arab video music has indeed become a major component of a "virtual mediasphere" (Debray 1996, 3–10) or, one may say, mediascape, a world produced by media.

On the other hand, Arab video music has also contributed to the emergence of an Arab ethnoscape (Appadurai 1996), a virtual space where Arab ethnicity is produced, without leaning on geographic ties to the actual Arab world, and relying solely on cultural signs identified as part of an Arab cultural code, for example, belly dancing, the use of certain instruments such as 'ud (Arab lute), and distinctive dress, such as the men's *dishdasha* (robe).

The virtual space created by video music, on satellite channels, and on the Internet, has become a cluster of imagined (virtual) territories. The latter create a shattered experience of identity (yet one shared by many viewers) in the Arab world and its diaspora, rather than a sense of what Benedict Anderson calls "imagined communities." Anderson argues that communities view themselves as such because they imagine themselves as being united via their participation in certain practices, such as reading certain newspapers or drinking tea at five o'clock (Anderson 1983). Indeed, one may imagine Arab communities imagining themselves as such, because they allegedly watch Arabic video clips.

I argue, however, that watching video clips in Arabic does not create an imagined community. Instead, it opens an imaginary virtual territory, where consumers of Arabic video clips travel virtually, while watching, or—more

continuously—while connected to the virtual. My hypothesis is that this cultural practice does not underscore their sense of belonging to a community as much as it establishes a virtual space—imagined territory—where they collectively experience a sense of free desire.

The heterogeneity of these imagined territories is due to what Antonio Negri calls "the liberation of desire," that is, giving way to subjective manifestations of desire challenging state and moral controls (Negri 1991, 193–99). That is why it is more appropriate to speak about a multiplicity of territories of liberated desire, since desire is a multiple phenomenon. Its collective aspect could be the need for coming to terms with, let us say, sexual, religious, and political taboos, but the actualization of that collective desire most certainly takes multiple manifestations.

In the clip entitled "Awiz ti'raf?" (Would You Like to Know?) by Tina, the lyrics are about a female asking her admirer whether he would try to confess his love or not. In fact, the subtext is a question about one's first experience of sex. The central iconic trope is that of the bed, on which the female singer dances throughout the clip. This use of the trope of the bed is emblematic of the subversion by video clips of Arab cultural codes. As in globally consumed melodramas, the bed in Arab melodramas has traditionally been the scenic realm of the affirmation of a woman's sexual integrity, especially from the 1930s to the 1950s. In the golden age of Arabic melodramas, discussions about the female's body's integrity and its embodiment of purity and honor

Figure 13.1. Nawal Al Zoghbi, as pictured on the cover of her album, *Khalas sameht* (Enough, I Forgive You, 2008).

would often take place in the bedroom. It was only in the 1960s and 1970s that beds in Arab films were produced as subspaces of desire.

Video clips visually invest this same trope, as in Tina's clip, where the bed is clearly a space of desire, yet an imaginary one, since we only see the female body. The absence of the male body echoes the 1930s old-fashioned function of the bed in audiovisual popular entertainment, which is a teasing function and an allegedly morally conservative one: asserting that desire has not been fulfilled. The bed is ambiguous in Tina's clip, since the sexual connotation of her dancing and the barely veiled purpose of her question—"Would you like to know?"—lead us to imagine a sexual extra-textual conclusion of the narrative.

A similar reading of the bed's function can be made in Nawal Al Zoghbi's clip "Enek kaddabin" (Your Eyes are Lying), which seems to be an intensive reenactment of the Hollywood classic, *The Bodyguard* (1992), in which a female pop star is in love with her coach and bodyguard.[2] In this clip, the bed appears for a few seconds but summarizes the ambiguity of that trope, on the one hand as an icon of the female's refraining from having sex, and, on the other, as the imagined 'arena' of sexuality. In both cases this ambiguity is produced through the absence of the male body.

The clip entitled "'Adawiya," by Rushdie al-Sughayyar, is relocated to an Andalusian setting, where it is no longer a folkloric Egyptian ballad. Rather, it is about the kitschy combination of the local and the global. The images do not try to match the lyrics or to duplicate the musical spirit. Images are associated to any lyrics and any music, because they carry their own agency by the mere fact of being produced: they create the space where, outside of the nation's traditional political and cultural boundaries, marginalities can emerge. In this video clip, the lyrics of the love song, about an ideal beloved young woman, are constantly conflicting with the images of an Andalusian tavern, in a flamenco atmosphere. Here, a vamp woman lies on a table waving her hands to the men around her, in a clear indication of her being either a prostitute or sexually wild. Thanks to cultural importation, the table-bed becomes here a new avatar of the traditional trope of the bed. The hybridization of traditional lyrics with imported images of wild female sexuality produce a subversive effect, through kitsch.

Another more subtle example of the subversion of conservative codes is the emergence of gay sexuality in Arab video clips. "Majnun Layla" (Layla's Mad Lover) features a male singer who does not sing in Arabic, yet performs the great Arab-Islamic legend of love between Majnun and Layla, thus displacing the centrality of the Arabic language. The male singer never shares

the same frame with any of the three female characters who act in the music video. All of them are dressed in accordance with the values of heterosexual normality. But the voice, the gestures, and the look of the singer hint at his belonging to gay culture. The visual separation of sexes through framing seems here to be a metaphor of gender barriers.

The virtual liberated territories are unevenly distributed in the Arabic mediasphere. There is a difference between what a 'grounded' (terrestrial) national TV channel can broadcast, and the greater freedom—of aesthetics and taboo-breaking—enjoyed by channels deterritorialized via satellite. Traditional 'grounded' channels (for example, Egypt's Channel 1 and Channel 2) show 'safe' clips, while satellite channels show the hot stuff. What is striking is precisely the difference between the aesthetics and moral attitudes in the two cases. Traditional channels show clips with longer shots, lower budgets, more closeups (to avoid spending money on settings), and safer lyrics (no playing with suggested or explicit dirty words, more romantic scenes). The real money, and thus the real merchandising of the body, comes with satellite video clips.

Yet, the liberation of desire is mostly 'confined' to sex. Taboos of religion and politics are still shaping and defining the 'unthinkable' in Arab cultures. But video music's 'sexual revolution' also has micro-political and non-religious subversive implications. On the one hand, video music refrains from scripting icons directly related to the spheres of religion or politics. On the other hand, it gives a large space to empowered women, to marginal sexualities, and to tropes of global cultural hybridity.

Sex and politics seem to converge, though, in Nawal Al Zoghbi's clip "Yama alu" (People Have Been Talking), which features the singer dancing pseudo-tango with sexy men, while her image singing is shown throughout a city on public electronic screens. By the end of the clip, we see her in a 'guerrilla' outfit, chased by a battalion of handsome men in military uniform. It turns out that she is a simple girl, who was able to upload her clip to the public screens' electronic control system. The singer is playing on two opposite political positions—urban guerrilla and classy tango dancer—in a way that suggests that the simple girl's fifteen minutes of glory occurred when she was able to show her clip on the screens. But the sexual connotation of the image of a female running from a herd of muscled males cannot be separated from a political interpretation: the military repressing political opponents of the system. However, such video music, where "direct" politics is intermingled with sexual tropes, is rather rare in Arabic cultural production.

Traditions of the virtual

The virtual space created mainly by video music is actually anchored in an older tradition of cultural entertainment products going back to the nineteenth century, which have produced virtual and imaginary spaces in Arab societies since the importation—or violent introduction—of modernity's products, either through indigenous projects of modernization or through colonialism.

I have argued elsewhere that melodrama, especially in cinema, has been the realm where the production of an imaginary world took place in Egypt (El Khachab 2003). This world of 'imaginary reality' was completely independent from the 'real life' world. My argument was that before the modernization process, Egyptian culture—and Arab cultures generally—did not envisage the relationship between society, on the one hand, and the cultural production of figurations of that society, on the other, as a reflective one. The two realms, 'reality' and 'imaginary,' were independent of each other. They were not a reflection of one another, and yet they could interact.

I see the same relationship between the imaginary and virtual world of video clips, and the real social world. This relationship of independence and interaction is what underlies the specificity of video music within the Arab mediasphere. News, for example, is part of the real social world—an expression or account of reality—while also being part of the mediasphere. Video music, on the contrary, is an independent part of the mediasphere, inasmuch as it enjoys an autonomous reality that does not have to reflect the real social world.

The autonomy of the virtual and imaginary territories produced through popular entertainment is what paves the way to liberate these spaces. They become spaces where it is socially acceptable to act and to consume products which would elsewhere be socially unacceptable. In that sense, they have a carnival-like function.

The relationship between cinema and the video clip in Arab cultures undoubtedly goes beyond the debate about their respective lack of a mimesis theory, where the cultural product imitates or reflects a social or a natural model. It is certainly legitimate to investigate musicals and songs in films, in search of the aesthetic origins of video music, or in order to establish norms against which video clips are constructed. The relationship between cinema and video music in the Arab world is not different from that in Europe and North America (Goodwin 1992).

An additional indication of the growing cultural importance of video music in everyday life in Arab communities is the large number of films

dealing with video music that have been produced in recent years. These films usually feature the character of a singer or director involved in video clip production, and show the actual production process. In a film directed by 'Ali Idriss, *Kalam fi-l-hubb* (Love Talk) (Egypt, 2006), we see two different approaches to music combined with audiovisual image: one is a parody of a 'real video clip,' full of pretty, half-naked, dancing women, and the second is a moment of intense emotions, sober in all regards, where the two leading characters embrace each other on an isolated rock, by the seaside.

In the 'real video clip,' we actually see a caricature of video music: numerous blondes, many distorted close-ups, pans causing headache more than dazzling aesthetic effect, and silly lyrics about love. In contrast, after the shooting of such kitsch, we see the clip director, whispering gentle love words to his beloved girlfriend, then singing a classic love song from the 1940s with her as a duet, in a fixed medium shot. The film establishes an opposition between the realm of video clip—associated with fakery, sordid sex, commodification of the body, superficiality, and 'noise'—and the realm of 'real life,' of a moderate rhythm, of romantic love and poetic lyrics.

However, the cinematic reference in Arab video music is usually an intertextual one, through such processes as quotation, imitation, and parody. Nourhanne's clip entitled "Tab wana mali?" (What Could I Do?) is a parody of (and homage to) Nadia Lutfi's song in a film directed by Hassan Al Imam, *Qasr al-shawq* (The Palace of Desire), itself based on a novel by Naguib Mahfouz. As a matter of fact, the refrain in both cases, "*tab wana mali?*," gave its title to the song. The clip features Nourhanne dressed as a courtesan in the 1930s, washing her laundry in a metal receptacle *(tisht)*. A man, playing the ultimate dominating male-father (the legendary Mahfouz character Ahmad 'Abd al-Jawwad), enters and plays the drum with lust. Visually, the clip reconstitutes the film's equivalent images, where the song scene shows the hidden face of the conservative father, who acts decadently outside his household with his mistress, in a prelude to adultery. The parody in the video clip is more vulgar, because of the characters' exaggerated acting, especially in portraying sexual gestures.

In both examples, it appears that the opposition between 'real life' and 'virtual territories' is displaced. Video clip here is not opposed to real life, nor does it refer to the social realm. Instead, the realm of video clip contrasts with that of 'real cinema,' either quoting cinema or appearing as more fake than cinema by imitating it. This relationship between video music and film song emphasizes the autonomy of virtual spaces of entertainment

in Arab cultures. These spaces refer to each other rather more than they refer to 'reality.' Furthermore, new media produce newer virtual spaces. In a way, cinema is 'more virtual' than theater, while video clips are 'more virtual' than cinema.

Nationalizing the virtual body

Video music does not only effect virtualizations and deterritorializations of selves in the process of opening liberated territories of desire. The Self can also be territorialized, submitted to the moral order of law and state. In other words, the Self can be 'nationalized.'

Kadim Al Sahir (b. 1957) is one of the most popular male singers in Arab culture today. Yet he is only an extension of his 'ancestor,' Abdel Halim Hafez (1929–1977). Both singers romanticized the nation and nationalized Arab romanticism—with the difference that Abdel Halim was the voice of the rising ideology of pan-Arabism, the cultural equivalent of Nasser. Kadim, an Iraqi whose career blossomed in the aftermath of the 1991 Gulf war, witnessing the first major armed confrontation between two Arab countries (Iraq and Kuwait), is a product of the decline of the pan-Arab political utopia. Abdel Halim was the expression of a progressive and 'messianic' hope, while Kadim is the voice of nostalgia, the weeping of a wounded nation. That is why Kadim's clips seem to present what Abdel Halim would have recorded if he were still alive: safe lyrics and images, emphasizing performance of words.

Like Abdel Halim, Kadim does not confine his songs to overtly political content. A recent hit on satellite channels features him dressed as a groom in a black suit, surrounded by a dozen blondes in white bridal dresses. This image could be interpreted as the perpetuation of stereotypes about Arab machismo, as a re-actualization of the harem trope, or as a denial of the decline of the paradigm equating macho masculinity to macho nationalism.

On the other hand, female pop icons of the video clip era—Ruby, Haifa Wehbe, and Nancy Ajram—are the expression of a postmodern body wholly for sale, and not just voices concentrating the nation's pathos, expressing and materializing the transcendence of a national spirit, psyche, or trauma. There is no transcendence in Ruby; she is all in the immanence of money and body. What is immaterial in her clips is the gap between value and production, between commodity and currency, between gold and the first banknotes. She is not the embodiment of a national(-istic) divinity. She creates new divinities, by virtue of virtualizing her body through video. She is not the

voice of God speaking through prophets; rather she is the pagan priestess creating the gods, through her shaping of (their own) forms. Her gods are simply Venus, Eros, and Petro-Dollarus.

However, the female body sometime engages in the narcissist audiovisual self-indulgence of nationalism. The case of Egyptian culture celebrating Egyptianness is emblematic in that regard. Lebanese singer Nancy Ajram's clip "Ana masri" (I Am Egyptian), produced in the aftermath of the Sharm El Sheikh bombings in 2005, pays a 'patriotic' tribute to Egypt. Here, the performer's body disappears from the screen, while the central icon is that of the Egyptian flag which occupies the entire frame's background throughout the clip. This clip could be read as an act of compassion with a nation under attack, or as the means to enjoy full institutionalization in a society where nationalistic discourses are predominant.

Nationalist and patriotic clips are a restoration of nation-state relics. They take part in the establishment of the law's adjuvant—in this context, the nation. That is why they do not proceed from the liberation of desire. They shape the Self according to a preconceived transcendental model, that of patriotism, and thus leave no room for desire's free becoming. On the few occasions when a patriotic clip is produced in the Arabic mediasphere, the relics of an age of state-oriented cultural production reemerge, as a reminder that video clips' agency, toward liberating desire and opening imaginary territories free of bourgeois order, is only a virtual process.

References

Anderson, Benedict R. O' G. 1983. *Imagined communities: Reflections on the origin and spread of nationalism.* London: Verso.

Appadurai, Arjun. 1996. *Modernity at large: Cultural dimensions of globalization.* Minneapolis: University of Minnesota Press.

Debray, Régis. 1996. *Media manifestos: On the technological transmission of cultural forms.* New York and London: Verso.

Goodwin, Andrew. 1992. *Dancing in the distraction factory: Music television and popular culture.* Minneapolis: University of Minnesota Press.

Hammond, Andrew. 2005. *Pop culture Arab world!: Media, arts, and lifestyle.* Santa Barbara, Calif.: ABC-CLIO.

El Khachab, Walid. 2003. *Le mélodrame en Égypte: Déterritorialisation: Intermédialité.* Montreal: Université de Montréal.

Lévy, Pierre. 1995. *Qu'est-ce que le virtuel?* Paris: La Découverte.

Negri, Antonio. 1991. *The savage anomaly: The power of Spinoza's metaphysics and politics*. Minneapolis: University of Minnesota Press.
al-Tammimy, Iqbal. 2005. Mu'akhkhara jadida tashghal ihtimam al-shari' al-'arabi. *al-'Arabiya*, http://www.alarabiya.net/views/2005/09/23/17039. html (March 21, 2009).

Notes

1 See, for instance, Iqbal al-Tammimy on singers Ruby (Egyptian) and Nancy Ajram (Lebanese) (al-Tammimy, 2005).

2 See http://www.youtube.com/watch?v=pV6LlqxHXRM.

14

The Biographies of Starlets Today: Revolutions in Sound and Image

Wael Abdel Fattah

Sherine and Ruby

It seems that the success stories of Egypt's female artists are intriguing—to the point of confusion.

A dark girl called Sherine, who has become the most renowned of singers, was first attacked by the snob elite.[1] Sherine comes from a poor background and was catapulted to the screen amid a wave of manufactured blond beauty. She overcame the crisis of social evaluation to enter another kind of debate: that of morals. Success tempted her to enter the market of cosmetic makeovers, and she reinvented herself as Latina chic, enhancing her original sprightliness. Eyes moved maliciously, on the lookout for a scandal to attribute to her. They said that the clothes she wore in her video clips were outrageously indecent. They said she was socially uncouth. But each time her voice and performance won out against such petty malice. The spontaneity with which she adapted current fashions in dress and attitude shattered the myth of Amr Diab's phenomenal distribution figures.[2] She even pulled ahead of him in her last album. She did not succumb to social drills; rather, she talked frankly about her poverty and deprivations and her desire to enjoy the fortune she expects to make from singing. She still relies on her voice. She trains it the way professionals do, and at the same time she fine-tunes her performance skills.

Sherine may be an anomaly in the midst of stars who have come to singing through other channels: modeling, beauty contests, television, and so on. She started off as a backup singer in the chorus of modest singing groups. Then she sang behind well-known singers until she finally found a chance to perform a duet with the celebrated singer Mohamed Mohie. Then she was noticed, and instantly caught the line that was thrown to her. In fact she became all the rage. A girl rising from the lower social echelons, depending only on her talent, in the midst of those who have landed from above via the parachutes of powerful connections and support of dubious intent, was not to be scoffed at. She, an Egyptian artist, in the midst of a social atmosphere where girls are increasingly submitting to notions of the *harem*. Where rebellion against that retroactive mode, now in fashion across the Arab world, is only hoped for from the direction of Lebanon. An Egyptian woman who enters the field of the performing arts enters under the protection of a tent. She is on the lookout for a social umbrella and seeks it under the slogans of 'decent art,' as though apologizing *a priori* for being an artist. That Sherine did not do.

But Sherine opened the door for Ruby,[3] the small actress who first appeared in Youssef Chahine's film *Skoot hansawwar* (Silence, We're Rolling, 2001).[4] Ruby created her shock in the clip directed by Sherif Sabri (the most renowned commercial and video clip director in Egypt). Here she sang, danced, and wore an Egyptian belly-dancing outfit. She was completely free in movement and body language. Hence, she too became a target in the social battle for 'decency' waged by the arch-conservatives. Her case was even debated in parliament. She was attacked in a screen magazine, where she was charged with indecency. People spoke about her in a way that grouped her with prostitutes. It seems she only scandalized people on the surface, however, for one could detect a secret admiration behind all the slander, perhaps due to the fact that an Egyptian girl actually dared break a taboo, something usually reserved for the Lebanese and maybe the Russians.

A famous journalist actually took the trouble to talk about the sexual influence of Ruby's video clip. Gossip told of 'adventures' and promised the public an even stronger performance in a film by Sherif Sabri. The sick gaze is in control, and popularity rests in the capacity to abuse an imagination that is on the outlook for scandal. These are all telling signs. A society that haphazardly votes in a heroine, to survive thereafter on gossip about her, has a lot to offer by way of food for thought. But Ruby is not alone in this. Dina was crowned the queen of a scandal she hadn't created, and Zikra was the victim of greed and hysterical power mongering.

Zikra and the talent show[5]

Zikra: a singer inheriting an exceptional, powerful voice. Unskilled in stardom, she was anarchistic, bohemian (as she described herself in a radio chat show). Her natural spontaneity exposed her to violence, once she acquiesced to Ayman al-Suwaydi.[6] He was a wealthy businessman enamored of enticing female stars into his golden cage, afflicted with madness, camouflaged by his love for weaponry. Al-Suwaydi had the psyche of a spoiled child who would destroy what he couldn't possess. Before Ayman appeared in her life, Islamic fundamentalists had hunted her, snipers of heresy, for her spontaneous speech. In an interview, she had compared her suffering to that of the Prophet, causing a Saudi *faqih* to proclaim a fatwa that put her life on the line.[7] The same *faqih* has recently apologized for similar *fatwas*, in the context of whitewashing the theological aspect of Saudi authority, then seeking to improve its image, especially in America. But he did not rescind his fatwa against Zikra. Yet she outlived the fatwa. No attempts were made on her life as a consequence of that *faqih*'s sentence. Rather, she died at the hands of Ayman al-Suwaydi, victim of a murderous love.

Zikra, too, had come from a poor family. She built her financial security from professional singing, as singers had done long ago. She did not expect money from her rich husband. She waited, hoping to lead him out of his pathological love for her, to tame this spoiled, violent child. She declined his money, and resisted him by her capacity to earn her own living through her talent. He wanted her to be a slave girl, at his beck and call; she wanted freedom through hard-earned work, with the power of independence. She refused his offer for a regular, generous stipend in exchange for giving up singing, just as his first wife—the Moroccan dancer Nadia—had done, and she did not run away from confrontation, like Hanan Turk.

She played on her freedom, and her freedom appears to have been the cause of her trouble at times. She revolted against the companies that wished to monopolize her and stayed away from the parties and the flashing media lights. Her marriage was part of a psychological game, it seems. She would never have imagined that the short story would end up in full-fledged tragedy in a luxurious apartment whose windows almost touched the banks of the Nile, whose soundproofed walls absorbed the sounds of the murderous party.

Perhaps Zikra's story with Ayman al-Suwaydi was a parade of wealth and machismo in the face of femininity and fame. This is the usual appraisal, or the secret which may have moved the threads of the amazing tale, for all those who were around Zikra. But the matter ended up as a defense of

caprices: the caprice of playing with guns, the destructive traits of a business-man of the second generation following the 'open door' policy (one of those who view the right of banks to call in their loans a type of fraudulence).[8] Now his clout and self-esteem stood threatened; he was on the verge of becoming a convict or a fugitive, living a moment of fear that the prey would get away with her silence.

She was waiting for her new album to be released, with high hopes after a long absence; worried over her possible failure to join the first ranks if her album was not the success she had worked for. Singing would have made of her marriage a passing game, a capricious moment. She got cold feet from settling down with a maniac who dictated his values and views. She had also possibly changed her mind about motherhood and remained the prisoner of her commitment and his extremism.

Both television journalism and the Internet published photos of Zikra the way she was found in the drawing room where the party had been held. She looked perfectly in surrender, not a single sign of terror on her face. She had not imagined that the game of her spoiled husband would actually turn into reality and bring the curtain down on her story. The press was cruel and unsparing with its images. Still, the press could not make of Zikra a flirtatious seducer. She remained "kind hearted, generous, helpful." She was real, and now, emerging from the debris of the bloody scene, a voice that has left an unfilled space on the map of song.

Perhaps the murderer's suicide added an extra dimension to the tragedy. It exposed a society where children play with enormous wealth, after the fashion of Roman emperors, where satiety made nothing come to nothing indeed.

Dina and 'red-line' journalism[9]

Certain papers voluntarily veiled Dina during a moment when she had seemed somewhat unsure; using graphic techniques widespread in the inde-pendent press, they published pictures of her donning the *hijab*.[10] That sort of journalism is known to the rich and famous and powerful as 'yellow,' perhaps because it uses a style that plays on the political and sexual 'unsaid.' Or because it invests the space left for freedom of speech to the maximum to sell that freedom, the way smuggled goods are sold.

Graphics in this case are essential in putting together an 'imaginary' pic-ture, which is almost impossible to get in reality due to the complicated 'red lines' that are in operation today more than at any other moment in the past.[11]

There is always an upper hand that can expel anyone from the heavenly life behind the red lines, with all its protection from the exposure of trespasses. The upper hand times the expulsion itself, so that such a person becomes an 'open target,' for exposure and scandal.

Remarkably, this has become the game of the secret police. In this game they use modern technology such as discs, alongside the old tactics of leaking information, or opening secret files of major political (now business) figures, or famous artists. In other words, they attack corruption, speak of sexual bribery, and listen in on telephones. At the same time, these channels provide the scandalmongers with 'products' to sell. They provide 'evidence' found during 'investigations' to those who would use them for sale, and a whole trade ensues, in perfect secrecy and duplicity, causing society to sentence a scandal's protagonist to moral death, while his persecutor spends the night alone enjoying the scandalous behavior on video tape.

Books may have become old-fashioned in this trade after the appearance and wide distribution of modern media, such as CDs. Previously the banned material took the form of books such as *al-Rawd al-'atir fi nuzhat al-khatir* (The Perfumed Garden) or *Ruju' al-shaykh ila sibah* (The Return of the Shaykh to his Youth) or even *Awlad haratina* (Children of the Alley) by Nobel Laureate Naguib Mahfouz.[12] The new competition is to acquire complete 'evidence' of the latest scandals involving a priest or a doctor—and most recently Dina and Hossam Aboul Fotouh.

The 'red lines' move in secret tempos, controlled by the network of connections creating a sort of 'democracy' worthy of study. A democracy that survives on the leftovers of the struggle between the new tycoons and authority. It is there to protect, or rather cover up for, a sacred elite, first and foremost. News of that elite is taboo. The papers know their limits very well, while people in the street, or in coffee shops and unsurveilled gossip gatherings, consume large numbers of stories smuggled over the high political fence. Then scandals and stories worthy of *A Thousand and One Nights* seep through, about people who had been safe behind the red lines but who, as a result of 'democracy's' upper hand, have emerged to become the subject matter of these secret stories that people exchange.

This is a unique game benefiting from the idea of classified information, leaking out whatever stories it wishes, leaving the impression that the whole truth is being told. The 'secrets,' however, are concentrated in popular areas: sex and women. Most of these stories relate to sexual mores and misdemeanors: from Yusuf 'Abd al-Rahman to Randa al-Shami, to Muhammad

al-Wakil's Viagra, passing by Ragab Hilal Hemeida, and most recently Hossam Aboul Fotouh. The political meaning of corruption is buried under the moral lack of integrity for men who once lived behind the safety of the red lines.

The rationale of scandal is widespread and popular. Every important man lives behind a huge fence where he conducts a whole life totally out of view. The space between what is openly admitted and what is secret has become immense, rivaled only by the space between the standard of living enjoyed by the thin crust of the cream of society and the rest of the people. Wealth has become a veil that covers its owner from the eyes of those who wish to spy on him. He protects it using his connections and bodyguards. And because the source of wealth is dubious and legally suspect, it is considered by the masses as *haram*.[13] His life is presented to the popular imagination as comprising wild parties, naked women, and limitless pleasures.

That is why people consider vengeance a form of tradeoff for a political position that is not allowed to be voiced. Talking about a sexual scandal is not on the list of forbidden practices, while approaching the truths of political and economic corruption brings trouble, perhaps calamity. Thus, with every new scandal society holds faster to aspects of conservative behavior, as a reaction to the corruption of the elite.

A society starved of freedom of speech survives on scandals, and social mores intersect with politics to the point that puritanical and extreme conservative behavior and attitudes come to be considered the height of dissent. We do not 'disagree' with a high official or minister of the government on issues of political corruption, or take offense at his policies. Rather, we take issue with him only if he becomes the protagonist of a sex scandal. In other words, political misdemeanors are not an issue; rumors of a relation with a dancer or an actress are what count because the dancer in the popular imagination is supposed to enjoy more freedom and outrageousness. She is the other side of authority, with its bullying and power struggles and battles for control; she is the other side of wealth, with its capacity to buy bodies and souls. The man of power or wealth finds his 'freedom' in the dancer, while she finds her 'influence' and 'bank account' in him.

Thus rumors spread a short while ago that a famous dancer had decided to publish her memoirs. This was followed by news of the consternation of some highly placed politicians who feared that their names would appear in the book. Some were said to have tried to buy her silence, while others were reported to have threatened her. This appears to be a story inspired by Sartre's play, *The Respectful Prostitute*, around whose axis turned many an Arabic

literary work (among these is a play of nearly the same title, by the late writer and politician Fathi Radwan, and a story by the journalist and novelist Ihsan 'Abd al-Quddus, which was turned into a film called *al-Raqisa wa-l-siyasi* (The Dancer and the Politician).

The theme of the 'virtuous prostitute' features yet another aspect: exposure. Exposure in a conservative society evokes violent reactions. Thus the story of the famous dancer and her memoirs resembles popular stories in which people look for reasons for passive vengeance against men of power and celebrities.

The interesting thing is that a number of state apparatuses join in the game of attacking corruption; there is invariably talk of sexual bribery and listening in on telephones. At the same time, these same apparatuses provide the market of scandal with the 'evidence' caught at the scenes of those crimes.

Dina is the latest victim of this type of 'democracy.' It is amazing that for a long time Dina's clothes were a problem for the authorities. The length and transparency of her dancing outfits were topics of debate between this star of dance and the vice police. Dina is provocative and outspoken, and cleverly exposes her body, whose measurements are ideal for Oriental dancing. Her talents lay not so much in dancing, as in the way she revealed her body while dancing. But she also wanted an extra advantage. She insisted on continuing her education. After she was expelled from the Institute of Theater Arts she enrolled in the Department of Philosophy at Ain Shams University, where she eventually graduated and spoke of obtaining an MA and even a PhD.

Her education, however, has placed her in an odd position and was subject for ridicule. She was already one of the highest paid dancers on the scene. Her body was a hot commodity. Her competitors were Fifi Abdo and Lucy, each of whom earned LE25,000 an hour, especially on New Year's Eve.[14] She was no longer a second-rate entertainer, but a star, acting in cinema, theater, and video clips. If she was not a professional actress, she was more than capable of representing the 'out-of-order' female escaping the *harem*'s high fences. Once again freedom—her audacity and cheek—was less popular merchandise than her dancing. But she was an important sign denoting a certain type of daring and license.

Who bought such freedom? To begin with, the affluent who could afford paying the bills at nightclubs, which have changed addresses from the notorious Pyramids Road to reputable hotels.[15] This came about as a new entrepreneurial class of businessmen entered the arena, coming, by and large, from the middle classes. The members of this class generally wished to distance

themselves from those who had amassed their fortunes during the 'open door' policies of the previous era, since the latter typically came from less prestigious social backgrounds and were judged to be uncultured and uncouth.

Dina also came from the middle classes and was very ambitious and nervous. She had the experience of her older sister, Rita, to worry about. Rita started as a singer and then suddenly donned the *hijab*, and eventually the *niqab*.[16] In other words Dina was caught between her family's notion that education provides the way to social mobility, and the rationale of the 'quick buck' mentality prevalent in the seventies as a means to escape the impending failure to which the 'loser' middle classes were subject. In the midst of all that, Dina lived an unstable life, marrying and divorcing, and generally was surrounded by malicious rumors. She parented a child whose father died of cancer, and began to contemplate taking on the veil herself.

This happened in parallel to her rise in the field of dancing as a serious competitor to others of her generation. She played the game of freedom to the full, making her social life a burning flame, ready to singe her at every turn, which is exactly what happened when she fell prey to a tycoon who was also a politician.

Was Dina really free in parading her 'freedom' each night on the dance floor? Or was she captive to her own concocted image? Did she veil as a symbol of curbing that freedom, and as an apology for her 'shameful' past? Or was she declaring her initiative and freedom of choice this time to erase the image that had been fed by her ambitions and propagated by the social machine?

Whatever the answers, the fact remains that Dina is the star who suffered an incident of deep humiliation at the hands of a businessman obsessed with secretly viewing women. Unbeknown to her, he took pictures, invading her humanity and privacy. Once more her 'freedom' became a commodity in the market of taboos in Egypt.

The shock was no doubt too much to bear, and so she took off to Mecca for pilgrimage, veiling upon her return. Naturally, this change pleased the fundamentalists and their allies, as well as the moral conservatives. But it appears that there are other signs behind Dina's veiling. She may have wished to run away, become anonymous, to disappear between the lines of veiled women. Today the veiled woman is socially advantaged. The *hijab* is a sign that the wearer accepts prevailing social norms. The message she sends is one of chastity and obedience. She places herself almost beyond moral suspicion, innocent until proven otherwise. The *hijab* is a license to social mobility.

On the other hand, the unveiled woman is considered immodest and has to prove she is beyond reprimand. She remains a rebel, nonconformist, until she succumbs and returns to the fold. None of these women thinks of the issue in legalistic religious terms. She does not consider herself chosen, but rather that she is performing a duty. That is what I have heard. And so it seems that Dina was put at ease by the fact that someone else, someone hidden, has taken the decision to veil for her.

But why after this breathless rhythm, oscillating between exposure and hiding, does Dina return to the lights, to New Year's Eve parties, and with her new stories about her risqué dress?

Ruby and the revolution of sound and navel[17]

Ruby came as a shock in an atmosphere in which 'clean art' was being propagated. Every actress would speak with pride about her morally pure stance. That was an eye-catching phenomenon. It is the artistic side of the *hijab* phenomenon among the middle classes. At the same time, it is met by complete licentiousness, expressing the need to escape rotting traditions. On the other side stood the hawks of conservatism.

So it appears that the songs of today are similar to those of the old days, when the queen of *tarab*, Munira al-Mahdiya, reigned, deploying the *hank wa rank*, (in the words of Fathy Ghanem) ". . . the soft undulations in song, invented by Muhammad 'Uthman in the days of Khedive Ismail and his ostentatious soirees,[18] when the singer spent ten consecutive hours playing up and down the whole range of his voice, while repeating a single poetic sentence. Munira al-Mahdiya was a virtuoso in this type of song, using vocal hoarseness to create sexual innuendo, just as some American singers do today in their dance songs" (Ghanem 1966, 17).

Munira al-Mahdiya's approach is quite similar to that of Nancy, Haifa, and Elissa.[19] Elissa has stated that in a song 50 percent goes to voice, 25 percent to presence, and the rest to femininity. She does not deny that she wishes to sweep men off their feet through the display of that femininity. In a duet with Ragheb Alama she resorts to that technique via the effective use of eyes and mouth. Haifa has even said that she is not a singer. Nancy does not depend on her voice alone; rather, as she has stated in interviews, she mixes the femininity of Hind Rostom and the coy but no less inviting Shadia.[20]

This return to *hank wa rank* may constitute a shock now, but it is amazing that when Umm Kulthum herself first appeared she shocked the critics, who complained of the loss of the undulating softness that had thus far been the

order of the day in tasteful performances. Taste was changing, as all things do. Umm Kulthum turned against prevailing tastes when she appeared, but she created a new one. Today it is the adherents and fans of Umm Kulthum's style who oppose the new trends as a 'chaos.'

This is a type of extremism, because this 'chaos' is merely a sign of the desire for change, perhaps even a rebellion against the stagnation of the moral code and its hypocrisies: secret or temporary marriage; seeking the latest scandal in the papers.

We can also point to the appearance of Nancy, Haifa, Elissa, and (later) Ruby as concurrent with the teenage fashion of exposing the navel. The phenomenon of the naked navel first exploded on Lebanese satellite television, before finding its way to the streets of Cairo. It presents a kind of excitement that is not taboo in a direct sense. The navel belongs neither to the upper nor the lower erogenous zones, but insinuates both. It appears innocent enough but certainly erotic. For the traditional man of the lower social strata, such a fashion is an invitation to sex and a means of animating their images of a world of sexual freedom, according to popular stories about the sex life of the rich, who supposedly exchange wives and sleep with their own daughters. The fashion was spread through satellite television and was clearly playing on sexual repression, especially in the Gulf area. Here the style of the naked navel circulated, and with it the flirtatious attitudes of teenage girls.

It is not strange that more than one of today's female stars first appeared as a satellite TV announcer (Razan, Haifa, and Danya) or on a talent search program (Elissa on *Studio El Fann*, Nancy on *Studio al-mustaqbal*).[21] With satellite channels, the art of the video clips broadened, to become nearly an independent art, neither song nor drama, but a mixture of both, providing endless opportunities.

The beauties of Lebanon have excelled in this new medium, because the video clip became a scene for freedom from the old forms (traditional singing, for instance). No longer was performance measured by vocal beauty or talent; rather the measure became the capacity to perform. The Lebanese mentality combined with Gulf financing, transforming the scene to a daring bodily expression.

The formula for success in a society that innovates a new type of sexual excitement via satellite television attempting to circumvent all the censors (religious, moral, and social), a society that does not accept sex movies can easily accept video clips and naked navels.

While it is difficult to imagine Arabic channels broadcasting sex movies, ordinary audiences watch musical channels *en famille*. Hence the sexual advances of Elissa's would-be lover (a European model) are available to millions of teenagers. The director even concentrates on thirsty lips as a way to differentiate her from others, such as Nancy, whose movements and image are the repository of her femininity.

Nancy is still young, and does not hide the four silicon surgeries she has undergone (exaggerating rumors speak of 18). She coyly reminds people that she started singing at the age of twelve but that she is different now. It may be because her agent, Gigi Lamara, is the one who changed Aline Khalaf from a classic Lebanese singer to the 'rocket' (to use the modern business jargon) she is now. When Gigi left Aline, she was no longer in the spotlight. The lights all went to the dominant star, Nancy. In other words, the agent plays the role the composer played in previous times. He not only selects the music, but also the image, the 'look' of his star. The Lebanese have proven very good in that area. (Lebanon's female stars are a continuously renewed advertisement on the making of a 'look'; plastic surgery centers even feature what is called "the Lebanese look").

Haifa's agent has selected the breasts, making her appear, in the end, like a Ninja warrior: a wild provocation. Like Elissa, she had been a fashion model, and the second in line for Lebanon's beauty queen. (Her title was rescinded when the committee discovered she was married.) In other words, she came to song as from another world. It is a somewhat different world from the time when Nawal Al Zoghbi (b. 1972), Pascale Machaalani (b. 1964), and Diana Haddad (b. 1976) were working as models, and then reinvented themselves into song (at a time when Egyptian female voices were in a quandary, pulled between the dominance of Umm Kulthum, the lightness of Shadia, and the level-headedness of Nagat). These now appear classical and old-fashioned in the shade of the new 'rockets' of sensationalist excitement on video clips. While the industry seems to have achieved a degree of proficiency (as attested by the video clips of Elissa and Nancy), the shock to public taste and the endless variations on the feminine capacity to seduce remains a Lebanese game. We mean the clever ones of Lebanon, because there are in Lebanon secrets that cannot be detected in the revolutions in sound and navels!

References
Hanem, Fathi. 1966. al-Kitab al-dhahabi. *Rose al-Youssef,* June 1966.

Notes

1 [Sherine Abdel Wahhab (aka Sherine) is a popular Egyptian singer, born in Cairo in 1980, and highly acclaimed for her superb vocal abilities. –Ed.]

2 [Originally from Port Said (Egypt), Amr Diab (b. 1961) is regarded as one of the Arab world's most popular singers. –Ed.]

3 [Rania Hussein Tawfiq (aka Ruby), born in 1981, is a popular Egyptian singer, dancer, and actress. –Ed.]

4 [Youssef Chahine (1926–2008), director, writer, producer, and actor, was one of Egypt's most illustrious and accomplished filmmakers. His first film, *Baba Amin* (Father Amin), appeared in 1950. –Ed.]

5 [Dhikra Muhammad `Abdullah al-Dali (aka Zikra) (1966-2003) was a popular Tunisian singer, highly regarded by critics for her fluency in traditional Arab singing. –Ed.]

6 ["Friday, 28 November, 2003, 16:39 GMT, BBC News: *Tunisian singer shot by husband.* A popular but controversial Tunisian singer has been shot dead by her businessman husband in Egypt. Police said Zikra was shot with a sub-machine gun by her husband Ayman Suwaydi, who also killed himself and two other people. Reports says neighbours heard the couple arguing before the killings. Earlier this year a Saudi cleric said Zikra should face the death penalty for comparing her sufferings to those of the Prophet Mohammed. Police say Zikra was found with 15 bullet wounds to her head. The other two people who died in the shooting incident, at Zikra's Cairo home, are believed to be business associates of the couple. The 42-year-old singer was a well-known figure in the Arab world and had lived in Egypt for several years. She recently had a domestic dispute with her husband—whom she married last summer in France—which went to court" (http://news.bbc.co.uk/2/hi/middle_east/3247556.stm (July 6, 2010)) –Ed.]

7 [A *faqih* is a Muslim scholar learned in *fiqh*, the traditional Islamic sciences of jurisprudence, as based on Qur'an and Hadith. A *fatwa* is a legal ruling by such a scholar, based on traditional Islamic law. –Ed.]

8 [Gamal Abdel Nasser, who led Egypt from the 1952 Revolution until his death in 1970, formulated an 'Arab socialism' with Soviet support. But these policies were discredited following Egypt's 1967 defeat. After the 1973 war, Nasser's successor, President Anwar Sadat took a new tack with his 'open door' policy *(infitah)*, promoting laissez-faire economics, and opening the economy to foreign investment and imports, in the hope of attracting foreign capital. Culturally and politically, the *infitah* was a move toward the West. Many got rich quick; many more were gradually impoverished. –Ed.]

9 [Dina (b. 1964) is one of Egypt's greatest belly dancers, and perhaps the fore-
 most exponent of *al-raqs al-sharqi* ('Eastern dance') worldwide. Talented, intel-
 ligent, and highly educated (she received an MA in philosophy from Cairo's
 Ain Shams University), Dina is also a film and television actress and a singer.
 A tremendous scandal erupted in 2002, when a videotape showing her in bed
 with Hossam Aboul Fotouh (one of Egypt's most prominent businessmen) was
 leaked and distributed as pornography through the extensive underground video
 CD market. Aboul Fotouh was being investigated for tax and customs evasion,
 and illegal possession of firearms. Some believe that the video was leaked by the
 prosecution when Aboul Fotouh was arrested and his possessions confiscated.
 After the scandal broke, it was alleged that Dina and Aboul Fotouh had been
 secretly married at the time of the taping. –Ed.]

10 [*Hijab*: a veil, usually meaning the woman's veil, ranging from a simple scarf
 covering mainly the hair, to a *tarha* concealing also the neck, but leaving the
 face exposed. –Tr.]

11 [*al-Khatt al-ahmar* (the red line) denotes the implicit limits to press freedom
 in the Arab world, the unspecified edges of censorship, whose contours shift
 according to the politics of the day. The game of Egyptian journalism entails
 that editors and writers must attempt to negotiate a path passing as close as
 possible to this imaginary line, without crossing over into the forbidden zone.
 –Ed.]

12 [*al-Rawd al-'atir fi nuzhat al-khatir* by Shaykh Muhammad Nefzawi (fifteenth
 century), and *Ruju' al-shaykh ila sibah*, attributed to Ibn Kemal Pasha (d.
 1535) are Arabic erotic works: traditional sexual manuals, relying on medicine
 and psychology to enhance pleasure, and treat sexually related diseases. –Tr.
 and Ed.]

13 [*Haram*: what is forbidden by religious law. –Tr.]

14 [In 2008, LE25,000 was equivalent to about $4,600. –Ed.]

15 [Shari' al-Haram (Pyramids Road) extends approximately 10 km west, from Cairo
 to the pyramids at Giza. The Pyramids Road area is famous for its nightlife.–Ed.]

16 [*Niqab*: A veil, usually black, covering the face, worn over a free-flowing long
 dress to ensure that no part of the female anatomy—except perhaps the eyes—is
 visible. –Ed.]

17 [The translation conceals a pun. The subtitle of this chapter is "*Thawrat al-sawt
 wa-l-sura*" (The revolutions in voice and image). The present heading is "*Ruby wa
 thawrat al-sawt wa-l-surra*" (Ruby and the revolution in sound and navel). –Ed.]

18 [The Khedive Ismail (1830–95) ruled Egypt in 1863–79. He was also a generous
 patron of the musical arts, both Western and Arab. Muhammad 'Uthman was

one of the most famous composers and singers of the latter nineteenth century. Munira al-Mahdiya (d. 1965) was a celebrated female Egyptian singer prominent in the early twentieth century. –Ed.]

19 [The author refers to three contemporary Lebanese popular singers, who have become superstars since 2000 or so, in the era of satellite TV. Elissa M. Khoury (aka Elissa; b. 1972) initiated a public singing career with a silver medal on the LBC television program, *Studio El Fann*, in 1992. Haifa Webe (b. 1976) became a singer after a successful modeling career. Nancy Nabil Ajram (b. 1983) came to public attention after winning a gold medal in a televised Lebanese music competition, *Nujum al-mustaqbal*, at the age of twelve. –Ed.]

20 [Actress Hind Rostom (b. 1931) was Egypt's sex symbol par excellence; actress Shadia was born in 1929. –Tr.]

21 [All three are Lebanese. Razan Moughrabi, presenter, actor, and singer, started her career as a presenter on Future Television (www.razanmoughrabi.com). Danya Khatib (b. 1973) also started out as a television announcer. –Ed.]

15

Real-politics: Televised Talent Competitions and Democracy Promotion in the Middle East

Katherine Meizel

In 2004 a show called *Talents* debuted on al-Iraqiya, a localized terrestrial television channel funded by the U.S. Department of Defense. *Talents* was the brainchild of the 101st Airborne Division in Mosul, specifically a project of their psychological operations team. That a televised talent competition might be used to steer Iraqis away from the anti-American outlook of Arab satellite channels (Garrels 2004) is not so surprising, at a moment when pop culture and politics intersect in a proliferation of similar programming all over the world. It's not a new idea, and not an Iraqi one, but a descendant of traditions like the intensely politicized Eurovision Song Contest and of various turn-of-the-millennium reality television formats. As James Friedman has remarked, the recent domination of reality programming—a nebulous category with a wide range of subgenres—does not indicate a sea-change so much as a marketing strategy; it is not a new product, but a new sales technique. He writes, "What separates the spate of contemporary reality-based television from its predecessors is not the form or content of these programs . . . but the open and explicit sale of television programming as a representation of reality" (Friedman 2002, 7; also cited in Holmes and Jermyn 2004, 5).

Therein lies the source of much talk, both within and outside of Arab nations, that imbues participatory television with direct democracy-advancing powers. Viewer participation, the chance to compete, or the chance to vote

291

for a contest winner, can be sold and experienced as real political action. Even if it cannot truly determine any policy or select a governmental representative, such programming nevertheless figures discursively in the negotiation of regional, national, and diasporic political identities. The reality of any talent-show politics is defined by its multivalence, the fact that it is inscribed with layered meanings in many contexts.

The current wave of talent contests was catalyzed by the colossal success of a particular franchise known as *Idols*.[1] When British entertainment executives Simon Fuller and Simon Cowell set out to peddle their new reality TV show to American television networks, the idea was to sell it as a story of "the great American dream" (King 2006). The project was turned down, so Fuller, the CEO of 19 Entertainment,[2] and Cowell, in A&R (Artists and Repertoire) at BMG, took it home across the Atlantic and in the fall of 2001 made it into the U.K. sensation *Pop Idol*. The next year, they finally managed to sell the American Dream back to America in a U.S.-specific *Idol* series, and when that flourished, they also quickly dispensed the Dream to Canada, Australia, Germany, the Netherlands, Belgium, Norway, Poland, and South Africa, and to the Lebanon-based Future TV with its regional and pan-Arab show *Super Star*. Other localized series followed, and as of 2008 the *Idols* franchise claims more than forty versions past and present.[3] This means that more than forty territories have had a tailor-made national or regional *Idol* program, with some created for a single country and some broadcast to large geographical areas, involving a number of participating nations.

On the surface of this programming, it initially seems clear what's for sale—albums on Sony/BMG labels, Ford cars, cellular plans, Lipton tea, Coca-Cola. But there's something else at stake, too. It's a flashy two-for-one package that neatly wraps up the exquisitely political action of voting and the Hollywood version of the American Dream, in the perfect commodified marriage of democracy and capitalism. Each of these series is infused with variants of the narrative Fuller and Cowell associate with the American Dream, the understanding that an ordinary person might transcend an unsatisfactory socio-economic situation, become recognized as extraordinary, and make his or her voice heard.[4] It is by no means a purely American condition to dream of a better life, but the *Idols* version of the Dream is deeply infused with ideologies of American capitalism, in which Hollywood-style fame is synonymous with commodification, and of an idealized democracy understood as the offer of equal opportunity.

The worldwide reach of the *Idols* franchise underscores the continuing reconfiguration of this concept in the intertwined contexts of transnational industry and global politics. And *Idols* was really only the beginning; since *Pop Idol* debuted in 2001, dozens of similar talent-competition formats have launched singers' careers through other local and international franchises (for example, Endemol's *Star Academy* chain,[5] a regional version of which has overtaken *Super Star*'s popularity in the Arab world). Of the psy-ops project in Iraq, NPR reported that "the idea behind the *Talents* show was to show that in post–Saddam Hussein's Iraq, there's a chance for everyone to share the spotlight regardless of family position or personal politics" (Garrels 2004). The dissemination of that American Dream-like ideology of equal participation is a key consideration in the analysis of the millennial transnational media industry. This chapter draws on observations made tangentially to my study of *American Idol*, which has its own global presence, and influence on other programming (Meizel 2007a). In the end, what at first glance appears to be a superficial, commercially driven reality TV format becomes a symbol and factor in the negotiation of geopolitical realities.

Regional talent competitions in globalized forums

In addition to the Mosul-centered *Talents*, Iraq has also seen a show called *Iraq Star*. It is designed in a near-facsimile *Idols* format (but is not affiliated with *Idols*) and airs on the Iraqi satellite network al-Sumaria, based in Beirut. *Iraq Star* received international media attention for an emotional 2005 performance delivered by a twelve-year-old boy, mourning the country's devastated situation (Jaafar 2005; Raghavan 2006; Who Will Become the Next "Iraq Star"? Stay Tuned 2006; Iraqis Cheered by Pop Idol Show 2005). It has also been noted in the Western press for being filmed in the security nightmare of beleaguered Baghdad, at a studio just blocks from the International ('Green') Zone and subject to interruption by the noise of military helicopters (Jaafar 2005). The show, co-existing in literally the same space occupied by U.S. democratization efforts, takes a clearly articulated political stance. In 2006 one *Washington Post* journalist pointed out the buttons worn by the director, judges, and cameramen at pre-season auditions, reading "For the Unity of Iraq" (Raghavan 2006).

'Unity,' in diverse forms, is a trope of *Idols*-style competitions, and is strongly connected to the participatory politics of the interactive format. The idea is often encouraged in the rhetoric of the shows themselves but does not always manage to trump conflict. As Marwan M. Kraidy points out,

expressions of pan-Arab regionalization are countered on the reality TV screen by articulations of rivalry among Arabs with different national allegiances (Kraidy 2005, 8). Among the few *Idols*-franchise series built on the larger, multinational scale, Future TV's *Super Star* has consistently stood out as a theater where intra-regional politics are performed as entertainment. What is played out in each weekly broadcast constitutes a drama of competitive nationalism, juxtaposed with the vocabulary of 'pan-Arab' unity (see Kraidy 2005; Lynch 2005; Meizel 2007b). In spite of the pan-Arab angle touted in the show by producers and in Western media, nationalized voting has remained a defining element of *Super Star*. With contestants granted official government-sponsored *Super Star* campaigns and official endorsement by important political figures, and with nation-specific phone services offering discounts to those who vote for a national representative, it is no wonder that such voting becomes a patriotic obligation, 'a national duty' (Pan-Arab Song Contest Fuels Passions in Jordan 2003).

This feeling is furthered by the devastating effects of ongoing conflict among Arab nations. Some of these tensions have directly impacted Lebanon, where *Super Star* is produced, and have contributed to the controversy surrounding the show. Such troubles have included the Syrian occupation of Lebanon (until April 2005), the 2005 assassination of former Lebanese Prime Minister Rafik Hariri, who owned Future TV (and whose slaying was rumored to be a Syrian act), and the 2006 destruction of Beirut by Israeli bombs. Competition between Lebanese and Syrian contestants has sometimes led to competition and hostility among Lebanese and Syrian viewers. Toward the end of the first season, *Super Star*'s Beirut studio audience erupted into an outright brawl after Lebanese contestant Melhem Zein was eliminated, a voting result that provoked suspicions of Syrian vote manipulation (Saoud 2003; also cited in Lynch 2005).

Other political strain has come from the situation of Palestinians and the ways in which Arab nations have addressed it, a problem foregrounded in reality television when the second season of *Super Star* came down to Ayman al-Aathar, a Libyan medical student, and Palestinian musician Ammar Hassan. The Palestinian Ministry of Culture in Gaza supported Hassan and planned a public viewing of the season finale, but when the end of the competition coincided with an escalating hunger strike carried out by thousands of Palestinian prisoners in Israeli detention centers and prisons, the more directly political cause won out. Members of Hamas denounced the allocation of funds for the support of *Super Star* and Hassan, feeling that the prisoners' plight was being

neglected in favor of a frivolous pursuit (Toameh 2004). A similar argument arose after the U.S. entered Iraq, with the Islamic Action Front—the Jordanian political branch of the Muslim Brotherhood Movement (Mroue 2003)—and even Mu'ammar al-Qaddafi (In Pictures: Arab Pop Idol Finale 2004) expressing strong concern that Arabs were casually singing as Iraq burned, that the show might distract people from the more serious problem of the war.

Linked to the notion of unity, a difficult balance among intertwined levels of political identity—ethnic, national, regional—has proven to be an outstanding theme throughout many *Idols* and *Idols*-inspired talent competitions. Contestants become cultural representatives of identity-based communities, and, as part of the Hollywood-style dream for which they are reaching, often bear a substantial burden of responsibility as they sing. Fame imbues contestants with an intensified version of the responsibilities that accompany fulfillment of the American Dream. With success comes a duty, a mission to inspire others to succeed as well. The Dream positions those who live it as public role models for other individuals, and identity often plays a part.

When Iraqi-born Shadha Hassoun won the fourth season of LBC's multinational *Star Academy* in March 2007, al-Sumaria reported that she dedicated her victory to "the Iraqi people who came together regardless of their religion," and that she would now "hold the message of unity and peace . . . representing to the Arab World the new Iraq" (Iraqi Shaza Hassoun Star Academy Winner 2007). Upon being named the winner, Hassoun immediately wrapped herself in the very specifically Iraqi flag. This flag has a history that underlines the show's tenuous double emphasis on local and pan-Arab nationalisms—there are three stars that once symbolized a never-realized hope for a union with Egypt and Syria, and then during Saddam Hussein's dictatorship were recontextualized to represent the three tenets of the Ba'ath party (unity, freedom, and socialism). During his administration, the *takbir* on the flag (*Allahu akbar*, or God is greater) was purported to be in his own handwriting. In 2004, after his removal from power, the script was changed, and this is the flag Hassoun took as a mantle on her shoulders.

Hassoun bore the responsibility of uniting her country of origin and of representing it in the larger context of *Star Academy*. Her cosmopolitanism as an Iraqi living in Morocco (her mother is Moroccan) also underscores the complicated construction of Arab identity in diaspora, as does the case of *Super Star* 4's runner-up Saad Mjarred, a Moroccan singer who had been living in New York before his successful audition. And the fact that *Super Star* 4 expanded its audition tour to three North American locations (Los Angeles,

where *Super Star* 3 had previously held auditions, Detroit, and Montreal) also indicates a broadened entertainment-industry definition of 'pan-Arab' unity that extends beyond geographic region to emphasize broad, composite ethnic and cultural identities. It is perhaps significant that the Los Angeles auditions took place in the city most associated with the American Dream, and the episode covering that location even included footage of the iconic Hollywood Walk of Fame. In its new transnational context, though, it is a Dream dislocated.

In 2003, *Super Star*'s first winner, Diana Karazon, was assigned a set of responsibilities even more complex than Hassoun's, first representing Palestinians and the nation of Jordan in the regional *Super Star* competition, and then representing the "Arab world" in the one-off event *World Idol*. When she won *Super Star*, she declared her gratitude to "the people of Lebanon, Jordanians, on top of them his majesty King Abdullah, and the children of Palestine" (Mroue 2003). On December 25, 2003, the newly elected pop star Karazon stood onstage in a London television studio to represent the "Pan-Arab Nations" in *World Idol*, an international re-working of the *Idols* competition. The judges offered Karazon cautious praise, three of them[6] calling her "brave" for choosing to perform in Arabic and to "sing in a completely different way," and one telling her that he was "very proud to be part of a program that can embrace a culture like [hers]" (World Idol 2003).

The contest was the culmination of the first three years of the *Idols* franchise. By then, 19 Entertainment and Fremantle Media had established more than twenty *Idols* series internationally, all following the universal format in which votes from a geographically determined audience propel a young singer to stardom. Like the similarly structured, though much larger, Eurovision Song Contest *World Idol* carried strong political overtones. Many choices in language and symbolism seemed quite consciously planned as political—early in the Christmas Day broadcast, co-host Anthony McPartlin declared, "Look at what we're doing here—it's like the United Nations of pop!" (World Idol 2003). Correspondingly, introductory graphics during the preliminary credits had featured a glossy, computer-generated figure striding along an avenue of flags evocative of those lined up outside UN headquarters in Manhattan. This allusion was augmented as the camera panned the assorted flags clutched by audience members inside the Fountain Studios. The eleven contestants were critiqued by eleven judges from their respective series, judges whose nationalities were further indicative of the fluid boundaries of the worldwide music industry. It is worth noting, for

the sake of illustrating both the transnational and monopolistic qualities of that industry, that not only the judge representing the U.K.'s *Pop Idol*, but also the U.S., Australian, and German judges, were British in origin. The politics of *World Idol* comprised not only an atmosphere of nationalist competition, but also an overarching multiculturalist sensibility and emphasis on unity.

The first season of *Super Star* involved the participation of the twenty-two nations in the Arab League, and all their concomitant political frictions. *World Idol*, which brought eleven series winners together to vie for a global title in front of eleven series judges and millions of viewers, overlooked the intense internal conflicts among *Super Star*'s participating countries in favor of the idea of a united 'pan-Arab' region. Precisely what culture *World Idol* was "embracing," as Australian judge Ian Dickson phrased it, was unclear, because it was subsumed in the monolithic "Eastern music" admired by his colleague, British judge Pete Waterman (World Idol 2003). The conflation of regional, ethnic, and cultural 'Easternness' played into the show's presentation of Karazon. She was identified during the show as the 'pan-Arab' (or sometimes 'pan-Arabic') contestant, not assigned to a nation, though when the camera panned to her adoring fans, they were clearly holding Jordanian flags. Onscreen in the broadcast edited for the U.S., the words 'pan-Arab' also appeared beneath the name of Elias Rahbani, the designated judge from the *Super Star* series. While hosts Anthony McPartlin and Declan Donnelly did note that "twenty-two nations" had participated, neither the Arab League nor the countries involved in *Super Star* were ever named outright on *World Idol*.

As in the Eurovision Song Contest, which introduced the idea of a popular vote submitted via telephone in the late 1990s (a few years before the *Idols* format emerged), *World Idol* was an international election. Also as in Eurovision's system, the vote was weighted to mitigate the potential dominance of more populous contingencies. Viewers were not allowed to vote for the representative of their own national or regional contingency, so each singer automatically received the maximum of twelve points from their *Idol* show's geographic area. Beside the twelve points from her 'pan-Arab' viewers, Karazon's highest score came from the U.S., which placed her fourth. Most other contingencies placed her toward the bottom of their lists.

The weighted voting was unfamiliar to many viewers, as it was significantly different from the process followed in individual *Idols* programs. In shows like *Super Star* and even *American Idol*, coalition voting based on

various identity factors, including (among others) geographical location, nationalism, regionalism, and local pride, practically defines the system. It also defines the results, providing a built-in market for a winning singer's post-competition albums. In *World Idol*, the winner, Norwegian Kurt Nilsen, placed second in most of the national/regional contingencies' votes (beneath the automatically-awarded twelve points for each contingency's own representative). This might have made him an overall well-liked candidate, but not a global pop star, and did not ensure that every contingency contained an eager market for his music. Americans who placed him second preferred to buy American Idol Kelly Clarkson's album, and they did. These results highlight the distinction between the direct democratic process hyped in *Super Star* discourse and the representative process established for *World Idol*—the latter of which, as one U.S. journalist noted, bore some resemblance to the structure of the American Electoral College (Stevens 2003).

The Idols-style election and democracy promotion

The *Idols* format is built on an inescapably political premise, a conflation of consumer choice and democratic process in which a nation-wide or region-wide audience votes to select a new pop star. Even in the context of what seems to be a light television diversion, voting is no idle act. Discourse about *Idols* programming suggests that the election of an Idol is a process inscribed with significant sociopolitical meaning. For example, *Super Star* made global headlines in August 2003, when the convergence of onscreen rivalries and regional political tensions that had been escalating all season finally erupted in a studio-audience uprising. David Lyle, President of Entertainment and Drama for Fremantle Media North America (part of the corporation that produces and distributes *Idols* shows), attributed the incident, an intense reaction to the season's penultimate vote, to what he viewed as the regional novelty of the democratic process in Arab nations. Furthermore, he suggested that the *Idols* enterprise actually had a role in the introduction of democracy there:

> Well, we did a pan-Arabic version. . . . And as that got to the sort of pressure point, there was a small riot in which some members of the audience . . . did resort to bringing out blades. You've got to realize that for many countries that pan-Arabic show went out in, this was the first time the public ever had to cope with something as unusual as voting, so it was a very novel moment for them—the idea of casting a vote, and probably even more novel, that the votes actually were counted correctly and the right person won. (Gladstone 2003)

Lyle's comments indicate that *Idols* producers see explicit political content in the design of their show. They are not the only ones. In 2003, after Diana Karazon won the first season of *Super Star*, Beirut *Daily Star* editor Rami Khouri told the *New York Times*:

> I do not recall in my happy adult life a national vote that resulted in a 52 to 48 percent victory. . . . Most of the "referenda" or "elections" that take place in our region usually result in fantastic pre-fixed victories . . . so a 52 to 48 percent outcome—even for just a song contest—is a breath of fresh air. (Friedman 2003)

Idols has emerged at an historical moment when Western discourse and policy, particularly regarding Arab nations, are heavily focused on democracy promotion. With the *Idol* voting system and the mythology of the American Dream serving as commodified metonyms for democracy, critics often cite the shows as educational sites where democracy can be learned. They are examples of "democratainment," as John Hartley terms it, teaching viewers to be democratic citizens (Hartley 2004, 526). In 2006, the State Administration of Radio, Film, and Television in China placed restrictions on television programming patterned after *Idols*.[7] The Administration's statement asserted that talent shows must contribute to the maintenance of socialism, and that they must "have a favourable influence on morality" (Savadove 2006). When CNN's Larry King broached this issue in an interview with *Idols* co-creator Simon Cowell, the music executive replied,

> Well, because it's a democracy, isn't it? You know, I mean, it's the public voting. So you can understand why they're getting slightly nervous about it. . . . And the public got to vote. And suddenly there were demos, and it was democracy. (King 2006)

Both the Chinese statement and Cowell's interpretation underline the symbolic weight of consumer choice reimagined as suffrage.

Despite the concentration of *Idols*-related economic power among a small number of transnational corporations, the inclusion of the audience vote implies a more democratic distribution of power. But the *Idols* franchise only becomes a vehicle for the transmission of a democracy that has been severely reduced, identifiable only through the iconic action of voting. In the case of *Idols* formats in the Arab world, as Marc Lynch states, the contributions of

reality television to "Arab democratization are rather more ambivalent than its enthusiasts might hope," the viewer participation possibly more important to the harnessing of new media technologies than to sociopolitical change (Lynch 2005). To begin with, as Lynch reminds us, parliamentary and municipal elections existed in Arab countries before *Super Star* came along, even if they did not generate any noteworthy results (Lynch 2005). So the claim that participatory television is introducing democracy to Arab states is, to say the least, exaggerated.

Additionally, what is being referred to as democracy is, in fact, little more than a political twist on the meritocracy promoted by the American Dream mythology, in which the *Idols* format is rooted. Lynch goes so far as to suggest that it might inhibit the growth of any real democratic behavior, as it has encouraged identity-based voting rather than policy-based voting (Lynch 2005). On the other hand, coalition voting also exists in the electoral politics of many firmly democratic states, including the U.S. The fact remains, either way, that *Idols* treats the election as a limited, emblematic stand-in for the totality of democracy as a political, economic, and social system. In 1961, Daniel J. Boorstin warned that the export of American cultural products, such as movies and television, transmitted around the world would result in the supercession of 'image' over 'ideal' (Boorstin 1962, 241).

And perhaps it is the *image* of democracy, in the election rituals played out on television screens everywhere, which dominates the current wave of democratization. The reduction of democracy to consumer choice, with its questionable implications of agency, establishes what Marc Lynch calls "democracy lite," a case of "form without substance" (Lynch 2005). Indeed, since the onset—or onslaught—of *Idols*, the political word 'vote' has taken on a number of extremely nonpolitical meanings in American and global media. Today what are simply opinion polls are renamed so that, for example, a question at CNN.com reading "Lindsay Lohan in crisis: Can her career recover?" (July 1, 2007) instructs readers to 'vote' yes or no. But, as the origins of al-Iraqiya's *Talents* imply, the political qualities of the talent competition format can also become a convenient, compact tool in the promotion of this incomplete democracy.

In 1996, William I. Robinson described how, since the early 1980s, U.S. promotion of democracy abroad has focused on the establishment of a particular type of political democracy known as 'polyarchy,'[8] in which the election is paramount. In polyarchy, popular participation in policy decision

is restricted to the election of leaders, in a process closely directed by competitive groups of elites (Robinson 1996, 623–24). This kind of democracy promotion centers on governmental forms only, at the expense of economic and social systems. For Robinson, the disjuncture constructed in polyarchy between governmental, economic, and social forms of democracy fosters an emphasis on democratic *process*—voting—over *outcome*. The shift to polyarchy from authoritarianism is also indicative of a new transnational emphasis on consensual forms of control over coercive ones (Robinson 2004, 83). As Robinson put it in 1996, economic globalization "provides the basis for the first time in history for world order based on a Gramscian hegemony" (Robinson 1996, 654). As a political symbol, the democratic election creates a sense of agency strong enough to cement this hegemonic state of consensual domination (Robinson 1996, 628).

In the context of Robinson's scenario, the establishment of transnational pop culture by transnational corporations offers a practical apparatus for consensual hegemony, and the *Idols*-based programs, at the very least, reflect this. John Fraim, president of the marketing, consulting, and publishing firm The GreatHouse Company, has written a compelling study of American popular culture immediately after 9/11. In *Battle of Symbols*, Fraim asserts that today, "leading symbols in an electric consumer democracy like America are products, people, places, and events, 'voted' into ascendancy (bottom up) rather than proclaimed into ascendancy (top down) by producers and leaders" (Fraim 2003, 47). He discusses symbols as "the core of soft power" (Fraim 2003, 34), a kind of power "composed of indirect cultural co-option" (Fraim 2003, 32; after Nye 2002b).

Joseph Nye's original concept of soft power situates it as a complementary strategy to the exertion of 'hard power,' that is, military and economic power. Where hard power is coercive, Nye writes, soft power is co-optive (Nye 2002b), and "the soft power that comes from being a shining 'city upon a hill' . . . does not provide the coercive capability that hard power does" (Nye 2002b, 239). He believes that both hard and soft power are needed for the United States to establish a "successful foreign policy in a global information age" (Nye 2002b, 239)—both co-option and coercion, in terms with slightly less negative implications than those evoked by the word 'hegemony.' Still, the 'soft power' of democratic symbols, of elections and the American Dream, entails the negotiation of power, through symbols tied to "institutions, values, culture," as well as "brands, services, software," and information technology (Fraim 2003, 32).

The impression of democratic agency afforded by the *Idol*-style vote goes beyond mere interactive consumption to sustain a polysemic variety of political meanings. If it is a form of "democratainment," then the *Idols* model may be considered an instrument of the latest democratization efforts, educating audiences worldwide in the processes of polyarchic democracy. It also reinforces a vast global network, in which the economic and the political are, as Sheldon Wolin has suggested, collapsed into a new entity, an "economic polity" corresponding to a transnational state (Wolin 2001, 571). And the global scope of the symbolic vote in *World Idol* in particular implies the potential existence of a transnational, emblematically democratic politics for that transnational state—a global political entity virtually defined by a globalizing entertainment industry. In the increasing transnationalization of popular culture and its industries, the meaning of Fuller's and Cowell's American Dream also expands and changes. Regarding the effects of globalizing processes in the United States, Jim Cullen discusses the American Dream as a "kind of lingua franca, an idiom that everyone—from corporate executives to hip-hop artists—can presumably understand" (Cullen 2003, 6). The idea that it might function this way, as a national common idiom, raises questions about its larger symbolic potential as the American pop-culture Dream is relocated in a transnational context.

The association of corporate industry with politics taps deep anxieties about the distinctions between democratic participation and participatory consumption. Cornel West writes with alarm about current perceptions of democracy, observing that certain "dogmas" are diminishing its meaning. In the dogma of "free-market fundamentalism," according to West, *freedom* has been conflated, or confused, with *free-market,* the market positioned as "*idol* and fetish" (West 2004, 3; my emphasis). Democratic decision is equated with pop culture consumption. If in the real-world (non-*Idol*) political arena, as Sheldon Wolin has written, "electoral politics [have become] assimilated to the practices of the market place" (Wolin 2001, 571; also quoted in West 2004, 24), then the structure of the *Idols* format is a glaring neon sign of its times.

Renske Doorenspleet observes that the post-9/11 U.S. administration seems now to expect its foreign policy to result in a fresh wave of democratization throughout the Middle East, initiated with the regime transition in Iraq (Doorenspleet 2005, 163). The idea that democratization has historically occurred in 'waves' was introduced in Samuel P. Huntington's 1991 book, *The Third Wave: Democratization in the Late Twentieth Century* (1991). A

wave represents a cluster of regime transitions from non-democratic (often authoritarian) to democratic, within a designated period. Additionally, these transitions must occur in greater numbers than reversals that shift regimes away from democracy (Doorenspleet 2005, 163). For Huntington, the latest was a third wave extending from the 1974 coup in Portugal (1991, 3) to the fall of the Soviet Union, shortly before the publication of his book. Analyses of democratization since that time have sometimes considered the years of decommunization, through the end of the twentieth century, to make up a distinct "fourth wave" (McFaul 2002; Doorenspleet 2005).

Doorenspleet builds on Huntington's model of transitions to democracy, but stresses a more explicit application of his operational definition of democracy. Her own version of the definition, a linear descendant of definitions put forth by Huntington, Robert Dahl (1971), and Joseph Schumpeter (1976), comprises the two major characteristics of *competition* and *inclusion* (Doorenspleet 2005, 15). These qualities encompass, respectively, systemic checks and balances, and unrestricted suffrage among adult citizens. In addition, Doorenspleet refers to the measurements of democratic competition proposed by Ted Robert Gurr et al. in relation to their Polity IV project (Gurr, Jaggers, and Marshall 2005), a widely respected database of regime information for all independent states. Among the traits listed in this formulation is a "[c]ompetitiveness of executive recruitment" (Doorenspleet's phrase) in which "subordinates" have "equal opportunities to become superordinates" (Gurr 1974, 1483; also quoted in Doorenspleet 2005, 24).

It would not be an outrageous stretch to recall here that this particular aspect of democratic competition is also vital to the competitive individualism championed in *Idol* interpretations of the American Dream. This competitive conception of the Dream, along with the interactive format of the audience-based election, has been performed in the thirty-eight total *Idols*-franchise variants around the world, and transmitted via *American Idol* itself to 113 nations.[9] The format's impact on the media industry is evident in the statistics. Among the broader regionally-based *Idols* shows, *Super Star* involves twenty-two participating nations plus contestants auditioning in North America; the now defunct *Pop Idol* included the U.K.'s four constituent countries; the West African *Idols* encompasses seventeen countries;[10] *Latin American Idol* broadcasts to six countries;[11] and the French show *Nouvelle Star* includes both France and French-speaking Belgium.[12] Thus, the different versions of *Idols* cover, by my count, eighty-three nations (plus the two North American audition sites for *Super Star*). According to the *World Almanac and Book of*

Facts (Nations of the World 2006, 747), as of 2005 there were 193 independent nations in the world (this number does not include dependent territories), giving localized or regionalized *Idols* programs a presence in 43 percent (or 44 percent counting those U.S. and Canadian audition sites) of all countries; *American Idol* alone is available in 58.5 percent of all countries. This is a lot of territory for ideas and ideologies of democracy to cover, and the above statistics include just the programming within the *Idols* franchise.

Conclusions

We know that popular culture both reflects and contributes to the construction of social realities. But it is not possible to guess now whether the kernels of democracy so widely disseminated through participatory television will ever grow into viable political systems. A show like *Talents*, created with the express purpose of endorsing democratic ideals, is a risky proposition, though apparently a gamble the U.S. military was willing to take. It is very likely that such programming will continue to impact the politicization of entertainment marketing. And if, as Marc Lynch proposes, the real power of reality television lies in the normalization of new technologies like SMS and the Internet (Lynch 2005), it is conceivable that these technologies, the sites where pop culture and politics converge most often, might themselves play a role in the negotiation of politics in the future.

While it is not easy to untangle what is negotiated onscreen from what is happening offscreen, it is clear that reality-show politics sells, particularly when it forecasts a brighter future in a struggling region. In uncertain times, feelings of helplessness on any side of a conflict might be allayed by a proffered sense of agency, no matter how ineffectual it proves to be. Regardless of their indeterminate capacity to effect actual structural change, the politics present in programs like *Talents* and *Iraq Star* is experienced as socially real—just as real as what is playing out in the streets of Baghdad.

References

Boorstin, Daniel J. 1962. *The image: or, What happened to the American dream.* 1st ed. New York: Atheneum.

Cullen, Jim. 2003. *The American dream: A short history of an idea that shaped a nation.* Oxford: Oxford University Press.

Dahl, Robert Alan. 1971. *Polyarchy: Participation and opposition.* New Haven, Conn.: Yale University Press.

Doorenspleet, Renske. 2005. *Democratic transitions: Exploring the structural sources of the fourth wave.* Boulder, Colo.: Lynne Rienner Publishers.

Fraim, John. 2003. *Battle of symbols: Global dynamics of advertising, entertainment and media.* Einsiedeln, Switzerland: Daimon.

Friedman, James. 2002. *Reality squared: Televisual discourse on the real.* New Brunswick, N.J.: Rutgers University Press.

Friedman, Thomas L. 2003. 52 to 48. *New York Times,* September 3, http://www.nytimes.com/2003/09/03/opinion/03FIE.html (March 6, 2004).

Garrels, Anne. 2004. Analysis: Efforts to enliven Iraq's new television network. January 28 *All Things Considered,* NPR.

Gladstone, Brooke. 2003. Idol worship. Interview with David Lyle. *On the Media.* NPR/WNYC. October 17. http://www.onthemedia.org/transcripts/transcripts_101703_idol.html (February 27, 2004).

Gurr, Ted Robert. 1974. Persistence and change in political systems, 1800–1971. *The American Political Science Review* 68 (4): 1482–1504.

Gurr, Ted Robert, Keith Jaggers, and Monty G. Marshall. 2005. *Polity IV data set,* August 10, http://www.cidcm.umd.edu/inscr/polity/ (December 11, 2005).

Hartley, John. 2004. Democratainment. In *The television studies reader*, ed. R.C. Allen and A. Hill 524–533. London and New York: Routledge.

Holmes, Su, and Deborah Jermyn. 2004. Introduction. In *Understanding reality television*, eds. S. Holmes and D. Jermyn. London and New York: Routledge.

Huntington, Samuel P. 1991. *The third wave: Democratization in the late twentieth century.* Norman: University of Oklahoma Press.

In pictures: Arab pop idol finale. 2004. BBC News World Edition 2004, http://news.bbc.co.uk/2/hi/in_pictures/3590136.stm (August 23, 2004).

Iraqi Shaza Hassoun Star Academy Winner. 2007. Al-Sumaria Iraqi Satellite TV Network 2007, http://www.alsumaria.tv/en/events-iraq-alsumaria-events/38-Iraqi-Shaza-Hassoun-Star-Academy-Winner.html (July 1, 2007).

Iraqis cheered by pop idol show. 2005. BBC News 2005, http://news.bbc.co.uk/2/hi/middle_east/4181696.stm (August 24, 2005).

Jaafar, Ali. 2005. "Star" lights up auds in Iraq. *Variety,* August 28, http://www.variety.com/article/VR1117928122.html?categoryid=1445&cs=1 (March 16, 2007).

King, Larry. 2006. Interview with Simon Cowell (transcript). CNN 2006, http://transcripts.cnn.com/TRANSCRIPTS/0603/17/lkl.01.html (March 17, 2006).

Kraidy, Marwan. 2005. Reality television and politics in the Arab world: Preliminary observations. *Transnational Broadcasting Studies*, no. 15, http://www.tbsjournal.com/Archives/Fall05/Kraidy.html (January 17, 2007).

Lynch, Marc. 2005. "Reality is not enough": The politics of Arab reality TV. *Transnational Broadcasting Studies*, no. 15, http://www.tbsjournal.com/Archives/Fall05/Lynch.html (January 17, 2007).

McFaul, Michael. 2002. The fourth wave of democracy and dictatorship: Noncooperative transitions in the postcommunist world. *World Politics* 54 (2): 212–244.

Meizel, Katherine. 2007a. America singing: The mediation of identity politics in *American Idol*. PhD dissertation, University of California, Santa Barbara.

———. 2007b. Idol thoughts: Nationalism in the Pan Arab vocal competition. In *A song for Europe: Popular music and politics in the Eurovision song contest*, eds. I. Raykoff and R. D. Tobin, 159–70. Aldershot, England and Burlington, Vt: Ashgate.

Mroue, Bassem. 2003. Arab world's "Idol" inspires patriotic fervor. Lawrence.com. August 19, http://www.lawrence.com/news/2003/aug/19/arab_worlds/ (November 27, 2009).

Nations of the World. 2006. In *The world almanac and book of facts 2006*, ed. W.A. McGeveran, 747. New York: World Almanac Education Group.

Nye, Joseph S. 2002a. The American national interest and global public goods. *International Affairs* 78:233–244.

———. 2002b. *The paradox of American power: Why the world's only superpower can't go it alone*. Oxford and New York: Oxford University Press.

Pan-Arab song contest fuels passions in Jordan. 2003. *Jordan Times,* August 17, http://www.aljazeerah.info/News%20archives/2003%20News%20archives/August/17n/Pan-Arab%20song%20contest%20fuels%20passions%20in%20Jordan.htm (February 17, 2004).

Raghavan, Sudarsan. 2006. In Iraq, singing for a chance at hope and glory. *Washington Post,* September 1, http://www.washingtonpost.com/wp-dyn/content/article/2006/08/31/AR2006083101675_pf.html (July 1, 2007).

Robinson, William I. 1996. Globalization, the world system, and "democracy promotion" in U.S. foreign policy. *Theory and Society* 25 (5): 615.

———. 2004. *A theory of global capitalism: Production, class, and state in a transnational world: Themes in global social change*. Baltimore: Johns Hopkins University Press.

Saoud, Dalal. 2003. Arab rivalry sours song contest. *United Press International,* August 14, http://www.highbeam.com/doc/1G1-106596309.html (July 1, 2007).

Savadove, Bill. 2006. China: Brakes put on TV talent programmes. *AsiaMedia: MediaNews Daily,* March 17, http://www.asiamedia.ucla.edu/article-eastasia.asp?parentid=41120 (July 1, 2007).

Schumpeter, Joseph Alois. 1976. *Capitalism, socialism, and democracy.* 5th ed. London: Allen and Unwin.

Stevens, Dana. 2003. Global domination: The *World Idol* contest promises to crown a god among amateurs. *Slate,* December 30, http://www.slate.com/id/2093302/ (July 1, 2007).

Toameh, Khaled Abu. 2004. PA pins hopes on its own "SuperStar" contestant. *Jerusalem Post Online Edition,* August 18, http://www.jpost.com/servlet/Satellite?pagename=JPost/JPArticle/ShowFull&cd=1092712292218 (August 22, 2004).

West, Cornel. 2004. *Democracy matters: Winning the fight against imperialism.* New York: Penguin Press.

Who will become the next "Iraq Star"? Stay tuned. 2006. *USA Today,* July 13, http://www.usatoday.com/news/world/iraq/2006-07-13-iraq-star_x.htm (July 1, 2007).

Wolin, Sheldon S. 2001. *Tocqueville between two worlds: The making of a political and theoretical life.* Princeton, N.J.: Princeton University Press.

World Idol. 2003. Fox Network, December 25.

Notes

1 Fremantle Media, the international production company that distributes these programs, lists '*Idols*' on its Web site as the name of the franchise in its totality (http://www.fremantlemedia.com).

2 In early 2005, 19 Entertainment was acquired by Robert F.X. Sillerman's New York-based company, CKX.

3 See Fremantlemedia.com. The count is actually thirty-eight in total.

4 Fuller and Cowell told CNN's Larry King in 2006 that their design drew on "the great American dream, which is somebody who could be a cocktail waitress one minute, within 16 weeks could become the most famous person in America." (King 2006)

5 *Star Academy* programming debuted in France and then in Spain (as *Operación Triunfo*) just weeks after the 2001 premiere of *Pop Idol* in the U.K.

6 Dutch judge Henkjan Smits in the version of *World Idol* edited for and broadcast to the U.S., Canadian judge Zack Warner, and British judge Pete Waterman in the version edited for and broadcast on Beirut's Future TV.

7 This incident, and media discourse about its implications for democracy, are also mentioned in Lynch (2005).

8 Polyarchic democracy is introduced and discussed extensively in Dahl (1971).

9 The Web site for 19 Entertainment (www.19.co.uk) listed this figure as of December 3, 2005.

10 As listed on the show's Web site as of July 1, 2007 (http://www.mnetafrica.com/idols/SiteSection/default.asp?Id=2), these include Benin, Burkina Faso, Cape Verde, Cote d'Ivoire, Gambia, Ghana, Guinea, Guinea-Bissau, Liberia, Mali, Mauritania, Niger, Nigeria, Saint Helena, Senegal, Sierra Leone, and Togo.

11 As listed on the show's Web site as of July 1, 2007 (http://www.canalsony.com/lai/), these include Peru, Colombia, Chile, Venezuela, Mexico, and Argentina.

12 Belgium also has a Flemish-language version, entitled *Idool*. My count of eighty-three nations acknowledges Belgium only once.